Seeing Medieval Art

rethinking the middle ages • volume one

SERIES EDITORS: PAUL EDWARD DUTTON AND JOHN SHINNERS

Seeing Medieval Art • Herbert L. Kessler

broadview press

National Library of Canada Cataloguing in Publication

Kessler, Herbert L., 1941-
 Seeing medieval art / Herbert L. Kessler.

(Rethinking the Middle Ages ; v. 1)
Includes bibliographical references and index.
ISBN 1-55111-535-2 (v. 1)

1. Art, Medieval. I. Title. II. Series.
N5970.K47 2004 709'.02 C2004-902910-X

Broadview Press Ltd. is an independent, international publishing house, incorporated in 1985. Broadview believes in shared ownership, both with its employees and with the general public; since the year 2000 Broadview shares have traded publicly on the Toronto Venture Exchange under the symbol BDP.

We welcome comments and suggestions regarding any aspect of our publications—please feel free to contact us at the addresses below or at broadview@broadviewpress.com.

North America:

PO Box 1243, Peterborough, Ontario, Canada K9J 7H5

3576 California Road, Orchard Park, NY, USA 14127

Tel: (705) 743-8990; Fax: (705) 743-8353
E-mail: customerservice@ broadviewpress.com

UK, Ireland, and continental Europe:

NBN Plymbridge
Estover Road
Plymouth PL6 7PY UK

Tel: 44 (0) 1752 202301
Fax: 44 (0) 1752 202331
Fax Order Line: 44 (0) 1752 202333
Customer Service:
cservs@nbnplymbridge.com
Orders:
orders@nbnplymbridge.com

Australia and New Zealand:

UNIREPS,
University of New South Wales
Sydney, NSW, 2052

Tel: 61 2 9664 0999
Fax: 61 2 9664 5420
E-mail: info.press@unsw.edu.au

www.broadviewpress.com

Book design and composition by George Kirkpatrick

PRINTED IN CANADA

For Suprotik Basu, Yve-Alain Bois
and other steadfast friends

Contents

Illustrations

Figures

9

Plates

Introduction

FROM TIME to time after I published "On the State of Medieval Art History" in 1988 (*Art Bulletin*, volume 70, 167-87), colleagues have asked me, once again, to sum up research in the field. I always declined. However, when my esteemed friend and sometime collaborator Paul Dutton invited me to launch the Broadview Press series *Rethinking the Middle Ages* with an overview of current developments in the discipline, I eagerly accepted the commission. I believe that sufficient time has now passed to warrant another introduction for persons with a serious interest in medieval art, though I am also keenly aware that expansion of the field during the past fifteen years and dramatic shifts in approaches to the material render any such attempt necessarily only partial and idiosyncratic.

Like the *Art Bulletin* "think piece," this book sets out to identify some of the issues being discussed in the most interesting scholarship and tags them with exemplary books and articles; but *Seeing Medieval Art* is both longer and more concentrated than its predecessor. In the mid-1980s, I set out to summarize scholarship on Early Christian, Byzantine, and medieval art up to 1400; now, reflecting my own interests, I have limited my purview to the art of the Latin West and mostly to the period 800-1300. Even while claiming that context is essential for understanding

works of painting, sculpture, and other arts, I do not treat architecture; architectural history is a distinct sub-discipline that requires the attention of a specialist, which I am not. I also do not treat questions of periodization, the dating and attribution of specific works, traditional iconography and source hunting, and other important topics that, by and large, are of interest only to professionals in the field. Instead, I focus on one of the principal medieval claims, namely, that art is a means to "show the invisible by means of the visible." I do so because much recent scholarship is, in one way or another, a response to this claim and because it opens up central matters presented to those seeking access to the material.

Even before 1988, the study of medieval art was being radically transformed in response to contemporary methodological currents. Since then, the metamorphosis has been accelerated because the subject seems particularly well suited to emerging humanistic strategies. Early on, the close relationship between images and words on many works caught the attention of semiologists; frequent quotation and reuse of materials have been amenable to post-modernist approaches; and the functionality of the objects has appealed to scholars with anthropological concerns. Conversely, the growing recognition of the central role played by visual things in medieval culture has attracted historians, historians of literature, and theologians to artistic materials; as the footnotes in this book amply document, much productive work in the last two decades has been accomplished by scholars who are not "card-carrying" art historians.

A glance at the illustrations in this book conveys something of medieval art's unusual character. Functional objects—books, altars, containers of relics, church doorways—are represented beside the "major arts" of painting and sculpture. Many of these are made of materials seldom encountered in the mainstream art of later periods—gold and precious stones, ivory, painted vellum, and stained glass. As Chapter 1 argues, matter mattered during the Middle Ages. Following decades of discussion about "images," the latest scholarship has begun to acknowledge the seemingly obvious fact that medieval art is much more than iconography. At the very moment art is being further disembodied through digitalization—perhaps as a reaction to the new technology—scholars are focusing more and more on how the materials themselves inflected images and on the techniques and ornament that formed and articulated art's status. Diverse medieval media had inherent properties and their own

significance; these aspects, too, motivated the processes by which art was apprehended and its meaning understood. Art was also associated with consecrated matter, relics and the Sacraments for instance; and it was often organized around fragments of earlier objects or assembled in collections to affirm political and religious agendas.

Little medieval art can be assigned to known "artists"; much more of it can be attached to *concepteurs* or patrons than to actual makers. Chapter 2 focuses on the characteristic modes of artistic production, on the often complex interactions between artisans and clerical sponsors, corporate creations, and the emergence of commercial production. It considers both the status of craft in medieval society and various legends that assign the making of art to supernatural agents.

Chapter 3 takes up the ways in which the Church accommodated the physical appeal of dazzling materials and the fascination of images in its essentially spiritual mission. It examines how Scriptural precedents were enlisted in theories of art to transform the pagan legacy into a Christian instrument, and it traces how Christ's dual nature became a foundation of sacred decoration. It also discusses various devices—typologies, inscriptions, seals, and personation—deployed to convey the widespread belief that what humans see with their eyes is not necessarily what they should believe.

Because Scripture was at the center of Judaeo-Christian culture, art engaged sacred words in myriad ways and the manuscript book was the principal vehicle for artistic expression. Chapter 4 introduces diverse types of manuscripts and the forms of decoration used to adorn, interpret, and unify them. It also examines the development of specific book components—covers, miniatures, initials, margins, frames, and two-page openings—each with its own place in the structured relationships between words and images.

Art also contributed fundamentally to the creation of sacred environments. Chapter 5 studies how mural decorations and richly adorned furnishings marked functional areas within church buildings and helped to conduct movement between them. It also considers the effect art had on the viewers in these consecrated spaces, in particular, how church decorations enacted the transition between the earthly church in which the faithful worshiped and the celestial prototype they sought to enter.

Chapter 6 reviews the ways in which medieval art engaged the world

outside the sanctuary, sometimes as an alternative to the sacred world it constructed, but often as part of a transformative process. It traces the origin of medieval naturalism, the importance of classical sources and empirical observation for scientific illustration, the development of secular art and historical narrative, the invention of courtly subjects, and the emergence of individual portraiture.

Because much medieval art was functional, it actively engaged social activities conducted in churches, domestic environments, and urban settings. Chapter 7 treats art's performative and somatic roles, and it examines some of the ways art was deployed in teaching, missionary activities, and preaching, how pictures guided devotion, and most important, how material images functioned in the Mass and other liturgies, including civic processions and pilgrimage.

The final chapter takes up the question of how medieval art was seen, investigating the inevitably conflicted role it played in a culture with complicated attitudes toward the physical world in general. Operating within the Augustinian distinction between carnal, spiritual, and intellectual seeing, it relied on various procedures for enacting movement from physical to mental apprehension, even while seeking to block any confusion with the highest mode of vision reserved for the blessed who would see God "face to face" at the end of time. The chapter examines how medieval art took advantage of the contrasts between the inside and outside, front and back, and illusion and object to initiate transcendental elevation; and it discusses the ways in which theological speculation about the Incarnation and Trinity influenced the making of art, as well as theory and aesthetics. Finally, the concluding chapter treats the roles of affect and memory in the movement from sensual to spiritual seeing.

Reflecting my belief that objects of art are themselves the primary materials for art-historical study, the book examines selected works in some detail. Chosen to elucidate the conceptual issues being considered, the examples represent various periods, centers, and media; some have been identified because they are much discussed in recent scholarship, the Bayeux Tapestry and the Ste-Chapelle, for instance, others because they correct biases that still distort the history of medieval art. Thus, while recognizing France's importance and the recent attention paid Abbot Suger of St-Denis and the Capetian monarchs, *Seeing Medieval Art* attends to the art of Spain, England, Germany, and Scandinavia. It also

gives the art of Rome its due, which, despite its significance, is often relegated to side-bars because its residual classicism is not considered sufficiently "medieval." The book makes little effort to situate the issues in specific historical contexts: how the status of the "artist" and the devotional function of images changed from time to time and place to place or how "seeing" itself was constructed historically. The job of the next phase of study is precisely to situate the issues highlighted here in their specific histories.

I have limited the citations to scholarly writings published after "The State of Medieval Art History." Restricting the references to recent publications was often difficult; so was resisting the temptation to add citations to works that have appeared after I finished this text. The very week I sent this book to the editors, Anne-Marie Bouché and Jeffrey Hamburger mailed me the typescript of *The Mind's Eye: Art and Theological Argument in the Middle Ages*, a collection of symposium papers they edited for which I had agreed to write an "afterword." I did not have the opportunity to incorporate reference to the essays in that volume, even though many treat subjects covered in this book. By the time *Seeing Medieval Art* appears, *The Mind's Eye* and many other books and articles will have advanced the topics considered here. That is how it should be. The study of medieval art is continuously evolving, which is why it has fascinated me over the course of a long career. I only hope that, even as other doors are opening ahead, this modest and already dated work provides a gateway for those intrigued by medieval objects and looking for ways to see them and discern their meanings.

As series editor, Paul Dutton read the typescript with care and intelligence and offered wise comments that I incorporated into the final text. He is an inspiration to all medievalists. At Broadview Press, Mical Moser, Emily Cargan, and Barbara Conolly need to be singled out for their concerted efforts to produce a readable and handsome book. With grace and exceptional persistence, Martina Bagnoli helped me secure a number of photographs; and other friends, including Adam Cohen, Cristiana Filippini, Bianca Kühnel, Charles Little, Giulia Orofino, Francisco Prado-Vilar, Elisheva Revel-Neher, James Rushing, and William Travis, provided pictures or helped me to acquire them. Ben Tilghman read the first set of proofs. I thank them all.

Chapter 1: Matter

OVERT MATERIALITY is a distinguishing characteristic of medieval art.[1] In most works, the substances used to fashion figures and ornament are apparent in ways that, say, the oil paint on a fifteenth-century Flemish panel or the marble of a Neo-classical sculpture are not. The materials do not vanish from sight through the mimicking of the perception of other things;[2] to the contrary, their very physicality asserts the essential artifice of the image or object. Such typically medieval media as mosaic, stained glass, and enamel all demonstrate this point.

Not only does the late-thirteenth-century apse mosaic in Santa-Maria-Maggiore in Rome (Plate 1)[3] adhere to and articulate the architectural surfaces, but it also keeps visible the process by which the figures and decorations are constructed of small bits of stone and glass. Here and there, a direct relationship is established between a depicted object and the substance from which it is created: a gem on Mary's sleeve, for instance, is an actual rock crystal and, in the border, tesserae are turned on end to suggest the forms of a porcupine; but the effect depends on substitution, not illusion.

The materiality of stained glass, the most original and important medium of the high Middle Ages, is even more evident. As in the mid-twelfth-century Peregrine Chapel at Saint-Denis (Plate 2), discrete

pieces of highly saturated glass, outlined by metal armatures and set in geometrical matrices, declare their material presence as both walls and images, with the result that the overall gem-like appearance is at least as important to the experience as are the figures depicted in the glass.

The same is true of cloisonné enamel; the small gold plaques set into the frame of a portable altar produced in the middle of the twelfth century in a Crusader atelier in the Holy Land (Agrigento, Museo Nazionale, Plate 3),[4] for instance, are articulated by figures made up of cells of colored glass outlined in gold. In these as in many other works, the overt materiality forces the viewer to bridge the gap between object and image through the exertion of imaginative will.

The same is generally true also of the more traditional media of painting and carving, in which traces of facture assert art's fundamental artificiality. On the frontispiece to Saint Luke's text in an eleventh-century Rhenish Gospelbook (Darmstadt, Landemuseum, Cod. AE 679, fol.126v, Plate 4),[5] for instance, the parchment is visible beneath thin washes of blue and green tempera. Evident goldsmith techniques unite semi-precious stones, pearls, and cameos in splendid array on the contemporary cross in Osnabrück (Cathedral Treasury),[6] a chalice from Léon (Colegiata de San-Isidoro, Plate 5),[7] and many other works.

The materials of medieval art had their own histories that, together with their inherent qualities, imparted meaning to the objects and images constructed of them.[8] Valued for their cost, purity, and luminousness in pagan Roman culture and Scripture, gold and gems were used in Christian art to figure heaven as a place of spiritual reward.[9] Inspired by Ezekiel's description of Eden as a "garden of God, adorned with gems of every kind: sardin and chrysolite and jade, topaz, cornelian and green jasper, lapis lazuli, purple garnet, green felspar [and] jingling beads of gold" (Ez. 28:13), for instance, paradise is imagined as a golden panel in the scene of Jacob's burial in the Ashburnham Pentateuch (Paris, Bib. nat., MS nouv. acq. lat. 2334, fol. 50r),[10] a manuscript perhaps produced in Rome at the end of the sixth century; and following the description in the Book of Revelation of the celestial city as built of "pure gold … adorned with jewels of every king" (Rev. 21:18-19), the early ninth-century mosaics in Santa-Prassede in Rome conceive the Heavenly Jerusalem as a city built of gold blocks set with rubies and sapphires and mortared with pearls (Fig. 1).[11] Thus, both the lost paradise and its

Figure 1. Mosaics, Santa-Prassede, Rome (817-24)

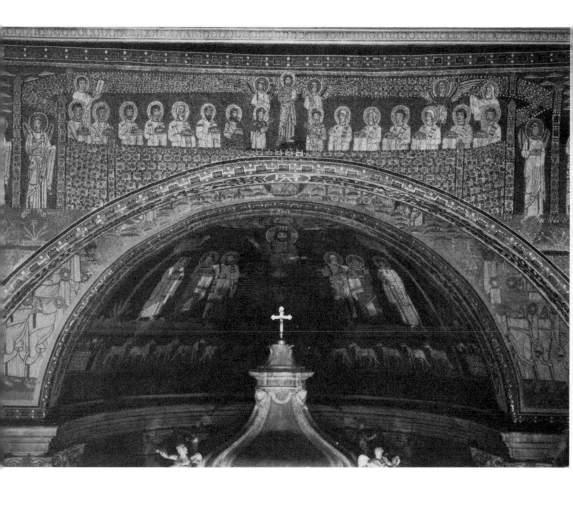

promised replacement, the beginning and end of the Bible, are figured in terms of materials prevalent in medieval art.

Called "living stones" in 1 Peter 2:4-8, Christ's saints were likened to the gold and gems of which the heavenly city was built; in Santa-Prassede, the metaphor is figured by picturing the Savior dressed in gold and the dedicatory saints clothed in bejeweled, golden garments. Two mid-twelfth-century reliquaries in Osnabrück (Domschatz, Fig. 2) apply the same idea to containers of the physical remains of saints; shaped like arms, they are covered by gold- and silver-leaf skin and adorned with gem-encrusted bracelets and cuffs.[12]

The Venerable Bede (ca. 673-735) considered sapphire to be the color of a clear sky and hence a symbol of Him who lives there, and Abbot Suger (ca. 1081-1151) extended the symbolism to the "materia sapphirorum" of his windows at Saint-Denis.[13] The other luxury arts, especially the vitreous media of stained glass and enamel, took on different significances.[14] Suger quoted Ezekiel's description of Eden in his own description of the Saint-Denis windows. When she celebrated the consecration of the church of Saint-Rupert in 1151, Hildegard of Bingen (1098-1179) saw the splendor of the stained glass there as a vision of Jerusalem.[15]

Stone and bronze, materials closely identified with pagan idols, presented special problems to medieval artisans and followed their own historical courses. Less expensive than goldsmith work, they were valued for their substantiality and durability, even earthliness. Porphyry, for example, which had long been associated with Roman imperial power, came to serve the ambitions of popes.[16] The use of stone and bronze could also be justified by biblical texts. In Ephesians 2:19-22, Christ is referred to as a cornerstone, for instance, and, in 1 Corinthians 10:4, He is compared to the rock from which Moses drew water in the desert.[17] One of the earliest surviving examples of monumental sculpture, a Christ in Majesty from Saint-Emmeram in Regensburg, bears a somewhat defensive inscription that makes patent the connection between material and image: "Because Christ was called a rock because of his unshakable divinity, it is appropriate to render him in a stone image."[18] Eventually, stone sculptures were built into the very fabric of medieval sanctuaries to establish physically the connection between Christ, Mary, and the saints

Figure 2. Reliquaries, Osnabrück (mid 12th cent.)

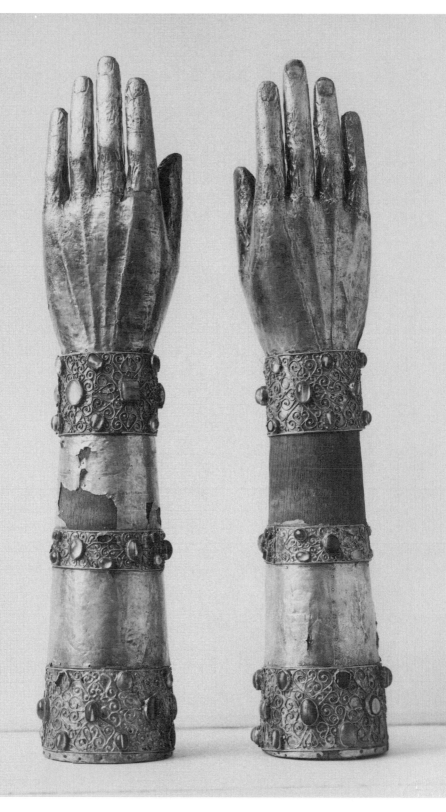

and the terrestrial church and, in turn, between them and the worshipers in that church (Figs. 32, 34, 35).[19] The late-twelfth-century candlestick in Saint-Paul's outside the walls in Rome actually deploys references to the ancient tradition of stone carving to express Christianity's ultimate victory over paganism, alluding to the form and relief bands of the great triumphal columns to assert Christ's conquest of death at the hands of Pilate's soldiers in His ascension to heaven.[20] Eastern legends of images miraculously formed in stone, translated into vernacular by Gautier of Coinci (ca. 1177-1236) and Alfonso X (the Learned [1221-84]), integrated actual practice into a narrative and, in turn, into narrative pictures. Thus, an illustration of Alfonso's Cantiga 29 (Escorial, Biblioteca de Real Monasterio, MS. T.I.1, fol. 44r, Fig. 3) depicts the story of the miraculously impressed stone image of Mary and Christ venerated in Gethsemane; most remarkably, it shows God actually forming the sculpture with His own finger.[21]

During the eighth and ninth centuries, popes and emperors vied over the connotations of authority invested in works of bronze.[22] Bronze was also deployed for tomb effigies, its permanence freezing the image of the deceased in contrast to the decaying body.[23] Justified by the brazen serpent Moses raised in the desert and the brazen sea in Solomon's temple, the material also acquired special characteristics related to the smelting process, which was considered evidence of trial by the fire used to form it.[24] The bronze door of the cathedral at Trier, for example, was inscribed, "The wax gives what should be, the fire takes it away, the bronze gives it back to you";[25] and subjects on twelfth-century bronze bowls used by nuns in a ritual of cleaning before confession incorporate references to antiquity, baptismal cleansing, and metamorphosis through spiritual trial. Some of these bowls feature pagan mythology (but in a context against paganism), while others bear on virtue; one in Berlin (Staatliche Museen) is adorned with personifications of Idolatry, Envy, Anger, Extravagance, Lust, and Greed, all neatly arrayed around Discord, the antithesis of monastic virtue. The bronze candlestick, column, and doors (Fig. 4) commissioned by Bernward of Hildesheim (d. 1022) reinforce both the material's message and its use. The reference to Roman monuments is obvious in these works and the material's durability is alluded to in the door's dedication;[26] here too, however, the allusions serve an explicitly Christian purpose.[27]

Figure 3. Illustration, Alfonso's Cantigas, Escorial (13th cent.)

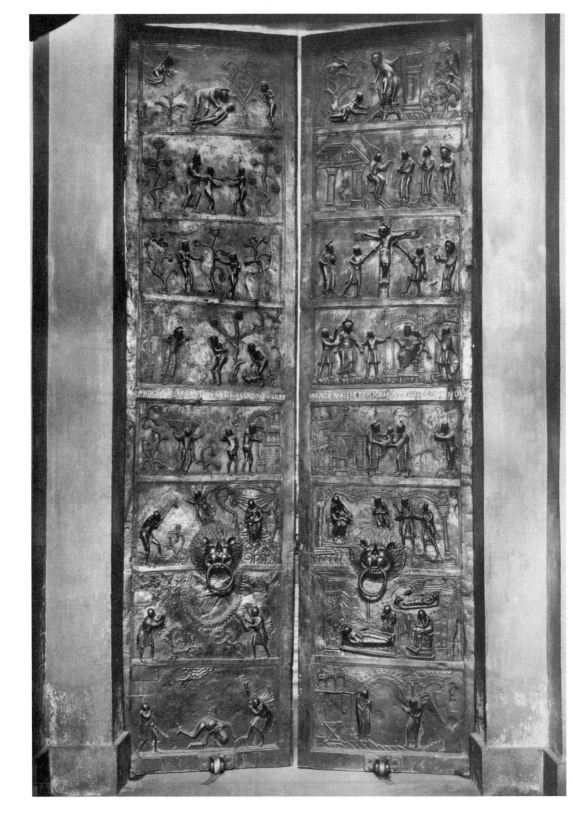

Organic materials—wood, ivory, cloth, wax, leather, and parchment especially—often conveyed meaning in much the same way. These, even more than metal and stone, would have attracted touch as well as gaze, and it is not surprising that the act of feeling is often introduced as an element of their imagery. Associated with the cross on which Christ died, wood was used in the very first three-dimensional depictions of the Crucifixion. Recent carbon-14 dating of the Crucifix in San Sepulcro puts the earliest surviving example of a large-scale wood sculpture into the first half of the ninth century and ties it to the legend, known in the Latin West by the eighth century, which claimed that a miraculously carved sculpture of Christ on the cross (the *Volto Santo)* had been given to Nicodemus, the learned Jew who had helped lower Christ into the tomb and who wanted to keep the Lord's appearance alive in his mind.[28] By the end of the Middle Ages, fine woods were prized for an altogether different purpose: the enjoyment of nobles. Charles V of France, for instance, owned a figurine of a fox in Franciscan garb holding up pearls parodying the Eucharistic host.[29]

Ivory, the smooth, creamy tusk of an elephant or walrus, conveyed the luxuriousness it had already acquired in antiquity and the symbolism Christianity had given whiteness and also elephants.[30] Like gold, bronze, and porphyry, ivory also retained political connotations through its sumptuousness and history in imperial service;[31] and, although much ivory was delicately polychromed and, as in antiquity, detailed in gold, it conveyed fleshiness and invited handling.[32] For those reasons, it was often used to portray Christ, as ca.1063 on the magnificent Cross of Ferdinand and Sancha (Madrid, Museo Arqueológico Nacional), which still also bears traces of gold highlights.[33] A tenth- or eleventh-century diptych in Berlin (Staatliche Museen, Fig. 5) takes advantage of ivory's character by opposing a depiction of Moses receiving the Law with Thomas proving Christ's resurrection by probing His wound. Most likely once book covers, the paired plaques consciously use the material to reveal two ways in which God offered Himself to man: through tablets inscribed by His finger and through the word-made-flesh, Christ, whose divinity was not only seen, but in the case of the doubting Thomas, also felt.[34] Inside, words written on parchment—literally flesh—would have figured the same idea again; Hrabanus Maurus related Christ to the vellum on which Scripture is written, a trope repeated throughout the Middle Ages.[35]

Figure 4. Doors, Hildesheim, cathedral (early 11th cent.)

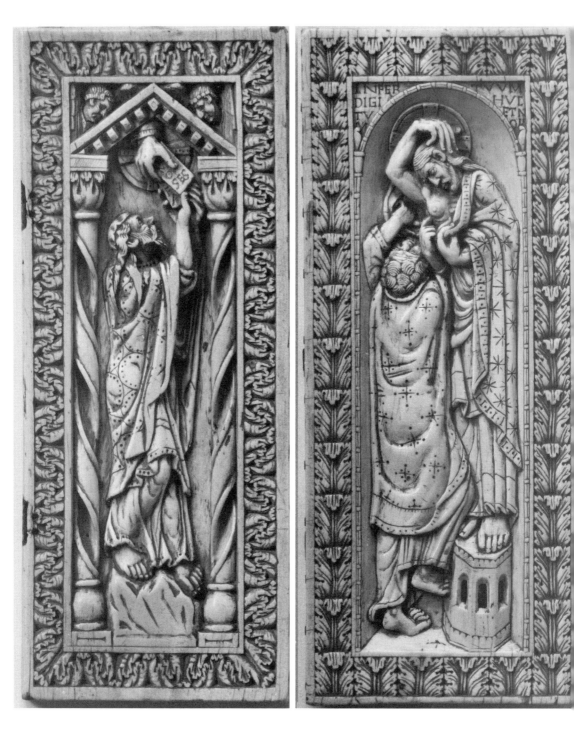

With its association with light (through candles) and purity (through asexual bees), wax had its own history in medieval art.[36]

Many materials were selected because they seemed, in their very nature, to negotiate between the world of matter and the world of spirit (gold, gems, and glass, for instance), which were continuously being transformed in changing light. Meditating on the gem-encrusted *vasa sacra* in Saint-Denis, Suger reported in a well-known revery that his thoughts were transferred "from that which is material to that which is immaterial" (*De admin.*, 33). Thought of as petrified water, rock crystal was considered the perfect material for a representation of Saint Paul, who was transformed from a persecutor of Christians into an apostle (Paris, Bib. nat., Cabinet des Médailles);[37] veined stones, such as fine marble and agate, seemed to capture spiritual presences.[38] A jug in Quedlinburg (Domschatz) made use of the transmorphic character of alabaster; from the sixteenth century, at least, it was associated with the transformation wine at the Marriage at Cana.[39] The ancient bowl and dish used in the eleventh century as the foot and cup of the Urraca chalice were certainly chosen, not only for their ancient pedigree, but also because the clouds of white in the deep-red sardonyx (one of the Scriptural stones) seem to embody the very essence of the sacramental mystery that came to be termed transubstantiation. Portable altars, such as the one made by Roger of Helmarsheim (d. ca. 1125) in Paderborn (Erzbischöfliches Diözesanmuseum und Domschatzkammer),[40] feature marble, alabaster, or porphyry at the center to figure the transformation of the Eucharistic species realized on it.

Juxtapositions and contrasts of materials were deployed to construct meanings and figure metamorphoses. On the Agrigento portable altar, for instance, fine enamels frame an irregularly cut piece of griotte, a course-grained marble that vigorously conveys materiality, indeed, earthiness; the marble asserts the reality of the place where Christ lived and died (figured on the back by an embossed double cross in gilt brass) while the finer materials suggest His ineffable aspect.[41] On an Anglo-Saxon cross-reliquary in London (Victoria and Albert Museum),[42] Christ's body is rendered in ivory to emphasize its fleshiness, the symbols of the evangelists in enamel to suggest their celestial status, and the cross itself in gilt-silver. A similar spiritual hierarchy is created on the Mondsee Gospels in Baltimore (Walters Art Museum), produced in Regensberg in

Figure 5. Ivory diptych, Berlin (10th or 11th cent.)

the third quarter of the eleventh century,[43] which pictures Christ in gold
covered by rock crystal and the evangelists in ivory set in silver. It may be
no mere coincidence that, when the author of the *translatio sancti Dionysii*
(who lived in Regensberg at the moment the Mondsee Gospels was
being made) looked at the Carolingian Codex Aureus of Saint-
Emmeram, he saw the heavenly Jerusalem in the rectangular cover of
gold set with gems and the sun of justice illuminating the city in the
figure of Christ at the center. Contrasting materials served in Santa-
Prassede to distinguish the passions, that is the earthly histories of the
saints, pictured in fresco in the transept, from the glorification in heaven
represented in luminous mosaic on the triumphal arch.[44] At the end of
the thirteenth century, the tomb of Gonsalves Garcia in Santa-Maria-
Maggiore (Fig. 6) deployed stone and mosaic to make the same distinc-
tion;[45] the sarcophagus and effigy of the dead cardinal are rendered in
marble, the portrait of Gonsalves before the Virgin and Child in gold and
brilliant color. The twelfth-century painting in the *Chapelle des moines* at
Berzé-la-Ville (Fig. 7) originally used semi-precious stones inserted into
Christ's mandorla to suggest the heavenly seat and an oculus, perhaps
once filled with colored glass, to indicate the spiritual summit.[46] To
figure the burning coal sent from heaven to cleanse Isaiah's lips, a
reflective disk was inserted into the fresco in the church of Saint-Martin
at Vicq.[47]

 Derived, to a great extent, from associations with gems and other
precious materials, color likewise acquired symbolic meaning associated
with natural qualities and references in Scripture and lapidaries;[48] Suger,
Hildegard of Bingen, and other commentators attest to its importance.[49]
Like ivory, sculpture was painted in brilliant color, at one time enhancing
both its realism and the sense of transformation;[50] like gold and precious
stones, it assaulted the senses and evoked a response among those who
looked at art.[51] No wonder that Rashi (1040-1105) argued that it weak-
ened the Israelites' resistance to sin.[52] Colorlessness, in turn, also had its
uses, to echo penance during Lent for instance or to index the super-
natural state of angels,[53] as in the case of the angel bringing Habbakuk to
Daniel in an early twelfth-century Commentary of Jerome in Dijon
(Bib. Mun. MS 132, fol. 2v, Fig. 9).[54]

 In these and many other medieval works, the traditional separation of
matter and image, with its implied opposition of body and soul, cedes to

Figure 6. Tomb of Gonsalves Garcia, Santa-Maria-Maggiore, Rome (late 13th cent.)

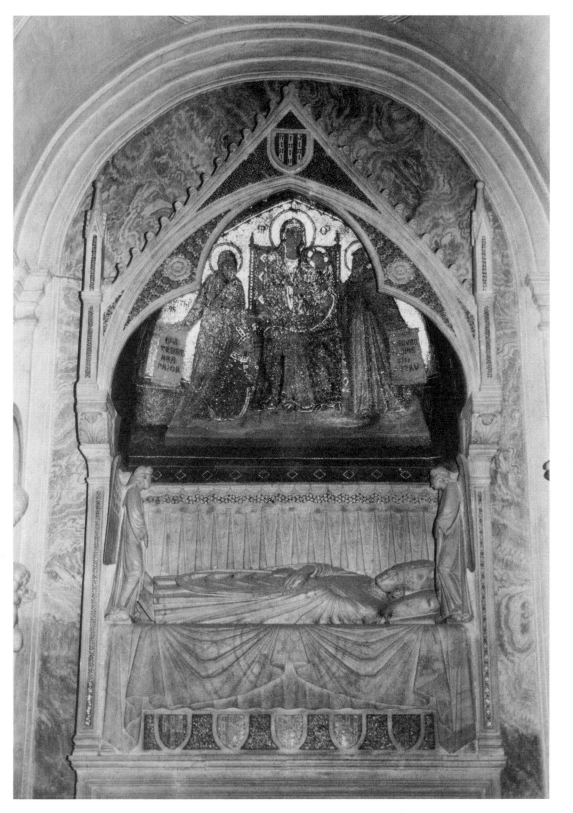

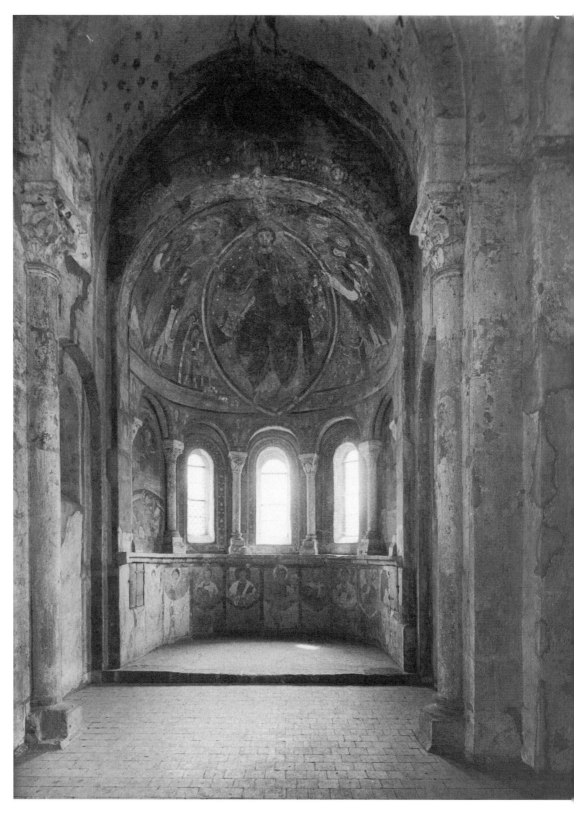

a dynamic process that transacts the relationship between the two.
Developing the trope that Scripture written on parchment figured the
Incarnation, the colophon of the Godescalc Lectionary (Paris, Bib. nat.,
Ms. nouv. acq. lat. 1203), richly adorned between 781 and 783 and long
studied as the earliest extant witness to Charlemagne's revival of art,
asserts that the golden letters are to be understood as the shimmering
eternal life provided by Christ's sacrifice symbolized by the red-dyed vel-
lum.[55] Mechthild von Magdeburg (1212-ca. 1281) went further still, see-
ing Trinitarian meaning in the very body of the manuscript—its parch-
ment, physical words, and meaning symbolizing the
Son, Father, and Holy Ghost respectively.[56] In

like fashion, the rock-crystal casing of a reli-
quary produced in Germany during the
second quarter of the thirteenth century
(Copenhagen, Nationalmuseet, Plate
6) symbolizes Christ's divinity and
the parchment painted with the
Crucifixion (and the martyrdoms of
Lawrence and Stephen) represents
His human nature. Here as in other
works, color understood as light
made visible also played an important
part in the spiritual transformation.[57]

Fictive materials served the same
transmorphic purpose: the *faux marbre* that
transforms the material supports in many
churches, for instance, and the imitation
engraved gems and stones in Carolingian manu-
scripts such as the Codex Aureus of Saint-Emmeran (Munich,
Cod. lat. 14000). Rendered as an "enamel" reliquary, the Crucifix at the
center of the apse of San-Clemente in Rome (1118/19) realizes the fact
that a fragment of the true cross was hidden within the mosaic;[58] and
translated into painted velum, the "stone" *acheiropoieton* pictured in the
Cantigas manuscript captures perfectly the concept of incarnation
referred to in the text.[59] Though natural, the aggregate stone on the
Agrigento altar recalls collections of stones gathered at the actual sites
where Christ had lived and died, as those in a pilgrim's box in the Vatican

Figure 7 (facing page). Apse, Chapelle-des-Moines at Berzé-la-ville (12th cent.)
Figure 8 (above). Stained glass window, Peregrine Chapel at Saint-Denis
(detail)(12th cent.)

Museum.[60] With their rich allegorical references, the fictive hangings that decorate the lower registers in some fresco cycles embody the very concept of a thing under the image of another.[61] Art's capacity to re-materialize matter was thus an allegory of spiritualization, as in the medallion at Saint-Denis depicting the Chariot of Aminadab (Fig. 8); there, the Crucifixion is rendered as a bronze crucifix, in part to connect it to the Ark of the Covenant, which it had transformed and replaced. The three-dimensional meander in the Dijon manuscript and in many churches, where it is run beneath the rafters, does not represent any physical thing but rather renders the very process of elevated seeing, the movement from object to spirit.[62]

In churches, fictive materials were used to raise the entire structure; from the fourth century, that is from the very beginning of Christian ecclesiastical building, the decorations of Roman churches were framed in bands of imitation gems,[63] identifying the buildings with the heavenly city of which they were deemed to be images. In Santa-Prassede, Santa-Maria-Maggiore, and—around the lower windows—in Berzé-la-Ville, the main architectural fields are bordered with pictured cabochons and pearls. Building on the symbolic reference to Scripture's sacred precincts, the movement from mosaic or paint to precious stones struck by light enacts the imagined relationship between particular building and celestial archetype. In Santa-Prassede, the process extends to the entire mosaic; the gold tesserae that describe the stones and gems of the heavenly city, for example, clad the actual structure, just as the pictured city of the saints figures the ninth-century church in which the remains of 2,300 martyrs, gathered in the ninth century from the catacombs, are preserved.

In essence an enormous reliquary, Santa-Prassede exemplifies one of the principal functions of medieval art, which is to make visual the sanctification of the humble but sacred remains of Christ and his saints, such as bones, pieces of flesh, and fragments of clothing, and other objects made powerful by contact with them. By sheathing such earthly materials with lustrous substances, the container elevated them, making their worth evident and raising them up as elements in the Heavenly City of Jerusalem.[64] Guibert of Nogent commented on the power of material embellishment to render the relic present: "enclosed ... in a costly shell of gold [it is] visible evidence descending to this age to

Figure 9. Illustration, Commentary of Jerome, Dijon (early 12th cent.)

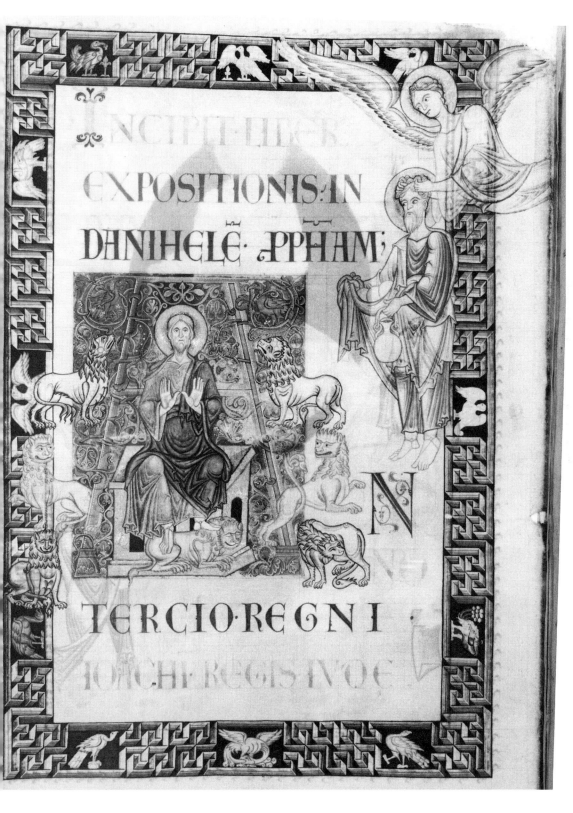

provide fresh testimony."[65] Rupert of Deutz imagined God himself pointing to golden reliquaries on an altar as the most sublime of all earthly things.[66] A cross in metal on the back of the Agrigento altar attests to the relic's authenticity and origin in the Holy Sepulcher, while the marble and enamels on the front raise the sliver of wood to a higher realm suggestive of Christ's own being in heaven. During the Carolingian period, the relationship between artistic materials and relics became an issue, with the *Libri Carolini* and the Council of Paris (825) distinguishing between the two, Claudius of Turin dismissing both as physical matter that can not participate in the sacred, and Jonas of Orleans and Dungal adopting a moderate middle ground.[67] In these writings, as in later ones, the connection between art and relics inevitably implicated pilgrimage as well; the faithful sought the presence of the saints, but they also reacted to the visual richness that accompanied it.[68] Like the gold and gems of reliquaries, the brilliant mosaics on the upper walls of of Santa Prassede make visual the spiritual presence of the saints whose remains are buried in the crypt fitted out with marble and stucco and equipped with recycled Early Christian sarcophagi.[69]

A fragment of one sarcophagus actually serves as the lintel of the doorway into the crypt at Santa Prassede, an example of the widespread practice of reusing materials still recognizable in the new contexts.[70] Promoted already by Constantine, the use of spolia was a characteristic Christian system from the start, not as is often supposed a response to economic decline, but a reflection of the desire to insert Christianity into the succession of Roman history.[71] At times, pagan works themselves were marked with crosses;[72] but mostly, the idea was developed by introducing fragments into new contexts and framing them in such a way as to make the relationship between the old and new situations evident.[73] A good example is the so-called Dagobert throne (Paris, Bib. nat., Cabinet des Médailles, Fig. 10). Most likely made at the start of the Carolingian period in imitation of an ancient Roman *sella curulis*, it was provided in the middle of the ninth century with a back and arms and refitted again in the middle of the twelfth century when, attributing it to the seventh-century king Dagobert, Abbot Suger imbued the bronze chair with new political meaning.[74] The incorporation of antique cameos in the Osnabrück cross and glass-paste copies in the Léon chalice was intended to contribute to the triumphant aspect. A large aquamarine engraved

Figure 10. Dagobert throne, Paris (8th to 12th cents.)

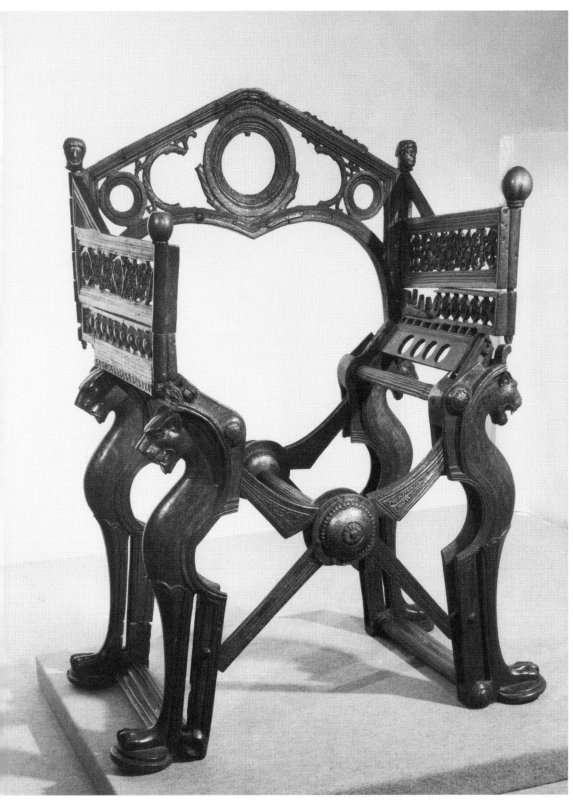

with the portrait of a woman at the top of a ninth-century reliquary screen known as the *Escrain de Charlemagne* was selected because of its celestial color and also because it served as an image of Mary; another reused gem surmounts it, a sapphire inscribed with the epithet in Greek: Holy Mother of God, Jesus.[75] Even more striking is the use of spolia on the Lothar Cross in Aachen (Palace Chapel), produced ca. 973-82 and incorporating among the precious stones an enormous cameo of Augustus (ca. 20 BC). Such a cameo was chosen, at least in part, to recall the fact that Augustus was emperor when Christ was born and, hence, to establish the direct continuity between Rome and Christianity.[76] A particularly elaborate and eloquent example of the use of spolia is the incorporation into the front of San-Marco in Venice of porphyry portraits of the tetrarchs, the "pilastri acritani," and bronze horses all looted from Constantinople.[77]

The assembling of objects from the distant past and far-off places extended also to the amassing of collections and their purposeful display.[78] Treasures of objects in secular, religious, and monastic contexts served as means for assembling wealth; at the same time, they also negotiated the relationship between the material and spiritual worlds and between lay and clerical realms.[79] The Late Antique, coptic, Celtic, Anglo-Saxon, East Christian, and Merovingian objects were probably collected in the Sutton Hoo burial to attract the gods' attention and to enlist their support.[80] In turn, the display of bronze and stone sculptures in the piazza outside the Lateran is to be understood as part of an ongoing project to assert the popes' secular authority in Rome.[81]

From the very beginning, a direct relationship was established between spolia and relics, between Constantine's deployment of fragments of imperial monuments in Rome and his gathering of sacred remnants around his tomb in the church of the Holy Apostles in Constantinople;[82] and the association remained strong throughout the Middle Ages. In Santa-Prassede, the spoliate lintel is carved with scenes of Jonah, a common theme on Early Christian sarcophagi and selected because its resurrection symbolism was deemed appropriate to the graves of saints shown alive again in heaven on the mosaic over head. The mid-seventh-century box of Teuderic (Abbey of Saint-Maurice d'Agaune) is an assembly of intaglio gems and an imitation cameo that evokes the

third-century soldier saint, just as the relics (presumably once collected inside) made him actually present.[83] Suger tells us that he built the choir of Saint-Denis to "present the reliquaries of the [three patron] Saints, adorned with gold and precious gems," and to display columns from the earlier building set prominently against the walls dividing each chapel "to respect the very stones, sacred as they are, as though they were relics."[84] The reciprocal relationship between the base remains and elevated artistic materials was essential. Objects of art associated with persons who were later venerated were often themselves transformed into relics. Suger not only converted the Dagobert throne into a secular relic, but he raised the gemmed cross attributed to the sainted goldsmith Eloy on the altar of Saint-Denis;[85] and in the fourteenth century, a (twelfth-century) paten believed to have been used by Bernward of Hildesheim was encased in a monstrance, as if it were a relic of the sainted bishop himself (Cleveland, Cleveland Museum of Art).

The integration of sacred remains and precious materials, including spolia, culminated during the thirteenth and fourteenth centuries in reliquary chapels constructed to preserve and present special collections. Successive popes constructed, remodeled, and between 1277 and 1280 rebuilt the oratory of Saint Lawrence at the Lateran palace to serve such a purpose.[86] The "Sancta Sanctorum" housed a rich array of body parts and touch relics, including Christ's umbilicus and foreskin and a fragment of the true cross, the Lord's sandals, the Virgin's hair, some of her milk, and her veil, bread from the Last Supper, the heads of Saints Peter, Paul, Agnes, and Euphemia, John the Baptist's coat, Matthew's shoulder, and Bartholomew's chin all inventoried at the entrance. In the final medieval setting, these were framed by rich materials and spolia, including magnificent porphyry columns and slabs looted from ancient Roman monuments, bronze grills and doors taken from a safe made by Pope Innocent III (1198-1216) inserted into an altar constructed from antique marble pieces, and, inside the altar, boxes within boxes, a modest cypress chest made by Pope Leo III (795-816) containing the reliquary cases provided by Paschal I (817-24) containing still other containers for relics wrapped in cloths, including one encased in an earlier gemmed cross. Materials of all kinds thus hid, protected, and made visible relics of diverse types and, in so doing, created a suitable sacred space for the

liturgy performed by the Church's high priest and, as important, tracked
the pontifical lineage back to Peter. The Lateran chapel had been
inspired, in part, by another "sancta sanctorum," the Sainte-Chapelle built
by Louis IX (1214-70) in Paris to house sacred booty pillaged by the
Crusaders from yet another sancta sanctorum, the Pharos Chapel in
Constantinople: Moses' rod, relics of Christ's Passion including, most
notably, the Crown of Thorns, and fragments of Saints John the Baptist,
Blasius, Clement, and Simeon.[87] A miniature in the *Très riches heures*
(Chantilly, Musée Condé, fol. 158r, Plate 7) painted ca. 1475 after an ear-
lier drawing (Paris, Bib. Mazarine, ms. 406, fol. 7) conveys the reliquary-
like aspect of King Louis's chapel.[88] At floor level, the chapel is clad in
wood and stone and is occupied by the clergy, court, and citizens of
Paris; an elaborate gilded shrine displaying the bejeweled, gilt-silver and
copper reliquary, known as the Grande Chasse, rises into the higher,
light-filled realm of the stained-glass windows occupied by saints ren-
dered in gilt-stone and painted glass (living stones) and culminating in
the star-studded vaults. The worked physical matter renders the relics
visible within a facsimile of the heavenly kingdom.[89]

Reflecting the choice of materials and tying together or dividing one
substance from another, ornament enhanced visibility and helped to
establish the cognitive relationship between the physical world and the
heavenly realm beyond. Expanding on aspects of the material, it made
theological and political statements in its own right and, hence, was
another instrument of spiritual enhancement.[90] The acanthus leaves
carved on the frames of the Berlin diptych, for instance, not only assert
the very materiality of the ivory tusk in a way that reinforces the message
of the iconography, but also aestheticize the ivory, thereby enlivening the
pieces of dead matter.[91] The ornamental vocabulary also reinforces the
recollection of antiquity and authority associated with the choice of
medium. Ivory covers fitted onto a Book of Psalms made between 1131
and 1143 for the Crusader Queen Melisende (London, Brit. Lib., MS.
Egerton 1139; Fig. 11)[92] deploy acanthus scrolls in a fashion characteristic
of Islamic carved work, embellished with turquoises and semi-precious
stones and sandwiched between classical bead-and-reel borders that flow
into circular paths connecting eight medallions to one another and
separating them from the fields beneath. In the apse of San-Clemente,
rich acanthus-leaf ornament copied from a fourth-century model in the

Figure 11. Ivory cover, Book of Psalms of Queen Melisende, London
(between 1131 and 1143)

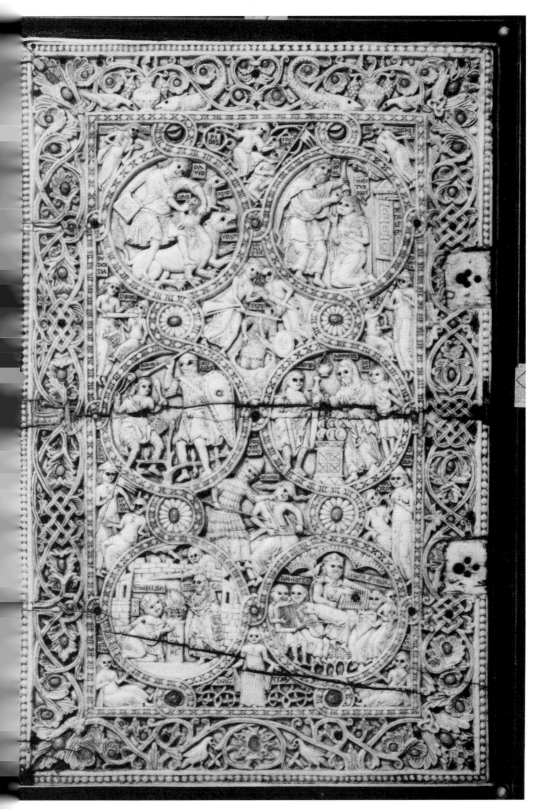

nearby Lateran Baptistery marks the place sheltering relics as the source of life, deploying dazzling beauty itself to offer the promise of a glorious reward to those who accept the faith.[93] Unlike the relics, however, or even the Sacraments below, which remained hidden, the color and energy of the ornament made visible the spiritual aspect of matter.

Architectural framing also carried rich meaning. An aspect of the revival of Early Christian forms during the Gregorian Reform, the acanthus, lotus and palmette motifs in twelfth-century Italian paintings, such as those used to frame the murals in San-Felice II in Ceri (Plate 8), were used specifically as a means for inserting monuments associated with the papacy into the history of Roman rulership.[94] The extravagant use of ornament in Celtic-Saxon works appears to construct a system of contemplation.[95] In part recapitulating the collecting of diverse tribal vocabularies assembled, for instance in the Sutton Hoo treasure, pages such as one of the frontispieces before John's Gospel in the Book of Kells (Dublin, Trinity College Library, fol. 290v; Fig. 12) deploy spirals, interlace, imitation enamels, and fretwork to assert unity and, in so doing, also to provide visual form to the concordance of the four Gospels. Introducing the magic of certain ornamental styles, such as the apotropaic function of knotted serpentine beasts biting their own bodies, the ornament inscribed on pages of Scripture also orders the physical and spiritual worlds.[96]

Material, color, and ornament served to attract medieval viewers from the chaotic world of real life and to construct the spiritual experience. The twelfth-century De diversis artibus assures painters that "by setting off the ceiling panels and walls with a variety of kinds of work and a variety of pigments, [they] have shown the beholders something of the likeness of the paradise of God" (Bk. III, prologue).[97] In making his argument, the author, presumably Roger of Helmarshausen, drew on Psalm 25.8: "I love the beauty of thy house, the place where thy glory dwells,"[98] one of several Scriptural passages deployed to justify the making of art.

Figure 12. Illustration, Book of Kells, Dublin (late 8th or early 9th cent.)

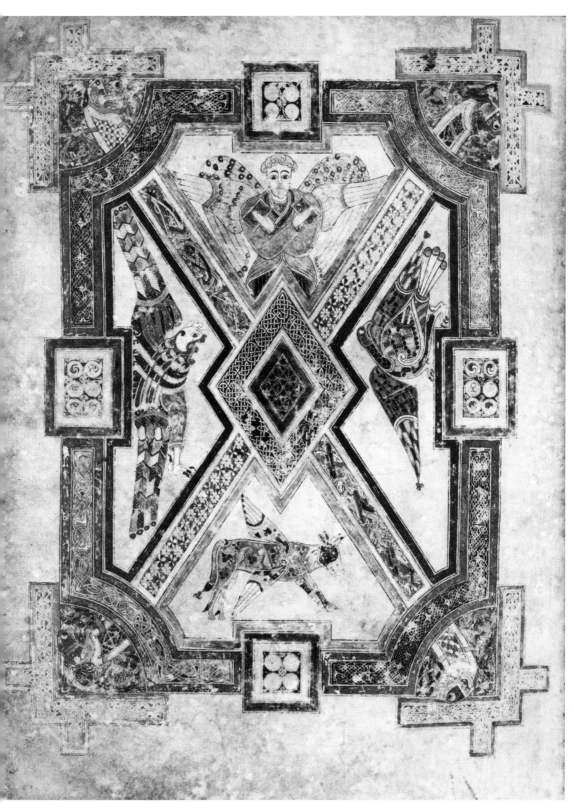

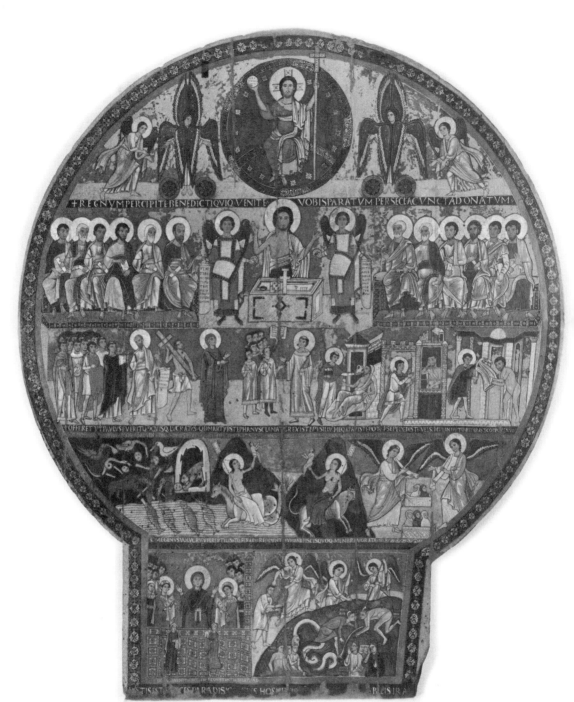

Chapter 2: Making

IN A CULTURE that sharply distinguished the mechanical from liberal arts and that favored such craft media as metal-working, the conceptual role of makers and the contribution of advisors and patrons were often vexed.[1] Because the word "artist" (*artista*) was not applied to the making of artistic objects until the end of the thirteenth century, the use of the term, with its modern associations of individualism, self-identification, imagination, and innovation, is itself contentious.[2] To be sure, many medieval craftsmen signed their works, but the colophon-like signatures themselves must be interpreted.[3] When in the late sixth or early seventh century Valerianus inserted his name prominently in the painted gemmed cross at the end of his Gospel book (Munich, Bay. Staatsbib., Cod. lat. 6224, fol. 202v), for instance, he was surely appropriating a scribal tradition to assert his achievement as a transcriber of Scripture; whether or not he was also laying claim to artistic originality remains debatable.[4] The role of Hugh, who identified himself as the "painter and illuminator" of the eleventh-century manuscript of Jerome's *Commentary on Isaiah* in Oxford (Bodleian Library, Ms. Bod. 717), has been given various interpretations.[5] Some signatures may even refer, not to the person who physically produced a work, but rather to the person who conceived or sponsored it; the famous Gislebertus, for instance, whose name is inscribed on the lintel at Autun, may be the donor and not, as nine-

Figure 13. Panel of the Last Judgment, Vatican (11th cent.)

teenth-century writers had it, the sculptor.[6] Indeed, the "me fecit" (so-and-so "made me") attached to many signatures may simply express pride in fine workmanship;[7] and, having the object itself speak as it were the formula put its maker in a clear, secondary position.

The elaborate signature on the back of the Teuderic reliquary in Saint-Maurice d'Agaune provides evidence of what might have been the normal division of labor during the early Middle Ages: "The priest Teuderic ordered it made (fieri iussit) in honor of Saint Maurice. Amen. Nordolous and Rihlindis managed (ordenarunt) its fabrication. Undiho and Ello crafted (ficerunt) it."[8] This structure of production seems to pertain to the eleventh-century panel of the Last Judgment in the Vatican (Pinacoteca apostolica, Fig. 13), on which the makers are named in the inscription beneath the resurrection of the dead: "at the sound of the trumpets, the painters Nicholas and John rise from the dust of the earth"; but the abbess Constantia, who probably commissioned the panel, and Benedicta, who may have paid for it, are actually pictured with their offerings outside the walls of Paradise.[9] Here the hierarchy of placement and the difference between portrait and written name may reflect the roles of *concepteurs* (persons who conceived the work) and painters. As late as the end of the thirteenth century, when the word "artist" was already current, the apse mosaic in Santa-Maria-Maggiore (Plate 1) was still a collaborative effort. Signed by the "painter" Jacopo Torriti, it was planned by Pope Nicholas IV (1288–92), as a letter to one of the patrons, Jacopo Colonna, makes clear;[10] the execution—including such inventive details as the tesserae figuring porcupine quills turned on edge—was surely the whim of the anonymous craftsmen who did the manual labor.

Procedures revealed through advanced analytical techniques of the frescoes in the upper church of San Francesco at Assisi have furthered the deconstruction of the notion that the makers of medieval art were like post-Renaissance "artists."[11] In the very cradle of artists' identity, evidence of *patroni*, actual-size paper models that were used and reused for details and entire figures, suggests a more collective procedure—especially for large-scale undertakings—than the earlier searches for identifiable personalities allowed and that discussions of local styles assumed.[12] Models were deployed throughout the period, some for planning, others for connecting a new work to an earlier tradition, and still others for organizing "workshop" procedures.[13] Serial production is also well documented.[14]

The question in each case concerns the significance of the choice of models and of variations introduced in copying or producing multiples. Thus, now that the dependence of the mosaics of San Marco on a fifth-century Greek manuscript is established, the motivations underlying the use of this source in thirteenth-century Venice and the adaptations made in transferring the miniature cycle onto the atrium domes emerge as central issues.[15] Long thought to have followed a scheme comparable to that of the transmission of authoritative texts, the production of the *Bibles moralisées* is seen in more complex terms, involving commonalities to be sure, but also simultaneity and repeated interventions.[16]

Clerical participation in the choice of models and conception of art is documented in numerous instances, particularly during the Carolingian period and the twelfth century when the propriety of material representations was being debated. Thus, Theodulf of Orleans (ca. 750-821), who was famously involved in the early Carolingian controversy over images and whose oratory at Germigny-des-Prés has long been understood as a reflection of his iconoclastic views, is seen to have contributed directly to the actual designing of the apse mosaic; indeed, Theodulf's personal experience of art during a trip to Rome underlay the composition and is an element in his dispute about art.[17] Audradus Modicus, a brother at Saint-Martin's, was the author of both the poems and certain of the pictures in the First Bible of Charles the Bald (Paris, Bib. nat. MS lat.1),[18] and both Einhard and John Scotus Eriugena seem surely to have been involved in the production of art.[19] Hincmar (ca. 806-82), bishop of Rheims and a very influential church leader, is emerging, not only as a major patron of art, but also as the determining intellectual force behind the creation of such important works as the Utrecht Psalter (Utrecht, Bibliotheek der Rijksuniversiteit, MS 32, Fig. 28),[20] the throne of Charles the Bald (Vatican),[21] and the San Paolo Bible (Rome, Monastery of Saint-Paul's-outside-the-walls).[22] Similar roles are being assigned the eminent theologians Anselm of Canterbury (1033-1109)[23] and Peter of Celle, abbot of Saint-Remi at Reims from 1162 to 1181.[24] Uta (d. ca. 1025) was undoubtedly involved in the production of the lectionary that bears her name and portrait (Munich, Bayer. Staatsbibliothek, Clm.13601), even though the book was written and painted in the (nearby) monastery of Saint-Emmeram, not at Niedermünster, of which she was abbess.[25] Later bishops also were important sponsors of art,[26] as were monks and friars.

In Rome, popes and cardinals were active participants in the produc-
tion of art throughout the period:[27] John VII (705-07),[28] Paschal I (817-
24),[29] and many others. Innocent III was a promoter of art,[30] as was his
successor Honorius III (1216-27), who is pictured in the apse mosaic he
commissioned for Saint-Paul's-outside-the-walls flanked by the
Adinolfus and John of Ardea, the church's sacristan and abbot who per-
haps oversaw the actual work.[31] A century later, Cardinal Stefaneschi was
not only the patron of the *Navicella* in the atrium of Saint-Peter's, but
also an advisor to Giotto (ca. 1267-1337) who, in later historiography,
became the originary "artist."[32]

The richest evidence of clerical involvement in the production of
medieval art is that of Suger, who left an account of his extremely conse-
quential involvement in the rebuilding of France's most important
church (Plate 2).[33] Suger boasted that he had summoned craftsmen from
various regions to complete the work, but he left little doubt that he was
the guiding intellect behind the architecture, sculpture, stained glass, and
goldsmith's work of the building considered to be the birthplace of
Gothic. What governed the abbot's aesthetic principles? To realize such a
sophisticated and consequential project, Suger must have relied on the-
ologian advisors, perhaps Hugh of Saint-Victor (d. 1142) who could have
transmitted to him the ideas of the Ps.-Dionysius.[34]

It does not follow, of course, that because a work of art relates to ideas
expressed by a known cleric that that person was active in its production.
Frescoes in Vicq have plausibly been connected to the writings of
Herveus of Déols, for instance, but the monk's direct participation need
not be assumed;[35] the same is true of Rupert of Deutz, whose theology
permeates the decorations at Schwarzrheindorf.[36] The precise relation-
ship between Christina of Markyate, an anchoress living near Saint-
Alban's in the 1120s and 1130s, and the illuminations in the Albani
Psalter (Hildesheim, Dombibliothek, MS St.-Godehard 1) is still being
hotly debated.[37]

At the same time, some clerics strove to control art by intervening in
production. Bernard of Clairvaux railed against artistic excess;[38] follow-
ing in his footsteps, the anonymous author of the *Pictor in Carmine* set out
guidelines that he hoped would "curb the license of painters."[39] Lucas,
the thirteenth-century bishop of Tuy, sought to censor innovative icono-
graphies, ex post facto.[40]

Figure 14. Illustrations, Gospel book, Hildesheim (11th cent.)

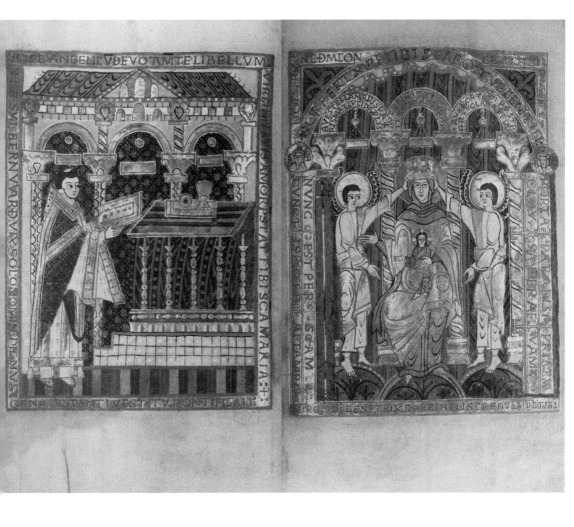

Considerable evidence survives that certain clerics were themselves artisans. Eloy (ca. 588-660), the most famous goldsmith of the Middle Ages and a patron of art, seems to have moved socially from artifex to member of the court to bishop and, finally, to sainthood.[41] Æthelwold of Winchester (963-84) may also have participated directly in the production of the Benedictional (London, Brit. Lib. MS Add. 49598) that bears his name and the imprint of his interests and personality.[42] The dedication specifies that the Bishop ordered the book to be adorned with gold, beautiful colors, frames, and various figures; and a (later) account of his life claims that he was himself a practicing goldsmith. The same is true of Bernward of Hildesheim, whose commissions have long been related to his travels to Rome and elsewhere.[43] The close conceptual relationship discoverable between the imagery of the illuminated Gospel book he presented to Saint-Michael's (Hildesheim, Dom-Museum, MS 18, fols. 16v-17r; Fig. 14)[44] and the doors he commissioned a few years before (Fig. 4) is to be put into the context suggested by Bernward's biographer Thangmar, who described him as skilled in art.[45] The chronicle of the monastery of Saint-Gall (*Casus sancti Galli*) described Tuotilo, a monk who died ca. 913, as a goldsmith, ivory carver, and painter, and Ekkehard II, an abbot, as skilled in the writing of capital letters and work in gold.[46]

Wolvinius, the "phaber" (that is, *faber*, maker), prominently portrayed alongside the patron Angilbertus II (824-59) on the golden altar of Sant'Ambrogio in Milan seems not to have been ordained;[47] but the metalworker Roger was a monk at Helmarshausen[48] and the "pictor" (painter) Jacopo Torriti who designed the Santa-Maria-Maggiore apse mosaic (Plate 1) may well have been a Franciscan brother.[49] Hugh of Saint-Victor constructed images for lectures collected in the *Ark of Noah*;[50] his contemporary, the anonymous illuminator of the *Moralia in Job* in Dijon (Bib. Mun., MS 173), revealed his own erudition and creative evolution in the sequence of initials he provided as a reading of the text.[51] Hildegard of Bingen was a prominent theologian who seems to have been actively engaged in the production of intellectually complex art; potent arguments support the conclusion that she composed the pictures of her mystical treatise known as the *Scivias* (formerly in Wiesbaden, Nassauische Landesbibliothek, MS 1)[52] and *Liber divinorum operum*. The (self-)portrait in the early thirteenth-century manuscript of the latter in Lucca (Bib. Communale, Cod. Lat. 1942, fol. 1v, Fig. 15),[53]

Figure 15. Illustration, *Liber divinorum operum*, Lucca (early 13th cent.)

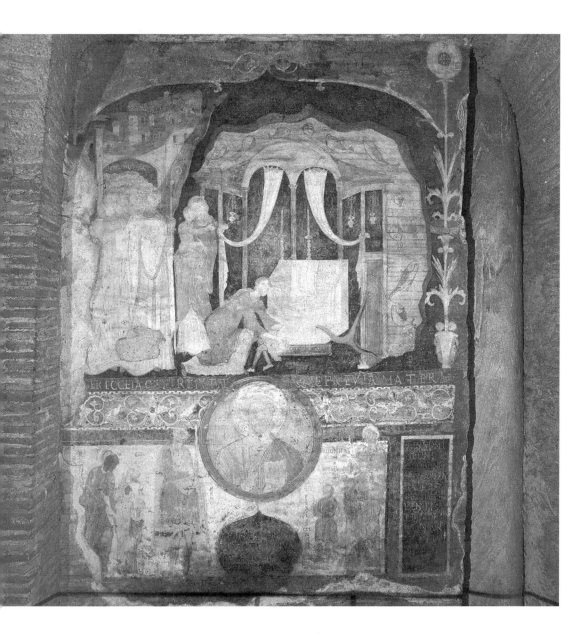

painted from an autograph design, shows her in the presence of the nun Richardis, transcribing her celestial vision directly onto wax tablets, smoked to render the figures more clearly; and in a separate space, it pictures her secretary Volmar transcribing the words onto parchment.[54] The depiction turns on its head the claim made in the life of Saint Eloy that the goldsmith-turned-cleric kept a book open while he worked so that he could engage in mental contemplation even while he finished a piece of metal work;[55] here, it is Hildegard who incorporates her inspired visions directly into pictures and into (spoken) words. Any argument that the makers of medieval art were "artists" in the modern sense would have to be based on a case like Hildegard's.

Legends about miraculously produced images, most of them originating in Byzantium, were invoked to justify art and were adapted to the structure of production prevalent in the Latin West. In contrast to the eastern emphasis on images made directly from the face of Christ, cited in Hadrian's response to the *Libri carolini* and other texts, the early Roman church generally favored myths involving human intermediaries.[56] Most important was the story of the encaustic Christ Emmanuel icon in the Lateran, painted on canvas glued to panel and still kept in the Sancta Sanctorum (Fig. 16). According to legends recorded at various times, it was the work of the Evangelist Luke who was chosen because, as a Greek, he excelled as a painter; but even an evangelist could not capture Christ's amazing aura and the icon had to be finished by an angel. The Lateran icon was fitted with a painted cloth cover in the tenth century and with an elaborate silver-gilt case embossed with cosmological symbols ca. 1200. Similar legends eventually came to be attached to the *Madonna Avvocata*.[57] Gautier of Coinci (ca. 1177-1236) imported some of the stories into French and Alfonso X, King of Castile and León, translated them into Galician-Portuguese, whence they were rendered in paint.[58] Alfonso's Cantigas is rife with pictures bearing on images, including the illustration of the Gethsemane story of the Madonna and Child impressed in stone (Fig. 3). True relic-images, most notably the Veronica, gained importance at the same time, that is at the very moment when the idea of the artifex was being reformulated. Innocent III, for instance, greatly advanced the cult of the Holy Face of Christ in Saint-Peter's and the "image-not-made-by-hand" was frequently copied, for example, in the Book of Hours of Yolande of Soissons

Figure 16. Christ Emmanuel icon, Sancta Sanctorum, Rome
(6th or 7th cent., 10th cent., and 12th cent.).

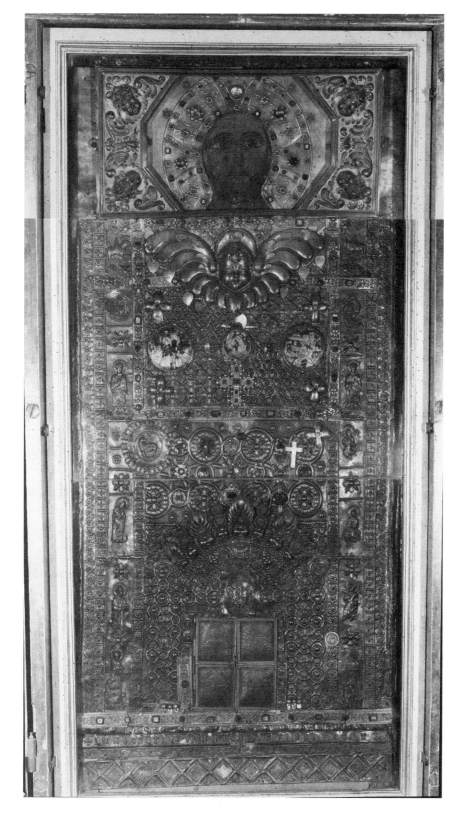

(New York, Pierpont Morgan Library, M. 729, fols. 14v-15r, Fig. 17).[59] It is telling, then, that the earliest representation of the Veronica in Matthew Paris's Arundel Psalter of ca.1240 (London, Brit. Lib. MS. Arundel 157) is inscribed on the verso with a verse attributing the image to the "artifex's diligence";[60] from the beginning, copies of the "vera icona" implicated human manufacture.[61]

While certain arts such as manuscript illumination (before 1200) were largely the monopoly of the monastic artifex, others — particularly forms requiring more physical than intellectual activity — seem also to have engaged secular workers. Metalwork was practiced inside and outside the cloister, and individual makers crossed over between domains; an example was Tuotilo, who left Saint-Gall to work in Mainz. Courts were also artistic centers, but consistent patterns are difficult to establish for their involvement in production. Thus, even though the Carolingian court functionary Einhard (ca. 770-840) was nicknamed "Bezaleel" after the crafter of the desert tabernacle and was certainly active in the making of objects, the depth of his direct engagement is not clear;[62] and during the thirteenth century, when court patronage and production can be documented in considerable detail, there is still scant evidence of permanent ateliers.[63]

Throughout the Middle Ages, courts interacted with monastic artisans. Thus, Saint-Martin's at Tours produced illuminated manuscripts rife with political messages for both sides in the struggle for power during the 840s.[64] A miniature from the Toledo *Bible moralisée* (New York: Pierpont Morgan Library, MS 240, fol. 8r) pictures what must have been a fairly common circumstance; beneath Blanche of Castille and her son Louis IX, a cleric is portrayed with a book in his hand (perhaps bearing the words "Let it be left to faith to paint") instructing a miniaturist at work on a sheet of vellum already subdivided into medallions for the miniatures; nonetheless, the question remains whether the encyclopedic cycles of miniatures were, in fact, constructed by a learned master.[65] Matthew Paris, a Benedictine monk, moved freely between Saint-Albans and the court and produced art that combines both worlds;[66] and King Henry III (1207-72) favored the work of William, a monk of Winchester, simply ordering that work made for him be "proper," "beautiful," and "expensive." How kings and masters actually interacted with one another is virtually impossible to determine. In general, it seems

Figure 17. Veronica, Book of Hours of Yolande of Soissons, New York (14th cent.)

Innocens le pape de rome qui christe on
son en remission de tous peturs qui conte
dit cette orison au sacrement il ara. le
iours de pardon.

Psalmus dauid.

Deus miseratur nostri
signatum est.

ac mecum signum in bono ut videat
qui oderunt me qui tu domine adiuuisti
me et consolatus es me.

Deus qui nobis signatis uultus tui
lumine memoriale tuum ad instantiam
ueronice ymaginem tuam sudario impressa
relinquere uoluisti per passionem et crucem tuam
et scm̃ sudarium tuum tribue nobis ut ita nos
in iris per speciem in enigmate ueniat adora
re honorare ipsum ualeamus ut te ubi faciem
ad faciem uenientem super nos iudicem secun in
deamus dominum nostrum ihm xpm. Amen

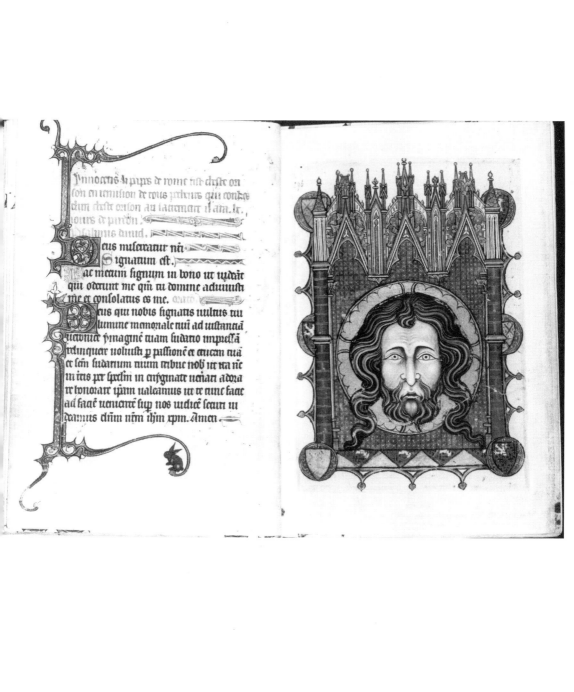

highly unlikely that rulers participated in the actual designing and manu-
facture of art.[67] Even Frederick II, who "authored" the *De arte venandi
cum avibus*, the age's most important treatise on natural history, surely did
not paint the birds and animals in the illustrated volume even though,
like the text, they are rich in scientific detail.[68] The great monarch was a
promoter and patron, not a craftsman. Alfonso, on the other hand, who is
portrayed in numerous miniatures of the Cantigas, may have been more
engaged in the production of his great manuscripts.[69] The problem with
attributing too much direct participation to a famous ruler is not that
history might be distorted or a noble's role in the work exaggerated, it is
that the sponsorship of other court groups might be overlooked and with
it art's interesting function as a device for teaching, exhorting, flattering,
and even scolding the ruler.[70]

A rigid distinction between secular and religious production may, in
any case, belie medieval reality. The warrior Vivian shown with the
brethren presenting the First Bible to Charles the Bald was a "lay abbot,"
as was Einhard. Many members of the clergy were, themselves, aristo-
crats, and royalty fashioned itself as part of the sacred order.[71] In turn,
many religious groups admitted seculars: Brother Rufillius, pictured
painting the letter R in a late-twelfth-century Passionale from Weissenau
(Geneva, Bibl Bodmeriana, Cod. 127, fol 224), was a "white canon";
although tonsured, he was not a monk.[72] The Order of Penitence among
Franciscans, which did not require the relinquishing of lay status, allowed
diverse forms of interaction,[73] and the importance of para-clerical groups
such as confraternities in the commissioning of art grew during the
thirteenth and fourteenth centuries.[74] In the fourteenth-century Luttrell
Psalter (London, Brit. Lib. Add. Ms. 42130), making is assigned to the
patron by the standard "me fecit" inscription beside Lord Geoffrey's por-
trait, though the actual production seems to have been the work of liter-
ate laymen.[75] Even as laymen emerged as the principal producers of
medieval art, however, their precise status is often unclear, as in the case
of the famous Villard de Honnecourt.[76] The transition to dominant lay
patronage was fully realized only in the fourteenth century.[77]

Commercialization of production further complicated the interactions
among various members of society, including members of minor orders.
It reinforced family production and inheritance.[78] The relationship

between the Master Honoré and the Papeleu Master, long recognized by means of stylistic affinities, is now documented as a relationship between father-in-law and son-in-law, and the active participation of spouses is also well attested.[79]

An overriding ambivalence toward manual labor underlay artistic production throughout the Middle Ages.[80] Although the *Rule of Saint Benedict* and, within a wide range, other monastic ordinaries allowed for work, physical labor was still largely understood as servile and carnal.[81] Carving, painting, working in precious metals or stones, and other crafts were "mechanical arts" less highly regarded among human activities than the "liberal arts" and the opus Dei. The distinction came to be elided at the start of the twelfth century. Roger of Helmarshausen's *De diversis artibus* comprises three chapters of recipes intended to instruct artisans in the crafts of making glass, cementing gold, and carving ivory, but it also asserts that manual skill alone does not produce art. According to the author, a craftsman must exercise a gift of the Holy Spirit to realize his talent in the production of images of Christ and the saints.[82] Thus, like Roger himself who was both an artisan and a cleric, a craftsman must bring two qualities to bear: skill and divinely-bestowed wisdom. Rupert of Deutz and Hugh of Saint-Victor provided positive interpretations of the "artes mechanicae"; the latter, for instance, placed goldsmithing at the top of his list of the mechanical arts and art among the "scientiae mechanicae."[83] Still, for Hugh and Richard of Saint-Victor (d. 1173), manual art was necessary only because the Fall had deformed perfect creation.[84] Honorius Augustodunensis (ca. 1080-ca. 1154) added the "work of metal, wood, marble, and especially painting, carving, and the manual arts" to the seven liberal arts;[85] and in his *De divisione philosophiae* of ca. 1150, Domingo Gundisalvo provided a theoretical basis for the elevation of art by giving mechanical and liberal arts equal status.[86] Hildegard of Bingen tied art to the dual nature of Paradise.[87]

The evolution of the role of the maker was certainly tied to increasing acceptance of the created world as good.[88] Although Christ as creator of the world had long been compared to human artists, the literal iconography of Christ as *artifex mundi* originated about this time,[89] a mature example being the portrait that opens several manuscripts of the *Bible moralisée* showing Christ composing the primordial world by circum-

scribing the terrestrial orb with an enormous compass. The illuminator, one should remember, mimicked this creative act when he put his own compass at the center of the folio and twirled it between his fingers.

Modern conceptions of the autonomous innovator are just as misleading as nineteenth-century notions of the self-effacing medieval artisan. Medieval artistic production must be understood as a process in which the actual maker functioned within a system in which resources were provided by a donor and external constraints were imposed by a patron or other authority. While historically grounded notions of production vary with individual circumstances, they usually reveal a complicated inter-working of craft practices, authoritative models, individual talents, and ecclesiastical or other supervision. For example, by following the long tradition going back to the Early Christian basilicas of Saint-Peter's and Saint-Paul's, the *concepteurs* of Assisi certainly intended to tether the new mother church of the Franciscans to the apostolic basilicas in Rome;[90] but they also relied on intermediary reworkings of that tradition as exemplified by the frescoes at Ceri (Plate 8) and they refreshed it with interpolations from antiquity and observations from nature. They certainly exhibited "artistic license," but who was the "artist"? The arguments that have always turned around Vasari's claims might better be reformulated in terms of a complex interaction among patrons, designers, and makers, all playing important roles.[91]

As they continued to be later, donors were often very important participants.[92] An inscription around the bust portrait of the donor on the portal sculpture from St-Emmeram leaves little doubt that the Abbot Reginward simply ordered the work; however, the portrait on the book cover of Hugo d'Oignies (Namur, Soeurs de Notre Dame) vividly attests that the boundaries between patron, *concepteur*, and maker could also be quite permeable. Hugo was himself a lay-brother, and he is presented both as the book's scribe and as its donor.[93]

Patronage often extended far beyond the commissioning and funding of a project.[94] Some patrons took charge of assembling craftsmen, Suger for instance, and Pope Honorius who summoned to Rome mosaicists in Venice to work on the apse of Saint-Paul's-outside-the-walls. Papal patronage certainly accounts for the appearance of the same masters at both Anagni and SS. Quattro Coronati in Rome.[95] Patrons

may also have provided models. The iconographic and programmatic
unity of church decoration in twelfth- and thirteenth-century Lazio and
Umbria, for instance, is to be explained, in part at least, through the cir-
culation of model books sponsored by the papacy.[96] Similarly, the
Franciscans circulated forms and models,[97] and the Dominicans and other
orders were active in commissioning and supervising the production
of art.[98]

Moreover, the interaction between patrons and makers could be any-
thing but simple. The brethren at Saint-Martin's of Tours, for instance,
used art actually to subvert the interests of their lay abbot, or at least tried
to.[99] How various parties — the monarchy, aristocrats, clerics, and
guilds — interacted in the production of art under the Capetians is a par-
ticularly fraught issue.[100] The role of the corporate donors depicted in the
lower windows at Chartres has been variously interpreted. It certainly
seems reasonable that the narratives, drawn from Latin and vernacular
texts but developed in an original fashion, were dictated by the literate
clergy;[101] indeed, clerical donors and members of the nobility were
responsible for windows in the transept and high in the choir.[102] In like
fashion, the prominence of tradesmen in the lower windows of the
chevet might suggest that the lay associations that paid for the glass are
"co-authors"[103] or, conversely, reflect the chapter's strategy to attach the
church to the artisans and merchants.[104] Most likely, the principal aim was
to establish a place for the new class of donors within the history of the
Church.[105] In view of the subtlety of relationship between donor and
producer evident at Chartres, the nature of King Louis IX's involvement
needs to be interpreted with care.[106] In the Sainte-Chapelle, the king's
private chapel, Louis was thematized in the selection of subjects chosen
for the windows, but so was his mother Blanche of Castille.[107] What,
then, were the roles of clerics and makers? The question becomes even
more difficult to answer for works not directly tied to the king, such as
the Arsenal Old Testament (Paris Bib. de l'Arsenal, cod. 5211),[108] Morgan
Library Picture Bible (MS M 638; Fig. 24),[109] and Rheims cathedral.[110]
Here, the *Bibles moralisées* offer a guide and a warning. For all the similari-
ty of the four thirteenth-century manuscripts to one another (Vienna
2554, Vienna 1179, Toledo, and Oxford-Paris-London), their making was
anything but straightforward, nor was the relationship to the commission-

ers, planners, and the recipients—Louis VIII, Louis IX, and conceivably Marguerite of Provence.[111]

Although Blanche of Castille was a remarkable person, her contribution in the Capetian court to the making of art is not at all exceptional for a queen. Women were positioned to have an effect on artistic production through their role in gift-giving at Carolingian courts.[112] The Byzantine princess Theophanu, who married the Emperor Otto II and died in 992, had an extraordinary impact on Ottonian art.[113] A little later, Queen Ælfgyfu made donations of luxurious fabrics (women were responsible for weaving arts) to the Abbey Church at Ely, and she is pictured with King Cnut presenting the altar cross to the New Minster and Hyde Abbey in the *Liber Vitae* (London, Brit. Lib. MS. Stowe 944, fol. 6).[114] While the portrait promotes Ælfgyfu's position, it also raises a complicating issue, namely, the role of couples in the patronage of art.[115] That question, however, is but one variant of the many involving the collaborative production of medieval art.

What motivated the commissioning of art in the first place? In some instances, the making or donating of art was part of the age-old system of "giving in order to receive."[116] The poems in the First Bible of Charles the Bald, for example, make clear that the monks hoped that the king would respond to their gift by renewing the privileges of Charlemagne that Louis the Pious had conferred on their monastery.[117] More commonly, in patronage as in so many other aspects, medieval tradition was based on still earlier practice, namely offering gifts to the gods. In accord with heathen Germanic custom, for instance, the great burial mounds in which the Sutton Hoo treasure was interred seem to have been intended to buy Woden's favor.[118] One aspect distinguishing medieval art patronage from that of its predecessors was its appeal to intermediaries—Christ, Mary, and the saints—which inserted it into a hierarchy of supplication.[119] The mediator between God and man par excellence, Christ is addressed directly in many works: the Sancta Sanctorum reliquary box,[120] for instance, and the First Bible of Charles the Bald. In the mosaic decorating the tomb of John VII in Saint-Peter's, the Pope had himself portrayed at the foot of *Maria Regina* and described in inscriptions as the unworthy "servant of God" who made the work.[121] Service to God is also referred to in the caption of the miniature picturing the Abbess Uta offering her book to the Virgin and Child;[122] referred to as a "votive,"

Figure 18. Shrine of the Three Kings, Cologne, cathedral (late 12th cent.)

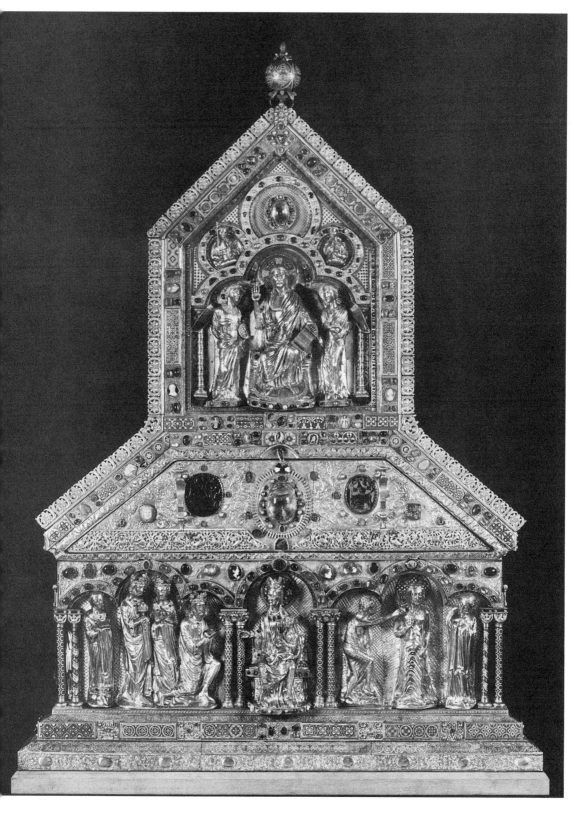

Uta's offering implies reciprocity, that is, eternal reward. The same is implied by the positioning of Benedicta and Constantia outside the Heavenly City on the Vatican Last Judgment panel, where, however, saints provide intermediary steps in the process. Indeed, numerous works were given specifically to saints: an inscription in Santa Prassede (Fig. 1) proclaiming that Paschal had the radiant apse "decorated with silver and gold" in honor of Saint Praxedes and the saints whose bones are interred below. A whole chain of supplications is pictured in a fresco of ca. 1085 in the lower church in San-Clemente in Rome (Plate 9).[123] Flanking a portrait of the dedicatory saint, the donors Beno and Maria de Rapiza and their family are pictured bearing offerings of candles and wax; an inscription makes clear that the gifts, including the painting itself, were for the redemption of the donor's soul. A particularly elaborate example of a donor's expectations is evident in the portrait of King Otto IV on the Shrine of the Three Kings in Cologne (Cathedral, Fig. 18).[124] Inserted behind the three archetypal gift-givers, it attests to the king's own tribute to the magi — whose skulls are preserved inside — and through them to Christ, Mary, and God, whose kingdom, pictured at the top, he hopes to enter. In turn, the greater the number of gifts or the more elaborate, the more powerful the saint would seem to be. An inscription on the great reliquary of Saint Remaclus at Stavelot (destroyed, but known in a drawing in Liège, Archives de l'état; Fig. 19) proclaims that Abbot Wibald gave one hundred marks for the gold and silver used in its making in the hope of gaining the saint's intercession with God.[125]

A related function of patronage was to preserve the memory of the donor and, in so doing, to keep her or him alive in the thoughts and prayers of those who came afterward. Converting the ancient custom of equipping the dead for the afterlife, it traded donations to the church for perpetual supplication by churchmen. Theodulf of Orleans made this explicit in the titulus of his apse when he called upon those gazing at the mosaic to include "Theodulf's name in your invocations."[126] An inscription beneath the portrait of Saint Clement also invokes prayer, albeit with an admonition that those who seek him with their prayers must themselves be free of evil. A titulus at the bottom of the case Innocent III provided for the Lateran Christ recalls his generosity and inserts him in a continuous (and perpetual) process of papal entreaties. The final opening

Figure 19. Reliquary of Saint Remaclus at Stavelot, (drawing, Liège)(12th cent.)

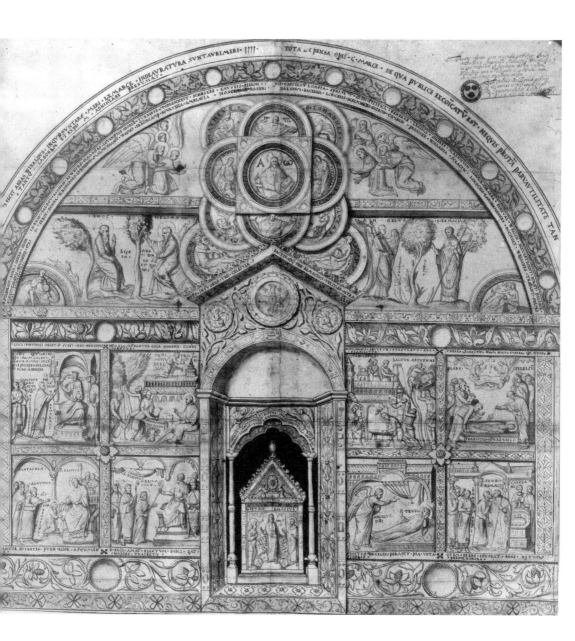

of Herrard of Landsberg's great compendium *Hortus Deliciarum* (Strasbourg, Bib. de la Ville; destroyed in 1870) portrays some sixty members of the community of nuns as a way of staging perpetual veneration for the monastery's founder by later users of the book.[127]

The making of sacred art during the Middle Ages was, then, largely a part of the devotional structure; and any understanding of its producers must take that into account. In the ecclesiological domain, the production of art was understood as a spiritual act, inspired by the Holy Spirit and implicated in the process of restoring carnal beings to the invisible God. The mechanism is pictured in the Lucca portrait of Hildegard, who like the Virgin Mary receives divine emanation and gives it physical form; and it is evident in the succession of depictions of struggle in the Dijon *Moralia in Job*, which culminates in a picture of the *miles Dei* firmly in control of the animal world and of his own person.[128]

Chapter 3: Spirit

THE LURE of luxurious materials and the attraction of intricate crafts-manship were recognized even by those generally suspicious of art; indeed, an appreciation of art's seductiveness only reinforced objections to it. Although he insisted that the value of decoration depended exclusively on the intrinsic worth of the material and workmanship, Theodulf of Orléans accepted its legitimacy; but he also insisted that it was only food for the eyes devoid of all spiritual nourishment. Bernard of Angers reports in the early eleventh-century *Liber miraculorum sanctae Fidis* that, when he first saw the statues of the saints Gerard and Faith at Conques "fashioned out of the purest gold and the most precious stones," he reacted as if they were idols of Jupiter or Mars and Venus or Diana.[1] Bernard of Clairvaux went further, arguing that those who promote art "stimulate the devotion of a carnal people with material ornaments because they cannot do so with spiritual ones";[2] and Richard of Saint-Victor considered craftsmanship to be an "adulterous" result of the fall that seduced humankind away from the spiritual to the physical.[3] The scene of Joseph Fleeing Potiphar's Wife at Ceri depicts the perceived danger (Plate 8);[4] the Hebrew youth, who was understood in the Middle Ages to be a type of Christian virtue, flees from the temptress — enthroned within an elaborate palace — whose pink robe embroidered with gems and patterns and bejewelled tiara and earrings represent the seductiveness of adornment.

While a steady current ran against art throughout the Middle Ages,[5] it was a trickle compared to the steady stream of support for it as a useful, even necessary, instrument of spiritual elevation. Paulinus of Nola (353-431) believed that even "carnal food" could deliver benefit to rustic pilgrims who, "feed[ing] their eyes with this attractive and charming fast, [would] turn more slowly to thoughts of food" (Carmen 27.588-89); Bruno of Segni (ca.1040-1123) asserted the elevating potential of art's sensual appeal, maintaining that through gold ornament "the whole church rises up into a state of contemplation, and she is lifted out of the earthly realm into the heavenly" (Sententiae, II, chap.12).

In defending art, Bruno of Segni and others could cite the sacred buildings, objects, and images God had ordained in Scripture. Of these, the most important were the desert tabernacle and its replacement, the Jerusalem temple, equipped with gold utensils—the Ark of the Covenant adorned with cherubim, seven-branch candlestick, bronze sea, and other appurtenances.[6] Introduced during the iconoclastic period to justify art, the Jewish vasa sacra were deemed to partake of the sacred even in the Libri carolini,[7] the attack on art authored by Theodulf and others in Charlemagne's court; they were cited by virtually every defender of Christian art. Roger of Helmarshausen alluded to them and to the divinely inspired artisan Bezaleel who made them; for William Durand (ca. 1230-96), they were the origin of church ornament.[8] The theoretical argument activated actual production. A magnificent frontispiece in the ninth-century San Paolo Bible (Rome, Monastery of San Paolo outside the walls, fol. 32v) pictures the seven-branch candlestick, the golden ark flanked by the cherubim within the "sancta sanctorum," and craftsmen sewing the curtains of the outer courtyard.[9] Suger featured the Ark of the Covenant at Saint-Denis (Fig. 8). References to the Temple permeated the pope's Sancta Sanctorum at the Lateran and many other buildings.[10] An allusion to the Ark underlies Nicholas of Verdun's reliquary in Cologne containing relics of the three magi (Fig. 18).[11]

Christians believe that Christ's sacrifice had replaced the priesthood and the annual rites of expiation conducted in the inner sanctum, making them available to all believers everywhere: "the blood of Jesus makes us free to enter boldly into the sanctuary by the new, living way which he has opened for us through the curtain, the way of his flesh" (Hebrews, 10:19). Thus, the eighth-century Franks Casket (London, Brit. Mus.)

pictures, on one side, the Romans destroying the Jerusalem Temple, and, on another, the Adoration of the Magi;[12] and, to assert the supersession of the Jewish cult by the blood and body of Christ on the altar below, Theodulf of Orléans featured the Ark of the Covenant in the apse of his private chapel at Germigny-des-Prés.[13] The Ark of the Covenant also underlies the decoration of the base of the twelfth-century Lisbjerg Altar (Copenhagen, Nationalmuseet, Fig. 20);[14] at the center of the elaborate gilt structure is the arched structure labeled "City of Jerusalem" flanked by two cherubim. While Bernard of Angers struggled to understand the anthropomorphic reliquary of Sainte Foy at Conques, he was prepared to accept it as "a more precious treasure than the ark of the Covenant" containing bones of a saint, "without doubt one of the outstanding pearls of the heavenly Jerusalem."[15] The Jewish temple also lay behind Abbot Odo's installation of an actual seven-branch candlestick, eighteen feet high, beside the main altar in Saint-Remi at Rheims, perhaps influenced by Peter of Celle, who had written an interpretation of the tabernacle.[16]

As the actual instrument of Christ's redeeming sacrifice, the cross was the particular focus of the argument. Together with a book and other instruments of the Passion, a gold cross is exhibited on the altar on the Vatican Last Judgment panel (Fig. 13), its precious material transforming the sign of Christ's debased death into an emblem of victory. In so doing, it alludes to the "sign that heralds the Son of Man" that will herald the Second Coming (Matt. 24-25) and, specifically, to Constantine's (d. 337) decision to create a golden banner (*vexillum*) as a way of recalling the luminous cross that had appeared to him in a dream just before his victorious entry into Rome.[17] The depiction above the altar of the apocalyptic Christ bearing a globe in one hand, inscribed with the words "I have conquered the world" (Jn.16.33), and a gold cross set with jewels confirms the sign's function as an emblem of triumph. An important hymn, *Vexilla regis prodeunt*, perpetuated the connection between the cross and battle standard; the association underlay Augustine of Canterbury's entrance into pagan England bearing a book and gold cross in 597 and the victory of Covadonga in 718, the beginning of the Christian re-conquest of the Iberian peninsula, when a gemmed cross was made in imitation of the *labarum*. The *crux gemmata* remained a potent multivalent sign of Christian triumph[18] and was readily assimilated to traditions of barbarian metalwork. The Anglo-Saxon cross associated with Saint Rupert of

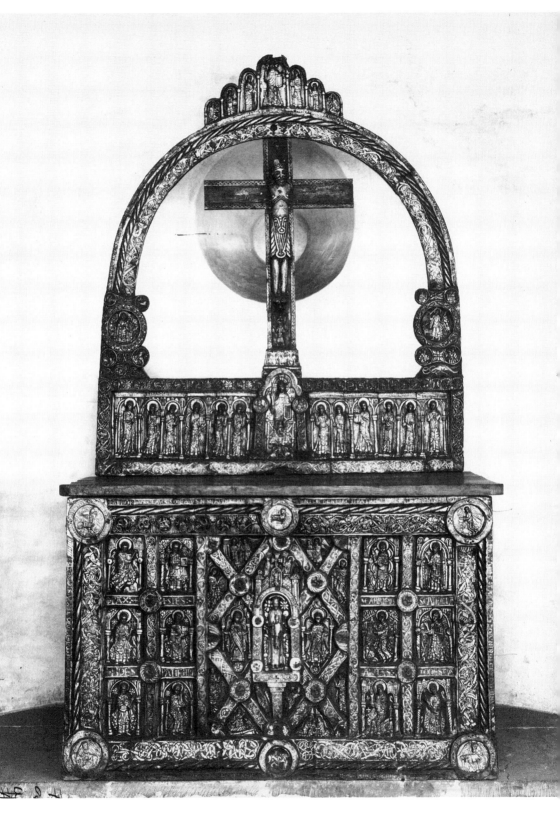

Salzburg (Pongau, Bischofshofen), for instance, applies to the Christian sign the interlace, knot-work, and stylized vine scrolls used by the tribal peoples that occupied northern Europe during the first millennium. Suger still acknowledged the triumphal meaning when he furnished Saint-Denis with "the adorable, life-giving cross, the health-bringing banner (vexillum) of the eternal victory of our Saviour" (*De Admin.*, 32).

Matter, even elevated matter, still evoked the question of idolatry, as Scripture itself attested. When Moses was on Sinai receiving God's law, for instance, the Chosen People melted down the Egyptians' gold and fashioned a golden calf (an episode pictured prominently at Saint-Denis [Plate 2]); and Hezekiah had to destroy the brazen serpent because "the Israelites had been burning sacrifices to it; they called it Nehushtan" (2 Kgs.18.4). Ezekiel witnessed the idolatrous abominations in the Temple (8.7-18), pictured in a manuscript from ca. 1000 of Haimo of Auxerre's *Commentaries on Ezekiel* (Paris, Bib. nat. Ms. lat. 12302, fol. 1r), which shows the Jews ignoring the Ark of the Covenant and censing reliefs of animals on the walls of the temple, women swooning before a naked idol, and twenty-five men worshiping the sun.[19] Bernard of Clairvaux must have had such examples in mind when he dismissed church decoration as "somehow represent[ing] the ancient rite of the Jews."[20]

In fact, Jews were generally even more resistant to art than were Christians, at least after the codification of the Talmud; but, like Christians, they too expressed a range of opinions about it. Thus, Rabbi Joseph Bekhor Shor of Orléans countered the Christian claim that Jews revealed their susceptibility to idolatry when they worshiped the golden calf by pointing to "the heaps of [Christian] statues whose number has no end." In the fourteenth century, Profiat Duran accepted the argument that the Temple justified book illumination: "just as God wished to adorn the place of His Sanctuary with gold, silver, and precious stones, so is this appropriate for His holy books, especially for the book which is 'His Sanctuary' [the Bible]."[21] From the tenth century until the end of the Middle Ages, Jewish art flourished under diverse styles, ranging from the characteristic micrography and abstract ornament derived from Muslim art to assimilative and creative responses to Christian narrative representations.[22] A miniature in a Hebrew Bible produced ca.1300 near Valencia (Lisbon, Bib. nat. Ms. 72, fol. 316v, Fig. 21) deploys gold and brilliant colors to picture the vision of return described in Zechariah 4.1-3;[23] other pages are adorned with the horseshoe arches and interlace

Figure 20. Lisbjerg Altar, Copenhagen (12th cent.)

ornament typical of Judeo-Islamic art. To a great extent, medieval Jewish art represents a distinctive tradition within the cultural practices of its Christian and Muslim neighbors.[24]

What distinguished Christian attitudes toward art from those of the Jews and others outside the faith was the fundamental belief that God had become a man and had lived on earth, where he was seen and touched. Although no systematic defense of art, of the sort that developed in Byzantium, was ever formulated in the Latin West,[25] a rudimentary theory gradually emerged, based largely on belief in the Incarnation. An interpolation introduced in the eighth century into Gregory the Great's letter to Secundinus makes the point:

> We do not, in truth, bow down before this image as before the divinity, but we adore him whose birth, passion, and enthronement in glory the image recalls. And thus, like scripture, the image returns the Son of God to our memory and equally delights the soul concerning the resurrection and softens it concerning the passion.[26]

Even while insisting that art could not represent Christ's spiritual aspect, Theodulf conceded that it was able to depict Christ's earthly life.[27] Three centuries later, however, Bruno of Segni accepted the implications of the orthodox belief that Christ's human and divine natures were inextricably united when he proposed that, unlike the embellishments of "heretics, pagans, philosophers and Jews," church decoration was elevated because it included representations of Christ's deeds (and those of his saints): "you see demons flee, the dead rise, the blind are restored, paralytics are cured, lepers are cleansed, and other miracles" (*Sententiae*, II, chap. 12). A century earlier, the ivory diptych in Berlin (Fig. 5) had made the same contrast visible but with a slightly different spin. Moses, who was unable to see God, receives the Law within the tabernacle adorned with cherubim; looking up at his face, Thomas proves the divinity of the resurrected Lord. The same concept is realized in the Odbert Gospels painted in Saint-Omer ca. 1000 (New York, Pierpont Morgan Library, Ms. 333, fol. 85r; Fig. 22);[28] the crucifixion is presented as a watershed in sacred history, separating the triumphant *Ecclesia* from the defeated *Synagoga*. Thirteenth-century frescoes in Sankt Johann at Taufers (Tubre) (Plate 10)

Figure 21. Illustration, Bible, Lisbon (ca. 1300)

build on the same contrast, picturing Moses delivering the Law to the Israelites on the right across from a spiritual baptism of Christ in which the waters teem with defeated demons and John is accompanied by hosts of acclaiming angels.

Miraculous images came to be accepted as verifications of the Incarnation. The Lateran Christ icon, which started its career around the time of Gregory the Great simply as a painted panel (Fig. 16),[29] was designated an "acheropsita" during the iconoclastic period, a corruption of "acheiropoieton" or object "not made by human hands."[30] An allusion to several oppositions found in Scripture of the Jewish Temple "made by hand" (Mk. 14.48, Hebrews 9.24, 2 Cor. 5.1) and the celestial city where Christ now abides, the name in itself conjured up Christ's replacement of the earthly sanctuary. The association with the Jerusalem Temple was furthered in a twelfth-century account reporting that the icon had been brought to Rome together with the spoils of the Temple when Titus conquered Judaea in 70 AD; the reference to the heavenly city was conveyed in the text by the claim that Luke had selected palm wood because of its triumphal symbolism. Christ's dual nature was incorporated in the account, not only in the legend that the image was made by Luke with the assistance of an angel, but also by inserting the icon into the story of the Ascension; the Lateran panel owed its origin to the fact that the human Christ seen on earth had ascended "beyond the Apostles' eyes." These several aspects were made visual when Pope Innocent III covered the venerable image in a golden case adorned with cosmological designs,[31] and, later, when it was set atop the altar containing the cypress wood chest holding diverse relics and known as the "Sancta Sanctorum."[32] By being assimilated to the instruments of the temple cult and the replacement of that cult through Christ's sacrifice, the painting was, in these ways, also reconfigured as a relic that re-enacted the incarnation itself.

The Veronica also served to demonstrate the two natures.[33] Believed to be the "vera icona" (i.e., the "true image") of Christ's face impressed directly onto a cloth when Veronica wiped his face,[34] it was at the same time both a relic of Christ's earthly life and evidence of his divinity made without human agency. The Veronica, too, came to be likened to the Jerusalem temple; an illustration of the breaking of the sixth seal (Rev. 6.12-17) in a thirteenth-century English Apocalypse (Lisbon, Calouste Gulbenkian Museu, L.A. 139, fol. 13), for example, shows

Figure 22. Illustration, Odbert Gospels, Saint-Omer (ca. 1000)

Christ enthroned in heaven holding a golden seal in his hands and the triumphal Roman soldiers bringing the temple veil—bearing the face of Christ—to Rome as proof that they had conquered Jerusalem in 70 AD.[35] Innocent III elevated the humble cloth relic by fitting it out with a gold and silver capsa set with precious stones; the same glorification is enacted in the Hours of Yolande of Soissons (Fig. 17), which shows Christ's face bodiless against the cloth and framed in a precious reliquary.

The most popular of all medieval depictions of Christ was the Crucifix. Connected with the Temple implements in Suger's medallion of the Chariot of Aminadab (Fig. 8) and Lisbjerg Altar (Fig. 20), it too was elevated by means of a legend. Applying the pattern of Luke's alleged work on the Lateran *Acheropita* to a wood crucifix in Lucca, one story maintained that a sculpture of Christ's death on the cross had been begun by Nicodemus and finished by an angel.[36] Nicodemus was the Pharisee in John 3, whom Jesus himself had addressed as "this famous teacher of Israel" and had tellingly asked,

> if you disbelieve me when I talk to you about things on earth, how are you to believe if I should talk about the things of heaven? No one ever went up into heaven except the one who came down from heaven, the Son of Man whose home is in heaven. This Son of Man must be lifted up as a serpent was lifted up by Moses in the wilderness, so that everyone who has faith in him may in him possess eternal life.[37]

Here, legend attaches the crucifix to another Old Testament example often cited to justify Christian art, i.e., the sign Moses raised in the desert to save the believers (Num. 21.5-9).[38] Suger pictured it, too, in his windows (Plate 2), surmounted by a Crucifix, and it is featured on the great ivory cross in New York (The Cloisters, Metropolitan Museum of Art), where the scene forms Christ's halo.

To trigger the process of elevation, many crucifixes were introduced as signposts on the pathway upward. On the Copenhagen reliquary (Plate 6), for instance, the painting of Christ's death is transformed by the crystal and then exalted by the picture of Christ in heaven rendered on the reverse; on the Lisbjerg altar, heaven is depicted above the mortal Lord

on the cross; and on both the Cloisters cross and in the Odbert Gospels, Christ's Ascension is pictured above the Crucifixion. In the latter, Christ's crucifixion is rendered as a vanquishing of evil, another allusion to victory and specifically to the conquest of sin, symbolized by the serpent beneath the cross; the reference to the devil who seduced Adam and Eve is reinforced by the four rivers of Paradise personified in the margins, transforming the Crucifixion into a demonstration of the purpose of the Incarnation, namely the redemption of sin. That is also the point of the vines adorning the crosses in Suger's medallions and of the great tree-vine that dominates the apse of San-Clemente in Rome, the acanthus "semper frondens" growing out of the crucifix joining earth to heaven.[39]

Most often, medieval image-makers deployed usual iconographic means to present Christ as both earthly and divine. For example, a manuscript in Stuttgart (Landesbibliothek, Brev. 128, fol. 9v) assimilates numerous texts and pictorial sources, the seven columns of wisdom's house of Proverbs 9.1, the heavenly city and twenty-four elders of Revelation, and the heaven and earth in Christ's hands, to establish the Lord's majesty; it incorporates personifications of light and dark and winter and summer to position Him in relation to this world.[40] Other depictions draw on an old tradition that identified Christ's upper body with his spiritual nature and his human aspect with his lower torso. In San-Clemente, for instance, Christ is pictured above the apse as a half-length figure framed by a starry band; in the Odbert Gospels, only Christ's feet are visible as he disappears into the clouds. A Mosan phylactery in Saint Petersburg (Hermitage) draws on this tradition by portraying the divine Christ from the waist up, flanked by angels and being seen by John the Evangelist, who bears a scroll with a quotation from his Book of Revelation: "Behold, I saw a door opened in heaven."[41] However, to make sure that the viewer did not mistake what he or she is looking at for a depiction of the invisible God, an inscription on the back warns that "What you see here is not a representation of a god or a man; this sacred image represents both God and man at one and the same time," a widely circulated distich that asserted the fundamental principle that even portrayals of the elevated Deity represented Christ in his dual aspect.[42] At Taufers, the elaborate integration of Old and New Testament words and events, including the depiction of Christ's naked body in the Baptism, culminates in a portrait of the Lord's upper torso in heaven, accompanied

by Mary and John also pictured half-length. The idea was also mapped onto cosmological depictions such as the mid-thirteenth-century *mappa mundi* in London (Brit. Lib., MS Add. 28681, fol. 9v), where Christ is bisected by the earth, his head in heaven being worshiped by angels and his feet on earth trampling demons.[43]

When God entered flesh and became human, he elevated matter. Therefore, Christ's whole body could be used as the channel of spiritual ascent. At Saint-Martin in Vicq (Plate 11), for instance, Christ is portrayed in the twelfth-century frescoes on the transverse wall with his upper body in the heavenly court of the apostles and his legs on earth. In Berzé-la-Ville (Fig. 7), the distinction is more subtle, with Christ's lower body shown turned slightly and his face penetrating the aureole at the top; but at nearby Vézelay the contrast between agitated legs and placid head and shoulders figures the ascent from earth to heaven, from body to spirit.[44] The same concept is realized on the Agrigento portable altar (Plate 3), where the stone from the Holy Land and the cross relic beneath it are elevated by the enamel picturing angels bearing Christ to heaven; it also underlies the thirteenth-century installation of the *Acheropita* in the Sancta Sanctorum, where Christ's feet "rested" on the altar containing earth from the pilgrimage sites in Palestine and his bust was pictured above in a mosaic.[45]

Mary, the source of the flesh, shared many characteristics with her Son. Because she, too, was believed to have been assumed bodily into heaven, she like Christ had left few corporal relics, though this was compensated to some extent by touch relics — clothing such as her slipper at Soissons, body fluids such as tears and milk, and her house(s) at Walsingham and Loreto.[46] Some images of the Virgin actually served as reliquaries, functioning literally as intermediaries between the physical world and the divine.[47] Thus, the heads of Mary and Christ rendered on high relief on the panel in Florence attributed to Coppo di Marcovaldo (Santa-Maria-Maggiore, Fig. 23)[48] sheltered relics of Christ's blood, a fragment of the True Cross, and perhaps a piece of the Virgin's veil. These were discovered only in the recent restoration, however, recalling Hugh of Poitiers's report that when the wood statue of the Virgin at Vézelay was opened after a fire in the 1160s almost destroyed it, a "lock of hair of the Immaculate Virgin and a part of the same Mary, Mother of God" were found inside.[49] Important for the evolution of

Figure 23. Panel attributed to Coppo di Marcovaldo, Santa-Maria-Maggiore,
Florence 13th cent.)

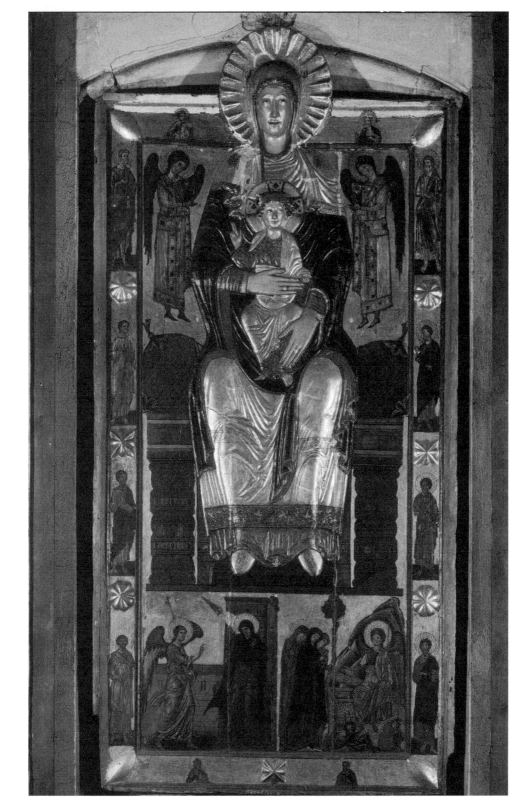

three-dimensional sculpture, such figural reliquaries—often called the
Throne of Wisdom—functioned largely simply as images, their sacred
contents apparently unknown to the viewers.[50]

Because of the dearth of Marian relics, a tradition emerged of miracu-
lously made images of the Virgin invested with legends. In the eleventh
century, an eighth-century icon of Mary became the object of a cult cel-
ebrated in Santa-Maria-Maggiore, the principal Marian church in
Rome;[51] and, like that of the Lateran *Acheropita*, its manufacture was
attributed to the Evangelist Luke, a product "not of a carnal hand but of
divine will." Because of its soft Early Christian technique, the image was
considered to be unfinished and was therefore copied (i.e., completed)
numerous times during the twelfth century and installed in Rome's
many churches dedicated to the Virgin. Showing Mary placing one hand
over her heart and directing the other toward (the unpictured) Christ, it
suggested the Virgin's role as intercessor between humankind and her
Son, as pictured on the Agrigento reliquary, in Santa-Prassede (Fig. 1), on
the Vatican Last Judgment, and at Taufers. The *Madonna Avvocata*, as this
type of portrait is called, was often juxtaposed with replicas of the
Lateran Savior, joining both Lucan paintings;[52] the mosaic in the apse of
Santa-Maria-Maggiore (Plate 1) quotes the two icons within a complex
narrative of the Coronation of the Virgin which, like the Ascension of
Christ, figures the transition from this world to the next.[53] Alfonso's
Cantiga 29 (Fig. 3) reports another legend of a Marian *acheiropoieton*,
making the essential point that all such depictions re-enact the entry of
the spirit into matter, which made God's divinity visible to bodily senses:
"God chose to depict her features on stone to demonstrate to us that all
creatures should honor his Mother, for he descended from heaven to take
on human flesh in her."[54] The argument is underscored by the
Annunciation at the end of the page which shows Mary receiving the
spirit in the form of light emanating from God in heaven, in Alfonso's
words, "bring[ing] light out of darkness."[55] (This contrasts to such early
depictions of the Annunciation as the one in John VII's chapel in Saint-
Peter's, in which Gabriel's salutation is figured, not by light but through
words inscribed on the image, the Word entering flesh.)[56]

In the Escorial Cantigas, Mary is portrayed not only as the vessel of
God's incarnation, but—following a long tradition—also as the queen
of heaven, flanked by angels and adored by all the creatures and hence
above the rest of the created world. The apse mosaic in Santa-Maria-

Maggiore also pictures "the holy bearer of God raised into heaven above the choirs of angels," bedecked in jewels and gold-trim garments, and she is represented as the heavenly queen in the Bernward Gospels (Fig. 15), on the Three Magi Shrine (Fig. 18), the Lisbjerg Altar (Fig. 20), and the Florence panel (Fig. 23). As such, she is identified as the church itself, the intermediary between the faithful and heaven and the source of expiation, a theme introduced in the Odbert Gospels as well, where Mary is enclosed in a mandorla and is paired with Saint Peter, holding the keys. A German weaving from 1160-70 (Berlin, Kunstgewerbemuseum, Plate 12) presents the allegory in its classic context, the institution of the apostolic church at Pentecost (Acts 1.13-26); crowned and posed as the *Maria Avvocata*, Mary is enthroned at the center of an elaborate architectural backdrop receiving a second incarnation as the Holy Spirit descends on her. The Santa-Maria-Maggiore mosaic depends on another, equally important, allegory of the church based on the Song of Songs. Inscriptions on the arches above the Virgin and Child in the Bernward Gospels (Fig. 14) refer to Mary as the door of the temple, opened by the Holy Spirit, and to a closed gate,[57] metaphors of the church that are actually realized on Bernward's bronze doors (Fig. 4), again identifying the Virgin as *Ecclesia*.

On the Hildesheim doors, Mary is also elevated by being set in opposition to Eve; as the mother of Christ personifying the church, she offers humankind access to the Paradise lost when the first woman sinned.[58] Here, as in many works, the divinity of Christ and of His mother is enhanced through juxtaposition to images of the terrestrial world; for example, in the lower margin of the Odbert Gospels a vegetal orb flanked by personifications of earth and sea provides a counterpoise to Christ's ascension. The process at Hildesheim, however, engages a foundation of Christian belief that the covenants and events described in the New Testament superseded those of the Old, namely typology; the relationship between Mary and Eve is presented not only through parallel narratives, but also by meaningful identifications: the tree of life and the cross (according to legend, made from its wood), Eve nursing Cain, and Mary holding the Christ Child.

Grounded in the notion of a seal and its imprint, literally a "tupos," typology was often conveyed by means of similitudes. In the Dijon compendium (Fig. 9), for instance, Daniel with his long hair parted in the center and short, pointed beard bears an unmistakable resemblance to

Christ, a point made clear in Jerome's commentary on the prophecy in the words that follow. As composer of the Psalms that foretold the coming of Christ and as his human ancestor, David was commonly assimilated to Jesus; on the cover of the Melisende Psalter (Fig. 11), he is pictured dictating to the four co-psalmists in a fashion that conjures up depictions of Christ and his evangelists. The analogy is also represented in the First Bible of Charles the Bald, where the "king and prophet" occupies the center of a mandorla (fol. 329v).[59] Human history is, in this way, elevated to the divine plan; as Abbot Suger stated in his description of his windows at Saint-Denis (Plate 2 and Fig. 9), the process of "making known the inmost meaning of the Law of Moses" leads the viewer "onward from the material to the immaterial."[60] The Crucifix replaces the Ark of the Covenant and Joshua (who bore Christ's name) witnesses the giving of the Law. Typology thus served the same transforming agenda as the precious materials themselves.[61] The process is particularly subtle in the Berlin ivory (Fig. 5), where Moses and Christ share not only the same features, but also a complex interrelationship worked out through the play of words and the depiction of touching.[62] At the close of the twelfth century, Nicholas of Verdun structured the great Klosterneuburg altar through elaborate typologies,[63] and, in the thirteenth century, so did the *Bibles moralisées*.[64]

Typological similitude was also extended to the period beyond Christ's life. The apostles and saints, for instance, imitated their Lord in deed and death;[65] thus, on the Berlin textile, Peter is pictured performing a miraculous healing in the same manner Christ had; and at Ceri, Andrew is portrayed being crucified in the same way Christ had been and Sylvester is represented subduing demons in a Christological manner. John the Evangelist was the most Christ-like of all, "marked" in God's image. In the Godescalc Lectionary and Book of Kells, he is represented with Christ's features; in the Weingarten Gospels (Stuttgart, Württembergische Landesbibliothek, Cod. HB II 40, fol. 146v), he alone of the four evangelists is shown elevated on a globe. In the Psalter of Yolande of Soissons (fol. 315r), John's face is virtually indistinguishable from that of Christ on the Veronica near the beginning (Fig. 17),[66] the implication being that to see sainted persons was to gaze at Christ himself. Church fathers, in turn, were modeled on the evangelists,[67] and blessed women were fashioned on Mary. Thus, in Santa-Prassede

Figure 24. Illustration, Picture bible, New York (mid 13th cent.)

vnxent Samuel Sanlem quem secreto unxerat. coram omni populo ungit in Regem.
et cum summa letitia ipse samuel quam populus sacrificat.

(Fig. 1), Saint Praxedes is pictured as the mirror-image of the Virgin; in
the Uta Codex, the presentation picture sets the "domina abbatissa" in a
reciprocal relationship to the "domina mundi";[68] and Hildegard of
Bingen is portrayed in the Lucca *Liber divinorum* (Fig. 15) in the manner
of the Annunciation.

Hildegard's portrait introduces a second way in which humans were
pictured as vehicles of spiritual elevation; saintly visions and acts are pre-
sented as having been inspired by God himself. Best known in depictions
of Gregory the Great, one trope had the dove of the Holy Spirit with its
beak at the saint's ear transmitting God's words into the saint, "personat-
ing" divinity in the literal sense of the word as a "sounding through."[69]
On the Melisende Psalter cover, the motif is applied to David, and it is
exceptionally prominent in both full-length portraits of the author of
Psalms in the St.-Alban's Psalter (Hildesheim, St.-Godehard, pp. 60 and
76).[70] Miniatures in the ninth-century Touronian Bibles merged the sev-
eral manners of conveying the idea of personation by creating a compos-
ite figure bearing the features of Moses, Paul, and John receiving its uni-
versal message from a horn held to its lips by an angel.[71] The implication
of such depictions is that the outward human appearance of the saints is
but a cover for the invisible words of God in heaven.

The same principles were extended to the aspirations of living
humans. Charles the Bald, for instance, was portrayed in the manner of
David, Solomon, Constantine, and his own grandfather Charlemagne;[72]
and imagery of Christ in Majesty was appropriated for the German
emperor Otto III to assert that, while he rules on earth, his authority to
do so comes from heaven.[73] Painters in Capetian France fashioned con-
temporary events after biblical models, a picture bible in New York
(Pierpont Morgan Library, Ms. 638, fol. 23v; Fig. 24) reads the Crusades
into the story of the Chosen People through the up-dating of costumes
and weapons, and the stained-glass windows of King Louis XI's Sainte-
Chapelle in Paris are permeated with allusions to Old Testament king-
ship.[74] Innocent III is portrayed on the bronze lunette over the niche of
the palliums in Saint-Peter's (Fig. 25), bearing the keys of Saint Peter and
being inspired by a dove at his ear; in this way, the reigning pontiff is
inserted into the succession of transmitters of God's law going back to
Peter through Pope Gregory the Great.[75]

The rondel from Saint-Peter's recalls nothing so much as a papal seal,
an appropriate reference in the room near Peter's tomb where the

Figure 25. Bronze lunette, from Saint-Peter's, Rome (early 13th cent.)

episcopal palliums were locked up overnight so that apostolic grace could be infused in them and also a perfect realization of the metaphor governing all typology and the entire system of personation. The metaphor of the seal, which had been deployed to explain the incarnation, was applied as well to the Veronica and other images of the invisible God;[76] the face of Christ impressed in a cloth invited a comparison with an impression made by a firm but unseen matrix printed on wax or clay. In the Gulbenkian Apocalypse, for instance, the "sixth seal" in Christ's hands and the seal-shaped mandorla in which the heavenly lord appears are set opposite the veil bearing his face; and on a copy of Boniface VIII's bull declaring the Jubilee Year (Rome, Museo del Palazzo di Venezia, Corvisieri Romana, inv. 9529/97), the Veronica is fashioned and applied to resemble a seal of authentication.[77] To be imprinted by the invisible God was an aspiration of the faithful, as Gertrude of Hefta (1256-1301/02) affirmed when she conveyed Christ's promise that,

> On all those who, attracted to me by the desire of my love, shall frequent the memory of the vision of my face, I will imprint by the grace of my humanity the vivifying splendor of my divinity. Its clarity shall shine through them perpetually with an interior light and, in the eternal glory, will make them more than the others radiate over the entire celestial court with a special similitude of my face.[78]

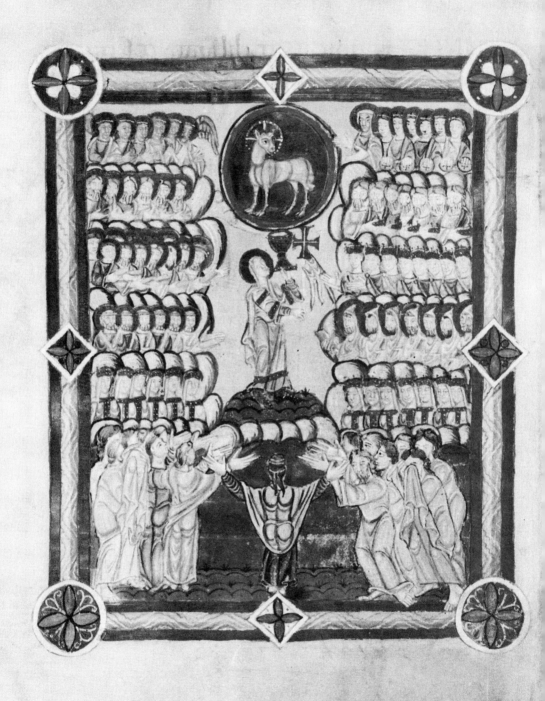

In this meditation on the Veronica, Gertrude sums up the divinization of matter in and through images; God impressed his divine nature in Christ's flesh allowing depictions of him which, in turn, provide models for all people. A miniature in the late tenth-century Sacramentary from Fulda (Udine, Archivio capitolare, Ms. 1, fol. 66v; Fig. 26) realizes the entire system.[79] On earth, in the foreground, a personification of the terrestrial church confronts the faithful with the heavenly church, her counterpart, who presides over the chorus of the saints, highlighted in gold and—within their ranks—nearly identical to one another. The celestial figures are intended to impress themselves on the souls of the faithful, softened like wax, by what they see.

Figure 26. Illustration, Sacramentary,
Udine (late 10th cent.)

Dixit ad aaron quid tibi fecit hic ppl's
ut ille induceres sup eum peccatum maximum
c ut ille respondit Ne indignaris dn̄s m's
ardum nostis ppl'm istum quod pronus sit
ad malum dixeruntq mihi fac nobis
deos qui precedant nos h mei au mosi
cuius est educta de aegypto nescim' quid
acciderit quib' ego dixi quis uestrum hab'
aurum tulerunt & dederunt mihi & pro-
iecit illud in ign̄ & egressus est hic uitul's

U idens ergo mosi s̄c ppl'm quod esset nudat's
spoliauerat eum aaron ppl's p̄ter ignominiam
sord's & inter hostes nudum consituerat eum

E dulis ueani t mihi. Congregatiq sunt una
ad eum omnes filii leui buis & a'a

H ec dicit dn̄s d's ̄ sl. Ponat uir gladiu d n̄
sup femur suum. Ite & redite s̄c deponit
uns̄c ad portam p̄ medium casarum & occidat
unusquisq̄ s̄c in eo cura & a̅ m'um suu
fecerunq̄ filii leui sicut au sermonem mosi

c ceciderunt illue illo die q̄si uigintia milia hominu

t a̅ s̄a mosi consecrast m'us s̄c hodie dn̄o
unusquisq̄ in filio & in fr̄e suo ut dei uobisbe
nedicero. ac au in die au alero uocatus̄ mosi ad
ppl'm. Peccast peccatu maximu
ascendam ad dn̄m. si quomodo eu ex
orare pro scelere uso̅. reuersus̄q ad dn̄m
o obsecro peccauit ppl's iste peccat̄
au maximum. fecerunq̄ sibi deos aureos
au aut dim̄t hanc noxa̅ au si non facis
dele m de libro tuo quē scripsisti. cui
respondit dn̄s. qui peccauerit mihi
delebo eu de libro meo. tu au uade & duc
ppl'm isuc̄ in locū quē tibi dixi ecce
meus p̄cedet te. ego au in die ulcionis
uisitabo & hoc pecc au in eos

p ccussit ergo dn̄s ppl'm pro reatu uituli
quē fecerat aaron
ocutusq̄ est dn̄s ad mosen uade ascende
de loc̄ isto tu & ppl's tuus quē eduxisti



decem exiyp̄ in terram au ̄ ui iuraui ab raha̅
Isaac & Iacob dicens. Semini tuo dabo
eā & mittam p̄ cursorē au angelum tu ut eicia
chananeu & amorreu & hetheu & phere zeu
& eueu & iebuseu & intres in terram
fluentem lacte & melle. Non au ascenda
tecum quia ppl's durae ceruicis es. Ne forte
disperdam te in uia. Audit̄q̄ ppl's sermonem
hunc pessimu luxit & nullus̄ de more indutus̄ est

D ixitq̄ dn̄s ad mosen Loquere filiis
s̄l ppl's durae ceruicis. Semel ascenda
in medio tui & delebo te. Iam nunc depone
ornatum tuum ut sciam quid faciā tibi

D eposuerunq̄ ergo filii s̄l ornatum suum
a̅ monte horeb. Moses quoq̄ tollens tabernaculum
tetendit ei extra casta procul. Uocauitq̄ nomen
ei' tabernaculum foederis & omnis ppl's qui
habebat aliqua quaestionē exibat
ad tabernaculum foederis extra castra. Cumq̄
egrederet̄ mosi ad tabernaculum surgebat
uniuersa plebs & stabant un̄ usquisq̄ in ostio
papilionis sui. aspiciebatq̄ tergu mosi donec
ingreder̄ et̄ tentorium. Ingresso aute̅ illo
tabernaculum foederis descendebat columna
nubis & stabat ad ostium. loquebatq̄ cu
mose cernentib' uniuersis quod colum̅nubis
staret ad ostiu tabernaculi. Scibanq̄
ipsi & adorabant p̄ fores tabernaculi suū

L oquebat̄ aut dn̄s ad mosen facie ad faciē
sicut solet homo loqui ad amicu suu. Cumq̄
ille reuerter̄ in casta minister ei' Iosue
filius num pu. non recedebat de tabernaculo

D ixit aut̄ mosi ad dn̄m. Praecipis ut educa̅
ppl'm isuc̄. & non indicas mihi quē missur̄
es mecum. p̄sertim cum dixeris noui te ex̄
& inuenisti gratiam coram me. Si ergo inueni
gratiā in conspectu tuo. ostende mihi faciē tuā
au ut sciā te & inueniā gratiā au oculos

Chapter 4: Book

As a RELIGION of written revelation, Christianity elevated the book by clothing it in rich ornament. Decorated with precious metals, gems, and ivory, carried in processions, and displayed on altars, service books were treated as *vasa sacra* (Figs. 13 and 14), not only the Bible, but also liturgical manuscripts and lives of saints. Their sacred contents were written in gold and silver on purple parchment, enlivened by brilliant letters, and elucidated by miniatures and diagrams. Like icons, they were considered to be the actual presence of their divinely-inspired authors; and, like relics, they were often enshrined in elaborately adorned boxes.[1] Ruminated, they were meant, like the Eucharist, to be incorporated into the readers' very bodies.[2] A miniature in the First Bible of Charles the Bald represents several aspects of the medieval conception. At the top of the frontispiece to the Book of Revelation (fol. 415v), an enormous codex, covered in gold and silver, is shown resting on a covered throne, its meaning—not just its words—about to be revealed as the seals are loosed. At the bottom, John is shown the mysteries and eats the book handed him by an angel, and a figure personating the unity of all scripture replaces the enthroned book. In turn, poems written in gold letters on purple parchment, inserted into the manuscript, liken the Scripture to bread and drink and exhort the recipient to become one with it.[3]

Figure 27. Illustration, Bible of Florentius, León (960) 87

QUIDAT NIUEM SICUT LANÁ
NEBULAM SICUT CINEREM
SPARGIT:
MITTIT CRISTALLUM SUUM
SICUT BUCCELLAS ANTE FA
CIEM FRIGORIS EIUS QUIS

SUSTINEBIT
EMITTE TUERBUM SUUM
ET LIQUEFACIET EA FLABIT
SPSRITUS EIUS ET FLUENT
AQUAE
QUIA DNUNTIAT UERBÚ

SUUM IACOB IUSTITIAS
ET IUDICIA SUA ISRAHEL
CONFECIT TALITER OMNI
NATIONI ET IUDICIA SUA
NON MANIFESTAUIT EIS

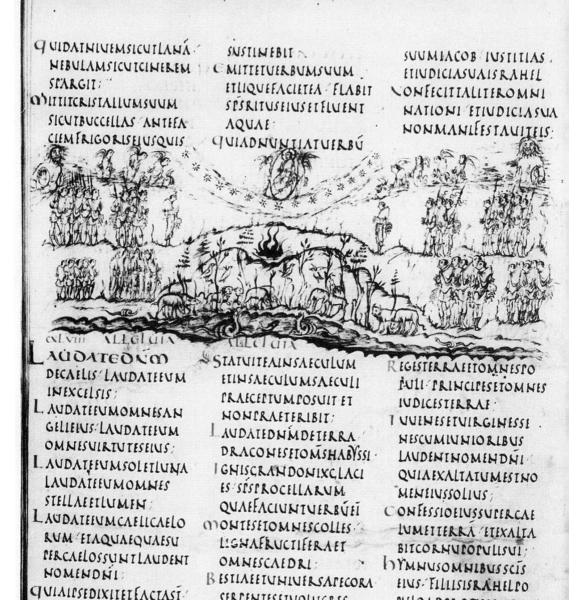

CXLVIII ALLELUIA

LAUDATE DNM
DE CAELIS LAUDATE EUM
IN EXCELSIS:
LAUDATE EUM OMNES AN
GELI EIUS LAUDATE EUM
OMNES UIRTUTES EIUS:
LAUDATE EUM SOL ET LUNA
LAUDATE EUM OMNES
STELLAE ET LUMEN:
LAUDATE EUM CAELI CAELO
RUM ET AQUAE QUAE SU
PER CAELOS SUNT LAUDENT
NOMEN DNI:
QUIA IPSE DIXIT ET FACTA SÍ
IPSE MANDAUIT ET CREATA SÍ

ALLELUIA

STATUIT EA IN SAECULUM
ET IN SAECULUM SAECULI
PRAECEPTUM POSUIT ET
NON PRAETERIBIT:
LAUDATE DNM DE TERRA
DRACONES ET OMS HABYSSI
IGNIS GRANDO NIX GLACI
ES SPS PROCELLARUM
QUAE FACIUNT UERBÚ EI
MONTES ET OMNES COLLES:
LIGNA FRUCTIFERA ET
OMNES CAEDRI:
BESTIAE ET UNIUERSA PECORA
SERPENTES ET UOLUCRES
PENNATAE:

REGES TERRAE ET OMNES PO
PULI: PRINCIPES ET OMNES
IUDICES TERRAE:
IUUENES ET UIRGINES SE
NES CUM IUNIORIBUS
LAUDENT NOMEN DNI
QUIA EXALTATUM EST NO
MEN EIUS SOLIUS:
CONFESSIO EIUS SUPER CAE
LUM ET TERRA: ET EXALTA
BIT CORNU POPULI SUI:
HYMNUS OMNIBUS SCIS
EIUS: FILIIS ISRAHEL PO
PULO ADPROPINQUE NTI
SIBI:

The book containing God's words was considered the embodiment of Christ, the "Word made flesh" (John 1). Its covers were thus often adorned with Christ's image (Fig. 11), and its vellum pages, covered with pen marks, were understood as a recapitulation of the Incarnation. The dedication in the Godescalc Lectionary makes the point explicit.[4] The conceit was elaborated further by the Cistercian monk Caesarius of Heisterbach (ca. 1180-1240), who wrote of letters written by the lash, rubricated by the nails, and punctuated by the thorn; and by Peter Berchorius in the fourteenth century, who described Scripture as the Holy Spirit written on virginal parchment.[5] The Berlin ivories (Fig. 5) interpret the contents transcribed within the book they once adorned; the Old and New Testament events carved in the flesh-like ivory depict divinely ordained words inside their physical vessels.[6]

Whole texts were sometimes transformed into pictures. Prologues in a Bible from La Cava dei Tirreni (Naples, Bib. della Badia, Ms. memb. I, fol. 69r), commissioned by King Alfonso II of Asturias in the early ninth century, for instance, are written out in the form of a cross;[7] other manuscripts, too, arranged the words as *carmina figurata* around the cross and other figures.[8] Most notable was Hrabanus Maurus's *De laudibus sanctae crucis*, a collection of figured poems composed for Louis the Pious in 814 that opens with a picture of Christ, His arms extended as if on the cross, comprising words written on the unpainted vellum that express "his human and divine nature," the one "like a vestment" hiding the other from "human sight."[9] Beginning in the ninth century, Jews also constructed pictures from words, straddling the line between verbal and visual representation through a refined technique known as *micrography*.[10] A particularly brilliant example of the deployment of Hebrew texts for pictorial effect is the thirteenth-century Castillean Bible in Marseilles (Bib. pub., MS 1626), decorated with nine carpet pages and other adornments.[11]

Illustrations in many medieval books provided a direct visual reading of adjacent texts to which they were closely allied.[12] In this, they perpetuated a system that originated in antiquity and survives in Late Antique manuscripts and numerous medieval copies.[13] The Bible illuminated in 960 under the supervision of the "magister" Florentius (León, Real Colegiata de San-Isidoro, Cod. 2, fol. 46v; Fig. 27), for instance, introduces nearly one hundred small pictures within the columns of the Old Testament;[14] two distinct scenes represent Moses calling the Levites to the

Figure 28. Illustration, Psalter, Utrecht (9th cent.)

tent and arming them (Ex. 32.:7) and another, also in its proper place, depicts the Israelites prostrating themselves when the pillar of cloud descended on Moses and Joshua inside the tent (33:9-11). Even poetic texts were illustrated in this literal fashion. Delicate pen-and-wash sketches in the ninth-century Psalter in Utrecht (Bibliotheek der Rijksuniversiteit, MS 32) relate to the poetic language in much the same way: the pairs of four-footed animals, serpents, fish and birds on fol. 82v (Fig. 28), for instance, illustrate the "wild beasts and cattle, creeping things and winged" of Psalm 148.[15] Many of the word-illustrations were copied from pre-existing pictorial models, however; the animals were taken from an illustrated *Physiologus*.[16] The essentially visual language of the Book of Revelation was a particularly fertile vehicle for pictorial rendering;[17] from the ninth through the fourteenth century, the Apocalypse was illustrated in diverse versions.

However closely they might be linked to the primary texts, pictures were always interpretations. In the Utrecht Psalter, for instance, the "Lord" of the Psalm is portrayed as Christ, providing a visual gloss on Hebrew Scripture. At the same time, personifications of the heavens holding disks of the sun and moon, like the borrowings from a *Physiologus* manuscript and the rustic capitals of the text itself, imbue the manuscript with a classical aspect that imparts a venerable aura to the whole work, including complicated iconographic inventions that respond to and fix Carolingian theological discussions.[18] Figures in the eleventh-century Tiberius Psalter (London, Brit. Lib., Add. MS Cotton Tiberius C. VI) play out another aspect of the Book of Psalms; reflecting the military struggles of the author, David, and of the poetry itself, they conceive the text in terms of Christ's victory over the devil.[19] Understood as prophecy, the Apocalypse, too, offered a field for contemporary ideas. The early eleventh-century Bamberg manuscript (Staatsbibliothek, Misc. Bibl. 140), for instance, incorporates millennial hopes in its "literal" pictures;[20] and thirteenth- and fourteenth-century illustrations filter the same text through Crusader ambitions and concern for Church reform.[21]

Few biblical manuscripts contained Scripture plain and simple; most rearranged the biblical narrative and incorporated extraneous material to render Scripture accessible and useful. Prologues and various harmonizing devices were deployed to demonstrate the fundamental unity of the four Gospels, or the texts were reordered to fashion a coherent account of

Christ's life. Ornament followed the same pattern. The Darmstadt Gospels (Plate 4) is typical: it includes twelve canon tables constructed of elaborate gold, silver, and painted arches to coordinate passages from the four texts; commentaries that explain the unity of the four texts such as the *Novum Opus* attributed to Saint Jerome, which is highlighted by an enormous decorated initial; and Evangelist portraits and ornamental pages that not only mark the beginning of each text but also, in their similarity to one another, demonstrate the essential harmony.[22] The Book of Kells (Fig. 12) includes numerous harmony pages and, before each Gospel, pictures the four evangelist symbols together. In the Godescalc Lectionary, excerpts from the Gospel are actually ordered according to the Church calendar, and the evangelist portraits are gathered at the beginning, followed by a portrait of Christ and a depiction of the Fountain of Life that reinforce the fundamental unity.[23] In the Gospelbook made two centuries later for Hitda of Meschede (Darmstadt, Landes- und Hochschulbibliothek, MS. 1640, fols. 6v-7r), a miniature of Christ in Majesty makes the same claim:[24] flanked by the four wheels of Ezekiel's vision (Ez.10:8), the enthroned Christ occupies the center of the page at the corners of which are the four evangelist symbols. The sixth-century Saint Augustine Gospels (Cambridge, Corpus Christi College Library, Cod. 286) had already tackled the more difficult problem of constructing a coherent narrative from the variant versions told and retold by the four evangelists; a cycle of scenes of Christ's Passion collected from several Gospels is pictured before the Gospel of Luke (fol. 125).[25] Later manuscripts struggled with the same problem. The Bernward Gospels (Fig. 14), for instance, retained the division of texts but interpolated pictures that manifested the essential coherency of the message.[26] In many biblical manuscripts, pictures often explicitly assert Scripture's divine provenance, the dove at David's ear on the Melisende Psalter cover (Fig. 11) or the picturing of John the Evangelist, in a dream with the book in hand, in Apocalypse manuscripts.[27] Consonance is evoked literally in a fragmentary early ninth-century English manuscript in London (Brit. Lib. Royal Ms 1 E. vi), once illustrated with selected narratives before each Gospel and a Majesty of the Lamb page bearing a titulus referring to the "four leaders [who] with harmonious voice celebrate in song the miracles of God."[28]

 Originally, the London manuscript included the entire Bible, Old Testament and New. Until the development of the "University Bible" in

thirteenth-century Paris, such single-volume Bibles were usually the products of reform movements and followed various patterns of adorn-ment.[29] The "giant Bibles" produced in the wake of the eleventh-century Gregorian Reform deploy diverse systems.[30] The two-volume edition in Cividale del Friuli (Museo archeologico nazionale, Bib. cap., I-II) includes two full-page miniatures, one picturing the Fall of Adam and Eve, the other Christ and the Apostles, while the later Pantheon Bible (Vatican, Bib. Apos., Cod. Vat. lat. 12958) introduces narrative pictures throughout and formulates certain Old Testament subjects, Ezekiel (fol. 152v), for example, as prophecies of Christ. In contrast, the Tabernacle/ Christ opposition organizes the early eighth-century Codex Amiatinus (Florence, Bib. Laur. Cod. Am. 1); an aniconic diagram precedes the Old Testament (the curtain before the Sancta Sanctorum marked with a cross) and a Christ in Majesty introduces the Gospels.[31] Charlemagne's under-taking to issue volumes of the revised Vulgate text led to the creation of remarkable illustrated Bibles, such as the First Bible of Charles the Bald (845) in which intricate visual cross-references in the eight frontispieces reveal the relationship between Moses, Paul, and John — three men privi-leged to see God — and between David and Christ.[32] The Carolingian achievement culminated in the San Paolo Bible of ca. 870 with its 25 full-page miniatures, many rife with typological allusions.[33] The mid-twelfth-century Floreffe Bible (London, Brit. Lib. Add. MS 17737-38) goes well beyond the Carolingian manuscripts in figuring the reconcilia-tion of biblical accounts as a process of spiritual contemplation.[34] Originally six full-page miniatures brought together Old Testament prophecies and Gospel narratives, portraits, and symbols to engage the viewer in an erudite meditation on the mystery of God's plan revealed in his Word.

To move beyond the external differences and excavate the underlying harmony within was considered a spiritual activity, as was the very move-ment from text to picture, which recapitulated the abrogation of the written covenant of the Jews to the visible Incarnation of the Christians.[35] As the caption confronting the Christ in Majesty in the Hitda Gospels declares, "this visible product of the imagination figures that invisible Truth whose splendor penetrates the world with the four lamps of his new words."[36]

In many cases, the interpretations were prompted by texts that were themselves included in the books of canonical writings. The Hitda Gospels, for instance, contains the prologue *Plures fuisse* which brings to bear various biblical images to affirm the canon of four Gospels; and the Cistercian depiction of Daniel (Fig. 9) is actually a frontispiece to Jerome's commentary on the Old Testament prophecy and a visual interpretation made through and on it.[37] The Lisbon Bible (Fig. 21) includes a *masorah* in addition to the Hebrew text. A majority of the thirteenth-century English Apocalypse manuscripts include Berengaudus's commentary on Revelation which in turn influenced the illustrations. The chain of interpretations that led to the inclusion of the Temple curtain/Veronica in the Gulbenkian manuscript, for instance, began with the understanding of the breaking of the sixth seal as the rejection of the Jews.[38] In the Utrecht Psalter, the psalms are followed by canticles and other texts, including the Apostles' Creed (fol. 90r), which is illustrated with events that confirm the reality of the articles of faith: Christ's trial, crucifixion, resurrection, descent into Hell, and ascension.[39] Appropriating the prologue tradition, sequences of pictures were introduced as prefaces to Psalters from the twelfth century on; the St.-Alban's Psalter, for instance, begins with a sequence of thirty-nine full-page miniatures that traces the story of salvation from the Fall of Adam and Eve to Pentecost (plus the legend of Saint Martin). In the thirteenth century, true picture books were made, such as the one in the Pierpont Morgan Library (Fig. 24) in which the texts were added (in three languages) only by later users.[40]

Exegetical texts were, themselves, illustrated. The eighth-century commentary on the Apocalypse by Beatus of Liebana was almost as popular as the subject of illustration as its canonical source.[41] Haimo of Auxerre's *Commentary on Ezekiel* was provided with illustrations (Paris, Bib. nat., MS lat. 12302),[42] as was the *Expositio in Cantica* of Honorius Augustodunensis (Munich, Bay. Staatsbib., Clm. 4450) and many other theological tracts.[43] Indeed, some of the most experimental illustrations occur in exegetical works such as the anonymous *Dialogus de laudibus sanctae crucis*, illuminated in Regensburg in the 1170s (Munich, Bay. Staastbib., Clm 14159)[44] with its remarkable series of typologies; there the fall of Adam and Eve and murder of Abel are interpreted as allegories of Christ's Passion that made the church necessary, and Ecclesia is featured

vanquishing the serpent and proffering the living cross to the sinners. The *Moralia in Job* (Dijon, Bib. mun. MS 168-73), written and illuminated at Cîteaux ca. 1111, contains both the biblical book and Gregory the Great's commentary on it; the historiated initials lead the reader/viewer into meditation on both.[45] Hildegard of Bingen's treatises recycled traditional imagery in invented compositions to create new visual interpretations; the opening picture of the *Liber divinorum operum* in Lucca (Fig. 15),[46] for example, embellished a Trinitarian schema to picture the timeless God, the Son of God in mortal dress, and the lamb of charity Hildegard described in her vision. Traditional and innovative iconographies were incorporated into the *Bibles Moralisées* to create a set of highly original typological commentaries built largely of the pictures themselves.[47] To illustrate his Cantigas, Alfonso X consulted Islamic as well as Christian sources, processing the inherited material in an entirely personal fashion to attach the book to several audiences.[48]

Diverse texts, both canonical and exegetical, were often gathered together in compendia in which decoration served a unifying and interpretive role in the assemblages.[49] In some, natural history and sacred narrative were comprehended and illustrated in extensive volumes such as Hrabanus Maurus's *De natura rerum* in Montecassino (Abbazia, Cod. 132), furnished with more than 300 miniatures, some drawn from the traditional repertory and others invented specifically for the text.[50] Toward the end of the twelfth century, Herrard of Landsberg assembled a remarkable array of pictorial sources based on Scripture, Prudentius, and moralizing literature, as well as new compositions, for use in the instruction of nuns (Strasbourg, Bib. de la Ville, now destroyed);[51] James le Parler's *Omne bonum* (London, Brit. Lib., Ms. Royal 6.E.VI) is a vast encyclopedia written and illustrated during the third quarter of the fourteenth century and is arranged alphabetically (with cross references), preceded by three devotional miniatures and a pictorial preface of 106 scenes tracing sacred history from Creation to the Last Judgment.[52] A mid-thirteenth-century English compendium brings together miscellaneous texts to form a preacher's manual (London, Brit. Lib., Harley MS. 3244, fols. 27v-28r; Fig. 29) and introduces diagrams to fix them in the mind.[53] Another compendium assembled half a century or more later (Cambridge, University Library, MS G.g.I.1) gathers some fifty religious and secular texts in a single volume.[54]

Figure 29. Illustrations, Preacher's manual, London (mid 13th cent.)

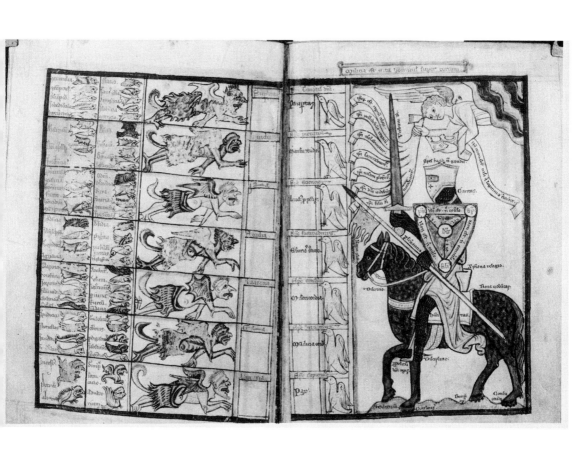

Pictorial narratives originating in Scripture were also inserted into vernacular paraphrases, mapping canonical words onto new languages and, in turn, responding to the new literary and social contexts.[55] The eleventh-century Old English paraphrase of the Hexateuch (London, Brit. Lib. MS Cotton Claudius B.IV) gains authority from the extensive cycle of traditional illustrations; at the same time, it is embellished with new material such as the Fall of the Rebel Angels that introduces extra-biblical legends and provides a new way to read God's word itself.[56]

Many biblical manuscripts were used in the liturgy. The Bernward Gospels (Fig. 14) actually pictures the golden codex being brought to the altar already furnished with a paten and chalice; and its text capitula keyed Hildesheim liturgical usage;[57] the Lindesfarne Gospels too includes capitula and other indications that it (or at least its model) was used in the church service.[58] As the oldest service book, the Psalter was also fur-nished with liturgical markings and additional texts such as litanies of the dead.[59] In addition, specific types of manuscripts were created for litugi-cal use: sacramentaries, antiphonals, benedictionals, missals, hymnals, pontificals, and many others.[60] Because of their public or semi-public use, these were sites of special artistic inventiveness. Depictions in the Gellone (Paris, Bib. nat. MS lat. 12048, fol. 143v)[61] and Drogo Sacramentaries (Paris, Bib. nat. MS lat. 9428), for example, not only tack the texts read during the church celebrations to their historical bases but also interpret the events in terms of the ceremonies they engendered; miniatures in a late tenth-century Sacramentary from Fulda (Fig. 26) picture feasts not based on biblical happenings and insert them into the historical sequence.[62] Illustrations in the late eleventh-century Sacramentary of Warmond of Ivrea (Ivrea, Bib. Capit. Cod. LXXXVI) go farther still, making visual the hoped-for harmony between Church and empire.[63] In certain of these manuscripts, the illustrations were meant only for clerical eyes. The depiction of Jacopo Stefaneschi placing the papal tiara on Boniface VIII's head in the *De Coronatione* of ca. 1299 (Vatican, Bib. apos. 4933, fol. 7v), for instance, was intended to help legit-imate the unusual succession after the retirement of Celestine V, who is shown literally leaving the scene.[64] Others were viewed by the faithful, at least occasionally. For example, Exultet rolls were unfurled over the ambo on Holy Saturday as the late eleventh-century example from Montecassino (Vatican, Bib. apos. Cod. Barb. lat. 592, Fig. 30) actually

Figure 30. Illustration, Exultet roll, Vatican (late 11th cent.)

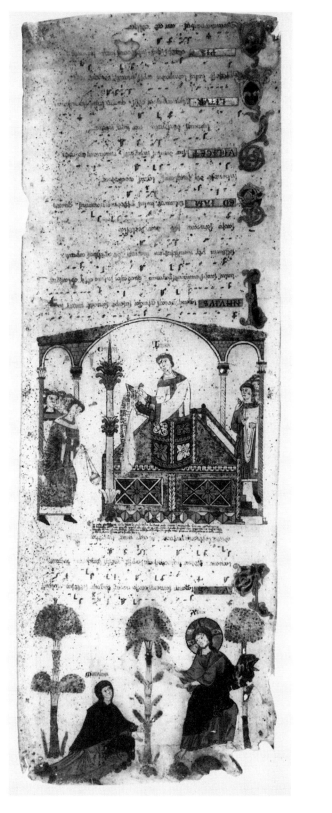

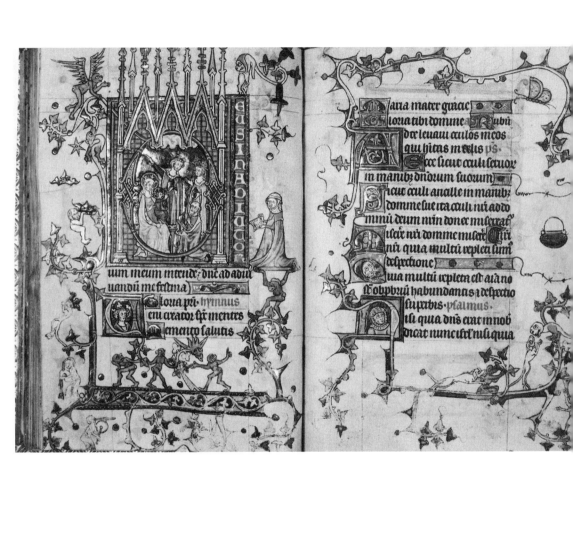

shows. In these, the pictures were painted so that the congregation could view them while the priest singing the hymns read the words and notes transcribed in the opposite direction.[65] As in other liturgical books, miniatures join the ceremony, in this case the blessing of the paschal candle, to the scriptural event, here Christ appearing to Mary Magdalene after the resurrection.[66]

From the tenth century, books of saints' lives were also profusely illustrated as means for promoting cults and attracting the interest of lay supporters.[67] The *Vita sancti Martini* illustrated ca. 1100 in Tours (Bib. mun. MS 1018, fol. 18r), where Saint Martin had long been venerated is characteristic; in the manner of Christ and his immediate followers, Martin is shown reviving a slave who had been hanged on the noose still dangling over his head.[68] Empowered by the divine Hand descending from a cloud, Martin effects the resurrection with a gesture of his powerful arm, the saint's primary instrument (enshrined in numerous "talking reliquaries" such as those in Osnabrück [Fig. 2]).[69] The power of the saint's "home" is also often underscored, as in the twelfth-century Life of Saint Edmund (New York, Pierpont Morgan Library Ms. 736, fol.18v), which depicts how thieves breaking into his church were paralyzed by the force of his presence there.

The development of para-liturgical manuscripts was particularly important during the later Middle Ages, reflecting a shift of patronage and use toward the private sphere. Emerging during the twelfth century from Psalters made for monks, the illustrated prayer-book evolved in the context of the pastoral care of nuns and came to acquire singular importance for private devotion during the thirteenth and fourteenth centuries.[70] Like their more formal cousins, these books were themselves compendia and so were their illustrations, comprising scriptural narratives, scenes from the lives of saints, and occasional additions such as portraits of the recipient in prayer. The Hours of Yolande of Soissons (Fig. 17), for instance, includes a variety of illustrations, among them scenes of Creation, the Raising of Lazarus and Crucifixion of Christ, Saints John, Christopher and Francis, and the Veronica; the early fourteenth-century Flemish Book of Hours of Marguerite of Beaujeu (London, Brit. Lib., Cod. Add. 36684, fols. 46v-47r; Fig. 31)[71] is typical in adorning the opening words of the morning prayer, "O God, hasten to my aid," with a depiction the Adoration of the Magi. From ca. 1300, Jews in Spain and

Figure 31. Illustration, so-called Hours of Marguerite de Beaujeu, London (early 14th cent.)

northern Europe decorated their *haggadoth*, the slim prayer-books used during the Passover meals; drawing in part on Christian iconography, these nonetheless introduced rabbinical and folklore elements to enliven and interpret the biblical narratives.[72]

In addition to or instead of full-page or inserted miniatures, many manuscripts were decorated with ornamented initials, marginalia, and elaborate frames, forms that, in themselves, carried significance. Beginning in the seventh century, adornment of the letters opening John's Gospel, for example, was used to affirm the belief asserted in the text that Christ, the "Word-made-flesh, was the agent of Creation";[73] in the Odbert Gospels (Fig. 22), the initial **I** features the incarnate God hanging on the cross, a literal realization of the duality conveyed also by the following letters written in gold and inscribed on purple vellum. The Church and Synagogue personified in the lower part of the **I** gloss the words in the same chapter, "while the Law was given through Moses, grace and truth came through Jesus Christ" (John 1.17). Indeed, the very association of a figure with an initial conjured up Christ; Bede had explained that the Greek for picture, "zoographia," meant "living writing," and the concept seems to have been applied to the development of historiated initials beginning, essentially, in the ninth century. When the initial **T** of the "Te igitur" that introduces the canon of the Mass in sacramentaries was adorned with the crucifixion, it tied the word (written and spoken) to the Incarnate God. In the Gellone Sacramentary, Christ's blood is literally identified with the rubricated verses and the letters "T" enlarged to recall the cross; and in the Drogo Sacramentary, vines enliven the letter **D** of "Dominus" of the Pentecost text. In the Dijon *Commentaries*, Daniel is portrayed against the letter **A** (of "Anno"); adorned with vines and birds, the initial reinforces the Prophet's identification with Christ,[74] the living and life-giving Word and, at the same time, stands for the authorial voice behind all sacred Scripture. The Throne of Mercy in the initial **D** of Psalm 110 in an English Psalter of ca. 1220 (Cambridge, Trinity College, Ms. B. II. 4, fol. 130r)[75] glosses the first verse with a particularly full reading:

The Lord said to my lord, "You shall sit at my right hand while I make our enemies the footstool under your feet."

Here the letter is constructed to separate this world occupied by "ene-
mies" of God and a menacing centaur, from heaven pictured as a church
inhabited by the Trinity and devout nuns. The theme of struggle is
incorporated in the initial **B** of the St.-Alban's Psalter featuring the
inspired David,[76] in which the beasts entangled in the letter itself symbol-
ize the word subduing the forces of evil and, in so doing, capture the
essence of the spiritual battle sung in the poems that follow. Spiritual
battle is also embodied by the hybrids and violent struggles that fill the
initials of the Dijon *Moralia in Job*; there, the frenzy was intended to
ensnare readers of the text in combat,[77] the culmination of a long tradi-
tion of inspiriting the sacred words on a page and engaging the reader in
a process of disentangling the meaning.[78]

Initials are only one of the elements that served to organize books
visually. Margins provided spaces for painters to illustrate the adjoining
text, as in the mid-thirteenth-century *De arte venandi cum avibus* (Vatican,
Bib. Apos. MS Pal. lat. 1071, fol. 15r) where hunters are shown sailing
out, a hawk is pictured nabbing its quarry from the water, and geese are
depicted flying gracefully over the surf.[79] Marginalia also offered pictorial
interpretations of the adjacent texts; in the Saint-Alban's Psalter, for
instance, two knights are pictured in full battle directly above the portrait
of David to represent the theme of the "church's holy battle on earth"
referred to in the accompanying marginal commentary.[80] Positioned at
the very beginning of the Book of Psalms, the pictured warriors suggest
that David's prophetic verses are a *psychomachia*, a battle between virtue
and vice.

Frames were particularly active features of manuscript decoration.[81]
On the simplest level, they marked the boundaries between the pictorial
and textual spaces on a page or cover. In the Darmstadt Gospels (Plate 4),
for instance, the acanthus border distinguishes the world of the
reader/viewer from the celestial region beyond; and in the Book of Kells
(Fig. 12), the frame filled with apotropaic knots isolates demons in the
corners from the visionary creatures symbolizing the evangelists. These
and the less structured margins create a semantic field in which different
levels of reality intermingle, sometimes benignly and other times as arenas
of struggle, providing potent places for transformation and confrontation.
In the Uta Codex, for instance, the borders on which the abbess stands as
she lifts her gift book to the Virgin and Child represent the "wreaths of

virtues" referred to in the caption,[82] while in the Hours of Yolande of
Soissons (Fig. 17), a hound shown chasing a rabbit and hybrid creatures
threaten to distract the reader's attention from God's word and face, thus
setting up a spiritual struggle. On the covers of the Melisende Psalter
(Fig. 11), the margins are filled with knots and scrolls populated with
birds and fish borrowed from Muslim sumptuary arts and bearing on the
theme of triumph.[83] The margins of a frontispiece in a late thirteenth-
century *Histoire universelle* from the Crusader Holy Land (London, Brit.
Lib., Ms. Add. 15268, fol. 2) are also adorned with motifs derived from
Islamic art,[84] though whether these betray the shared culture of a
Levantine Christian, an assertion that Islam was outside God's true cos-
mos (pictured in the main field), or an accommodating vision of the
earthly paradise remains uncertain. Flat, Islamic-style ornament in the
frame of the opening miniature of the Dijon compendium (fol. 2r) pro-
vides a starting point for the spiritual elevation pictured in the miniature
of the Old Testament prophets holding inscribed books and scrolls
around Christ in heaven;[85] and it is in dialogue with the framing ele-
ments on the verso, the three-dimensional fret pattern built around the
sign of the cross, that cues the reading of Daniel in the Lions' Den as a
prophecy of Christ.[86]

Ornamental framing could have quite specific meaning. The columns
that enclose the opening pages in the Benedictional of Æthelwold sym-
bolize the spiritual edifice built of the saints honored in the book and the
Mass;[87] and the Gothic edifice containing the Veronica in the Hours of
Yolande of Soissons recalls nothing so much as the Heavenly Jerusalem,
pictured for instance in the slightly later *Bible historiale* of Jean de Papeleu
(Paris, Bib. de l'Arsenal, MS 5059).[88] The frame around the opening of
John's Gospel in the Odbert Gospels (Fig. 22) maps a more complicated
program. A viewer might begin with the acanthus-filled wheel flanked
by personifications of land and sea at the bottom, the terrestrial world
that is quartered at the four corners and hence projects the cartographic
aspect onto the page itself. Personifications of the four rivers that
watered the Eden conjoined with the quarter circles present the page as a
plan of the earthly Paradise, at the center of which is the new tree of Life,
the Cross, victorious over the serpent. Two medallions intersecting the
margins and text field depict intermediary worlds, the Three Marys at
the Tomb and the Descent into Hell, events that affirm Christ's resurrec-

tion. These lead to the culminating scene at the top of the Lord leaving the earth and returning to heaven, after having established His church, the new Paradise on earth, overseen by Peter with his keys and Mary-Ecclesia.[89] Thus, while the text begins in the upper left and exits below, the frame moves in the opposite direction, leading the eye upward through several images of Christ's body and then off the page at the top.

In thirteenth- and fourteenth-century manuscripts, margins and frames were often the sites of fanciful combats between animals representing the body devoid of reason or grace and, hence, contrasts to the sacred words and main pictures. The praying woman imitates the oldest king as she gazes at the Adoration of the Magi sheltered within the letter **D** framed by the heavenly city, but she is still outside the sacred space, a point made clear by the ape who is ominously shown raising her to her viewing position. A symbol of humankind's animal nature and of mimicry devoid of reason, the ape suggests that Margaret's offering may be an empty imitation of the magi's and her prayers mere prattle copying the priestly incantations.[90] Three other apes at the bottom explicitly parody the magi, as do grotesque men bearing crowns in the outer margin, half-men half-beasts that, like the apes, act out the dangers implicit in sensual attraction.[91] Musicians playing bagpipes and drums in the margins reinforce the message, offering debased earthly music as the alternative to the celestial hymns of the written text.

In Marguerite's Hours, as in many other manuscripts, the marginal decoration unites the facing pages and, in so doing, establishes the opening as the basic visual unit of the manuscript. Thus, Marguerite's posture is to be read against words behind her back on the facing page, "I raised my eyes to you who lives in heaven" and in relation to the monkey subdued by a hound that catches him satisfying his carnal senses by smelling a flower. Even early manuscripts reveal the illuminators' awareness of the opening's possibilities. In the Godescalc Lectionary, for example, not only do framing designs respond to the figures, but the pairing of John with Christ also makes the theological statement that, of the four evangelists, John is the most important and closest to his Lord.[92] In the First Bible of Charles the Bald, a poem and dedication picture facing it were intended to be read together, the former beginning "this painting actually shows" and the latter suggesting the way in which the king was expected to make permanent the privileges bestowed by his father and grandfather

mentioned in it.[93] Likewise, prayers and the Veronica in the Hours of
Yolande de Soissons establish a reciprocal relationship, the one directed at
the other. In the Rothschild Canticles (New Haven, Yale University,
Beinecke Rare Book and Manuscript Library, MS 404), an extraordinary
"diptych" opens a sequence of miniatures based on the *Song of Songs*,
which itself provides continuous commentaries on the text passages writ-
ten on the facing pages. Beneath a depiction of Christ embracing the
"sponsa" and then leading her into Paradise, a woman is shown seated
with a lance in her hand looking across the gutter at the naked Christ,
who points out his wound simultaneously to the "sponsa" and to the
manuscript's reader/viewer.[94] Texts and ornament tie the paired dedica-
tion pages in the Bernward Gospels together; the verses bearing on the
gift extend from the one to the other and the church represented by
three arches behind the bishop is understood as the earthly realization of
the heavenly church rendered in the three arches behind the Virgin and
Child, just as the paten and chalice on the altar are figures of Christ on
Mary's lap.[95] The Psalter of Louis the IX (Paris, Bib. nat., Ms. lat. 10525)
is organized as a succession of paired paintings.[96]

In fact, miniatures and ornament were often deployed to structure the
reading and interpretation of manuscripts as a whole. In the Godescalc
Lectionary, the Fountain of Life inscribed with the capitulum of the
Christmas vigil on the verso of the Christ page helps to make the transi-
tion from figures to text when the reader turns the page; the emblem of
the unity of the Gospels and symbol of the Incarnation bridges the por-
traits to the first pericope on the facing page.[97] A diagram of the
Jerusalem temple was inserted at the head of the ninth-century
Valenciennes Apocalypse (Bib. mun. Ms. 99, fol. 2) to anticipate the
depiction of the heavenly city at the end and hence to suggest the entire
meaning of the Book of Revelation as this world ceding to the next.[98]
Similarly, the insertion of the Veronica at the very end of the Lambeth
Palace Apocalypse (London, Lambeth Palace Library, Ms. 209, fol. 53v)
pictures the reward promised at the Last Judgment when the blessed will
again enjoy the vision of God "face to face."[99] Decoration was particular-
ly important for providing a sense of unity in books with heterogeneous
texts. In the Cîteaux *Moralia in Job*, bookend miniatures anchor the cen-
tral theme of the meditation on the text realized in the succession of ini-
tials picturing spiritual struggle; Job at the beginning is figured as an

example of the restored good man, and a knight at the end stands for the *miles Christi* who has triumphed in spiritual battle.[100] Word and image in the First Bible of Charles the Bald had a similar agenda; in its complex imagery and even in its position as the replacement of the Apocalypse picture originally intended to close the book, the portrait of the young king receiving the enormous codex fulfills the hope that Charles will read and reread Scripture and make it part of his very person.[101]

In these and many other medieval books, art not only effected an elevation by ornamenting the dead flesh and carnal words, but also engaged the very processes of reading and interpreting as essential to the spiritual struggle.

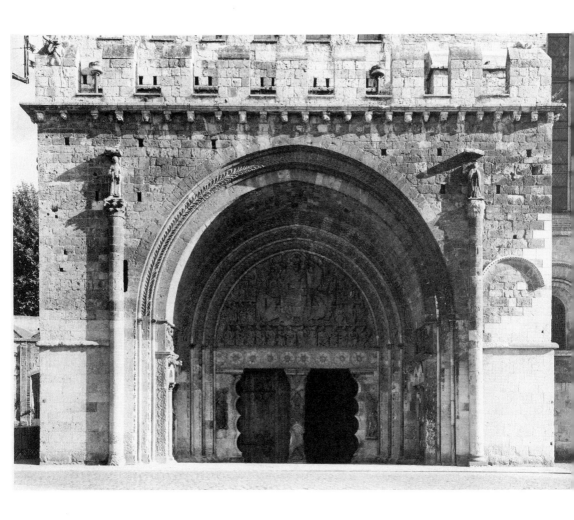

Chapter 5: Church

IN CERTAIN respects, church decoration was an extension of book illustration. Following Gregory the Great's often-repeated justification of art as the "bible of the illiterate,"[1] the adornment of some churches was actually based on illustrated manuscripts or composed to recall them in content and format. One of the most famous and striking examples is the sequence of some one hundred scenes from the Book of Genesis rendered in the atrium mosaics of San-Marco in Venice, certainly copied from a fifth-century book of Genesis now in London (Brit. Lib. Cotton MS Otho B VI), which, for long sequences, follows the narrative step-by-step. Even in this case, however, the relationship between book model and church ornament is complicated.[2] For one thing, the choice of an ancient Greek manuscript was exceptional, dictated by a particular interest in Early Christian spolia in thirteenth-century Venice;[3] for another, lacunae in the old manuscript required the mosaicists to improvise, which they did in part by turning to other venerable sources. The detailed fauna in the creation and Noah cycles, for instance, were added ad hoc,[4] perhaps from another mosaic such as the pavement in nearby Aquileia. Moreover, the old models were also adjusted to present contemporary ideas: the Rebuke of Adam and Eve was refashioned after a Last Judgment of the sort found nearby in Torcello;[5] and scenes from the life of Joseph were reworked to make typologies evident.[6] Most important,

Figure 32. Portal complex, Saint-Pierre at Moissac (early 12th cent.) 107

the very conditions of seeing and understanding the mosaic were entirely different from those of reading the manuscript. The accompanying inscriptions are in Latin and quite cursory, and the movement through the spaces, not the turning of pages, controlled the reading. The scenes from Genesis and Exodus, by being arrayed in the atrium, are transformed into precursors of the Christian subjects displayed inside the church; the domes create "chapters" within the pictured text, such as the four cupolas that focus on Joseph and Moses, which emphasize Israel's history in Egypt, the land Saint Mark converted to Christianity. Moreover, some events relate to spatial function: Abraham is shown greeting the angels and Sarah peers out of the door of the tent directly above one of the actual entranceways, linking an important Old Testament typology to the basilica itself and to the sacramental activities inside.

In like fashion, the Hildesheim doors (Fig. 4) drew on an illuminated ninth-century Bible to configure the entrance into the church as a book; but they also thoroughly transformed the literal illustration from the source to suit the new context.[7] The insistent parallels established between Eve and Mary, for instance, were designed to figure the same Marian allegory that in Bernward's Bible (Fig. 14) is written out on the arches over the Virgin's head: Mary is the open door of paradise and the portal of God. The scene of Expulsion features a closed-off gateway, and in the concluding depiction of the Noli me tangere, Christ invites the Magdalene—standing for all penitent Christians—into the door of heaven, i.e., the door of the church.[8] Parallels to illustrated manuscripts can also be found for Suger's stained-glass windows at Saint-Denis (Plate 2),[9] and a close relationship exists between the decorated churches in and near Rome and the contemporary "Giant Bibles."[10]

The church was itself subjected to exegesis; it was God's house, the replacement of the Jerusalem Temple and the precursor of the heavenly city.[11] To a far greater extent than books and other adorned objects, the richly decorated consecrated spaces were able to restore something of the sacred spectacle that humankind had once been privileged to see and that only saints now enjoy.[12] The ordered narratives and rich materials inside the churches stood in dramatic contrast to the chaotic urban life or untamed landscapes outside, in themselves conveying the sense of a more

elevated world.[13] Paulinus of Nola (353-431) understood that "however earthly, [churches] are a blessed preparation for our heavenly dwellings";[14] Bruno of Segni praised the elevating function of church ornament;[15] and even a practical manual, the *De diversis artibus*, interprets the adornment as an allegory of the lost Garden of Eden.[16] The borders of Paradise were sometimes demarcated by landscapes inhabited by exotic creatures, as in the Ulrich Chapel at Müstair, where hybrid sea creatures over the entranceway, like drolleries in the margins of manuscripts, mark off the sacred space. At Ceri (Plate 8), the lowest register is framed by creatures from the netherworld, a chimaera near the entranceway and a dragon, vanquished by Saint George, at the altar end.[17] The idea that the church is an image of the heavenly Jerusalem was made directly visual through arches and symbols painted on the walls in the palatine basilica of San Julián de los Prados in Oviedo;[18] and the close relationship between the earthly church and its celestial prototype was figured at Ceri by saints portrayed within the gemmed walls of Eden on the reverse façade (as pictured also at the bottom of the Vatican Last Judgment [Fig. 13]).[19]

Although recognized as a pagan legacy, ornament was appropriated as essential to the configuration of Christian sacred spaces. Indeed, in his *Sententiae* Bruno of Segni claimed that church decoration had been introduced by Constantine, who needed it as part of the weaning process from the heathen traditions. When pagan temples and utilitarian structures were converted to Christian use, the introduction of painted ornament was an important part of the process: in Saints-Cosmas and Damian, Saint-Hadrian's, Santa-Maria-Antiqua, Santa-Maria-Egiziaca, Sant'Urbano-alla-Caffarella in Rome, the chapel of Thomas Becket at Anagni, and San-Nicola near Galluccio.[20] As late as the twelfth century, a Mozarabic building was transformed into the church of San Baudelio at Berlanga, in part through the introduction of paintings.[21]

From the very beginning of Christian art, pictures of appropriate subjects also were used to attach sanctified spaces to their historical origins and, in so doing, to their functions. Many were literal and obvious, for example the Baptism of Christ pictured in a baptistery or a saint's martyrdom at his tomb;[22] others, such as examples of salvation depicted in burial places, were more interpretive: Noah in the ark, the three Hebrews in the fiery furnace, Daniel in the lions' den, Jonah cast up, the raising of

Lazarus—all represented in the mid-fourth-century sepulchral monument at Centcelles.[23] The tradition continued throughout the Middle Ages. Eleventh-century paintings of Christ charging Peter, for instance, provided an appropriate backdrop for monastic administration conducted in the chapter house at Vendôme.[24]

As churches were increasingly subdivided to accommodate the developing liturgy, the same principle was introduced within larger structures,[25] where pictures not only marked off diverse functions but also helped to effect the transition between various spaces. In their form and imagery, porticoes and façades signaled the transition between the material and spiritual worlds accomplished when the faithful entered the consecrated precinct. They did so, among other ways, by "advertising" the presence of relics inside and the relationship between this church and the church in heaven above. The theme of transition from the outside into the church determined the placement of a painting of the translation of Saint Clement's body near the entranceway of San-Clemente,[26] underscored by the inscription, "He is brought from the Vatican to this place by Pope Nicholas, who buried him with divine hymns and aromas," and enlivened by the papal entourage bearing a stational cross and banners. In much the same way, Christ delivering the keys to Peter, pictured over the portal used by pilgrims, reminded those entering San-Pietro-al-Monte at Civate that the church of Rome was the dispenser of salvation; depictions of Saint Marcellus and Pope Gregory receiving catechumens in the vestibule within help to effect the transition to the vision of the Heavenly Jerusalem directly above.[27] Two hundred years later, frescoes introduced into the portico of Old Saint-Peter's traced the story of the martyrdom and burial of the Prince of the Apostles and the translation of his relics to the Vatican church, while the mosaic on the façade portrayed Christ in heaven and Peter as one of the intercessors.[28] About the same time, the façade of Santa-Maria-Maggiore was adorned with a picture of the celestial polity and narratives documenting the miraculous foundation of the church itself, a church originally devoid of relics.[29]

In northern Europe, façade decorations were generally of stone, realizing the identification of the church founded on the rock, Peter, with the building itself and visualizing the metaphor in the Epistle to the Ephesians (2.11-22) of Christ as the keystone of the Lord's holy temple built on a foundation laid by the prophets and apostles.[30] Following the

Figure 33. Portal, Saint-Pierre at Moissac (detail) (early 12th cent.)

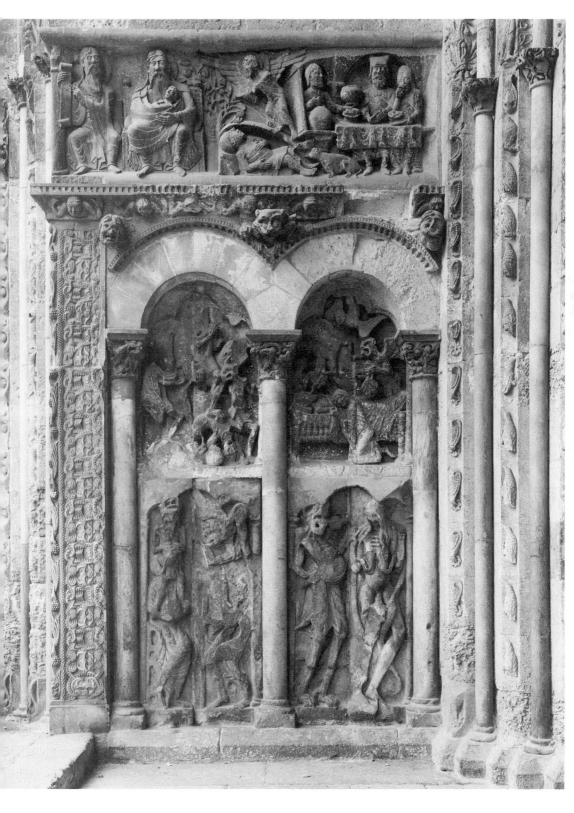

tradition going all the way back to the fourth-century façade of the eponymous church in Rome, the early twelfth-century portal complex of Saint-Pierre at Moissac (Fig. 32), for example, features Christ as the focus of the main tympanum in a synthetic composition based on the twenty-four elders adoring Christ (Rev. 4-5) in the celestial church.[31] Recalling a Roman arch in its very shape, the portal is supported by an enormous lintel made of ancient spolia that, with the trumeau, forms a Tau-cross, the Crucifix that leads into the church and supports Christ's glory.[32] Drawing on an old tradition associating beasts with the tree of life,[33] the trumeau introduces paired lions as guardians of the portal and counterparts to the paired Old Testament prophets and Peter and Paul who established the material Church. Narratives flanking the entrance-way extend the meaning of the principal subjects by attaching the theophany to Christ's incarnation and to the Last Judgment (Fig. 33). Along the top at the left, the rich man of the parable (Luke 16.19-31) is shown dining at the table with his wife, oblivious to the suffering of the poor man Lazarus whose sores are licked by two dogs outside the rich man's house;[34] in contrast, Lazarus is shown safe in Abraham's bosom, the spiritualized father, brought there by an angel.[35] Two arches guarded by monsters represent the "great chasm" between heaven and hell, pictured in the reliefs depicting the rich man's death and torture and large figures of demons on the ground level, one accompanied by a figure of Luxury being consumed by animals. The message is inescapable: those who live worldly lives will not enter heaven; by implication, those who give to the church will. At the entrance to the church, the faithful are reminded of Christ's warning about admittance: "It is easier for a camel to go through the eye of a needle than for a rich man to enter the kingdom of God" (Luke 18:25).

Many of the same themes, conveyed through different subjects, under-lie the façade of the Cathedral of Amiens adorned more than a century later (Fig. 34).[36] The trumeau (Fig. 35) is here occupied by Christ himself, the "door" of John's Gospel (10:1-9), flanked by the five wise and five foolish virgins, each in her own church, to remind those entering the sanctuary of the need to prepare for the final judgment. Christ stands atop the two beasts of Psalm 91 and above King Solomon, the embodiment of wisdom, author of the Song of Songs (alluded to by the lily), and founder of the Jerusalem Temple (replaced by Christ's very person); these

Figure 34. Façade, cathedral of Notre Dame, Amiens (13th cent.)

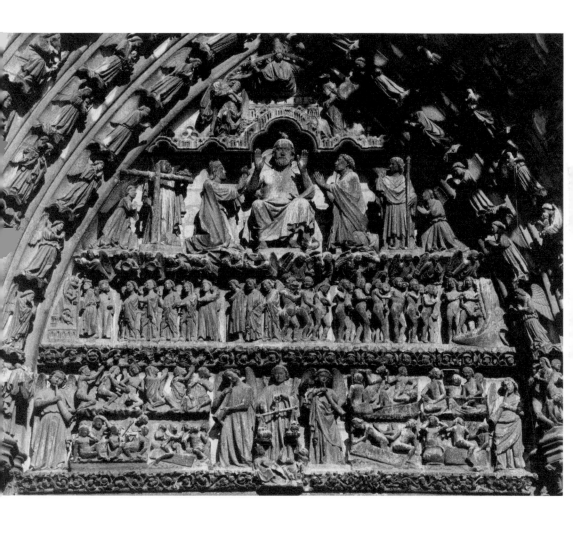

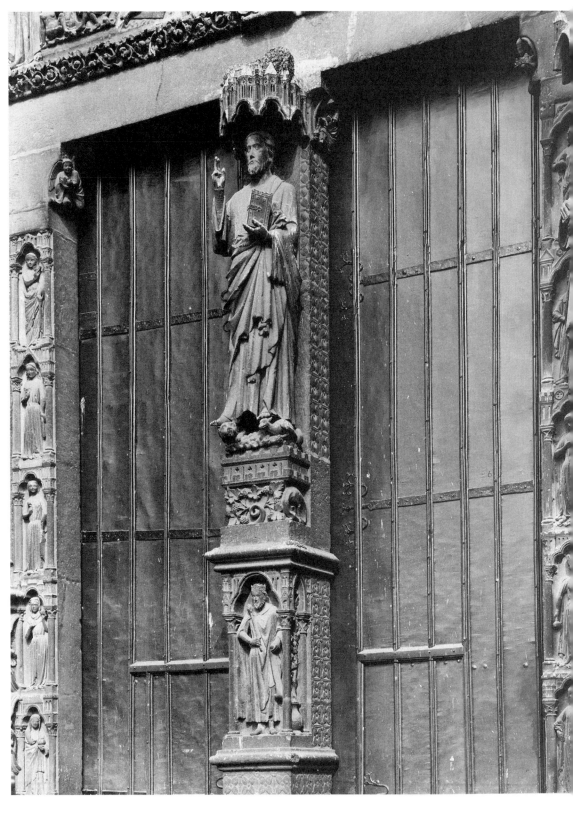

themes are taken up in the tympanum, which culminates in a depiction of the Savior framed by the Heavenly Jerusalem displaying his wounds and flanked by Mary and John the Evangelist, who pray for the expiation of humankind. Continuing the entranceway imagery in the register below, sinners are shown being pushed into a hell mouth at the right and the blessed, led by the recently canonized Saint Francis, are pictured being ushered by Peter into heaven. The thematic relationship between sculpture and portal is asserted as well in the north portal, where the tympanum features the translation of Saint Firmin's relics into the church; a procession of priests is shown bearing the reliquary shrine that, until the French Revolution, occupied the apse.[37]

The theme of power passed on through relics preserved in the church also underlies the depiction in San-Clemente of the miracle of the child at Saint Clement's first underwater tomb (Plate 9); both the legendary grave of the dedicatory saint and, by extension, the church in which he is now buried restore the dead child. Positioned above an actual tomb in the liminal space outside the church proper,[38] the painting bears directly on one of the portico's special functions, which was to introduce the graves of the laity near the sacred relics of a saint.[39]

Inside the portal, sacred history was generally revealed in the nave, the basic communal space. Although lateral walls provided the main surfaces, pictorial adornments were also deployed on ceilings and floors.[40] Ceilings were traditionally reserved for cosmological themes; at Beverly Minster, for example, Archbishop Ealdred (1060-69) "covered the whole church on top … with the work of a painter which they call a *caelum*";[41] and in his general defense of images, Honorius Augustodunensis cited "paintings on ceiling panels of exemplary deeds of virtuous men."[42] A wood ceiling of this sort survives at Saint-Martin's at Zillis, painted with Christ's life and that of the dedicatory saint and providing a celestial vision bordered by the terrestrial world;[43] and at nearby Taufers (Plate 10), the summit of the vault offers a glimpse of heaven and the walls picture God's manifestations in time. Floors, by contrast, were paved with subjects that figure the terrestrial world: in Aquileia a great seascape featuring the Jonah story, and in Otranto the stories of Adam and Eve, Cain and Abel, Noah, and Babel, as well as pictures of the labors of the months and spiritual battle.[44] The victory of virtue over sin also underlies the representation of Abraham fighting the four kings of Canaan (Gen.14.1-12) on floor

Figure 35. Trumeau, façade of cathedral of Notre Dame, Amiens (13th cent.)

mosaics from the presbytery of San-Evasio at Casale Monferrato; and in Santa-Maria-del-Popolo at Pavia, a theme appropriate for the wall is pictured on the floor: Saint Eustace being sentenced and martyred.[45]

Narratives disposed on the lateral walls generally served several purposes at once. The sequential flow asserted God's working in historical time; juxtapositions, oppositions, and thematic repetitions chronicled a divine plan; and spatial positioning plotted spiritual movement.[46] Following a system introduced during the fourth or fifth century in Saint-Peter's and Saint-Paul's, many churches, including Ceri and San-Pietro-in-Valle at Ferentillo, opposed Old and New Testament sequences on facing walls of the nave and joined them together with a scene from the Book of Revelation.[47] In Ferentillo, for instance, visitors entering the church follow the story of creation through the expulsion from Eden in the upper register and then continue to trace God's covenants with Israel culminating in the entrance into the Promised Land; and, beginning near the apse on the facing wall, follow the life of Christ. However, no fixed system governed decoration.[48] In Ceri, an Old Testament cycle closely related iconographically to that in Ferentillo is disposed in the opposite direction. Moreover, even in these churches, trans-temporal themes effect complicated counter-movements. In San Pietro in Valle, paintings between the windows on both walls identify paradise—past and present—as a region of light;[49] and Adam naming the animals in Eden is set opposite Christ in heaven adored by angels across the nave. A vertical axis on the New Testament wall, moreover, leads the viewer's gaze through a series of adorations—when Christ entered Jerusalem at the nadir of His earthly life, when the three kings paid homage to Him, and his veneration by the angels. In Berzé-la-Ville, the triumph over death and humiliation that Christ received in the flesh is introduced in frescoes on the west wall picturing the Entry into Jerusalem and Last Supper, providing a model and foil for the elevating program of the apse.[50] In many churches, the pictorial decoration responded to complex, sometimes competing purposes. It also helped to articulate intricate practices: at Civate, for instance, where pilgrims entered one portal and monks the other,[51] and at Bominaco, where frescoes articulate the areas of a small nave and choir accessible from three directions.[52]

Underlying these and most other church decorations is the creation of a sacred space through the demonstration of the coherence of, and hence

the plan underlying, sacral history. As on the Hildesheim door, the choice and juxtaposition of episodes and individual compositions convey this agenda. Old Testament events were constructed as prophecies of Christ; in the late twelfth-century painter's guide known as the *Pictor in Carmine*, for instance, hundreds of distichs spell out the typological significance of events reported in Hebrew scripture, organized according to the chronology of Christ's life.[53] At Ceri, Christ is inserted into the burning bush to realize the interpretation of God's speaking from a fiery bramble on Mt. Horeb as evidence of a dual nature.[54] Typologies served the same function in the Saint-Denis windows; as Suger explained, "What Moses veils, the doctrine of Christ unveils. They who despoil Moses bare the Law" (*De admin.* 34).

Compared to the Old Testament sequences, Gospel cycles were generally quite straightforward; their basic purpose, after all, was to affirm the reality of Christ's incarnation, death, and resurrection. The mosaics adorning the tomb chapel of John VII (pope 705-07), for example, included fifteen distinct episodes, beginning with the Word of God entering Mary's body and including secondary figures in other scenes to underscore Christ's humanity.[55] Particular attention was paid to the actuality of Christ's suffering and death;[56] thus, paintings at Vicq (Fig. 33) present the Lord's dead body sagging into Nicodemus's arms as the nails are pulled from his hands.[57] A particularly important function of pictorial narrative was to affirm the veracity of the Resurrection. Christ rising from the grave is depicted on the Berlin textile (Plate 12), paired with the three Marys at the empty tomb; and the Harrowing of Hell, interpolated into the John VII cycle, makes it clear that Christ really did not die but continued his work of redemption even after the Crucifixion and burial, an appropriate theme for a tomb monument.[58] Other non-canonical episodes and symbols were also introduced into the Gospel narrative to suggest the theological importance of the depicted events. Eleventh-century frescoes in the abbey church at Lambach, for example, draw on Josephus and other non-canonical texts to elaborate Herod's biography.[59] At Vicq, a story based on the *Protevangelium of James* of Mary defending her purity to skeptical Jews is inserted as a way of underscoring the fundamental belief that Christ was born of a virgin.[60]

Particular emphasis was given to subjects bearing on the establishment of the Church after Christ returned to the "right side of his Father," and

hence to the continuity between sacred history and the present time and place. Thus, the Pentecost is featured on the Berlin textile, where Peter prominently displays keys, and Mary — crowned and enthroned beneath an arch — symbolizes the corporate church founded at that moment. Based largely on apocryphal texts, Mary's own biography also entered church decoration; as early as 872-82, an extended narrative of her life was introduced into the Temple of Fortuna Virilis in Rome; and she appears in every scene on the transverse arch at Vicq. The evolution culminated in Santa-Maria-Maggiore (Plate 1) where Mary's death is portrayed at the center of a sequence featuring her role in Christ's life and where the entire conch is filled with her coronation, seen as a fulfillment of the Song of Songs: "Come my chosen one and I will put you on my throne."

Because they linked the period of grace directly with the present, the deeds of the Apostles were also important in church decoration. The Gospel story is extended on the Berlin textile, for instance, with the scene of Peter working a healing miracle at the golden gate; and the *Pictor in Carmine* imagined the decorated church to continue with the lives of Christ's disciples. The John VII Chapel continued the mosaic cycle with episodes from the life of Saint Peter;[61] and, in Ceri, Sylvester subduing the dragon in the Roman forum, the martyrdom of Saint Andrew, five standing saints, and George conquering the dragon constitute a third register beneath the Old Testament cycle.

As in many other churches, such pictures tie saints venerated locally to the apostolic Church.[62] That was the overall theme of the paintings in the upper church of San Francesco at Assisi, which included a continuous narrative of Francis's life (Fig. 36) rife with references to the Church of Rome and to the saint's place in its history.[63] Another principal purpose of hagiographical narratives was to provide the historical context for relics preserved in the church and, in so doing, to authenticate them.[64] Thus, the mosaics in the John VII chapel end with Peter's martyrdom in the city, and in Santa Prassede (Fig. 1) the passions of a few of the 2,300 saints whose remains Paschal I had brought into the church from the catacombs are pictured in the north transept.[65]

Insofar as they imitated Christ's own life and sacrifice, saints were also exemplary humans who served as potent models for proper behavior on

Figure 36. Fresco, upper church, San Francesco at Assisi (late 13th cent.)

earth. Paulinus of Nola assumed that "when one reads the saintly histo-
ries of chaste works [in pictures], virtue induced by pious examples steals
upon one" (Carmen 27.589-91). The apostles' divine virtue is contrasted
to Simon Magus's devilish magic in the John VII chapel; in the crypt of
Aquileia cathedral, the choice between good and evil is also presented
beneath depictions of saints, in the form of personifications of the vices,
battles between crusaders and infidels, and representations of pilgrim-
age.[66] At Ceri, Aegeas, who put Saint Andrew to death, is shown being
torn apart by devils for his evil deed; nearby, sensual satisfaction is
opposed to the spiritual nourishment offered at the altar through a
depiction of a man basting a pig on a spit, sausages and prosciutte hang-
ing overhead, and two women carrying baskets of bread (Fig. 39),[67]
painted in line with other examples of carnal temptation: the fall of
Adam and Eve and Joseph fleeing Potiphar's wife.

The most sacred area of the church was, of course, the choir with its
adjacent crypt and transept.[68] Facing the rising sun, it was generally a
particularly luminous space, the shrine of the church's principal relics,
and the stage of the liturgical mysteries, where, in Suger's words, God,

> conjoined the material with the immaterial, the corporeal with the
> spiritual, the human with Divine, and sacramentally reforms the
> purer ones to their original condition. By these and similar visible
> blessings you invisibly restore and miraculously transform the pre-
> sent [state] into the Heavenly Kingdom. (De Cons., chap. 8)[69]

The choir's sacrality was often signaled already in the nave. At Saint-
Savin, the Eucharistic typologies of Noah in the vineyard and Noah
enjoying the grapes are represented above the altar.[70] In Cruas, the apse is
paved with typologies of Paradise,[71] and in Saint-Remi with themes
bearing on altars: Jacob's ladder at Bethel (before the steps) and the
sacrifice of Isaac.[72] In Santa-Maria-Maggiore, the narrative flow of the
fifth-century Old Testament cycle was actually disrupted so that
Abraham meeting Melchizedek and Abraham's hospitality, two events
rife with sacramental meaning, were depicted closest to the altar; and
both are pictured in a more ceremonial fashion than the other scenes.[73]
In San-Pietro-in-Valle at Ferentillo, the scene nearest the apse on the left

wall pictures Adam and Eve being ushered out of Eden, which is rendered as the Heavenly Jerusalem with yellow-gold walls set with sapphires, rubies, and pearls.[74] Fusing the start of sacred history described in the Book of Genesis (3:23) to the end envisioned in the Book of Revelation (21:10-21), the depiction is a synecdoche of the church itself, a haven for Adam and Eve's progeny adorned with Old and New Testament narratives on facing walls of the nave and an apocalyptic vision on the triumphal arch.[75]

From at least the seventh century, screens of various sorts separated the communal space from the choir in certain churches, some decorated with figures and narratives. In Vicq, for instance, three scenes bearing on the Incarnation and two relating to the altar are represented on the dividing wall;[76] the reference to the curtain separating the outer court from the Holy of Holies of the Jewish tabernacle is realized in the themes of incarnation on the face and also in the pictorial narrative in the presbytery which comments on Christ's dual nature. The special area beneath the choir of Saint-Peter's, where the episcopal pallia were consecrated, was treated as a portal to the more sacred space (Fig. 25). In a particularly charged fashion, the thirteenth-century choir screen in the cathedral of Naumburg functions as a site of transition and passage;[77] the cross provides immediacy and the barrier itself marks the holiest part of the church. In other churches, the *schola cantorum* served as a wall and a bridge to the apse; in Old Saint-Peter's the privileged space of the canons in the nave was provided with its own (two-faced) altar, simultaneously closing off and opening up areas of the basilica.[78]

In many churches, the decoration of apsidal and triumphal arches also bridged the historical narratives on nave walls to the liturgical spaces below. In Santa-Prassede, for instance, the earthly sufferings of the martyrs pictured in the transept are transformed into victory on the "triumphal arch," where the saints are pictured whole and pure entering the heavenly Jerusalem. In other churches, images on the apsidal arch bear directly on the altar below. At Müstair, for instance, Adam and Eve are pictured sinning and being expelled from Paradise at the right, God rejects Cain's offering and accepts Abel's lamb at the center, and, at the left, the two Saint Johns are represented with the medallion of the Lamb of God.[79]

In most churches, the decoration of the apse unified the other adornments around the Incarnate Savior.[80] Christ is most often portrayed at the center; in Santa-Prassede and Berzé-la-Ville, for instance, he is represented with Peter and Paul and local saints. It was in this context that the Ark of the Covenant in Germigny-des-Prés is to be understood as Theodulf's argument *against* the tradition of representing Christ in the apse and in support of the Eucharist below as the only true presence of the Savior.[81] Because it provided the historical basis of the sacraments while engaging the process of the transformation of *historia* into *icona* recapitulated in the liturgy itself, the crucifixion was the most common theme pictured near the altar. A cross dominates the apse of San-Clemente, actually a reliquary containing a fragment of the True Cross, transformed there into a symbol of regeneration.[82] At Saint-Remi, a crucifix is isolated at the center of the clerestory windows. Crucifixions painted on panels and suspended over altars became popular during the twelfth century in Italy; the depiction of Saint Francis praying in San-Damiano includes a realistic rending of one in situ. As on the *croce dipinta* in Pisa, these often included cycles of the Passion and Resurrection,[83] at the bottom emphasizing the establishment of the terrestrial Church at Pentecost and, at the top, Christ's return to the heavenly realm. The same implicit emphasis on Christ's divine and human natures underlies the Last Supper and the Three Marys at the Tomb, positioned outside the narrative order near the altar in San-Baudelio.[84] Mary was pictured in some apses, the vessel of Christ's incarnation and the heavenly intercessor,[85] the mosaic in Santa-Maria-Maggiore being the most splendid example.[86] In the cathedral of Siena, the life of Mary painted on one side of Duccio's *Maestà* was continued in the stained glass above with the Assumption and Coronation, through the very medium moving from the Virgin's earthly to her heavenly realm.[87]

The conjoining of heaven and earth in the area near the altar is often a specific theme of apse decorations. In San-Pietro at Tuscania,[88] the Sancta Sanctorum, and many churches, the transformation effected through the sacramental consecration is echoed in Christ's Ascension pictured in the apse. In San-Clemente, for instance, a great vine sprouts from the base of the apse and rises toward heaven, the tree of Eden through which humankind fell but, as the inscription makes clear, also a

symbol of the church of Christ that brings renewed life. Eden is also evoked in the apse mosaic of Santa-Maria-Maggiore, through the vine filled with birds and by the four streams that flow into the river that separates this world from the celestial vision, the fountain that watered Paradise and now symbolizes the church. Two harts drink from the streams, an allegory of the Christian souls desiring salvation, and in the middle, two men are sheltered within the walls of Eden guarded by the fiery sword: Enoch and Elijah who ascended after death. Santa-Prassede makes an explicit link between the heavenly residence of the saints and the church sheltering the remains of the martyrs. So does Berzé-la-Ville, where the windows framed with floral designs and the arches supported on the columns surrounding the windows are painted with imitation pearls and precious stones. The ornament connects the architecture visually to the bejeweled women, the wise virgins who, in the biblical parable, had entered Paradise. Suger had the same idea in mind when he invoked Ezekiel's description of Eden as "a garden adorned with gems" in his account of the Saint-Denis choir, which he imagined as existing "neither entirely in the slime of the earth nor entirely in the purity of Heaven" and which reinforced his yearning to be "transported from this inferior to that higher world."[89] The allusion to the Heavenly Jerusalem is made even more directly in the late twelfth-century church of Saint-Remi at Reims by means of a great candle wheel adorned with twelve towers and the tall windows "bright as clear glass."[90] At Lincoln Cathedral, heavenly bliss is evoked by the smiling sculpted angels that adorn the choir, representing the joyous return to God effected through the sacramental blessing staged at the altar.[91] The Fulda Sacramentary (Fig. 26) pictures the hoped-for confrontation in the church's choir; it represents a group of believers gazing in a picture at the celestial church presided over by the triumphant *ecclesia* collecting the blood of Christ from the Lamb of God.[92]

Inspired by the reference in the Book of Revelation to "the souls of those who had been slaughtered for God's word" beneath the altar, illustrated literally on the Vatican Last Judgment panel (Fig. 13),[93] the passion and burial of dedicatory saints were often depicted close to altars containing their relics — in the transept, crypt, or on the altar itself. In Saint-Paul's-outside-the-walls, the holy innocents entombed in the chord

of the apse are pictured above; and, following the precedent of Saint-
Peter's, Santa-Prassede represents martyrdoms in the transept. Paintings in
the crypts at San-Vincenzo-al-Volturno,[94] the cathedral of Aquileia,[95]
and the Thomas Chapel at Anagni[96] all bear on the deaths of the local
saints. Where a church lacked a transept or crypt, the saint was honored
in the apse. At Berzé-la-Ville, the martyrdoms of Saints Blaise and
Vincent flank the triple window behind the altar and nine other saints
venerated at Cluny are portrayed below.[97]

Altars were often decorated, mostly with textiles and metalwork, but
some also painted.[98] They frequently featured the saints whose relics were
honored in the church, a practice officially accepted at the Lateran
Council of 1215 when it accepted images as one of the ways altars could
be identified.[99] The ninth-century altar of Sant'Ambrogio in Milan is
adorned with narrative reliefs of the life of Christ facing the nave of the
Lord's local representative, Saint Ambrose,[100] facing the choir; Ambrose is
thus configured as Christ's representative and elements in the Ambrose
narrative connect his life to the altar's function. For example, he is shown
working a miracle while standing at an altar; and his body remains behind
on an altar-like bed when the angel lifts his soul to heaven. Like a church
façade, but here separating the choir and ambulatory, the great enamel
altarpiece in the abbey of Stavelot (Fig. 19) created an access to the relics
for the lay visitors and for the clergy, a reflection on the proper life;[101]
doorways are a theme on the Lisbjerg Altar (Fig. 20) adorned with the
portal of the Temple, the gate of Eden, and the entranceway to heaven
joined by the crucifixion. Itself a model of a church, the Last Judgment
panel features an altar at the very center displaying the instruments of the
Passion together with the gold cross and Gospel book on top.[102]

Although the development of the altarpiece has been linked to the
mandated elevation of the host at the Lateran Council of 1215, the
Vatican Last Judgment and other early examples suggest a much more
complicated evolution including the developing cult of saints and history
of patronage.[103] The Madonna and Child from Santa-Maria-Maggiore in
Florence (Fig. 23) is to be understood in this context; actually a reliquary,
it not only realizes in figural form the sacred materials it encloses, but
also figures the Sacraments in the two narratives attesting to Christ's dual
natures and in the enthroned deities.[104]

As the dedication miniature of the Bernward Gospels documents[105] and as many surviving *vasa sacra* confirm (cf. Plate 5 and Figs. 5, 11), the altar was richly furnished. A miniature in the Uta Codex pictures Saint Erhard, clothed in elaborate vestments, performing the Mass before an altar adorned with precious textiles on which the ninth-century Arnulf Ciborium and other *vasa sacra* are displayed. In the depiction, Erhard and his deacon are framed by a canopy of the general type found in some actual churches. In the Sainte-Chapelle (Plate 7), for instance, a great baldachin focused attention on the altar;[106] and in Saint-Paul's-outside-the-walls, Arnolfo di Cambio's baldachino effected the transition between the material and spiritual worlds by superimposing an open, white marble Gothic image of the Heavenly Jerusalem adorned with gold mosaics atop severe, dark columns.[107] The same form of honorific canopy was thus used over the body and blood of Christ and on the tombs of mortals (Fig. 6).

In stark contrast to the light-filled eastern end, the darkest place of the nave, the reverse façade, was used to remind the faithful leaving the church of the burden they were required to bear if they were to enter the celestial Paradise. In Saint-Paul's, from the eleventh century at least, and in Sant'Urbano-alla-Caffarella, scenes of Christ's Passion brought to mind the sacrifice through which salvation was made possible.[108] In the Becket Chapel at Anagni, along with Saint Christopher, the patron of travelers, female saints in the guise of the wise virgins (Matt. 25:1-13) called to the minds of those returning to the world that eternal preparation was needed if they were to be among the blessed at the end of time.[109] It was a perfect theme of separation, for the virgins' foolish counterparts are portrayed around the corner being dragged into Hell by demons, the damned in a depiction of the Last Judgment.[110] Because Christ promised that he would return in the final days, when "all the peoples of the world will see the Son of Man coming on the clouds in heaven with great power and glory" (Matt. 24:30), the Last Judgment was often pictured above the exits of medieval churches.[111] At Civate, for instance, the great lunette over the vestibule depicts Christ's ultimate victory over death and the forces of evil.[112]

Spaces outside the main body of the church were also decorated and had their own history. The San Zeno chapel in Santa-Prassede, for

instance, was furnished with a decoration that served the specific func-
tion as a burial space;[113] and the palace chapels in Paris and Rome were
decorated in ways that inserted local politics into Church history.[114]
Because of their small scale and often-private control, chapels were places
for artistic innovations. In the thirteenth century, side chapels seem to
have promoted the development of the altarpiece.[115]

As the miniature in the *Très riches heures* records, church decoration
was disposed in consecrated spaces to move the faithful from this world
and its history toward the altar and then upward toward heaven; the pic-
ture shows the congregation entering the chapel at the right, its attention
directed toward the altar by sculptures and stained glass, and then through
the reliquaries and baldachin to meet the angels. The decorations in the
apse at Berzé-la-Ville function in the same way, effecting a visual pil-
grimage that begins with eastern saints painted behind the (now
removed) altar, continues through local martyrs, and passes up to the
heavenly Christ, who embodies a transition to God the Father (symbol-
ized by the Hand), and toward the Holy Spirit, symbolized by the oculus
borne by two angels that is both the eye of God and a source of illumi-
nation in the apse.[116] While the distribution of pictures in these and
other churches suggests an ordering of pictorial narratives in response to
the functional spaces, the structure was, in fact, never rigid. As the *De
diversis artibus* reminds artisans, "a human eye cannot decide on which
work it should first fix its attention."[117]

Whose eye? Who saw, understood, and benefited from church dec-
oration?[118] Gregory's dictum that pictures were to serve the illiterate in
particular was paraphrased by numerous later theologians and incorporat-
ed into canon law;[119] to judge from the fifteenth-century rendering, even
the Sainte-Chapelle served townsfolk as well as members of the court.
The material splendor itself was accepted as a useful means for attracting
the uneducated. Indeed, Bruno of Segni believed that ornament had
been allowed in the first place because "gentiles and unbelievers used to
take the greatest delight in seeing [it] and were drawn to a love of Christ
through it";[120] and the *Pictor in Carmine* makes much the same argument:

> For since the eyes of our contemporaries are apt to be caught by a
> pleasure that is not only vain, but even profane, and since I did not

think it would be easy to do away altogether with the meaningless paintings in churches, especially in cathedral and parish churches, where public stations take place, I think it an excusable concession that they should enjoy at least that class of pictures, which being the books of the laity, can suggest divine things to the unlearned, and stir up the learned to the love of scriptures.[121]

When the anonymous author of this text extended Gregory's "illiterates" to laymen more generally, he was recognizing the fact that, like the ones he was himself proposing, most pictures were accompanied by captions and, hence, would have appealed to an educationally stratified audience.[122] Of course, audiences differed according to context. Attempting to reconcile monastic renunciation of luxury with Pope Gregory's dicta, for instance, Bernard of Clairvaux was willing to allow pictures in secular, but not in monastic churches,[123] a view echoed in the *Pictor in Carmine* and implied in Honorius Augustodunensis's rephrasing of Gregory's metaphor of pictures as "laicorum litteratura."[124] Moreover, church decorations would have served the different groups in diverse ways. Residents near Ceri, for instance, had years to peruse the pictures, read (or have read) the captions, and (perhaps) hear references to the decorations in sermons and liturgical celebrations; pilgrims to Santa-Maria-Maggiore, on the other hand, would most likely have paid only fleeting attention to the mosaics that verified the site's history.

Not only did members of the clergy sponsor art for the laity, but they also used it themselves.[125] Hugh of Fouilloy seems to have had lay-brethren in mind for his *Aviarium*,[126] one of the many intermediary groups toward which art was directed. Abbot Suger assumed that only those who could read the Latin inscriptions on his altar would be able to understand the pictures,[127] and, indeed, his windows are filled with complicated images and intricate inscriptions (Fig. 8). The meaningful mixture of Latin and vernacular inscriptions in the Mass of Saint Clement in San-Clemente certainly implies sophisticated viewers.[128] Moreover, clergy had exclusive spaces that were decorated to suit their own private needs. For example, paintings in the chapter house at Vendôme were designed to reassure resident monks of the privilege of immunity the pope had granted them.[129] In cloisters, sculptures served

various purposes. At Saint-Paul's-outside-the-walls, for instance, the Cosmatesque courtyard completed in 1230 included admonitory vignettes such as Adam and Eve (in another garden) eating from the forbidden tree and a fox in monastic garb distracted from his reading by a tempting goat.[130] In St-Michel-de-Cuxa, early twelfth-century capitals filled with monstrous and overtly lascivious figures conjured up evil thoughts, precisely in an effort to convert them into pious aspirations.[131]

Art in churches was intended also to elicit emotional responses to the events portrayed and to direct those responses to the invisible presences. The affective potential of art was frequently cited in defenses of art, such as those of Paulinus, Gregory, Theophilus, and Rupert of Deutz (ca.1075-1130):

> while we externally image forth his death through the likeness of the cross, we may also be kindled inwardly to love of him ... and may always consider with pious affection (wrapped up in many and great sins as we are) what a great obligation we owe for his love.[132]

In other words, even narratives served devotional functions.[133]

The danger was that emotions stimulated by the material ornament of churches might lead not upward toward God but downward. At Ceri, the scene of Joseph fleeing Potiphar's wife offers a caveat against the seductiveness even of church decoration; the temptress is dressed as a personification of Ecclesia and is enthroned in a church-like structure, and the scene is depicted directly beneath scenes of concupiscence that had originally led to sin.[134] Particularly during the debate over images in the eighth and ninth centuries, attempts were made to differentiate "veneration" due God from "honor" accorded his picture. Many works deployed devices to resolve this problem. In Civate, as in certain other churches, the face of Christ at the end of time was painted on a panel inserted into the fresco to make clear that it was only an image;[135] in San-Giovenale at Narni, Christ in heaven is rendered in glass mosaic and the saints flanking Him are portrayed in the more earthly material of fresco. Such works realize the conceit that William Durandus of Mende would later state explicitly, i.e., that pictures are material signs of the invisible.[136] Windows occupy the acme of the spiritual ascents in the

Zeno Chapel at Santa-Prassede and Berzé-la-Ville, where portraits of Christ are expected, figuring Christ's essential duality by means of light and transparency.[137] Drawing on a long tradition of light symbolism, the stained glass that came steadily to replace fresco as the medium of pictorial narrative in churches of twelfth-century Ile-de-France built on this idea.[138] Passing through glass, the light that rendered the figures visible to carnal eyes recapitulated the entrance of God into matter and, hence, reinforced the fundamental relationship between church decoration and the very person of Christ. Thus, one of the tituli for the Annunciation recorded in *Pictor in Carmine* reads, "The sun shines through the medium of glass and does not sully the material."

Like all church decoration, however, even the magnificent stained-glass windows are only likenesses, only a "blessed *preparation* of the heavenly home." Sacred stories in consecrated spaces reminded the faithful that they could return to Paradise only at the end of time, "when the first heaven and first earth has vanished and ... the holy city, new Jerusalem, comes down out of heaven from God, made ready like a bride adorned for her husband" (Rev. 21).

Hic est uera concordia solis et lunę per XII menses
id est quantos dies circumit sol signum et
lunę uel quomodo concordant per
XVIII annos uel annum integrum;

KL mai natiuitas apostolorum philippi et iacobi fratr dni.
VII id mai aestatis initium habet nox XC id mai primu
pente costen XV kt iunii sol ingeritur VIIII kt iunii
aestas oritur VII kt iunii X aegyp mensis pauni Nox hor
VIII dier horas XVI XV kt iulii sol mansorum XII kt iulii

Chapter 6: Life (and Death)

WHILE THE NEED to channel the physical world toward religious purposes shaped much medieval art, the real world driven by human needs, ambitions, desires, and fears also engendered a lively tradition. So dominant is the view of the Middle Ages as an "Age of Faith" that the secular current of medieval art is generally overlooked or, as it is even in this book, grossly marginalized. In fact, a distinction between the two categories is often difficult to make. Astronomy was needed to calculate Easter; herbals were illuminated in monasteries; monarchs promoted theological study; and the story of Roland was represented in churches. At death, especially, physical existence ceded to theology. Although much medieval art rejected verisimilitude, it was still very much about representing the world, and, particularly at the end of the period, its forms and feelings drew heavily on nature and the human condition.

Classical antiquity provided a vast reservoir of scientific knowledge and contingent art.[1] Renewed during the Carolingian period and then under Frederick II, scientific illustration remained to a great extent a largely separable antiquarian production. Diagrams describing the circulation of the planets, the relationship of the elements and humors, tidal patterns, and other natural phenomena remained consistent over long

Figure 37. Schema, *De astronomia*, Laon (early 9th cent.)

periods; the schema prefacing an anonymous tract, *De astronomia*, in an early ninth-century manuscript in Laon (Bib. mun., MS 422, fol. 54, Fig. 37), for instance, uses a flower-like arrangement to imagine the movement of sun and moon through the months and the twelve signs of the zodiac and, in the four circles, the circulation of Saturn, Jupiter, Mars, the Sun, Venus, Mercury, and the Moon around the earth.[2] Likewise, an eleventh-century manuscript of Calcidius's translation of Plato's *Timaeus* from Cologne (Cologne, Erzbischöfliche Diözesan- und Dombibliothek, MS 192) contains numerous cosmological diagrams, many of them traceable in ancient papyri.[3] The Aratus manuscript from 830-40 in Leiden (Bibliotheek der Rijksuniversiteit, Ms. Voss. Lat. Q 79) includes not only a cosmological diagram but also figural representations of the constellations that transmit the mythological iconography and classical style of the Late Antique models.[4] Although refreshed with new observations, the scientific naturalism associated with Frederick II's court also had a strong classical foundation,[5] as manuscripts of the *Varia medica* in Florence (Bib. Med. Laur., MS Plut. 73.16) and Vienna (Nationalbib., Cod. 93) witness. When about the same time Matthew Paris recorded an unusual solar happening reported by an eyewitness (Cambridge, Corpus Christi College, MS. 16, fol. 83v), he adapted an astronomical diagram.[6]

The world of plants, represented largely for the practical purpose of identifying medicinal herbs, remained remarkably conservative; a French example from the turn of the eleventh century (Paris, Bib. nat. Ms. lat. 6862), for instance, preserves the ancient system of inserting portraits of plants into the texts describing their characteristics.[7] In contrast, animal treatises composed around the moralizing text of the *Physiologus* acquired a different character; although also rooted deeply in ancient scientific illustration, they were transformed into fables of virtue and vice and perhaps were used as exempla in teaching.[8] Written during the second decade of the twelfth century, Hugh of Fouilloy's *Aviarium* is a perfect example of the genre; preserved in seven illustrated manuscripts, it presents moral and theological messages in words, pictures, and diagrams concerning birds.[9] Purely practical manuals, such as the Latin translation of Soranos' *Gynecologia* of ca. 900 in Brussels (Bib. roy., Cod. 3701) conveys the essential information of its classical source, if not the style.[10]

Even within the relatively hermetic scientific traditions, medieval arti-

sans innovated. For one thing, they assembled diverse sources in compendia of knowledge that, through their very comprehensiveness, transformed the heritage; and they included new iconographies in these too. The key text was Isidore of Seville's *De natura rerum*, written because the seventh-century Visigothic king Sisebutus wanted to know the "reasons behind the nature of phenomena and material substances." It not only served intellectual and practical purposes, but also invested the natural world with a spiritual content, and it became the basis for many later works on natural history.[11] The same is true of other "scientific" compendia.[12] Thus, a ninth-century collection of astrological texts, preserved in copies in Munich and Vienna (Bay. Staatsbibliothek, Cod. 210 and Öst. Nationalbibliothek, Cod. 387), includes among its traditional diagrams and pictures a schema of the winds certainly (and appropriately) derived from a contemporary *Majestas Domini*;[13] and even such complex images of natural phenomena as the Laon diagram are often inserted into a religious context and may well have embodied religious associations in their very forms.[14]

Such compendia constructed new knowledge simply by bringing together diverse branches of science, often deploying pictorial elements to create a kind of unifying visual exegesis. The comprehensive eleventh-century edition of Hrabanus Maurus's *De natura rerum* in Montecassino (Abbazia, Cod. 132) assembles more than 300 traditional and invented miniatures drawn from various sources and organizes them in a Christian structure beginning with the Trinity and ending with secular themes;[15] in the fourteenth century, Robert Le Parler did something of the same thing in his *Omne bonum*.[16] The twelfth-century *Liber Floridus* in Wolfenbüttel (Herzog August Bibliothek, Cod. Guelf. 1 Gud. lat., fol. 64v) introduces the cosmocrator himself atop a diagram of the planets and constellations expanded to include the nine orders of angels.[17] As creator of the universe and its governor, God was not separable from nature. Moreover, because most scientific imagers also worked on religious art, they inevitably introduced Christian conventions into their work. The illustration of the derivation of a drug from urine accompanying Sextus Placitus' fifth-century text in a mid-thirteenth-century *Varia medica* (fol.169r, Fig. 38), for example, appears to be an example of genuine naturalism; while the rendering of the man's face and torso are

rather conventional, the specific source of the medicinal material is pic-
tured honestly and even with a sense of humor. However, the woman
holding a distaff who looks at what is happening is clearly patterned after
a picture of the Virgin Mary being approached by the angel Gabriel at
the Annunciation.[18] Something of the same irony is evident in a French
medical manuscript in London (Brit. Lib. MS Sloane 1977, fol. 8r) in
which pictures of Christ's Passion are set in relation to representations of
medical diagnosis.[19]

In other works, secular sources seem to have been tapped for a specific
conceptual purpose. At Ceri (Plate 8 and Fig. 39), the depiction of a man
basting a pig on a spit and women bringing in grain and oil, intended to
contrast carnal food to the spiritual nourishment offered on the adjacent
altar, alludes through inscriptions to its source in Terence's *Andria* and, in
so doing, extends the distinction between the secular and religious
worlds.[20] The attitude here is analogous to that of Hrotswitha of
Gandersheim a century before, who used Terence as a model for her own
plays, but only as a foil for contrasting the vanity of pagan literature to
the usefulness of Scripture. The same idea may lie behind the beasts
kneeling before Mary in the Cantigas (Fig. 3); they were probably copied
from a book on natural history, and their naturalism enhances the ani-
mals' baseness in contrast to the spiritual veneration due the Blessed
Virgin, just as the fully painted Mary realizes the uncolored *acheiropoieton*
above and hence the argument for religious art.[21]

The innate multi-valency facilitated the integration of scientific illus-
trations into sacred art.[22] The paired lions, cervids, and other animals that
illustrate the verse of Psalm 148 in the Utrecht Psalter (Fig. 28), for
instance, were copied from an illustrated *Physiologus* in which ancient
animal lore had already been assimilated to Christianity;[23] and even the
very classical Leiden *Aratea* included Christian features that paved the
way for it to be used as the source of the zodiac frame that figures the
celestial city illustrating Psalm 65 (fol. 36r).[24] In the eleventh-century
Catalan Bibles (Vatican, Bib. Apos. Cod. Vat. lat. 5729 and Paris, Bib. nat.
Ms. lat. 6), cosmic circles copied from scientific works introduce into
Genesis scenes Platonic notions of creation from the four elements.[25] At
the top of the Remaclus antependium (Fig. 19), a cosmological "flower"
of the sort incorporated into the Laon manuscript serves to depict Christ

Figure 38. Illustration, *Varia medica*, Montecassino (mid 13th cent.)

Capre stercī in panno inuolutū et collo sūspēsū;
remediū ē infantibʒ qui fantasma patiuntur
xluiī. vt dentes candidos faciaſ
Capri tali ꝏbusti q̄ et exinde dētes p̄ficab candidi
dētes fiunt. xlv. ad caducoſ.
Carnē capri que sup rogū hoīs mortui absatur
supta caducis remediū dicim̄. ꝏbusta caro cū
aqua suppuratōeſ ceruicū discutit quaſ ꝓ irūda
uocant. xlvi. ad alopitiaſ
Capraſ ungulas ꝏbustas pice u̇ q̄ a ꝯp̄llaſ in
ꝓitaſ alopitiaſ sanat oīa uehemtiore̅ efficatiā;
p̄stant. hircoſ n̄ q̄ capra lacte soliū ā̅cedat

de puero aut͛ virgine.

as the center of the universe and to connect to him satellite figures such as the evangelists, virtues, and rivers of Paradise.

The lozenge or *tetragonus mundus* used to picture the earth was one of the most important of the schemata; it dominates the Saint-Petersburg phylactery, for instance, and was most famously elaborated in the *Enchiridion* of Byrhtferth of Ramsey (ca.1010) where, inscribed with a cross, it is the foundation for correlating the four cardinal points, four winds, four elements, four humors and ages of humankind, and Adam's name.[26] Derived from a long tradition of exegesis, the lozenge establishes the relationship between the microcosm and macrocosm and asserts visually the belief that the rationality of the cosmos reflects the rational Creator-Logos.[27] The frontispiece to John's Gospel in the Book of Kells (Fig. 12) is built around it, creating an iconic image for the opening text, "In the beginning was the Word," and picturing the fundamental harmony between the world and the Word.[28]

The frescoes in the crypt at Anagni deploy other scientific elements to present something of the same argument: the zodiac, microcosm, and syzygy, as well as portraits of Hippocrates and Galen discussing the origin of the world.[29] Drawn from diagrams found in manuscripts of Boethius, Bede, and other natural philosophers, the syzygy asserts the fundamental agreement between the elements, seasons, humors, and ages of humankind. Similar schemata appear throughout the Middle Ages to correlate theological concepts;[30] they structure complicated thematic correlations in the Uta Codex and *Hortus Deliciarum*.[31] A miniature in Honorius of Autun's *Clauis physicae* (Paris, Bib. Nat. MS. lat. 6734) presents a Platonic understanding of the relationship between primal causes and the world of matter, as passed down through Eriugena's *Periphyseon*.[32] Cosmological schemata were orchestrated on the ceiling and floors of certain Templar churches.[33]

Maps of the world resulted from a similar synthesizing process. Derived to some extent from antique sources, they were adapted to Christian theology and empirical observations.[34] Inscribed on vellum and suspended for viewing or painted on walls and other surfaces, maps symbolized power as much as they served actual practice; a *mappa mundi* was included in Henry III's painted chamber at Westminster, for instance, perhaps as a reminder of the ephemeral nature of worldly power.[35] From the

Figure 39. Fresco, Santa-Maria-Immacolata, Ceri (early 12th cent.)

twelfth century on, moreover, maps were painted in naves as part of the spiritual pilgrimage enacted in churches.[36] Thirteenth-century maps such as those in Hereford cathedral and Ebstorf cloister,[37] with their circular forms and structures with Christ at the top and Jerusalem at the center, recall nothing so much as the Vatican Last Judgment panel (Fig. 13); the world with its riches was, from an early time, understood as an interim place before death and loss. Thus, the ninth-century monk Micon described a map as "an image of the world destined to perish."[38]

Contempt for the world, at least for the world of human works, is evident in much early medieval art. Like the kitchen scene at Ceri, the depiction of a woman offering a pig's head and feet to Saint Blasius at Berzé-la-Ville (Fig. 39) not only represents carnality but, engaging local customs, also sets up a contrast between flesh and spirit intended to lead contemplation heavenward.[39] At Saint-Denis (Plate 2), the Israelites banquet while Moses is on Sinai, evidence like the pictured golden calf of their alleged preoccupation with material things.[40] Food is also a theme at Moissac (Fig. 32), where the avaricious rich man and his wife are shown banqueting, in contrast to the emaciated Lazarus who is shown being eaten by dogs.[41] Monks, of course, fasted and in general controlled consumption, but that was a constant struggle.[42] Eating was not the only sensual pleasure presented as the antithesis of spiritual virtue. An early twelfth-century Psalter from Reims (Cambridge, Saint John College, Ms. B 18, fol. 1) is preceded by a miniature that contrasts profane and sacred music;[43] David, the "Beatus Vir" of Psalm 1, composing the Psalms with musicians is opposed to a bear-like man playing a tambourine as jongleurs dance and turn somersaults. The miniature recalls Bernard Clairvaux's judgment of minstrel theater as an excitement of sensual pleasures and an inversion of monastic values, which direct attention upward.[44] The *Beatus Vir* page in the thirteenth-century Luttrell Psalter (London, Brit. Lib. Add. Ms. 42130, fol. 13r) makes the same contrast, albeit more discreetly, by picturing a man with a bagpipe in the margin across from David playing the harp.[45]

No sensual temptation was of greater concern to Christianity than sex, and art engaged that as well.[46] Representations of dancing suggested either spiritual harmony or lust.[47] In the Egerton Genesis, the sodomites are pictured in activities so offensive to a later viewer that the genitals

were erased.[48] At Moissac, chaste conception represented by the Annunciation and Visitation is contrasted across the entranceway by a depiction of *Luxuria* being bitten on the breasts and genitals by reptiles;[49] and in the cloister of St-Michel-de-Cuxa and elsewhere, sirens and other seducers were depicted in a scheme intended to test and hence prove the monks' spiritual love of God.[50] The issue of sexual attraction and aversion underlies the "scientific" depiction in the Florence medical compendium; it is difficult, at least in modern eyes, not to see the young woman's response as a commentary on Mary's virginal conception.

As these works illustrate, secular art played an active role in the competition between sensual attraction and spiritual elevation that underlies much religious art. The familiar and even salacious imagery was understood to have a direct appeal to the faithful, though its purpose was to set sensual temptation in opposition to higher goals. The author of the *Pictor in Carmine* recognized the problem when he railed against "foolish pictures" of grotesques and fables that catch the eyes of the faithful with "a pleasure that is not only vain but even profane," and he recommended that they be replaced by "the panorama of the Old and New Testaments."[51] In many monuments, secular subjects were introduced as a kind of "bait and switch," seducing the eye and then engaging the mind in a process of elevation. That is the case at Ceri, where the kitchen scene is not only set in contrast to the altar, but also is seen in relation to the episodes of temptation directly above. It also applies to a fourteenth-century Book of Hours in Baltimore (Walters Art Museum, MS W. 82, fol. 100), which pictures the Trinity sheltered within the initial of Psalm 109 and lovers and a bathhouse scene that threaten to distract the reader's attentions to the dangerous margins.[52]

As an increasingly positive understanding of the created world emerged during the twelfth century, observed detail came to be integrated into art and ultimately to transform the basic means for channeling viewers' minds to the beyond.[53] At first, artisans turned to classical, Early Christian, and Byzantine models to enhance naturalism; in this they were enabled by the Crusades, with the renewal of contact with the eastern Mediterranean. The mosaics in the atrium of San Marco are typical; building on the rich details of a Late Antique manuscript probably brought from the East during the Fourth Crusade, they interpreted the

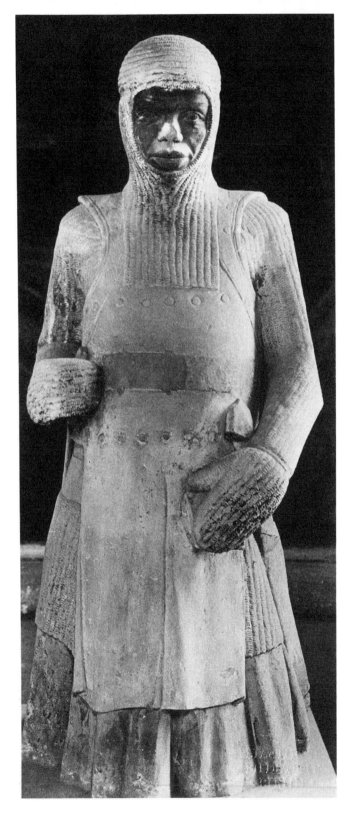

model through classical sources and contemporary concerns.[54] Hugh of Fouilloy still expressed an ambivalence toward mural paintings of Christ's deeds that are "pleasing" but empty of character;[55] for Bernard Silvestris, pictures "are not good but seem so."[56] Ambivalence toward nature is evident in works from the first half of the thirteenth century, such as Villard d'Honnecourt's lion drawn "from life" (Paris, Bib. nat., Ms. fr. 19093, p. 48), constructed from two compass-drawn circles in a ratio of 2:1, thus mapping Platonic idealism onto Aristotlean empiricism and, in turn, demonstrating to the viewer the relationship of reason and experience.[57] Likewise, Matthew Paris's elephant was surely pictured from the animal sent by Louis IX to Henry III (Cambridge, Corpus Christi College, MS. 16, fol. 4), but it is explained in the accompanying text by passages from Scripture, Bernard Silvestris, Virgil, Horace, and the bestiary.[58] To a certain degree, the recently discovered paintings in the Gothic hall at SS. Quattro Coronati in Rome, also of the same period, merely elaborate pictorially the scientific diagrams found at Anagni. In part the work of the same painters, they elaborate the themes of harmony between cosmic order and nature;[59] thus, May is personified by a young aristocrat riding through the countryside where two young men are harvesting olives. The thirteenth-century Roman paintings apparently lack the social implications of later depictions of the months.[60] Naturalism was still marginalized in the apse mosaic of Santa-Maria-Maggiore (Plate 1), with its grand theological theme and complex skein of theological sources: birds and animals, some derived from ancient sources and others from direct observation, are still relegated to the ornament, the peacocks symbolizing Paradise and the eagle killing a snake at the right teaching a moral lesson.[61]

During the course of the thirteenth century, realistic details applied to the rendering of sacred narrative attracted attention to the story and served to connect it to contemporary life. In the Morgan Library picture bible (Fig. 24), for instance, Crusader armor and machines of war such as the catapult envision the Israelite wars reported in the Book of Kings in terms of the contemporary ambitions to capture the Holy Land.[62] Likewise, the statue of Saint Maurice in the cathedral of Magdeburg from about the same period (Fig. 40) describes every detail of the chain mail and military apron to identify the third-century martyr as a living knight.

Figure 40. Statue of Saint Maurice, cathedral at Magdeburg (13th cent.)

Based probably on an African man in Frederick II's entourage, it honors the Early Christian leader of the legion from the Upper Nile in a way entirely different from that of the mid-seventh-century box of Teudéric in the abbey of Saint-Maurice d'Agaune.[63] According to legend, Maurice had inherited the lance that the Roman soldier Longinus had used to puncture Christ's side and, with his men, was massacred when he refused to sacrifice to the pagan gods.[64] Originally holding a lance in its right hand, the statue of the patron saint of Magdeburg thus connected a relic of Christ's Passion venerated in Germany to living soldiers in Christianity's struggle. Gold highlights on Maurice's chain mail and, most likely, the original setting elevated the statue and delicately muted the feeling of imposing presence.

Embodying the ideal of disciplined service to God, the knight came to personify victory in the struggle against earthly temptation. Thus, the Dijon *Moralia in Job* concludes with a picture of the *miles Dei* in full control of his person, both mind and body, moving through the world;[65] and the preacher's compendium (Fig. 29) interprets in the same way the fundamental teaching of the Book of Job that "The life of man on earth is a battle" (7.1) by condensing all Christian virtue in the armed knight astride his horse confronting monstrous creatures which represent human vices.[66]

Ultimately, the rediscovery of Aristotle through contact with Byzantium and Islam during the period resulted in steady, though complex acceptance of the real world, which to a certain extent was already underway.[67] Michael Scot, who translated the *Libri naturales*, for instance, influenced the empiricism evident in the works of Frederick II;[68] drawing on Aristotle, Thomas Aquinas argued that nature was God's masterpiece.[69] The impact of the new optics introduced by Alhazen and Witelo can be observed first in the treatment of sculpture and architecture; divine creations were spared the deforming aspect of illusionism until the true revolution of art intuited already in the Sancta Sanctorum in Rome and realized at Assisi, in which three-dimensional space, light, and the rendering of particular objects were integrated.[70]

In the early fourteenth century, Ugo Panziero argued that the image of Christ "outlined and shadowed" seemed fully incarnate in the mind of the faithful;[71] and a Yorkshire chronicle reports that a little later the abbot

of Meaux fashioned the crucified Christ on the altar after a naked man and that it attracted the devotion of women especially.[72] Steadily, art was being aligned with the growing somatic character of religion.[73] Therein lay a danger, of course, namely that the realism of object/images would satisfy sensual needs rather than subvert and transcend them; art's very success could engender idolatry.[74] Indeed, in 1337 the Pavian priest Opicino de Canistris likened the worldliness of his fellow Christians to idolatry, though he understood art in the traditional way as a physical means to draw the faithful up toward the invisible.[75]

The new naturalism was driven primarily by two factors, both peripheral to the established Church: the growing importance of mendicant orders and the continued shift of patronage to secular courts. Vernacular preaching transformed the audience for art;[76] both Franciscans and Dominicans advanced the image cult.[77] Even more important, the mendicants promoted a new form of art. Panziera was a Franciscan, and the two great English scientists Robert Grosseteste and John Peckham were both influential in Franciscan circles. It is not surprising, then, that some of the most consequential steps toward naturalism, such as the Santa-Maria-Maggiore apse and the frescoes in San Francesco at Assisi (Fig. 36), were taken on Franciscan ground.[78]

Assimilating folklore and oral traditions, medieval secular texts were written down and illustrated. A fragment of Wolfram von Eschenbach's *Willehalm* in Munich (Bayer. Staatsbibliothek, Cgm 193, III), for instance, uses formulae found also in the contemporary Cantigas to suggest the essentially performative aspect of the epic; Wolfram is the pivotal figure in the sequence of "acts" and is indexed to the accompanying text to establish continuity between the gesturing figures and lines of poetry.[79] Because of the complicated relationship between the secular texts and the oral traditions from which they were drawn, depictions were themselves often an interpretive retelling.[80] Richard of Fournival's late-thirteenth-century *Bestiaire d'amour* asserts at the beginning that text and pictures are of equal effect; indeed, they are both materializations of the oral tradition the author is writing down.[81] An early fourteenth-century tapestry in Wienhausen (monastery) tracks the Tristan story in three registers, each with its own theme and pictorial rhetoric, and interlards the narrative with words and rows of coats of arms.[82] Of course, numerous connections

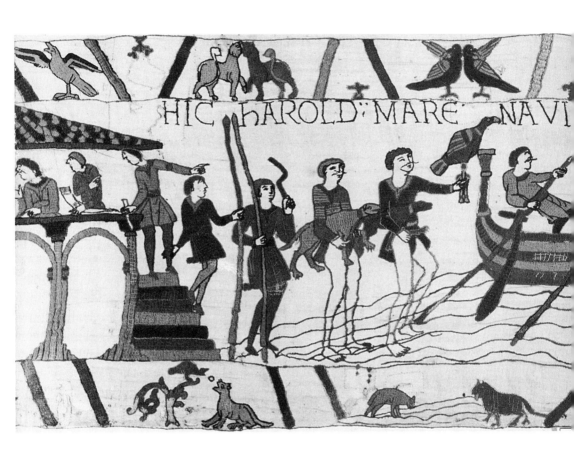

Figure 41. Scene from tapestry, Bayeux (late 11th cent.)

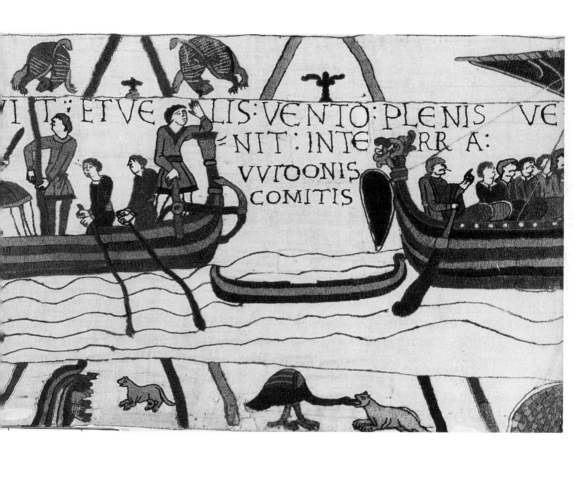

…IT ETVE…LIS : VENTO : PLENIS VE…NIT : INTE…RR A : VVIDONIS COMITIS

are made with religious themes in these too. The *Song of Roland* was illus-
trated in a pilgrim's guide because in it, Charlemagne and Turpin are
figured as Christian warriors.[83] Manuscripts of the *Roman de la Rose*, a
text that incorporates numerous references to art, were frequently illus-
trated with pictures that gloss the allegorical poetry as a commentary on
sacred and erotic love.[84] Two early fourteenth-century compendia of love
songs were also illustrated, adapting traditional elements to the highly
original pictures (Heidelberg, Universitätsbibliothek, Cpg 848 and
Stuttgart, Württembergische Landesbibliothek, Cod. HB XIII 1).[85]

Courts had long promoted an interest in antiquity and science; anti-
quarian interests during the Carolingian period transformed all of the
arts[86] and Ottonian ties with Byzantium led to a resurgence of luxury
art.[87] They also promoted new translations of natural history from Arabic
sources; Alfonso X, for instance, had compilations of Arabic astronomy
(and astrology) translated into Galician-Portuguese.

Courts sponsored the depicting of actual historical events as well.
Though carefully constructed within artistic conventions and literary
genres, including the classical triumphal columns, the Bible, and epic
poetry, the Bayeux Tapestry (Fig. 41), made shortly after the Norman
Conquest of England (1066), derives veracity from the rich incorporation
of details from real life and the matter-of-fact Latin tituli.[88] Accom-
panying the caption near the beginning of the pictured epic, "Here
Harold sailed the sea, and with the wind full in his sails, he came to the
land of Count Guy," a man is shown summoning Harold and his men
from a banquet; they then descend the steps of the manor house at
Bosham and, with trousers rolled up, wade to the craft carrying oars,
dogs, and a hawk. To cross the Channel, the Viking-style ship is driven by
man power as well as wind; and, as the French coast comes into sight, a
sailor at the prow is ready to cast the anchor. In contrast to the essentially
non-temporal structure of typology that governed much religious art,
moreover, the event is presented in a linear fashion.[89] Illustrations from
Aesop's fables in the lower margin—a fox tricking the crane to drop a
piece of cheese, a dog unwilling to leave her den after her litter is grown,
and a crane removing a bone from a wolf's mouth—provide an ironic,
perhaps even subversive commentary on the military encounter.[90] War
provoked the production of histories; Crusader illuminators produced

numerous copies of William of Tyre's *Historia* and of the *Histoire universelle*.[91] Matthew Paris continued the tradition of historical art in his densely illustrated Chronicles, which picture gems and seals, maps and itineraries, genealogies, relics and elephants, and numerous events, both ancient and contemporary. Although he was a Benedictine monk of Saint-Alban's and his *Chronica majora* is a monastic history, his work was encouraged by Henry III and is full of secular material. As the author himself informs us, the illustrations were directed so that "what the ear hears the eyes may see."[92] The historical attitude also transformed hagiography in Matthew Paris's *Passions of Alban and Amphibalus* (Dublin, Trinity College Library, MS 177) designed to move its courtly audience.[93]

Palaces were adorned with frescoes, tapestries, and other luxury arts. Paintings in Rodenegg castle near Brixen (Fig. 54), apparently dating to the 1220s, offer the earliest surviving example of purely profane art within a secular building.[94] Elucidated with Bavarian tituli, they recount the legend of Iwein known from Chrétien de Troyes's redaction and also transmitted orally throughout the period. Drawing on conventions long used in religious narrative art, the paintings structure and interpret the story of heroism; the scene of Lady Laudine grieving over Ascalon's body, for instance, was patterned after a Lamentation of Christ, providing a visual commentary on chivalric adventure.[95] Quite the opposite effect underlay Charles V's figurine of a fox in Franciscan garb holding up pearls representing the Eucharistic host[96] and late-thirteenth-century paintings in the Communal Palace at San-Gimignano[97] depicting hawking, hunting, and jousting, as well as a love tryst that culminates in a depiction of the couple bathing together. The one mocks religion for the amusement of an aristocrat; the other represents the good life that a properly governed commune affords, including sensual pleasures.

Sexual foibles that led Aristotle and the prodigal son astray are also represented in San Gimignano; and these and other examples of the power of love appear on secular ivories produced in fourteenth-century Paris as well; although made by the same carvers that produced similar precious objects used for intense religious devotion, the ivories were intended to provide aristocratic amusement by spoofing heroic literature.[98] Probably part of a trousseau, an ivory box in the Walters Art Museum in Baltimore, for instance, inverts the language of heroic

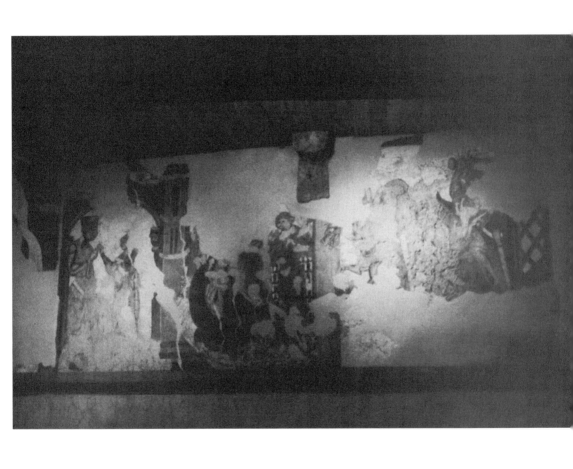

depictions of classical culture and Scripture as found in the Morgan Library picture Bible to tease the owner about romantic love.[99] The lid is a "triptych" centered on the Attack on the Castle of Love, an allegory of courting, flanked by the women surrendering to the knights and a mock joust in which women, bearing roses rather than lances, tilt with men. Fun continues on the other sides, on the front, for instance, where Alexander the Great is shown advising Aristotle to stay with his intellectual work and not chase women and then looking out as his resident tutor is made a fool by Phyllis who rides him like a horse;[100] and, continuing the theme of inversion, old men are shown on pilgrimage to the fountain of youth where they are miraculously rejuvenated. Derived ultimately from troubadour performance, these and the other stories assembled on the Walters casket had been written down in Romance literature of the twelfth and thirteenth centuries and would have been well known to the aristocratic owners of such objects. The erotic references would surely have been recognized in the profusion of lances, openings, and penetration—in the scene of the unicorn hunt, for instance, where the hunter pierces the mythological beast caught in the virgin's lap;[101] such themes were common in illustrations of the *Roman de la Rose* and were barely disguised in contemporary theater.[102] In these works, religion and valor are mocked and physical love, games, and youth promoted.

Real life was nowhere more evident in medieval art than in representations of the dead.[103] Directly below the scene of the banquet at Moissac, the rich man is shown dying; as his wife grieves beside his bed, devils fight for his soul.[104] To the left, he is pictured again suffering the torments of Hell to make the essential Christian point about a sinful life: its rewards are eternal damnation. By contrast, the death of Gonsalves Garcia Gudiel represented on his tomb monument (1299) in Santa-Maria-Maggiore (Fig. 6) is tranquil and full of hope.[105] The sculpted portrait of a counselor of King Alfonso X atop the sarcophagus that holds his mortal remains contrasts the permanence of the cardinal's holy station to the impermanence of his person; Gonsalves is clothed in the mitre, vestments, and episcopal gloves of his office.[106] No mortal mourns his death but angels instead, who draw the curtain over his human existence; Gonsalves is pictured above gathering the rewards of a good life ushered in by the saints to the presence of the Queen of Heaven. Relics of both

Figure 42. Frescoes, palace, Rodenegg (13th cent.)

Matthew and Jerome are preserved in the church and the figures hold inscriptions referring to this fact: "The high altar contains me" and "I rest next to the grotto of the crib"; thus, Gonsalves is well positioned to rise to the Heavenly Jerusalem at the final judgment. The connection is made even more real by the sculpture itself. Gonsalves' body is tilted up and his head turned so that he can "look" up toward the great apse (Plate 1) with its view of Heaven; in this, it realizes William Durandus's advice that a man should lie on his back in his deathbed so that his face is turned to heaven.[107]

Conventionality connects the figure of Gonsalves with others of his office such as William Durandus himself, as depicted in his tomb in Santa-Maria-sopra-Minerva in Rome;[108] in this, it is like the representations of Benedicta and Constanza on the Vatican Last Judgment or Alfonso X in the Cantigas (Figs. 13, 3). Throughout much of the Middle Ages, by far the most common venue of individual portraiture was the seal in which the depiction of the person is generic, linking him (or occasionally her) to the group, and the name and title are written out; it sometimes literally prolonged the body by including imprints of fingers or teeth and it was referred to as "imago noster," but it did not depict particular features.[109] Seals were closely related to another form of representation of the individual person, namely the coat-of-arms, which had begun during the thirteenth century to mark a person's identity;[110] in the Morgan Library picture bible, for instance, helmets obscure the fighters' faces altogether and emblazoned shields identify the combatants. Coats-of-arms prominently displayed on the platform and summit of the tomb incorporate the cardinal into his familiar group and, through it, to his earthly goods. At the same time, the square jaw, deep creases in the cheeks, and aquiline nose betray personal characteristics that suggest Gonsalves's actual appearance, the signs of true portraiture that emerged during the following century.[111] Portraiture had long been associated with death and absence; it was the visible proof of the unseeable dead person.[112]

Chapter 7: Performance

TO A GREAT extent, medieval art operated in phenomenal reality. It was used for instruction and preaching, served devotional practices, contributed to the physical and emotional spectacles enacted in the church liturgy and court ceremonies, participated in civic processions, and was a goal and attestation of pilgrimage. Often in motion or apprehended in changing environments, works of art were contingent on these performative contexts and were constantly reformed by them.[1] The miniature in the *Très riches heures* (Plate 7) captures something of art's environment, albeit from the end of the Middle Ages. It pictures the Sainte-Chapelle alive with singing and organ music, with people entering through a door adorned with figures, worshipers kneeling in humility within a space filled with ornament, effigies, and narrative, members of the faithful reading books (apparently adorned with pictures), or praying privately in the royal box, and clergy in brilliant vestments celebrating the Mass at the altar fitted with the elaborate Grande Chasse. Here private prayer and sacred ceremony, music and silence, and audiences of all three social classes are brought together in a charged world served and constructed by art.

Throughout the period, art was recognized as a pagan invention particularly well-suited to the conversion and education of illiterates and laity. Legends developed that attributed its acceptance in the church to Constantine, the originary convert, whose acceptance of Christianity

began with a vision of the (aniconic) cross and was confirmed in a dream-vision by icons of Peter and Paul brought to him by a Pope.[2] Art remained an important missionary and pedagogical tool throughout the period. Already in the late fourth century, Paulinus of Nola expressed the hope that someone capable of reading the captions accompanying the paintings would explain the depictions to the illiterate pilgrims in his church of Saint-Felix in Nola.[3] From the eleventh century, pulpits in southern Italy were adorned with depictions of prophets reinforcing Quodvultdeus's sermon *Contra Iudaeos, Paganos et Arrianos* preached every Christmas.[4] A vernacular sermon delivered at Amiens in the middle of the thirteenth century offers insight into how the complex theological constructs of the cathedral façade there would have been made accessible to the largely illiterate faithful by a clerical interlocutor (Fig. 34).[5] Preaching, and preaching techniques, also had an effect on the organization of art.[6]

As Paulinus of Nola had recognized and Gregory the Great set down in Church doctrine, art could teach in a dialogical process; and throughout the period, spoken words interacted with mute pictures.[7] The Cantigas illustrates this vividly, portraying King Alfonso in numerous miniatures pointing to the pictured stories and, in so doing, incorporating the explanatory voice of the text he composed.[8] Art was also used for instructing monastics. In the *Speculum Virginum*, for instance, schemata and figures explain the dialogue between "Peregrinus" (Conrad of Hirsau) and his student Theodora (and hence all readers of that widely read text).[9] The *Mystic Ark* includes a diagram perhaps copied from a mural painting at Saint-Victor that Hugh had used to lecture his students and that now was made available to other readers;[10] and Adam the Premonstratensian's *De tripartito tabernaculo* is organized around a diagram of Moses's tabernacle so that the monks of his abbey could construct a harmony between "what they read in the book and saw in the picture."[11] A late-thirteenth-century treatise for instruction of Dominican novices deploys illustrations to teach the ways the Christian soul can aspire spiritually, incorporating an original variant of the diagram from *De sex alis cherubim* (London, Brit. Lib. Arundel Ms. 83, fol. 5v),[12] a popular scheme in which each feather of the cherubim leads to the next, progressing toward God.

Art also served private devotion. Paulinus of Nola described a cross that "imparted immediate faith to the eyes that gaze closely upon it"; and for Suger, alone in his church, the precious materials and abstract signs helped him to banish worldly images from the mind and hence to direct his mind toward higher things.[13] Gregory the Great himself had imagined that art, though not to be venerated, could elicit compunction in illiterate viewers; by the ninth century, at least, figural representations were also used as instruments of meditation by educated believers. The (presumably) mid-century *Sermo de vita et morte gloriosae virginis Maurae*, by Prudentius of Troyes, reports that the young lay woman (saint) Maur prayed to images in the cathedral, including, it would seem, the Christ in Majesty in the apse, when she was by herself.[14] In this case, and surely in many others, pictures and sculptures made to adorn the walls of churches also became the focus of devotion. This would certainly have been true of the scenes on the barrier wall in Vicq (Plate 11), which include the three themes Prudentius mentions: Christ in his mother's lap, the crucifixion, and Christ in Majesty. The first, within the Adoration of the Magi, appears in a subject explicitly involving veneration; the second, as a deposition, invites the viewer's imagined assistance in lowering Christ's body; and the third, at the highest point on the wall, requires viewers to raise their heads and lift their eyes heavenward. At Ceri, the Martyrdom of Saint Andrew (Plate 8) not only confronts the faithful directly at eye level with a powerful depiction of suffering, but its caption also suggests that those looking at the picture should interact with the depiction: "Hanging, he lived for two days and taught the people."[15] Indeed, the *Acta Andreae Apostoli* on which the scene is based reports that Andrew had continued to preach and make converts even after he was hanged on the cross and that he expressed dismay because his words had still "not persuaded our own to flee from the love of earthly things!" Two converts pictured at the right cue the viewers' response; holding an ointment jar, a woman looks downward toward the body of the apostle she loved on earth, while a man beside her gazes toward the heavenly light descending on Andrew. The spiritual transformation pictured in the fresco was intended to transport the devout who looked at it and prayed to the Apostle's picture. In like fashion at San-Clemente, the saint's clipeate portrait is the object of devotion (Plate 9); the family that commissioned the

painting of the miracle of the saint's tomb is pictured in adoration bearing candles and gifts of wax, and an inscription records that Beno de Rapiza had had it painted "for the love of Clement and the redemption of the soul."[16] The painting establishes thereby a perpetual devotion at the tomb below, presumably of a member of the family, buried near Clement's grave. On the Vatican Last Judgment (Fig. 13), the very presentation by the two women is part of the devotional act; in late medieval nunneries, the making of art was considered a sanctified exercise.[17]

While any work of art could serve the purpose, dedicated devotional images gained currency particularly during the twelfth and thirteenth centuries,[18] some emerging from Byzantine icons, others from an association with relics. These focused above all on themes that evoked compassion, most notably on the tender Virgin with her child and the sorrowful Crucifixion, two subjects that confirmed the Incarnation. The Florence Madonna and Child (Fig. 23), for instance, uses varying degrees of tangibility, culminating in the almost three-dimensional heads, to evoke and guide the devotions of the contemplators;[19] and the *Omne Bonum* includes the *arma Christi*, crucifixion, and Man of Sorrows in a grid of thirty-nine rectangles accompanied by a prayer promising that "whoever recites in the presence of the arms of Christ the Pater Noster and the Ave Maria, and as often as he does so, shall be pardoned of 20,000 years of punishment in purgatory."[20]

The development of the personal prayer book replete with devotional images was the culmination of the trend.[21] Thus, an overtly Byzantine "diptych" was copied into the Winchester Psalter (London, Brit. Lib. MS Cotton Nero C.IV, fols. 29v–30r) to put the intercessor directly before the eyes of the viewer;[22] and in the Hours of Yolande of Soissons (Fig. 17), various written devotions are directed toward the Holy Face across the opening.[23] In the so-called Hours of Marguerite of Beaujeu (Fig. 31), the owner is shown being able through her prayers to imagine the magi adoring Christ, sheltered literally within the letter **D** that opens the office and framed by the heavenly city, the entrance to which is her aspiration. In the manuscript of *La sainte abbaye* illuminated in Maubisson ca. 1300 (London, British Library, Add. Ms. 39843, fol. 28r), a devout woman is pictured in one scene praying before the representation of a depiction of the Coronation of the Virgin, which is presented as the counterpart to

priestly absolution pictured in another and as the prelude to receiving the Sacraments and to seeing, in the mind's eye, the Throne of Grace atop a gemmed altar in the other two.[24] Gothic ivories served the same devotional practices in unique ways, their intimate scale, delicate carving, and luminous materials supporting the meditation on Christ's life.[25] By the fourteenth century, the Crucifixion was fused with the Madonna and Child in the devotional image par excellence, the pietà,[26] and it was deconstructed in the so-called "Man of Sorrows" or the "arma Christi."[27] Such images provoked compassion in the viewers first by appealing to Christ's human nature and then by evoking in their minds the full narrative context.[28] For all its particularity, the opening in the Rothschild Canticles reflects the general current around the turn of the fourteenth century.[29] Inserted within a commentary on the *Song of Songs*, itself understood as a parable of how to join the Lord through love,[30] the depiction invites the user of the book to follow the gaze of the "sponsa" toward a depiction of the naked and wounded Christ and, contemplating the cross, column, crown of thorns, and whip, to meditate on the Incarnation in a structured series of steps toward a transcendental experience.

Related to the development of devotional images was a long textual tradition that images came alive during veneration with its suggestion that, through prayer, a person could move from material images to direct communication with the divine.[31] The tradition was elaborated and embellished from the eleventh century on; for instance, in his *Dialogue on Miracles*, Arnaud of Clermont described a vision of Mary that the abbot Robert de Mozat had had in a dream and then made a statue based on what he had seen.[32] Caesarius of Heisterbach reported several instances in which devotional images worked miracles, granted expiation, and prevented sin.[33] A miniature in the mid-thirteenth-century Amesbury Psalter (Oxford, All Souls College, MS 6) pictures a nun at prayer before the open book, looking up at an enormous Christ in Majesty that makes visible her mental vision,[34] in a sense reversing the course of meditation tracked in the Lucca portrait of Hildegard of Bingen (Fig. 15). The rapidly evolving hagiography of Saint Francis incorporated a miraculous image that spoke to the young man as he prayed in the church of San-Damiano and effected a conversion of purpose (Fig. 36) and also refashioned the legend of the stigmata to incorporate the form of the

crucifix.[35] A sermon preached on the feast of Saint Francis in 1265 assured the faithful that the homage paid to a painted portrait is equivalent to veneration of the saint himself.[36] In turn, the direct dialogue that the painted Crucifix allowed with God and its impression on the devotees were elaborated by such later mystics as Angela of Foligno.

The other side of such intense emotional responses was the feeling that devotion before physical depictions had to be prescribed. Gestures were subjected to ecclesiastical control. A treatise recently attributed to Peter the Chanter (ca. 1220), for instance, distinguishes seven gestures of prayer, each justified by the Bible or a Church father, designed to express the humility and emotional response of a devout lay person;[37] a similar handbook, written by a Dominican brother between 1280 and 1288 describes, documents, and illustrates nine positions.[38] The spiritual progression in the *La sainte abbaye* manuscript is traced, in part, through changes in the woman's gestures,[39] and the idea is integrated into the several forms of veneration figured in the miniature, initial, and margins of the *Très riches heures* Sainte-Chapelle page.

Material images associated with altars and other liturgical furniture derived sanctity from formal liturgy and, in turn, contributed to it: the crosses, sacramental vessels (Plate 5), reliquaries (Figs. 2, 6, 18, 23), altars (Figs. 13, 19, 20), combs, fans, pulpits, candlesticks, service books (Figs. 5, 11), chancel barriers, curtains (Plate 12), vestments, and other liturgical furnishings. Like the miniature in the *Très riches heures*, the picture in the Vatican *Exultet Roll* (Fig. 30) pictures the interplay between decorated furnishings and the liturgy they served; the rotulus is draped over the pulpit so that the congregation could follow in pictures what the Easter Mass played out in words,[40] and the paschal candlestick is ornamented to recall the Tree of Life symbolizing Christ's resurrection.[41] Materials were chosen to support practice. During the Carolingian period, ivory seems to have been reserved exclusively for the altar; and, as Suger attests, precious metals and gems clustered near the altar effected a mental transition to its celestial archetype.

Liturgical practice, in turn, effected the development of iconographies. "Speaking reliquaries," such as those in Osnabrück (Fig. 2), acquired their form not from their contents but from their function in the Mass; at Essen, for instance, the arm reliquary of Saint Blaise was taken from the

altar and used to transmit God's power when the priest pronounced the final benediction.[42] The late sixth-century Ashburnham Pentateuch (Paris, Bib. nat., MS nouv. acq. lat. 2334) infuses Old Testament events with Christian liturgical details;[43] and the Daniel page in the Cîteaux compendium (Fig. 9) is fashioned as an allegory of the Mass. The prophet gestures as a priest does at an altar (cf. Plate 7); Habbakuk is posed as a deacon; and the crosses in the border conjure up the repeated references to Christ's sacrifice in the liturgy.[44]

Just as the liturgy itself was not limited to words and gestures, however, art was not connected to it only as an instrument of elevation; churches and their furnishings also helped to order the celebrations in place and time.[45] The pictured Mass of Saint Clement, for instance, is positioned close to the apse in San-Clemente.[46] In Saint-Peter's, processions during the Feast of the Exaltation of the Cross followed painted narratives in the nave from the apse to the altar of Simon and Jude beneath the crucifixion; lighted by rows of chandeliers, these created a movement from the sacred to the terrestrial realm. Developing the Roman practice, the enlarged crucifixion in the series of New Testament scenes on the right wall of the Collegiata at San-Gimignano was fitted with a curtain to transform it into an altarpiece for an altar directly below.[47]

In turn, the activities enacted near images affected how the subjects were interpreted. Because of the placement of his tomb near the relics of the saints (alluded to in the mosaic, Plate 1, and Fig. 6), Gonsalves would participate in every liturgy in Santa-Maria-Maggiore and would benefit from the prayers said to Matthew and Jerome (pictured leading him before the Virgin and Child in heaven). Eleventh-century paintings of Christ charging Peter in the chapter house at Vendôme provided an appropriate backdrop for the monastic administration conducted there and reassured resident monks of the privilege of immunity the pope had granted them; but on Maundy Thursday, when the vespers service was performed in the same place, the Supper at Emmaus would have become a type of the Sacraments.[48] Moreover, when changes in liturgy took place, art was adjusted; although the direct impact of the Lateran Council on the development of the retable may have been exaggerated,[49] changes in use did result in the steady development of the altarpiece, as when Charles the Bald's antependium was refashioned at Saint-Denis.[50]

Continuous reconfiguration of secondary liturgical spaces resulted in other transformations, even on occasion the removal, transfer, and modification of stained-glass windows.[51]

First and foremost, art served the Mass, the memorial of Christ's sorrow, death, and resurrection which unites the Christian community with God and which, in a celebration involving all of the senses, provides a glimpse of the Heavenly Jerusalem.[52] Responding to the *sursum corda* beneath triumphal arches on which the *canticum novum* was pictured, the congregation participating in the Mass would have experienced the unity of earthly and heavenly liturgies;[53] likewise, the congregation in Santa-Prassede singing the hymn *Urbs beata Hierusalem* would actually be seeing the "vision of peace built in heaven of living stones" (Fig. 1).[54] The All Saints miniature in the Udine Sacramentary (Fig. 26) represents the supposed unification of practice and image perfectly; the community of the faithful gathered together by the terrestrial church is united with the heavenly church of the saints presented to them as a picture.[55] At Vicq (Plate 11), the elevated Christ child in the Presentation and the lowered body of Christ in the deposition, both situated above altars, provided parallels to the raising and lowering of the Eucharist during the Mass.[56] The ciborium in Saint-Paul's-outside-the-walls in Rome engages the liturgy by representing typological subjects such as Adam and Eve eating from the forbidden fruit outside and paradisical motifs within, and by rendering visible the active connection to heaven (pictured also in the *Très riches heures*) with angels bearing censers descending onto the altar. Choir screens served to create the mystery by closing off the Holy of Holies where the priest effected what came to be called transubstantiation while, at the same time, presenting the historical presence in art; looking at the outward image that concealed the mysterious transformation, the faithful could imagine the body of God in the Sacrament they were about to receive.[57] Richly ornamented portable altars carried the system themselves; the one in Agrigento (Plate 3) shelters the requisite relic and alludes simultaneously to Christ's earthly life and death and His presiding presence in heaven.

Words accompanying images also engaged liturgies, for instance, the *SANCTUS, SANCTUS, SANCTUS* inscribed beneath the Majesty at Ferentillo and the *GLORIA IN EXCELSIS* proffered by one of the

angels in the apse at Tuscania.[58] Implicit in this relationship was a conflict or at least a competition, as the Eucharist was deemed to be the only true image of Christ; indeed, the Fourth Lateran Council, which in many ways affected art positively, contrasted the inner reality of the Eucharist to the empty outward appearance of paintings and sculpture.[59] Art's close association with relics, however, also led during the course of the twelfth and thirteenth centuries to a positive relationship with the sacraments,[60] and art was accepted as a way of figuring the mystery in an apprehensible way; Sicard of Cremona, for instance, likened woven curtains to Christ's dual nature.[61] The Veronica was elevated as well by a relationship to the other "vera icona," the Eucharistic species. A late fifteenth-century illustration captures the several aspects of the Veronica best, picturing Pope Sixtus IV displaying the Veronica to pilgrims in Saint-Peter's during the 1475 Jubilee Year; framed by a representation of the Annunciation and sacralized by putti swinging censers, the Holy Face is suspended directly above the altar.[62]

Of course, there were various kinds of liturgies, and art understandably played distinct roles in each of these. Scenes of the finding of the True Cross, the miracle in Beirut, and the legend of Saint Alexander on the thirteenth-century antependium in Siena (Pinacoteca nazionale) provide pictorial counterparts to the lections read during the Feast of the Exaltation of the Cross (September 14).[63] The Passion cycle in the Holy Sepulchre chapel at Winchester served the Holy Week liturgy performed in these spaces when a crucifix or a Eucharistic wafer was deposited in the chapel on Good Friday and returned to the main altar on Easter. In some places, the corpus of Christ himself was removed from the cross on Good Friday and placed in a tomb, its moveable arms lowered to the sides.[64] Likewise, figures of Christ on clouds were raised into the vaulting of some churches on Ascension Day and wooden doves lowered at Pentecost.[65] Words and figures in the apse mosaic of Santa-Maria-Maggiore (Plate 1) engage the church's great feast of the Assumption of the Virgin (August 15); Mary's death is pictured in the center of the narrative cycle between the windows, and a long inscription based on the *Song of Songs* intoned during the feast day service runs beneath the vision of Mary crowned in heaven.[66] Fitted with shutters, many altarpieces remained invisible except when revealed during special feasts.[67]

There were also liturgies of priestly ordinations, consecrations of churches, coronations, and many other rites, all of which involved art. The adornment of the doorway to the crypt of Saint-Peter's (Fig. 25), for instance, reflects the particular ecclesiastical liturgy celebrated in Saint-Peter's on Saint Agnes's day, when the wool-band insignia (pallia) about to be bestowed on new archbishops were consecrated by being kept overnight near the bones of the first bishop of Rome. One side pictures the *Agnus dei* before the entrance to the chamber; the other portrays the pope already wearing the band and twenty-three bishops who will receive theirs when the priestly choir sings the hymn "Agnus dei" and the pope proclaims, "Accept the pallium, taken up from the body of blessed Peter." Pontificals and other types of books used by the clergy for such liturgies were often illuminated.[68] The exceptionally rich illustrations of a manuscript from the time of Louis IX containing the coronation ordo (Paris, Bib. nat. MS. lat. 1246) served to interpret the "sacre royal" and to convey, through its esthetic formalism and color, the balance between ritual and ceremony inherent in the liturgy.[69]

Because the relationship between art and local liturgies depends on precise knowledge of particular ceremonies, it can be reconstructed only in the relatively few cases where art and liturgical documents survive. At Berzé-la-Ville (Fig. 7), the paintings bridged local customs to the official liturgies; the depiction of the woman presenting Saint Blaise with the head and feet of a pig before his own decapitation incorporates popular practices into the official ritual.[70] The function of the cloister as a transitional space at Moissac and the insertion there of important relics appear to have generated a complicated response to liturgical practice in the disposition of sculptures.[71] At Saint-Denis, an inscription in the scene of the Assumption of Saint Benedict clearly refers to the last responsory of the service on the saint's feast, leaving no doubt that the depicted *transitus* envisions the words spoken in the chapel on that day.[72] Likewise, it is certain that the shrine of the three Magi in Cologne (Fig. 18) was carried in procession on the Feast of the Epiphany.[73] Even more complicated is the way in which the Remaclus altar served the liturgy in the Stavelot Abbey (Fig. 19). A missal confirms that hymns sung on the saint's *dies natalis* (September 3) included Jesus Sirach 44:16, which explains why Enoch was portrayed in Paradise; and it helps to makes sense of the selection of

Color Plates

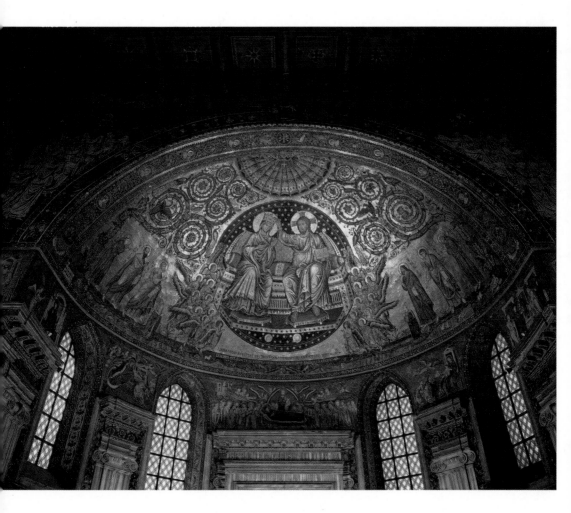

Plate 1. Apse mosaic, Santa-Maria-Maggiore, Rome (late 13th cent.)

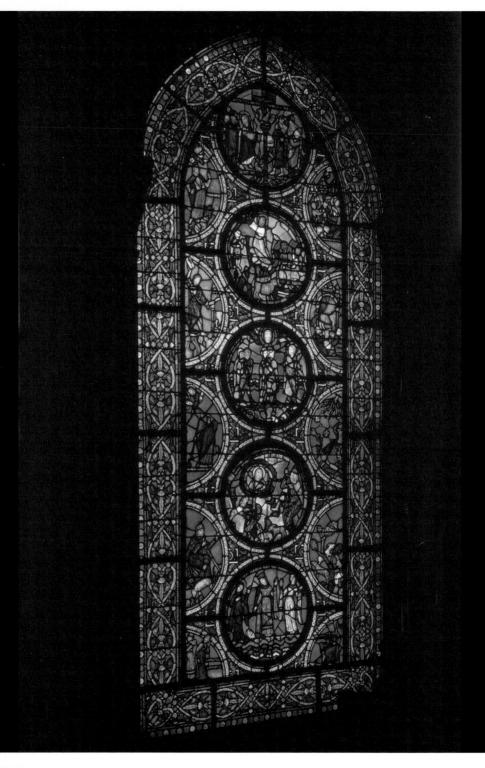

Plate 2. Stained glass, Peregrine Chapel at Saint-Denis (mid 12th cent.)

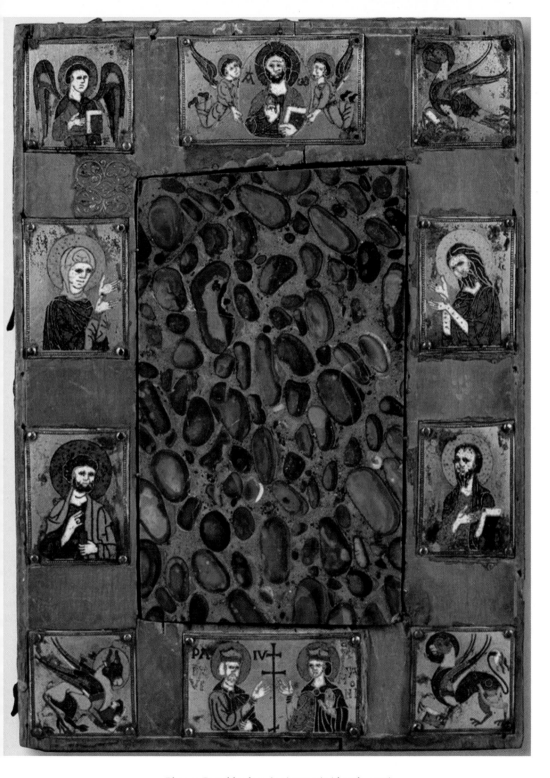

Plate 3. Portable altar, Agrigento (mid 12th cent.)

Plate 4. Illustration, Gospelbook, Darmstadt (11th cent.)

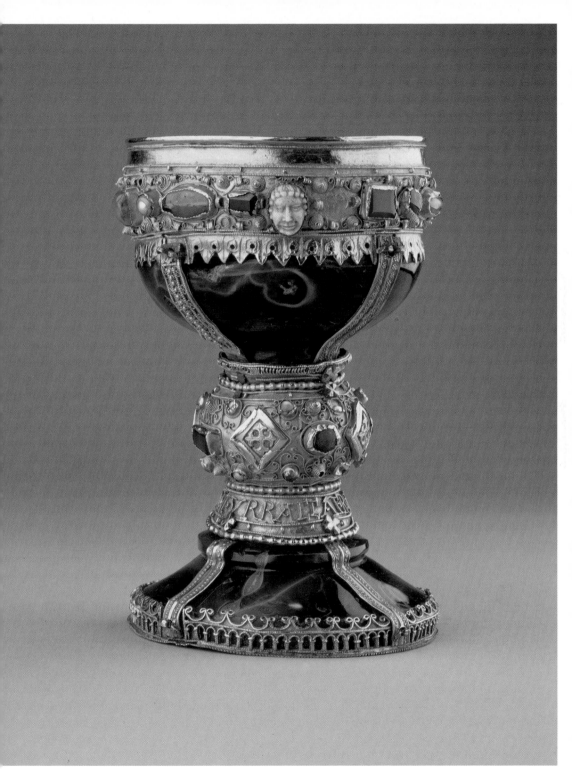

Plate 5. Chalice of Urraca, León (11th cent.)

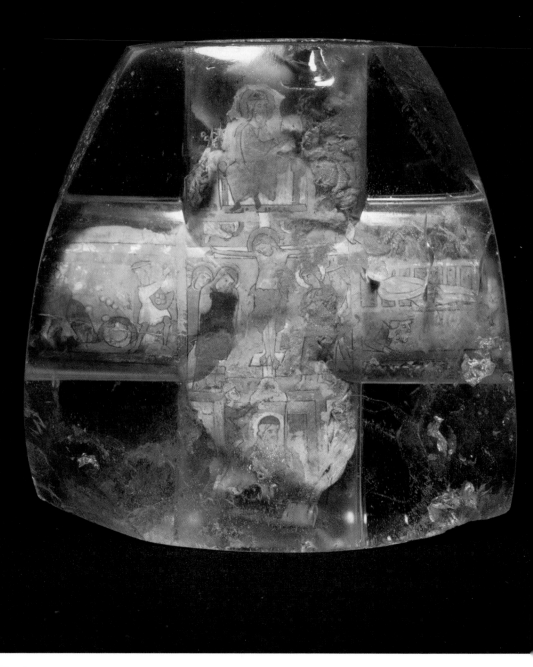

Plate 6. Crucifixion, Copenhagen (2nd quarter of the 13th cent.)

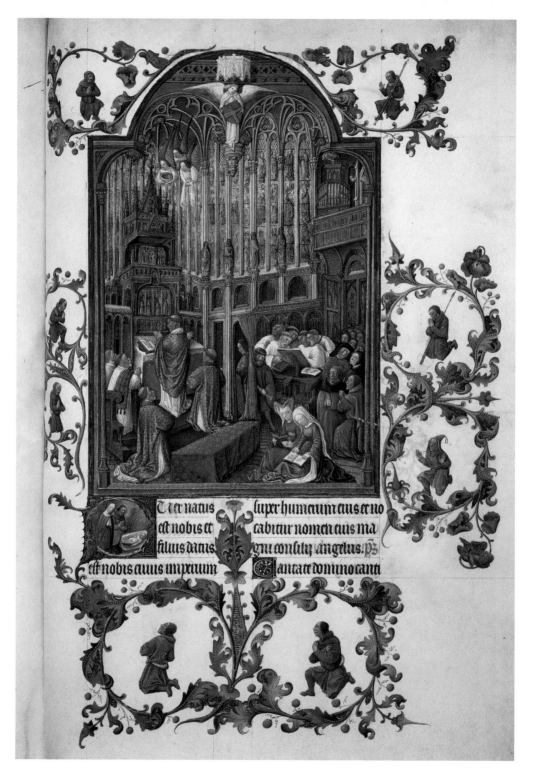

Plate 7. Illustration, *Très riches heures*, Chantilly (ca. 1475)

Plate 8. Frescoes, Santa-Maria-Immacolata, Ceri (early 12th cent.)

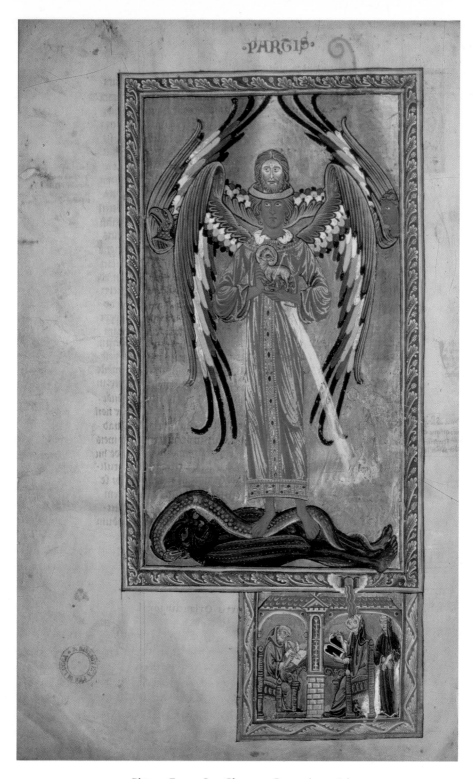

Plate 9. Fresco, San-Clemente, Rome (ca. 1085)

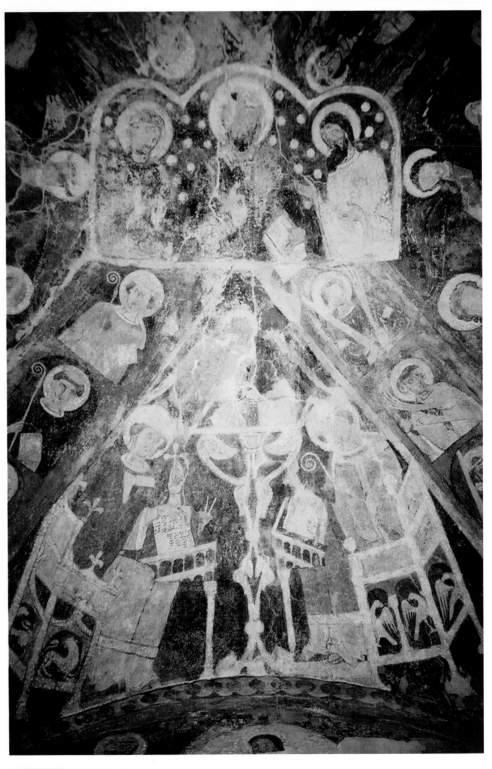

Plate 10. Fresco, Sankt-Johann at Taufers (13th cent.)

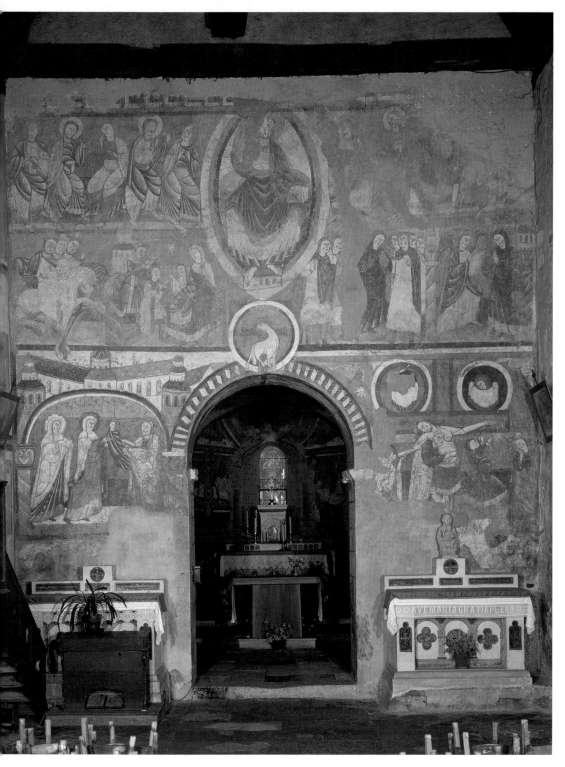

Plate 11. Frescoes, Saint-Martin in Vicq (12th cent.)

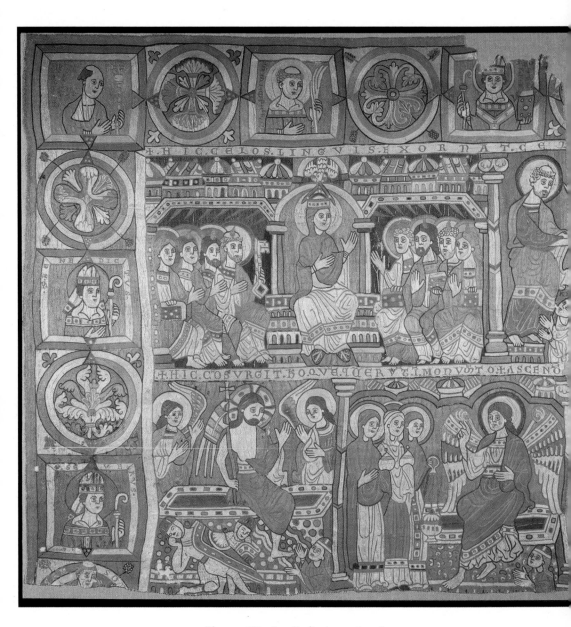

Plate 12. Weaving, Berlin (ca. 1160–70)

other narratives.[74] Nonetheless, here as in other examples, the connection between image and ceremony is not simple; the altarpiece engages the liturgy, but it also constructs its own concept, presenting one message to the laity and another to the clergy.

Paraliturgical rites were also invested with art. The bronze bowls inscribed with virtues and lives of virtuous women, for instance, were used in ceremonies of purification. In Pisa, the confraternity of *flagilanti* conducted rites in the Campo Santo interwoven with the figures in the Triumph of Death.[75] Rubrications in the Song of Songs of the early eleventh-century Saint-Vaast Bible (Arras, Bib. mun., MS 559) indicate that the dialogue between the bride and bridegroom of the Hebrew text and pictured in the miniature served monks in the refectory.[76]

Liturgical drama was also implicated in art.[77] Perhaps originating in the Holy Week ritual, the enactment of the dialogue between the three Marys at Christ's tomb and the angel, beginning "Quem quaeritis," is documented in the mid-tenth century.[78] The Berlin textile (Plate 12) relates to this tradition, since the scene of the Three Marys is inscribed with the litugical text and, appropriately, is observed by a devotee. The chapter house paintings at Vendôme provided a backdrop and field of visual response for the liturgical drama *Peregrinus* enacted there on Holy Thursday;[79] and the depiction of two women in the Adoration of the Magi at Lambach are the midwives who, in a dialogue with the Magi in the Christmas eve play, *Officium stellae*, exalt Mary and Christ.[80] In this case, as in others, artistic representation may itself have fed the development of the liturgical drama; the midwife story was derived from apocryphal texts and had entered illustrations of the Nativity during the Early Christian period. On the other hand, it is difficult to discover whether the well-known *Play of Daniel* had any impact on the historiated initial in the Dijon compendium.[81] By the fourteenth century, pictures themselves participated, not just in the liturgy, but also in these dramatizations.[82]

In urban settings, art was instrumental in civic liturgies. At Chartres, the bishop's entry into the cathedral with a procession singing of the entrance of Christ into the world was elevated to a higher plane by the sculptures on the three portals.[83] In Rome, the assembly of pagan spolia outside the Lateran portico affirmed the pope's temporal authority every time the bishop departed or returned from his palace.[84] On feast days, the

pope celebrated Mass at appropriate stations in the city, which explains
why the Translation of Saint Clement's body in San-Clemente features
a papal entourage bearing a stational cross and banners. The picture
not only authorized the relics inside the church but it also tied the
foundational moment to the annual processions to the church.[85] An
enormous silver gilt cross in the Lateran survives as a witness to the
importance of art in stational liturgy in Rome.[86] Of papal liturgies, none
was more elaborate than the procession of the *Acheropita* (Fig. 8) from
the Lateran to Santa-Maria-Maggiore on the eve of the feast of the
Assumption.[87] When the great icon was paraded through the Arch of
Titus, it re-enacted the triumphal procession with the spoils of the
Jerusalem Temple pictured there in the first-century relief sculpture. It
was enclosed in its own capsa furnished with little doors so that the pope
could wash his feet during one of the stations (Fig. 16), dramatizing the
abrogation of Judaism and the relocation of the cult to Rome and to the
new high priest. Displayed the next day at Santa-Maria-Maggiore along-
side an icon of the Virgin, the *Acheropita* took part in an enactment of
Christ's receiving the Virgin Mary in heaven;[88] and this meeting of icons,
too, is incorporated into the apse mosaic.[89] In turn, from the early
thirteenth century, the ritual came to be imitated at the Vatican where
the Veronica, fitted out with a gold and silver box inlaid with precious
stones, was paraded to the Hospital of Santo Spirito on the Feast of the
Wedding at Cana to symbolize the marriage of the divine and human in
Christ.[90]

In a more rustic version of the Roman enactments, figures of Christ
astride a donkey were led through towns throughout Europe on Palm
Sunday, engaging the entire populace in religious theater involving
artistic props. In the eleventh century, William of Volpiano devised an
elaborate dramatization of Christ's Entry into Jerusalem for a small north
Italian town. A representation of Christ was carried in procession to his
monastery of Fruttuaria and was greeted there with hymns and acclama-
tions, thereby identifying the monastery with the Holy City and merging
the sacred past with the present.[91]

Art attracted pilgrims, especially the adornment of saints' tombs and
processions involving sacred images. In his well-known account of pil-
grimage to Conques, Bernard of Angers describes peasants venerating

the relic-sculpture and healings and punishments effected during proces-
sions in the town.[92] In Spain, saints' tombs were designed during the
twelfth and thirteenth centuries to enable pilgrims suffering from diseases
and defects to crouch beneath, walk around, and touch the sacred burial
places.[93] A seventeenth-century watercolor copy of a fourteenth-century
fresco preserves such use at the tomb of Saint Margherita of Cortona.[94]
The depiction of all kinds of ailments on the tympanum at Vézelay
advertises the effectiveness of pilgrimage to Sainte-Madeleine; and,
indeed, the entire sculptural ensemble can be understood as a pilgrim's
guide.[95] Pilgrims to Rome, Santiago, Canterbury, and other destinations
collected souvenirs of various sites they visited during their travels,
among others, stamped metal badges that they attached to their clothes
and ampullae containing holy oil. Typically, these were decorated with
representations of the saints venerated at the pilgrimage sites, or in the
case of Saint-Peter's, with the Veronica.[96] A particularly fine specimen is
an early-thirteenth-century ampulla picturing Thomas Becket and
inscribed, "Thomas is the best doctor of sick people [who are spiritually]
good."[97] In papal Rome, the tradition culminated in the establishment of
the Jubilee year in 1300, when pilgrims visiting the sacred sites and par-
ticipating in the ceremonies could receive indulgences.[98] In several of the
important churches, art displayed outside served to frame the rituals, for
example, the baldachin-like benedictional loggia constructed by Boniface
VIII in the Lateran campus and adorned with painting designed to estab-
lished his legitimacy.[99]

Art used in secular ceremonies followed similar patterns. The attack
on the castle of love pictured on the Baltimore ivory box was an allegory
of courting actually enacted during festivals. The enormous marriage
document drawn up for the wedding of Otto II and Theophanu
(Wolfenbüttel, Niedersächsischen Staatsarchiv, 6 Urk. 11)[100] used imperial
forms, purple-stained vellum inscribed with gold letters and adorned
with medallions depicting griffins attacking sheep; its frame, like that of
the later cover of the Melisende Psalter (Fig. 11), is decorated with
confronting birds and animals, here interrupted by seven medallions por-
traying Christ, Mary, and saints as seals of the contract. With its Latin
inscriptions and "footnoted" narratives, the Bayeux Tapestry (Fig. 41)
seems to have been a portable history set up in various baronial halls and

elucidated by changing French-speaking interlocutors who could bend the narrative to different audiences.[101] At Rodenegg (Fig. 42), where the subjects were known through performances of chivalric poetry, the frescoes provided an inspiring setting for social events hosted by an aspiring ministerial family. The paintings at San-Gimignano may also have contributed to dinner-time entertaining.[102]

Chapter 8: Seeing

WRITING IN THE middle of the twelfth century, Herman-Judah reported that when he had looked at a picture in the Cathedral of Mainz twenty years earlier, he could see only a "monstrous idol."[1] Still "darkened by a cloud of Jewish blindness," he discerned in the crucifixion an abasement of the Almighty and in the image of the celestial God, only the work of artists' tricks.[2] Even after Rupert of Deutz countered with a defense of images, Herman-Judah, adhering to the Jewish belief that God is invisible, failed to comprehend how a likeness of Christ's death on the cross and a portrait of God in Majesty "elaborately wrought with the arts of painters and sculptors" could elevate pious minds to "the company of saints and to the eternal heritage of the Heavenly Jerusalem." A "carnal" Jew, Herman-Judah was incapable of seeing medieval art.[3]

What, precisely, Herman-Judah saw in the Cathedral of Mainz is not certain. He might simply have been looking at separate pictures of the human and divine Christ, as appear, for instance, on the Vatican Last Judgment (Fig. 13) or Lisbjerg altar (Fig. 20). Perhaps he encountered a two-sided representation of the sort preserved on the Copenhagen reliquary (Plate 6) picturing Christ's crucifixion on one side and the Majestas on the other, and was simply unable to integrate the historical depiction of earthly sacrifice with the heavenly court on the other. Most

likely, given his language of oppositions — humiliation and exaltation, lowering and raising, ignominy and glory — Herman-Judah was looking at a *Throne of Mercy*, the recently invented Trinitarian image (often associated with Rupert of Deutz) showing God the Father proffering his crucified Son and joined to Him through the dove of the Holy Spirit,[4] a version of which is incorporated in Chariot of Aminadab at Saint-Denis (Fig. 8). However it might differ in detail, Suger's image is a perfect example of what Herman-Judah was unable to apprehend. Replacing the Ark of the Covenant that had once sheltered the Jewish instruments of expiation, the finely crafted Crucifix presents the suffering incarnate Christ for the viewer's contemplation as a prelude to glimpsing the living God beyond the temple curtain in heaven.[5] The depiction at Assisi of Francis praying in San Damiano (Fig. 36) illustrates the intended experience. The painted Christ on the cross is so vivid that the young man praying before it believes that it speaks to him, while the seven candlesticks pictured on the apsidal arch above remind him (and the viewer of the painting) that God resides in heaven and will appear again to human sight only at the end of time.

The account of Herman-Judah's conversion to Christianity, the Chariot of Aminadab, and the painting at Assisi all embody the fundamental theory of medieval art. Appealing to the senses, images of Christ (and His saints) attract the viewer and excite religious desire, which, in turn, is channeled toward the Divinity who remains unseen. What enabled this theory was Christ's dual nature, the belief that man and God are mysteriously united in His person so that to see the one is to apprehend the other. The monastic scribe in eleventh-century Fruttaria described the process well when, even while directing participants in the Palm Sunday procession to honor the depiction of Christ "as if God Himself were present," he caught himself and cautioned them:

> Because, were it permitted to us to contemplate with [our] bodily eyes, it would seem that we ourselves have gone to meet the Son of God, which we must without any doubt believe we have done. Although he may not indeed be seen physically, yet the person whose inner eyes he will have opened has the power to see that we have gone forth to meet our Lord Jesus Christ.[6]

Like all non-believers, Herman-Judah lacked the "inner eyes" by means of which God can be contemplated in works of art; he himself admitted that he "was not able to detect the light of truth with [his] mental eyes." Some Christians, too, rejected art's capacity to convey divinity, even while accepting it as a legitimate means for representing (and affirming) Christ's life in the flesh. Theodulf of Orleans, for example, rejected it as a pagan invention that was food only for the eyes; Bernard of Clairvaux dismissed it; and later Cistercians referred to seeing art as ocular lust.[7] Henry of Ghent denied that corporal images can represent the invisible God; he was followed by Durand of Saint-Pourçain, who maintained that, while natural images conveyed the relationship between Father and Son, artificial images can reproduce only the accidents of appearance and not the substance.[8] Not surprising, Durand rejected depictions of the *Throne of Mercy*, which had already been denounced also by Luke of Huy and Alexander of Halles.[9]

For most Christian commentators, however, art's value was precisely its capacity to initiate a process of meditation, starting with physical sight and leading to inner contemplation. Thus, on the Hildesheim doors (Fig. 4), the sequence of narratives ends with Christ's appearance to Mary Magdalene in the garden, which in Scripture is one of the proofs that Christ's disciples could see him even after the resurrection (John 20:14-18), and shows Christ beckoning the penitent sinner to a garden occupied only by eagles, birds fabled for their ability to soar high enough to see his divinity in heaven.[10] Christ's human and divine natures are also represented in this scene in Bernward's Gospel book, albeit differently. In accord with Augustine's interpretation that Christ's divine nature was fully realized only when he left the world and returned to his Father's side, Christ, pointing to the tomb where his body once lay, is enclosed in a mandorla; and contrary to Scripture, Mary reaches in and touches him.[11] The play between sight and touch is a feature, as well, of the depiction of another post-Resurrection episode on the Berlin ivory (Fig. 5). By representing Thomas looking up at Christ's face while pushing his finger deep into his chest, the carving realizes perfectly the inscription based on John 20:27 written above—"Reach your finger here and be unbelieving no longer"—and, in turn, Gregory the Great's interpretation that at this moment, the Apostle "saw one thing and believed another ... He

apprehended a mere man and testified that this was the invisible God."[12] Moreover, the Doubting Thomas plaque juxtaposed to Moses Receiving the Laws (long identified with God's spirit hidden in carnal words) presents Christ's flesh as a second kind of covering of God's divinity that also needs to be interrogated.[13] The same sentiment underlies the distich, asserting the image's dual aspect, appended to many pictures of Christ.[14]

According to Augustine, Christ himself had had to disappear from sight so that his followers could redirect to his divinity the love they felt for his person. The idea underlies the iconography of the disappearing Christ in medieval depictions of the Ascension,[15] such as that in the upper margin of the opening to John's text in the Odbert Gospels (Fig. 22). In contrast to the fully formed "Word-made-flesh" of the crucifixion in the initial, only Christ's legs and feet are visible to Mary and the apostles as Christ leaves the earth; by implication, the frame cutting off his upper torso suggests that he has already left the viewer's space as well.[16] As pictured in the Odbert Gospels, the Lord's disappearance introduced the fundamental paradox of Christian art: as a man, Christ had been seen and cherished by other humans and therefore could be represented in material images; but his absence had to be asserted as well so that the love engendered by his person could be transferred to his invisible divinity.[17] In the "mere man," art had to attest to "the invisible God."

In part, this explains why Christians were not fully satisfied with traces of Christ's life on earth, for instance with words or relics. As Albertus Magnus and Thomas Aquinas explained, unlike the vestigium which does not share specific characteristics with its model, the image presents an agreement between exterior and interior things.[18] This is clear on the Agrigento reliquary (Plate 3): The marble plaque recalls the Holy Land where Christ walked and where the material and relic of the cross inside were collected; but only the enamel of the half-length Christ borne upward by angels actually evokes a longing for his spiritual presence. The Blickling homilist noted that the imprint of Christ's feet in the stone at Mt. Olivet (literally a *vestigium*) helps prompt a memory of the Ascension;[19] and Matthew Paris incorporated the idea in his *Historia Anglorum* (London, Brit. Lib. Roy.14. C. VII, fol. 146), where he depicted the disappearing Christ to illustrate his discussion of the relic that had been brought to England.[20] Matthew Paris, however, also reminded the reader that the image of Christ's face was preserved in the Veronica so

that his "memory might be cherished on earth"; and he included a depiction of the "vera icona" in his *Chronica Majora*, tellingly pasted into the margin so that it was seen as a separate object and accompanied by Innocent III's orison that includes the line, "lead us, wonderful image, to our true homeland [that is, heaven] so that we may see the face of Christ himself."[21] Prayer is essential, then, to activate the transition, but, as Matthew Paris reminds his viewer/reader, it is effective only in the presence of the image.

In many reliquaries and other sacred containers, the transcendental process involved relating the inside and outside, just as it did for the doubting Thomas. The external form of the "speaking reliquaries" in Osnabrück (Fig. 2), for instance, does not figure the contents but rather, by creating an image of the celestial body, creates a sign of the spiritual function.[22] Likewise, the gemmed outside of the Urraca Chalice (Plate 5) provides a glimpse of the heaven offered through the sacramental wine inside, and the veined sardonyx visualizes the transition itself. The functionality of the container activates the Florence Madonna and Child (Fig. 23) in an even more complicated way. In its entirety, the object creates a spiritual ascent from the real fragments within to the presence of Mary and Christ outside, reinforced with painted narratives at the base of the incarnation (Annunciation) and resurrection (Three Maries at the Tomb) that steadily are transformed into present, that is plastic, renderings of the Virgin and Child with their reference to the reality of the sacraments.

As on the Copenhagen reliquary, two-sided images functioned in much the same way,[23] or they divided audiences according to spiritual rank and thereby inserted the object into the liturgical hierarchy, as on the Remaclus retable (Fig. 19), which presented one face to the people and another to the clergy.[24] Suger had a cross made that depicted the Crucifixion on the front and was covered with gems on the back (*De adminis.*, 32); the one, he tells us, was intended to make Christ's sacrifice seem real ("the adorable image of our Lord the Savior, suffering as it were, even now in remembrance of his Passion") and was positioned toward the priest celebrating the Mass, while the other faced the congregation and offered them an abstract image of the Heavenly Jerusalem. The Vatican *Exultet Roll* pictures such a division: the monk on the pulpit displays the adorned scroll to his fellow clergy and the laity is able to witness the art and ritual only from the back.[25]

As the monk at Fruttuaria intuited, art's proper apprehension depend-
ed on the belief that seeing an image of the Son could bring the Father
to mind, an idea itself rooted deeply in Scripture and Trinitarian spec-
ulation.[26] The concept of "image" was introduced into discussions of the
relationship between persons of the Trinity. In the twelfth century, for
example, Abelard had used the seal metaphor to articulate Trinitarian
arguments, claiming that wax and an image in wax are simultaneously the
same and different, just as are the Father and Son. Abelard and other pre-
scholastics extended the analogy also to God's relationship to humankind
made, according to Genesis 1:26, "in God's image"; Thomas Aquinas
elaborated the trope, applying it also to Christian use of material images.
Referring to Aristotle's *De memoria et reminiscentia*, Aquinas argued that
reverence toward a material image leads to the (spiritual) thing of which
it is the image, and hence veneration of an image of Christ leads,
de facto, to reverence of God.[27] The seal metaphor recurred in dis-
cussions of material images.[28] The connection is implied in Matthew
Paris's *Chronica Majora* by the fact that, other than the Veronica, the only
other image pasted in as an object is the emperor's seal;[29] and it is explicit
in the Hours of Yolande of Soissons (Fig. 17), where the facing
prayers use the language of seals and identify the Veronica as an impres-
sion on the cloth.[30] In turn, Christ's image itself functioned in the fash-
ion of a seal matrix, as one of the texts claims: "the light of thy counte-
nance, O Lord, is signed on us." Christ had already transferred his coun-
tenance to his saints, Daniel in the Dijon compendium (Fig. 9), for
instance, and John the Evangelist in the Hours of Yolande of Soissons;[31]
and he could impress it on other devout persons. Describing a miniature
of the *Throne of Mercy*, for example, Sicard of Cremona wrote that the
Crucifix "which is depicted imprints itself on the eyes of the heart";[32]
and the hope was that, softened like wax through contemplation, souls
would be receptive to his image. Mechtild of Hackerborn envisioned
herself as receiving "the imprint of resemblance [to God] like a seal in
wax."[33]

Also defined in the context of Trinitarian discussion, beauty itself
could effect the *transitus*.[34] Beauty is the Son, whose body exhibited pro-
portion, harmony, and integrity,[35] and it is perceptible by humans who,
unlike animals, derive pleasure from it. Like nature represented through

intelligent contemplation, art provides a graceful vision that allows the mind to ascend; cleansed by Christ's sacrifice, it could exorcize dirtied pictures of worldly things.³⁶ The power to mediate between the sensible and intellectual was imagination, and it, too, rested in Trinitarian specula-tion.³⁷ Already in eighth- and ninth-century Hiberno-Saxon art, Trinitarian concepts were implicated in meditation on the ornamental forms, and many later images engaged Trinitarian issues.³⁸ Although "Beau-Dieu" (beautiful God) was first applied to the trumeau figure at Amiens (Fig. 35) only in the nineteenth century, the handsome, the classically inspired figure is part of a triad that includes the Man of Sorrows in the tympanum and the apocalyptic Son of Man penetrating the clouds at the top (Fig. 34).³⁹

To see an image of God, or even an image of the "Image of God," was not, of course, to see God himself. As the Apostle Paul made clear in his description of contemplation, "Now we see only puzzling reflections in a mirror, but then we shall see face to face" (1 Cor. 12:13). Included in Innocent III's prayer, the caution is applied to the picture of Christ's face in the Hours of Yolande of Soissons (Fig. 17); similar caveats are intro-duced in many other images through inscriptions and pictorial devices. The depiction of Christ in heaven on the front of the Saint Petersburg phylactery, for instance, is framed with the explicit instruction, "Revere the image of Christ by kneeling before it when you pass by it; but in so doing make sure you do not worship the image but rather him whom it represents."⁴⁰ A purely pictorial device is deployed on the Remaclus retable (Fig. 19), where the portrayal of the celestial Christ breaks from the narrative mode used to render the saint's life and is inserted into an elaborate cosmological schema. Some works distinguish the portrait of Christ in heaven from other figures by rendering it in a distinct material, thereby, as in Matthew Paris's rendering of the Veronica, designating it as an "image," not reality. In San-Giovanni-a-Porta-Latina in Rome and at San-Pietro-al-Monte at Civate, for instance, the face of the Apocalyptic judge was painted on separate panels inserted into the plaster; and in the Arena Chapel in Padua, the full-length figure of Christ among the angels is treated in a similar way.⁴¹ Something of the same effect is evident in the All Saints picture in the Udine Sacramentary (Fig. 26), where *Ecclesia* leads the weeping, softened sinners before the heavenly court, visible only

as a painting,[42] and at Taufers (Plate 10), where the vision of heaven at the apex of the dome is rendered explicitly as a devotional triptych.

These works all build on the medieval assumption that, while art is a fiction, it is a fiction containing truth; and by appealing to the senses, it can be useful as an instrument in the struggle against corrupting sensuality. Already in the fourth century, Paulinus of Nola hoped that pictures in the church of Saint-Felix could divert peasants from their food and drink and satiate them with sacred gratification; in the thirteenth century, Gertrude of Hefta wrote that material images are appetizers before the "hidden manna" of true visions.[43] They induce the distinct mental operations described by the monk at Fruttuaria and, engaged in the two-sided objects, they attract the devout through images of the Son but assert that God is glimpsed through, and not in, those images.[44]

Precisely how art could transform corporal seeing into a credible perception of the divine was the issue.[45] One way was to suggest that in looking at material images, the viewer, like the doubting Thomas, "saw one thing and believed another." Typology was a common technique to do this.[46] By showing Christ within the burning bush at Ceri and Saint-Denis (Plate 8, Fig. 8), the pictures assert that what the prophet saw with carnal eyes contained a higher, spiritual meaning; so too Joshua in the stained glass window who is designated as Christ. As Suger himself noted, by making "known the inmost meaning of the Law of Moses," his windows urge the viewer "onward from the material to the immaterial" (*De admin.*, 34). The transforming process was not restricted to the reading of Old Testament subjects; in his short treatise *De picturis principum apostolorum*, Peter Damian subjected the common apse composition of Peter and Paul flanking Christ (cf. Figs. 2, 7) to the same kind of exegesis, finding many meanings in the one image and, in so doing, undermining the very stability of art as a representation of a single thing.

Ambiguous and transformative forms also were cited to suggest art's essential fluidity. In Anglo-Saxon and Ottonian manuscripts, God's becoming visible was figured as a cloud.[47] In other works, the veil was used to suggest art's capacity simultaneously to reveal and hide divinity, an association enabled by the identification of images with the curtain before the inner sanctorum of the Jewish tabernacle, where the invisible God had communicated Moses and his successors (cf. Fig. 27) and which was identified with Christ's flesh.[48] The symbolism is incorporated in

Paschal I's mosaic in Santa-Maria-in-Domnica, where it is alluded to in the inscription,[49] and in the slightly earlier apse of Santi-Nereo-ed-Achilleo, in which a curtain hangs behind a triumphal cross against the blue of heaven.[50] The same idea is realized at Saint-Denis, where a golden veil separates the figured Crucifix from the celestial Deity, and was invested in configurations of the Holy Face, for instance, in the Gulbenkian Apocalypse, where the temple curtain is displayed by Vespasian's troops returning from Jerusalem, impressed with Christ's face.[51]

In turn, the temple curtain/flesh of Christ was understood as the firmament, the visible sky beyond which lies heaven. The idea inspired the remarkable frontispiece to Luke's Gospel in Darmstadt (Plate 4), where the washes of blue and green atop the fleshy parchment visualize the approach to God spelled out in the accompanying text. A miniature in the Breviary of the Grand Master Leo, produced in Prague in 1356 (Prague, Klementinum, MS XVIII 6, fol. 1v), realizes the metaphor in a picture of the Veronica against a star-studded blue sky, framed by prophets and apostles holding texts bearing on God's visibility (including Paul with 1 Corinthians 13).[52] Numerous pictures allude to the firmament: the Vatican Last Judgment (Fig. 13), the fresco at Taufers where the Divinity is pictured against a starry heaven, the apse mosaic in Santa-Maria-Maggiore which is dominated by the enormous dark blue opening before which Christ and Mary are enthroned (Plate 1), and the apse vault pictured in the Assisi fresco (Fig. 36); but the most consequential realization of its metaphoric application, by far, was the dark-blue stained-glass windows characteristic of Gothic churches (Plate 2 and Fig. 8).[53] Referred to by Suger as the "material of sapphires," the gem-like windows allude, not only to the Heavenly Jerusalem, but also to Christ's footstool at the interface between this world and the next and hence at the very juncture where art materializes the unseeable.

In Scripture and medieval aesthetics, light was the fundamental figure of the Divinity and the means through which God communicated with the human soul.[54] Christ declared himself the "light of the world," and depictions of the Annunciation showed God entering flesh as a beam of light (cf. Figs. 3, 23). At Berzé-la-Ville (Fig. 7) and San-Paolo-inter-Vineas at Spoleto, an oculus at the top of the painted decoration symbolizes the invisible God who activates the perception of the created

world.[55] In the Zeno Chapel at Santa-Prassede, a hierarchy of light sym-
bolism conducts the viewer in an ascent: Christ appears in a thirteenth-
century mosaic icon behind the altar in glowing gold and holding a scroll
declaring "Ego sum lux";[56] directly above, He is transformed through
light in the vision of the Transfiguration; He is imagined in heaven as a
half-length Christ in a celestial blue clipeus supported by angels; but He
is "seen" in the Deesis only by means of a window (probably originally
fitted with alabaster).[57] Several miniatures in Bernward's Gospel book
also feature light. The opening of John's Gospel (fol. 174r) portrays the
Trinity in heaven above a symbolic rendering of the terrestrial realm;
only light penetrates the division between the two, irradiating the Christ
Child, the Word of the Gospel prologue. Similarly, the dedication page
(Fig. 14), which represents the Incarnate Child in his mother's lap at the
center of three arches, identifies the central window of the church on the
facing page as Christ, his face blank glass framed by hair. The same idea
was realized almost three centuries later in Santa-Maria-Maggiore, where
Christ is shown appearing on earth to accept his mother's soul framed by
an arch the same size and shape as the actual windows and thus equated
with the light admitted into the apse. As Hildegard of Bingen's stunning
self-portrait depicts (Fig. 15), art recapitulates the very materialization of
divine light. From a door opened in heaven, light flows onto the eyes of
the mystic who traces her vision onto wax tablets blackened with soot
just as Volmar transcribes her words onto the skin of animals; the point is
clear: divine light can take physical form in words and pictures, just as it
did in Christ's own body. Still, and this is significant, even Hildegard is
unable to look through the window.[58] In much the same vein, the prayers
facing the Veronica in the Hours of Yolande of Soissons refer to light as
the agent that impressed God's image onto the devout reader/looker.

Stained glass more than any other medium embodies light. Pierre de
Roissy, who was chancellor of the chapter at Chartres from 1205 to 1211,
described the window there as "divine writings … that throw the light of
the true sun, that is to say the light of God, into the interior of churches,
that is, into the hearts of the faithful by filling them with light."[59] The
miniature of the Christmas Mass in the *Très riches heures* (Plate 7) makes
use of light symbolism by picturing the descending angels as merging
with the grisaille glass (which did not exist in the Ste.-Chapelle);[60] in so

doing, it taps into the wide-spread belief that angels were light, an idea apparent as well on the frontispiece of the Dijon compendium (Fig. 9), where the angel carrying Habbakuk to Daniel is diaphanous, and in the London compendium, where God's messenger is painted white (Fig. 29).[61]

Unlike the angels, the saints in the *Très riches Heures* appear in the windows in color and in sculptures covered in gold; and the Grande Chasse and altar are also rendered in gold and hence seen in reflected light. This distinction between "lux" (light) and "lumen" (illumination) is found in other works as well, the one symbolizing God, the other elevating physical matter.[62] Thus, the *Annales regni Francorum* reports a miracle in the year 823 in which a light transformed an ancient and nearly invisible picture in Como, rendering only the Virgin and Child and the gifts visible, but not the magi themselves.[63] Light flashing from the gold mosaics in churches created the same effect; indeed, the words "micat" "rutilat," "resplendens,""perlustrans" or synonyms referring to their visual splendor are often attached to them.[64] The profuse and light-reflecting ornamentation and highly-saturated colors of medieval art stunned the senses,[65] at least momentarily rendering the figures ungraspable, despite their visibility, and in that way too engaging the incarnation. Gonsalve's tomb (Fig. 6) managed the effect with vivid results.

Light imbued the visual environment, not just with illumination, but also with life.[66] The shifting light animated and continuously transformed these works, playing off reflective surfaces and perpetually rendering art visible or obscure according to time of day and the source of illumination.[67] The scintillating reflections from the gold highlights as a reader turns the page of the Udine Sacramentary (Fig. 26), for instance, animate the heavenly chorus and distinguishes it from its earthly counterpart, and flickering candles or moving lamps would have had the same effect on the vitreous material embedded in Christ's mandorla at Berzé-la-Ville, in the background of the "triptych" in Taufers, and in the fiery coal in the scene of Isaiah's vision at Vicq.[68] Particularly intense during the liturgy, the play of light further unified the pictured figures and narratives with the performances in their presence, reinforcing the sensual and emotional connection between the visible and unseen.

Lux was the active agent in stained glass; light passing through the

windows was transformed into rich color, understood to be the result of light being transformed into illumination and color and hence a sign of the incarnation.[69] As light conditions changed, this became an ongoing process; the colors metamorphosed and so did the appearance of the figures, themselves becoming performative; and from the outside the glass offered a distant and filtered glimpse of the sacred interior.[70] The most striking characteristic of stained glass, however, was its darkness, what has been called its "divine gloom," that asserted an upper limit on what could be seen in it. Darkness was an important aspect in other works of medieval art. At Amiens, for instance, God the Father is obscured by the shadows at the apex of the tympanum.[71] The distinctly deep tonality of some renderings of the Veronica also attested to the sacred image's antiquity and authenticity; indeed, prayers to the Veronica underscore both its luminousness and darkness, finding Christ's dual nature in this very tension.[72] Darkness enacted the viewer's imagination and memory.[73]

The experience was not restricted to seeing; art was felt, kissed, eaten, and smelled. A tenth-century account reports that a brother at Reichenau "touched" a painting of the Virgin and Child and "covered it with kisses";[74] and the eleventh-century Life of Saint Dominic of Sora tells of the miraculous cure of a child at the saint's tomb, but only after the father promised a donation of wax or oil, the boy kissed and embraced the saint's image, and the father repeatedly invoked the saint's name.[75] Rupert of Deutz went even farther by recording a vision in which, when he kissed a Crucifix, Jesus opened his mouth so that the monk could kiss him more deeply.[76] The Cantigas (Fig. 3) pictures devout people kneeling in prayer before the miraculous image and some kissing it. The red ink representing blood on a fourteenth-century drawing so obscures the outlined Crucified Christ that it defies seeing and invites the viewer to touch the paper, just as Saint Bernard and the nun do in the depiction itself.[77] Images of the baby Jesus and of the dead Savior were also subjected to rites of clothing and unclothing.[78] The depiction of Saint Michael bearing a censor at Chartres is related to the saint's feast when the main altar was sensed and the "aromatic smoke [rose] in the sight of God."[79]

In medieval theory, however, sight was the most powerful sense and, following classical rhetorical formulations, visual images were considered

more effective even than words in moving the soul. By engaging the passions and evoking fascination and fear, pictures were considered particularly powerful in rendering the words of Scripture memorable.[80] An eighth-century text circulated during the Middle Ages as an authentic teaching of Gregory the Great made the claim that pictures "show the invisible by means of the visible and return the Son of God to our memory and equally delight the soul concerning the resurrection and soften it concerning the passion."[81] In the twelfth century, Peter of Celle noted that, on earth, "spiritual seeing is constructed by means of our recollection of images of corporeal things";[82] Durandus cited the mnemonic power of images.[83] Even before ancient treatises on memory were revived, Alcuin, Aelfric, and others imagined the mind as a storehouse of visual impressions, retrievable because they were organized there in a rational manner.[84] Thus, while it provides a Christian reading of the poem, the illustration in the Utrecht Psalter (Fig. 28), for instance, cues the words of Psalm 148—"Lord," "heaven," "angels," "sun," "moon," and "stars"—and provides a memorable ordering for the chain of words in the sacred text.[85] The assembly and organization of diverse objects in medieval treasuries and in single works of art functioned in much the same way, creating a memorial narrative that linked Christ's human presence in history to His invisible divinity.[86] When he collected fragments from Dagobert's church in the Saint-Denis choir and refurbished Carolingian objects (Fig. 10), Suger attached the present building to its historical foundation.

To serve effectively, such pathways had to provide a clear, ordered course. Thus, following the rhetorical practice of contemporary preachers, the miniature before Peraldus's *Summa vitiorum et virtutum* gathers miscellaneous passages from Scripture and the visual traditions of diagrams, secular narratives, and religious symbols to construct an image that is memorable because it concentrates the entire treatise in a chain of correspondences based on spiritual combat.[87] Fully painted and most earthly, the knight engages the viewer directly, recalling defenders of the faith such as King Saul in the contemporary Morgan Library Picture Bible (Fig. 24) and secular heroes illustrated in the histories of Matthew Paris. He embodies Christian virtue: his sword, helmet, and other pieces of armor symbolize virtues and his shield is the *scutum fidei* of Ephesians

6:14-19, the shield of faith adorned with a diagram of the Trinity, its central circle representing "God" attached to the three persons in the corner by words and lines.[88] An angel descending from heaven bestows on him seven beatitudes, and the seven gifts of the Holy Spirit form a phalanx before him as he sets out to conquer the cardinal vices, each one generating secondary and tertiary vices rendered as demons neatly set in a grid. Like the texts included in the compendium, the diagram served the Dominican preacher by making memorable the rhetorical structures of enumeration and antithesis. In James Le Parler's *Omne Bonum*, the prefatory sequence also begins with a grid, there fitted with objects and images associated with Christ's passion, labeled fragments that provoke the reader to call to mind the Gospel narrative.[89] Accompanied by the prayer attributed to Pope Innocent IV promising indulgences for veneration of the Holy Face, they thus participate in a gradual freeing of meditation from physical stimuli. A subsequent page represents the ascent by showing a man and woman flanking a diagram of the terrestrial world, at the center of which Adam and Eve are shown eating from the tree; their prayers are lifted by light beams to a second level where Benedict and Paul are portrayed, two men privileged to have had direct visions of God, and finally to God himself, a solar Deity in heaven accompanied by angels. The sequence is completed by Pope Benedict XII's decree on beatific vision and a third illustration showing the souls looking at "the divine essence by intuitive vision and even face to face with no mediating creature but divine essence immediately revealing itself plainly and openly." Memory is evoked here, as in many other works of medieval art, as an intermediary between physical and mental seeing. What is important is not just the conventional relationship, but the very process by which the devout viewer moves coherently through temporal history, memory, and mental contemplation.

Because *seeing* medieval art is so contingent on conditions of viewing and temporal unfolding, *showing* it presents special problems. Realized already in the contextual settings of the Musée Cluny in Paris and the Cloisters in New York, the desire to exhibit medieval art in an environment that recreates aspects of the original viewing environment persists. An example is the Knight's Hall recently set up in the Walters Art Museum in Baltimore which, in contrast to the display of religious art in the same museum, attempts to provide an authentic context by assem-

bling armor, furniture, and secular and religious objects in a castle setting and invites visitors to sit at the central table and play checkers. Even if one ignores the incongruous application of modern notions of domestic privacy to the Middle Ages, the problem with such an exhibit is that it subordinates the objects to the display. The fascinating and beautiful ivory box featuring the castle of love, for instance, becomes in this context a sign of secular luxury rather than an object meant to be held by and to delight its owner with a playful message about courting. Likewise, while the *lumière* (light) of the "*spectacle*" staged on summer evenings at Amiens and Poitiers serves the useful function of reconstructing the appearance of the façade's original polychromy (Fig. 34), the *son* (sound) transforms the effect into a tourist show. More evocative of medieval seeing are processions still staged in Rome and elsewhere, even if these do not involve actual objects from the Middle Ages; I for one will never forget the Good Friday procession in Gubbio, with its hissing rattles, hymns, and candle-lit penitents walking along the town walls. The abbey at Frontrevaud has tried to apply all available resources to the recreation of the experience of medieval art, including music and pageantry, and also narrators and theater.[90] Technology can also go a long way toward restoring other aspects of the medieval experience, such as the sequencing of images and text in a manuscript as the "pages" are "turned,"[91] and creating a virtual reality of movement and shifting conditions in a cathedral.[92]

Paradoxically, attempts to reconstitute the original circumstances serve only to remind viewers that what is needed to comprehend medieval art is still an informed imagination. The magnificent objects seen with human eyes only go so far. As was true centuries ago, the perception of the invisible world these objects represent requires the mind's eye.

Notes

Notes to Chapter One

1 Jérôme Baschet, "Introduction: L'image-objet," in *L'image. Fonctions et usages des images dans l'Occident médiéval*, ed. Jérôme Baschet and Jean-Claude Schmitt (Paris: Léopard d'Or, 1996), 7-57.

2 On the intermediary aspect of Northern Renaissance painting, see Hans Belting and Christiane Kruse, *Die Erfindung des Gemäldes. Das erste Jahrhundert der niederländische Malterei* (Munich: Hirmer Verlag, 1994); Keith Moxey, "Reading the 'Reality Effect,'" in *Pictura quasi fictura* (Vienna: Verlag der österreichischen Akademie der Wissenschaften, 1996), 15-21.

3 Alessandro Tomei, *Iacobus Torriti Pictor* (Rome: Árgos, 1990), 99-125.

4 Marie-Madeleine Gauthier, *L'Œuvre de Limoges* (Paris: CNRS, 1987), 57; Bianca Kühnel, *Crusader Art of the Twelfth Century* (Berlin: Gebr. Mann Verlag, 1994), 141-48 and "L'arte crociata tra Oriente e Occidente," in *Le crociate. L'oriente e l'occidente da Urbano II a San Luigi 1096-1270*, ed. Monique Rey-Delqué (Milan: Electa, 1997), 341-53.

5 *Gold und Purpur. Der Bilderschmuck der früh- und hochmittelalterlichen Handschriften aus der Sammlung Hüpsch im Hessischen Landesmuseum Darmstadt* (Darmstadt: Hessisches Landesmuseum, 2001), 25-37.

6 Theo Jülich, "Gemmenkreuze. Die Farbigkeit ihres Edelsteinbesatzes bis zum 12. Jahrhundert," *Aachener Kunstblätter* 54/55 (1986/87): 99-258; Henk van Os, *The Way to Heaven. Relic Veneration in the Middle Ages* (The Hague: Koninlijke Bibliotheek, 2000), 119-22.

7 *The Art of Medieval Spain. A.D. 500-1200* (New York: The Metropolitan Museum of Art, 1994), 254-55.

8 Thomas Raff, *Die Sprache der Materialien. Anleitung zu einer Ikonologie der Werkstoffe* (Munich: Deutscher Kunstverlag, 1994).

9 Ulrich Henze, "Edelsteinallegorese im Lichte mittelalterlicher Bild- und Reliquienverehrung," *Zeitschrift für Kunstgeschichte* 54 (1991): 428-51; John Gage, *Color and Culture. Practice and Meaning from Antiquity to Abstraction* (Berkeley and Los Angeles: University of California Press, 1993); Aron Gurevich, *The Origins of European Individualism* (Oxford: Blackwell, 1995); Dominic Janes, *God and Gold in Late Antiquity* (Cambridge: Cambridge University Press, 1998); *Gemme dalla corte imperiale alla corte celeste*, ed. Graziella Buccellati and Anna Marchi (Milan: Universitá degli studi, 2002).

10 Herbert L. Kessler, *Spiritual Seeing. Picturing God's Invisibility in Medieval Art* (Philadelphia: University of Pennsylvania Press, 2000), 105-14.

11 Rotraut Wisskirchen, *Das Mosaikprogramm von S. Prassede in Rom* (Münster: Aschendorffsche Verlagsbuchhandlung,1990) and *Die Mosaiken der Kirche Santa Prassede in Rome* (Mainz: Phillip von Zabern, 1992).

12 Caroline Walker Bynum, *The Resurrection of the Body in Western Christianity, 200-1336* (New York: Columbia University Press, 1995), 202; Cynthia Hahn, "The Voices of the Saints: Speaking Reliquaries," *Gesta* 36 (1997): 20-31.

13 Kessler, *Spiritual Seeing*, 190-205.

14 Erik Thunø, *Image and Relic. Mediating the Sacred in Medieval Rome* (Rome: "L'Erma" di Bretschneider, 2002), 153-56.

15 Madeline H. Caviness, "Artist: To See, Hear, and Know, All at Once," in *Voice of the Living Light: Hildegard of Bingen and her World*, ed. Barbara Newman (Berkeley: University of California Press, 1998).

16 Sible de Blaauw, "Papst und Purpur. Porphyr in frühen Kirchenausstattungen in Rom," in *Tesserae. Festschrift für Josef Engemann* (Münster: Aschendorffsche Verlagsbuchhandlung, 1991), 36-50.

17 Thomas Raff, "'Materia superat opus'. Materialien als Bedeutungsträger bei mittelalterlichen Kunstwerken," in *Studien zur Geschichte der europäischen Skulpturen im 12./13. Jahrhundert*, ed. Herbert Beck and Kerstin Hengevoss-Dürkop (Frankfurt am Main: Heinrich Verlag, 1994), 17-22; Peter Low,

"'You who once were far off': Enlivening Scripture in the Main Narthex Portal at Ste.-Madeleine de Vézelay," *Art Bulletin* 85 (2003) 469-89. On Christ as cornerstone, see Robert Deshman, *The Benedictional of Æthelwold* (Princeton: Princeton University Press, 1995).

18 Raff, "'Materia superat opus'"; Jean Wirth, *L'image à l'époque romane* (Paris: Éditions du Cerf, 1999).

19 Wilhelm Schlink, *Der Beau Dieu von Amiens, Das Christusbild der gotische Kathedrale* (Frankfurt am Main: Insel Verlag, 1991); Mary Carruthers, "The Poet as Master-Builder: Composition and Locational Memory in the Middle Ages," *New Literary History* 24 (1993): 881-904; Stephen Murray, *Notre-Dame, Cathedral of Amiens: the Power of Change in Gothic* (Cambridge: Cambridge University Press, 1996).

20 Herbert L. Kessler and Johanna Zacharias, *Rome 1300. On the Path of the Pilgrim* (New Haven: Yale University Press, 2000).

21 Francisco Prado-Vilar, "In the Shadow of the Gothic Idol: The *Cantigas de Santa María* and the Imagery of Love and Conversion" (Ph.D. diss., Harvard University, Cambridge, MA, 2002).

22 Norberto Gramaccini, "Zur Ikonologie der Bronze im Mittelalter," *Städel-Jahrbuch* 11 (1987): 143-70; Ingo Herklotz, *Gli eredi di Costantino* (Rome: Viella, 2000), 41-94.

23 Paul Binski, *Medieval Death. Ritual and Representation* (Ithaca: Cornell University Press, 1996).

24 Gramaccini, "Zur Ikonologie"; Raff, *Sprache der Materialien*, 33-36.

25 Raff, *Sprache der Materialien*, 54.

26 The awareness of materials is certain; Claudia Echinger, "Zur Sündenfalldarstellung der Krümme des Erkanbald," in *Berwardinishe Kunst* (Göttingen: Verlag Erich Goltze, 1988), 127-52.

27 Wolfgang Kemp, *Christliche Kunst. Ihre Anfänge. Ihre Strukturen* (Munich: Schirmer-Mosel, 1994), 69-72.

28 Anna Maria Maetzke et al., *Il Volto Santo di Sansepulcro* (Cinisello Balsamo: Silvana Editoriale, 1994); Gerhard Wolf questions the early dating in *Schleier und Spiegel. Traditionen des Christusbildes und die Bildkonzepte der Renaissance* (Munich: Wilhelm Fink Verlag, 2002), 43-45.

29 Elizabeth Sears, "Ivory and Ivory Workers in Medieval Paris," in *Images in Ivory. Precious Objects of the Gothic Age*, ed. Peter Barnet (Princeton: Princeton University Press, 1997), 19-37.

30 Elizabeth C. Parker and Charles T. Little, *The Cloisters Cross. Its Art and*

Meaning (New York: Metropolitan Museum of Art, 1994), 16-19; Jean-Claude Bonne, "Les ornements de l'histoire. À propos de l'ivoire carolingien de saint Remi," *Annales, Histoire, Sciences Sociales*, 1996: 37-70.

31 Bonne, "Les ornements"; Dominique Alibert, "La matière antique dans l'imagerie politique carolingien," in *La Mémoire de l'Antiquité dans l'Antiquité tardive et le haut Moyen Âge*, ed. Michel Scot (Paris: Maison René Ginouvès, 2000), 81-103.

32 Anthony Cutler, *The Hand of the Master. Craftsmanship, Ivory, and Society in Byzantium (9th-11th Centuries)* (Princeton: Princeton University Press, 1994), 227-38; Danielle Gaborit-Chopin, "The Polychrome Decoration of Gothic Ivories," in *Images in Ivory*, 46-61; Harvey Stahl, "Narrative Structure and Content in Some Gothic Ivories of the Life of Christ," in *Images of Ivory*, 95-114.

33 *Art of Medieval Spain*, 244-45.

34 Christopher Hughes, "Visual Typology: An Ottonian Example," *Word & Image* 17 (2001): 185-98; William Diebold, "'Except I shall see … I will not believe' (John 20:25): Typology, Theology, and Historiography in an Ottonian Ivory Diptych," *Images, Objects and The Word: Art in the Service of the Liturgy*, ed. Colum Hourihane (Princeton: Princeton University Press, 2003), 257-73.

35 Jeffrey Hamburger, *Nuns as Artists. The Visual Culture of a Medieval Convent* (Berkeley and Los Angeles: University of California Press, 1997), 178-80.

36 Hugo van der Velden, *The Donor's Image. Gerard Loyet and the Votive Portraits of Charles the Bold* (Turnhout: Brepols, 2000), 247-59; Fabio Bisogni, "La scultura in cera nel Medioevo," *Iconographica* 1 (2002): 1-15.

37 Genevra Kornbluth, *Engraved Gems of the Carolingian Empire* (University Park: Pennsylvania State University Press, 1995), 70-73.

38 Georges Didi-Huberman, *Fra Angelico: Dissemblance and Figuration*, trans. Jane Todd (Chicago: University of Chicago Press, 1995), 28-34.

39 Dietrich Kötzsche, "Sog. Kana-Krug," in *Der Quedlinburger Schatz wider Vereint* (Berlin: Staatliche Museen, 1992), 38-39.

40 Jeffrey F. Hamburger, "Seeing and Believing. The Suspicion of Sight and the Authentication of Vision in Late Medieval Art and Devotion," in *Imagination und Wirklichkeit. Zum Verhältnis von mentalen und realen Bildern in der Kunst der frühen Neuzeit* (Mainz: Philipp von Zabern, 2000), 47-69.

41 Kühnel, *Crusader Art*, 141-44; Antonio Cadei, "Gli ordini di Terrasanta e il culto per la Vera Croce e il Sepolcro di Cristo in Europa nel XII secolo," *Arte medievale*, n.s.1 (2002): 51-69; Jean-Claude Bonne, "Entre l'image et la

matière," and "De l'ornemental dans l'art médiéval (VII–XIIe siècle). Le modèle insulaire," *L'image. Fonctions et usages*, 207-40.

42 Paul Williamson, *The Medieval Treasury. The Art of the Middle Ages in the Victoria and Albert Museum* (London: Victoria and Albert Museum, 1986), 96-97.

43 Richard Randall, Jr., *Masterpieces of Ivory from the Walters Art Gallery* (New York: Hudson Hills Press, 1985), 172.

44 Claudia Zaccagnini, "Nuove osservazioni sugli affreschi altomedievali della chiesa romana di S. Prassede," *Rivista dell'istituto nazionale d'archeologia e storia dell'arte*, 54, ser. 3, vol. 12 (1999): 83-114.

45 Kessler and Zacharias, *Rome 1300*, 138-40; Victor Saxer, *Sainte-Marie-Majeure. Une basilique de Rome dans l'histoire de la ville et de son église* (Rome: École francaise de Rome, 2001), 205-06.

46 Daniel Russo, "Espace peint, espace symbolique, construction ecclésiologique. Les peintures de Berzé-la-Ville (Chapelle-des-Moines)," *Revue Mabillon*, n.s.11, vol. 72 (2000): 57-87; Jean-Claude Bonne, "Concordia discors temporum. Le temps dans les peintures murales romanes de Berzé-la-Ville," in *Metamorphosen der Zeit*, ed. Éric Alliez et al (Munich: Wilhelm Fink Verlag, 1999),145-175.

47 Marcia Kupfer, *Romanesque Wall Painting in Central France* (New Haven: Yale University Press, 1993), 139-44.

48 Gage, *Color and Culture*, 72-74.

49 Michel Pastoureau, *Figures et couleurs : études sur la symbolique et la sensibilité médiévales* (Paris: Léopold d'Or, 1986) and *Couleurs, images, symboles. Études d'histoire et d'anthropologie* (Paris, Léopold d'or, 1989); Andreas Petzold, "'Of the Significance of Colours': The Iconography of Colour in Romanesque and Early Gothic Book Illumination," in *Image and Belief. Studies in Celebration of the Eightieth Anniversary of the Index of Christian Art*, ed. Colum Hourihane (Princeton: Index of Christian Art, 1999), 125-34; Françoise Gasparri, "La pensée et l'oeuvre de l'abbé Suger à la lumière de ses écrits," in *L'abbé Suger, la manifeste gothique de Saint-Denis et la pensée victorine*, ed. Dominique Poirel (Turnhout: Brepols, 2001), 59-82.

50 *La couleur et la pierre. Polychromie des portails gothiques*, Actes du Colloque. Amiens (Paris: Picard, 2002).

51 Bonne, "Rituel de la couleur."

52 Kalman Bland, *The Artless Jew* (Princeton: Princeton University Press, 2000), 71-91.

53 Madeline Caviness, "Stained Glass Windows in Gothic Chapels, and the

Feasts of the Saints," in *Kunst und Liturgie im Mittelalter*, ed. Nicolas Bock et al. (Munich: Hirmer Verlag, 2000), 135-48.

54 Walter Cahn, *Romanesque Manuscripts. The Twelfth Century* (London: Harvey Miller, 1996), vol. 2, 79-80; William Travis, "Daniel in the Lions' Den: Problems in the Iconography of a Cistercian Manuscript. Dijon, Bibliothèque Municipale, MS 132," *Arte medievale*, II ser., 14 (2000): 49-71.

55 Beat Brenk, "Schriftlichkeit und Bildlichkeit in der Hofschule Karls D. Gr.," in *Testo e immagine nell'alto medioevo* (*Settimane di studio del Centro italiano di studi sull'alto medioevo*) 41 (1994): 631-91; Bruno Reudenbach, *Das Godescalc-Evangelistar. Ein Buch für die Reformpolitik Karls des Grossen* (Frankfurt am Rhein: Fischer Taschenbuch Verlag, 1998), 50.

56 Horst Wenzel, "Die Verkündigung an Maria. Zur Visualisierung des Wortes in der Szene oder: Schiftgeschichte im Bild," in *Maria in der Welt. Marienverehrung in Kontext der Sozialgeschichte 10.-18. Jahrhundert*, ed. Claudia Optiz et al. (Zurich: Chronos Verlag, 1993), 23-52.

57 Anke Vasilu, "Le mot et le verre. Une définition médiévale du Diaphane," *Journal des Savants* (1994): 135-62.

58 Werner Telesko, "Ein Kreuzreliquiar in der Apsis?" *Römische Historische Mitteilungen* 36 (1994): 53-79.

59 Prado-Vilar, "Shadow of the Gothic Idol, 41-44 et passim."

60 Robert Ousterhout, "Loca Santa and the Architectural Response to Pilgrimage," in *The Blessings of Pilgrimage*, ed. Robert Ousterhout (Urbana and Chicago: University of Illinois Press, 1990), 108-24.

61 John Osborne, "Textiles and their Painted Imitations in Early Mediaeval Rome," *Papers of the British School in Rome* 60 (1992): 309-51; Thomas E.A. Dale, *Relics, Prayer, and Politics in Medieval Venetia. Romanesque Painting in the Crypt of Aquileia Cathedral* (Princeton: Princeton University Press, 1997), 73-75.

62 Jean Wirth, "Peinture et perception visuelle au XIIIe siècle," *Micrologus* 6 (1998): 113-28.

63 Lieselotte Kötzsche, "Der Gemmenfries — ein frühchristliches Ornament?," *Aachener Kunstblätter* 60 (1994): 37-43.

64 Cynthia Hahn, "Seeing and Believing: The Construction of Sanctity in Early-Medieval Saints' Shrines," *Speculum* 72 (1997): 1079-1106; Evan Gatti, "Reviving the Relic: An Investigation of the Form and Function of the Reliquary of St. Servatius, Quedlinburg," *Athanor* 18 (2000): 7-15.

65 Cynthia Hahn, *Portrayed on the Heart. Narrative Effect in Pictorial Lives of Saints from the Tenth through the Thirteenth Century* (Berkeley and Los Angeles:

University of California Press, 2001), 12. Guibert also doubted the authenticity of certain relics; cf. Jean-Claude Schmitt, "La croyance au Moyen Age," *Raison Présente* 113 (1995): 5-22.

66 François Bœspflug, "La vision-en-rêve de la Trinité de Rupert de Deutz (v. 1100). Liturgie, spiritualité et histoire de l'art," *Revue des sciences religieuses* 71 (1997) 205-29.

67 David F. Appleby, "Holy Relic and Holy Image: Saints' Relics in the Western Controversy over Images in the Eighth and Ninth Centuries," *Word and Image* 8 (1992) 333-43.

68 Hahn, "Seeing is Believing"; Georgia Frank, "The Pilgrim's Gaze in the Age before Icons," in *Visuality Before and Beyond the Renaissance. Seeing as Others Saw*, ed. Robert Nelson (Cambridge: Cambridge University Press, 2000), 98-115.

69 Kessler and Zacharias, *Rome 1300*, 111-12; Marizio Caperna, *La basilica di Santa Prassede. Il significato della vicenda architettonica* (Rome: Monaci Benedettini Vallombrosani, 1999).

70 Lucilla de Lachenal, *Spolia. Uso e Reimpiego dell'Antico dal III al XIV secolo* (Milan: Longanesi, 1995).

71 Beat Brenk, "Spolia from Constantine to Charlemagne: Aesthetics versus Ideology," *Dumbarton Oaks Papers* 41 (1987): 103-09; Giles Constable, "A Living Past: The Historical Environment of the Middle Ages," *Harvard Library Bulletin* 1 (1990): 49-70.

72 Øystein Hjort, "Augustus Christianus–Livia Christiana: *Sphragis* and Roman Sculpture," in *Aspects of Late Antiquity and Early Byzantium* (Stockholm: Almqvist and Wisell, 1993), 99-112.

73 Peter Cornelius Claussen, "Renovatio Romae. Erneuerungsphasen römischer Architektur im 11. und 12. Jahrhundert," in *Rom im Hohen Mittelalter. Studien zu dem Romvorstellungen und zur Rompolitik vom 10. bis zum 12. Jahrhundert* (Sigmaringen: Jan Thorbecke Verlag, 1992), 87-125; Jill Meredith, "The Arch at Capua: The Strategic Use of *Spolia* and References to the Antique," in *Intellectual Life at the Court of Frederick II Hohenstaufen*, ed. William Tronzo (Washington, DC: National Gallery of Art, 1994), 109-26; Dale Kinney, "Rape or Restitution of the Past? Interpreting *Spolia*, in *The Art of Interpreting*. ed. Susan C. Scott (University Park, PA: The Pennsylvania State University, 1995), 52-67; Bonne, "Entre l'image et la matière," 96; Ingo Herklotz, review in *Journal für Kunstgeschichte* 2 (1998): 105-16.

74 Brigitte Bedos Rezak, "Suger and the Symbolism of Royal Power: The Seal of Louis VII," in *Abbot Suger and St. Denis. A Symposium*, ed. Paula Gerson

(New York: The Metropolitan Museum of Art, 1986), 95-103; Danielle Gaborit Chopin, "Thrône de Dagobert," in *Le trésor de Saint-Denis* (Paris: Réunion des musées nationaux, 1991), 63-68.

75 Elena Poletti Ecclesia, "L'incanto delle pietre multicolori': gemme antiche sui reliquiari altomedievali," in *Gemme dalla corte imperiale*, 55-74.

76 Norbert Wibiral, "*Augustus patrem figurat*. Zu den Betrachtungsweisen des Zentralsteines am Lotharkreuz im Domschatz zu Aachen," *Aachener Kunstblätter* 60 (1994): 105-30.

77 Michael Jacoff, *The Horses of San Marco and the Quadriga of the Lord* (Princeton: Princeton University Press, 1993).

78 Philippe Buc, "Conversion of Objects," *Viator* 28 (1997) 99-143. Cf. *The Medieval Treasury*; *Trésor de Saint-Denis*; *Quedlinburger Schatz*; *Les dominicaines d'Unterlinden* (Colmar, Musée d'Unterlinden, 2000), *Le trésor de la Sainte-Chapelle* (Paris: Musée du Louvre, 2001); *Le trésor de Conques* (Paris: Musée du Louvre, 2001).

79 Xavier Barral I Altet, "Définition et fonction d'un trésor monastique autour de l'an mil: Sainte-Foy de Conques," in *Haut Moyen Age. Culture, éducation et société. Études offertes à Pierre Riché* (Nanterre: Éditions Publidix, 1990), 402-08; Daniel Thurre, "Les trésors ecclésiastiques du haut Moyen Âge et leur constitution. Éclairage à travers deux exemples helvétiques: Saint-Maurice d'Agaune et Sion," in *Les Trésors de sanctuaires, de l'Antiquité à l'époque romane* (Paris: Université de Paris X, 1996), 43-81; Buc, "Conversion of Objects"; John Elsner, "Replicating Palestine and Reversing the Reformation. Pilgrimage and Collecting at Bobbio, Monza and Walsingham," *Journal of the History of Collections* 9 (1997): 117-30; Éric Palazzo, "Le livre dans les trésors du Moyen Age. Contribution à l'histoire de la *Memoria* médiévale," *Annales* 1997: 93-118.

80 John Lowden, "On the Purpose of the Sutton Hoo Ship Burials," in *Studies in Medieval Art and Architecture presented to Peter Lasko*, ed. David Buckton and T. A. Heslop (London: Alan Sutton Publishing, 1994), 91-101.

81 Herklotz, *Gli eredi di Costantino*.

82 Arnold Angenendt, *Heilige und Reliquien. Die Geschichte ihres Kultes vom frühen Christentum bis zur Gegenwart* (Munich: C.H. Beck, 1994); Jaś Elsner, "From the Culture of *Spolia* to the Cult of Relics: The Arch of Constantine and the Genesis of Late Antique Forms," *Papers of the British School at Rome* 68 (2000): 149-84.

83 Thurre, "Trésors ecclésiastiques," 52-54.

84 William W. Clark, "'The Recollection of the Past is the Promise of the Future.' Continuity and Contextuality: Saint-Denis, Merovingians, Capetians, and Paris," *Artistic Integration in Gothic Buildings*, ed. Virginia Raguin, Kathryn Brush, and Peter Draper (Toronto: University of Toronto Press, 1995), 92-113.

85 *Trésor de Saint-Denis*, 56-59.

86 *Sancta Sanctorum*, ed. Carlo Pietrangeli (Milan: Elekta, 1995); Ingo Herklotz, "Die Fresken von Sancta Sanctorum nach der Restaurierung. Überlegungen zum Ursrpung der Trecentomalerei," in *Pratum Romanum. Richard Krautheimer zum 100. Geburtstag*, ed. Renate Colella et al. (Wiesbaden: Reichert Verlag, 1997), 180; Thunø, *Image and Relic*.

87 Daniel Weiss, *Art and Crusade in the Age of Saint Louis* (Cambridge: Cambridge University Press, 1998), 30-31; *Trésor de la Sainte-Chapelle*, 28-30.

88 *Trésor de la Sainte-Chapelle*, 25-26; Johannes Tripps, "Der Kirchenraum als Handlungsort für Bildwerke. 'Handelnde' Altarfiguren und hyperwandelbare Schnitzretabel," in *Kunst und Liturgie im Mittelalter*, 235-47.

89 On the reconstruction of Louis's Grande Chasse and its use in the Middle Ages, see Jannic Durand, "La Grand Châsse aux reliques," in *Trésor de la Sainte-Chapelle*, 107-12; on the windows, Alyce A. Jordan, *Visualizing Kingship in the Windows of Sainte-Chapelle* (Turnhout: Brepols, 2002).

90 Jean-Claude Bonne,"Noeuds d'écritures (le fragment I de l'Evangéliaire de Durham)," in *Texte-Image, Bild-Text*, ed. Sybil Dümchen and Michael Nerlich (Berlin: Technische Universität, 1990), 85-105 and "Entre l'image et la matière."

91 Bonne, "Ornements."

92 Kühnel, *Crusader Art*, 67-125.

93 Telesko, "Ein Kreuzreliquiar"; Jean-Claude Bonne, "De l'ornement à l'ornementalité: La mosaïque absidiale de San Clemente de Rome," in *Le rôle de l'ornement dans la peinture murale du Moyen Age* (Poitiers: Centre d'Etudes supérieures de civilisation médiévale, 1997), 103-19.

94 William Tronzo, "On the Role of Antiquity in Medieval Art: Frames and Framing Devices," in *Ideologie e pratiche del reimpiego nell'alto medioevo* (*Settimane di studio del Centro italiano di studi sull'alto medioevo*, 46) (Spoleto: CISAM, 1999), 1085-1111.

95 Bonne, "Noeuds d'écritures"; Ernst Kitzinger, "Interlace and Icons: Form

and Function in Early Insular Art," in *The Age of Migrating Ideas*, ed. Michael
Spearman and John Higgitt (Edinburgh: National Museums of Scotland,
1993), 3-6; Michael Ryan, "The Book of Kells and Metalwork," in *The Book
of Kells. Proceedings of a Conference at Trinity College Dublin 6-9 September 1992*,
ed. Felicity O'Mahony (Dublin: Trinity College Library, 1994), 270-79;
Bonne, "De l'ornemental."

96 Jean-Claude Bonne, "De l'ornemental" and "Relève de l'ornementation
celte païenne dans un évangile insulaire du VIIe siècle (Les *Évangiles de
Durrow*)," in *Ideologie e pratiche*, 1011-49.

97 Pierre-Alain Mariaux, "La 'double' formation de l'artiste selon Théophile:
Pour une lecture différente des prologues du '"De Diversis Artibus'" in
Florilegium. Scritti di storia dell'arte in onore di Carolo Bertelli (Milan: Elekta,
1995), 42-45; Daniel Alexandre-Bidon, "Une foi en deux ou trois dimen-
sions? Image et objets du faire coire à l'usage des laïcs," *Annales, Histoire,
Sciences Sociales* 1998: 1155-90.

98 Bruno Reudenbach, "'Ornatus materialis domus Dei.' Die theologische
Legitimation handwerklicher Künste bei Theophilus," in *Studien zur
Geschichte der europäischen Skulptur*, 1-16.

Notes to Chapter Two

1 Enrico Castelnuovo, "The Artist," in *Medieval Callings*, ed. Jacques Le Goff
(Chicago: University of Chicago Press, 1990), 210-41; Andreas Speer, "Vom
Verstehen mittelalterlicher Kunst," in *Mittelalterliches Kunsterleben nach
Quellen des 11. bis 13. Jahrhunderts* (Stuttgart-Bad Cannstatt: Frommann-
Hozboog, 1993), 13-52; Johann Konrad Eberlein, *Miniatur und Arbeit. Das
Medium Buchmalerei* (Frankfurt am Main: Surhkamp, 1995), 166-232;
Hamburger, *Nuns as Artists*, 177-211.

2 Piotr Skubiszewski, "L'intellectuel et l'artiste face à l'oeuvre à l'époque qui
'peint,'" in *Le travail au Moyen Âge* (Louvain-La-Neuve: Institut d'Etudes
Médiévales, 1990), 263-321; Peter Cornelius Claussen, "Nachrichten von
den Antipoden oder der mittelalterliche Künstler über sich selbst," in *Die
Künstler über sich in seinem Werk*, ed. Matthias Winner (Weinheim: VCH
Acta humaniora,1992), 19-54; Lawrence Nees, "The Originality of Early
Medieval Artists," in *Literacy, Politics, and Artistic Innovation in the Early
Medieval West*, ed. Celia Chazelle (Lanham: University Press of America,

1992), 77-109; Beat Brenk, "Originalità e innovazione nell'arte medievale," in *Arti e storia nel Medioevo*, ed. Enrico Castelnuovo and Giuseppe Sergi (Turin: Einaudi, 2002), 3-69; Sherry C.M. Lindquist, "Artistic Identity in the Late Middle Ages: Foreward," *Gesta* 41 (2002): 1-2.

3 Jacqueline Leclerq-Marx, "Signatures iconiques et graphiques d'orfèvres dans le haut Moyen Âge. Une première approche," *Gazette des Beaux-Arts* 137 (2001): 1-16.

4 Nees, "Originality" and "Reading Aldred's Colophon for the Lindesfarne Gospels," *Speculum* 78 (2003): 333-77; Laura Kendrick, *Animating the Letter. The Figurative Embodiment of Writing from Late Antiquity to the Renaissance* (Columbus: Ohio State University, 1999), 15.

5 Mary Carruthers, *The Book of Memory. A Study of Memory in Medieval Culture* (Cambridge: Cambridge University Press, 1990), 225; Jonathan J.G. Alexander, *Medieval Illuminators and their Methods of Work* (New Haven: Yale University Press, 1992), 10.

6 Linda Seidel, *Legends in Limestone: Lazarus, Gislebertus, and the Cathedral of Autun* (Chicago: University of Chicago Press, 1999).

7 Victor Elbern, "Auftraggeber und Künstler in der Goldschmiedekunst des frühen Mittelalters," in *Committenti e produzione artistico-letteraria nell'alto medioevo occidentale* (Settimane di studio del Centro italiano di studi sull'alto medioevo, Spoleto, 39 [1992]), 855-81.

8 Thurre, "Trésors ecclésiastiques," 53; Leclerq-Marx, "Signatures."

9 Robert Suckale, *Das mittelalterliche Bild als Zeitzeuge* (Berlin: Lucas Verlag, 2002), 12-122.

10 Alessandro Tomei, *Iacobus Torriti Pictor*, 153-56; and "Dal documento al monumento: Le lettere di Niccolò IV per Santa Maria Maggiore," *Studi medievali e moderni* I (1997): 73-92.

11 Bruno Zanardi, *Il cantiere di Giotto* (Milan: Skira, 1996) and *Giotto e Pietro Cavallini: la questione di Assisi e il cantiere medievale di pittura a fresco* (Milan: Skira, 2002).

12 Alessandro Tomei, *Pietro Cavallini* (Milan: Silvana Editoriale, 2000); Serena Romano, *La basilica di San Francesco ad Assisi. Pittori, botteghe, strategie narrative* (Rome, Viella, 2001), 207-20. On the employment of three-dimensional models, cf. Bisogni, "La scultura in cera."

13 Peter Parshall, "Imago contrafacta: Images and Facts in the Northern Renaissance," *Art History* 16 (1993): 554-79; Robert W. Scheller, *Exemplum. Model-Book Drawings and the Practice of Artistic Transmission in the Middle Ages*

(ca. 900-ca. 1450) (Amsterdam: Amsterdam University Press, 1995); Arturo Quintavalle, "Medioevo: i modelli, un problema storico" and other contributions in *Medioevo: i modelli*, ed. Arturo Quintavalle (Parma: Università di Parma, 2002), 11-83.

14 For example, *Exultet. Rotoli litugici del medioevo meridionale*, ed. Guglielmo Cavallo (cat. of an exhib.) (Rome: Libreria dello Stato, 1994); *Le Bibbie atlantiche. Il libro della Scritture tra monumentalità e rappresentazione* (cat. of an exhib.) (Rome: Ministero per i Beni Culturali, 2000).

15 Penny Howell Jolly, *Made in God's Image? Eve and Adam in the Genesis Mosaics at San Marco, Venice* (Berkeley and Los Angeles: University of California Press, 1997).

16 John Lowden, *The Making of the* Bibles Moralisées (University Park, PA: Pennsylvania State University Press, 2000).

17 Ann Freeman and Paul Meyvaert, "The Meaning of Theodulf's Apse Mosaic at Germigny-des-Prés," *Gesta* 40 (2001): 125-39; Herbert L. Kessler, "The Place of Rome between Judea and Francia in Early Medieval Art," in *Roma fra Oriente e Occidente* (Settimane di studio del Centro italiano di studi sull'alto medievale, Spoleto, 49 [2002]), 695-718.

18 Paul Edward Dutton and Herbert L. Kessler, *The Poetry and Paintings of the First Bible of Charles the Bald* (Ann Arbor: University of Michigan Press, 1997).

19 Yves Christe, "Influences et etentissement de l'œuvre de Jean Scot sur l'art médiéval," in *Eriugena Redivivus. Zur Wirkungsgeschichte seines Denkens im Mittelalter und im Übergang zur Neuzeit* (Heidelberg: Heidelberger Akademie der Wissenschaften, 1987), 152-61; Jeanne-Marie Musto, "John Scottus Eriugena and the Upper Cover of the Lindau Gospels," *Gesta* 50 (2001): 1-18.

20 Lawrence Nees, "Problems of Form and Function in Early Medieval Illustrated Bibles from Northwest Europe," in *Imaging the Early Medieval Bible*, ed. John Williams (University Park, PA: The Pennsylvania University Press, 1999), 9-59; Celia Chazelle, "Archbishops Ebo and Hincmar of Reims and the Utrecht Psalter," *Speculum* 72 (1997): 1055-77, and *The Crucified God in the Carolingian Era. Theology and Art of Christ's Passion* (Cambridge: Cambridge University Press, 2001), 166-72 et passim.

21 Lawrence Nees, *A Tainted Mantle. Hercules and the Classical Tradition at the Carolingian Court* (Philadelphia: University of Pennsylvania Press, 1991).

22 *The Utrecht Psalter in Medieval Art*, ed. Koert van der Horst, William Noel, and Wilhelmina Wüstefeld (Utrecht: HES Publishers, 1996).

23 Kristine Haney, *The St. Albans Psalter. An Anglo-Norman Song of Faith* (New York: Peter Lang Publishing, 2002), 320-26 et passim.

24 Madeline Harrison Caviness, *Sumptuous Arts at the Royal Abbeys in Reims and Braine* (Princeton: Princeton University Press, 1990), 43-53 et passim.

25 Adam Cohen, *The Uta Codex. Art, Philosophy, and Reform in Eleventh-Century Germany* (University Park, PA: Penn State Press, 2000).

26 Éric Palazzo, *L'évêque et son image. L'illustration du Pontifical au Moyen Âge* (Turnhout: Brepols, 1999).

27 Kessler and Zacharias, *Rome 1300*.

28 Ann van Dijk, "Jerusalem, Antioch, Rome, and Constantinople: The Peter Cycle in the Oratory of Pope John VII (705-07)," *Dumbarton Oaks Papers* 55 (2001): 305-28.

29 Thunø, *Image and Relic*.

30 Wolf, *Schleier und Spiegel*, 47-48, 113-17 et passim.

31 Valentino Pace, "Committenza Benedettina a Roma: Il caso di San Paolo fuori le mura nel XIII secolo," in Valentino Pace, *Arte a Roma nel Medioevo. Committenza, ideologia e cultura figurativa in monumenti e libri* (Naples: Liguori Editore, 2000), 125-36 and "La commitenza artistica di Innocenzo III: dall'urbe all'orbe," in *Innocenzo III. Urbs et Orbs* (Rome: Società romana di storia patria, 2003), 1226-44.

32 Helmtrud Köhren-Jansen, *Giottos Navicella. Bildtradition, Deutung, Rezeptionsgeschichte* (Worms: Wernersche Verlagsgesellschaft, 1993).

33 *Abbot Suger and Saint-Denis*; Conrad Rudolph, *Artistic Change at St-Denis. Abbot Suger's Program and the Early Twelfth-Century Controversy over Art* (Princeton: Princeton University Press, 1990); Jean-Claude Bonne, "Pensée de l'art et pensée théologique dans les écrits de Suger," in *Artistes et philosophes: éducateurs?*, ed. Christian Descamps (Paris: Centre Georges Pompidou,1994), 13-50; Louis Grodecki, *Études sur les vitraux de Suger à Saint-Denis (XIIe siècle)* (Paris: CNRS, 1995); Hanns Peter Neuheuser, "Die Kirchweihbeschreibungen von Saint-Denis und ihre Aussagefähigkeit für das Schönheitsempfinden des Abtes Suger," in *Mittelalterliches Kunsterleben*, 116-207; Andreas Speer and Martin Pickavé, "Abt Sugers Schrift *De Consecratione*. Überlieferung-Rezeption-Interpretation," in *Filologia medio-latina* 3 (1996): 207-42; *Suger. Œuvres*, ed. Françoise Gasparri (Paris: Les

Belles Lettres, 1996); Kessler, *Spiritual Seeing*, 190-204; *Abt Suger von Saint-Denis. Ausgewählte Schriften: Ordinatio, De consecratione, De Administratione*, ed. Andreas Speer and Günter Binding (Darmstadt: Wissenschaftliche Buchgesellscharft, 2000); *L'abbé Suger, le manifeste gothique de Saint-Denis et la pensée victorine. Actes du Colloque organisé à la Fondation Singer-Polignac (Paris)* (Turnhout: Brepols, 2001).

34 Bonne, "Pensée de l'art"; Speer, "Verstehen"; Dominique Poirel, "*Symbolice et anagogice*: l'école de Saint-Victor et la naissance du style gothique," in *L'abbé Suger*, 141-70.

35 Kupfer, *Romanesque Wall Painting*, 131-45 et passim.

36 Anna C. Esmeijer, "The Open Doors and the Heavenly Vision: Political and Spiritual Elements in the Programme of Decoration of Schwarzrheindorf," in *Polyanthea: Essays on Art and Literature in Honor of William Sebastian Heckscher* (The Hague 1993), 43-56; Christoph Dohmen, *Das neue Jerusalem: der Ezechiel-Zyklus von Schwarzrheindorf* (Bonn: Bouvier, 1994). For more concrete evidence of Rupert's involvement in the production of art, see Michael Curschmann, "Imagined Exegesis: Text and Picture in the Exegetical Works of Rupert of Deutz, Honorius Augustodunensis, and Gerhoch of Reichersberg," *Traditio* 44 (1988): 145-69; Bœspflug, "La vision-en-rêve."

37 Reviewed by Haney, *St. Albans Psalter*, 334-46.

38 Conrad Rudolph, *The "things of greater importance." Bernard of Clairvaux's Apologia and the Medieval Attitude Toward Art* (Philadelphia: The University of Pennsylvania Press, 1990).

39 Arwed Arnulf, *Versus ad Picturas. Studien zur Titulusdichtung als Quellengattung der Kunstgeschichte von der Antike bis zum Hochmittelalter* (Munich and Berlin: Deutscher Kunstverlag, 1997), 293-95.

40 Serafín Moralejo, "D. Lucas de Tuy y la 'actitud estética' en al arte medieval," *Euphrosyne. Revista de Filologia Clássica*, ns. 22 (1994): 341-46.

41 Leclerq-Marx, "Signatures."

42 Deshman, *Benedictional of Æthelwold*, 252-54.

43 *Bernward von Hildesheim und das Zeitalter der Ottonen* (cat. of an exhib.) (Hildesheim: Bernward Verlag, 1993); Quintavalle, "Medioevo: i modelli."

44 Rainer Kahsnitz, "Bronzetüren im Dom," in *Bernward von Hildesheim Bernward von Hildesheim*, II, 503-12; Adam Cohen and Anne Derbes, "Bernward and Eve at Hildesheim," *Gesta* 40 (2001): 19-38; Harvey Stahl, "Eve's Reach: A Note on Dramatic Elements in the Hildesheim Doors," in

Reading Medieval Images: The Art Historian and the Object, ed. Elizabeth Sears and Thelma K. Thomas (Ann Arbor, MI: University of Michigan Press, 2002) 162-75.

45 Eberlein, *Miniatur und Arbeit*, 217-18.

46 Eberlein, *Miniatur und Arbeit*, 200-10; J.-M. Sansterre, "Le moine ciseleur, la vierge Marie et son image: Un récit d'Ekkehart IV de Saint-Gall," *Revue benedictine* 106 (1996): 185-91.

47 Leclerq-Marx, "Signatures."

48 *Das Reich der Salier 1024-1125* (cat. of an exhib.) (Sigmaringen: Jan Thorbecke Verlag, 1992), 384-404; Peter Lasko, "Roger of Helmarshausen, Author and Craftsman: Life, Sources of Style, and Iconography," in *Objects, Images, and the Word*, 180-201.

49 Valentino Pace, "Per Jacopo Torriti, frate, architetto e 'pictor,'" in *Arte a Roma*, 399-414, with response to critics and supporters of the idea.

50 Patrice Sicard, *Diagrammes médiévaux et exégèse visuelle. Le* Libellus de formatione arche *de Hugues de Saint-Victor* (Paris-Turnhout: Brepols, 1993).

51 Conrad Rudolph, *Violence & Daily Life. Reading, Art, and Polemics in the Cîteaux* Moralia in Job (Princeton: Princeton University Press, 1997).

52 Madeline Caviness, "Anchoress, Abbess and Queen: Donors and Patrons or Intercessors and Matrons?," in *The Cultural Patronage of Medieval Women*, ed. June McCash (Athens: University of Georgia Press, 1996), 105-53; "Gender Symbolism and Text Image Relationships: Hildegard of Bingen's *Scivias*, in *Translation Theory and Practice in the Middle Ages* (Kalamazoo: Medieval Institute, 1997), 71-111; "Hildegard of Bingen: Some Recent Books," *Speculum* 77 (2001): 113-20; *Visualizing Women in the Middle Ages. Sight, Spectacle, and Scopic Economy* (Philadelphia: University of Pennsylvania Press, 2001); *Hildegard von Bingen in ihrem historischen Umfeld*, ed. Alfred Haverkamp (Mainz: Philipp von Zabern, 2000). Lieselotte Saurma-Jeltsch, *Die Miniaturen im "Liber Scivias" der Hildegard von Bingen: Die Wucht der Vision und die Ordnung der Blider* (Wiesbaden: Reichert, 1998); Richard K. Emmerson, "The Representation of Antichrist in Hildegard of Bingen's *Scivias*: Image, Word, Commentary, and Visionary Experience," *Gesta* 41 (2002): 95-110.

53 Cf. *Hildegardis Bingensis Liber Divinorum Operum*, ed. Albert Derolez and Peter Dronke (Turnhout: Brepols, 1996).

54 Horst Wenzel, *Hören und Sehen, Schrift und Bild. Kultur und Gedächtnis im Mittelalter* (Munich: C.H. Beck, 1995); Jean-Claude Schmitt, *Le corps des*

images. Essais sur la culture visuelle au Moyen Âge (Paris: Gallimard, 2002), 323-44.

55 Castelnuovo, "Artist," 216.

56 Hans Belting, *Likeness and Presence. A History of the Image before the Era of Art*, trans. Edmund Jephcott (Chicago: University of Chicago Press, 1994); *Il volto di Cristo* (catalogue of an exhibition) (Milan: Electa, 2000); Michele Bacci, *Il pennello dell'Evangelista. Storia delle immagini sacre attribuita a San Luca* (Pisa: Gisem, 1998).

57 Bacci, *Il pennello*, 235-328.

58 Belting, *Likeness and Presence*, 310.

59 *Il volto di Cristo*, 172-73.

60 *Il volto di Cristo*, 171-72; Wolf, *Schleier und Spiegel*, 52-53.

61 Herbert L. Kessler, "Face and Firmament: Albrecht Dürer's *Angel with the Sudarium* and the Limit of Vision," in *L'immagine di Cristo da van Eyck a Bernini*, ed. Christoph Frommel and Gerhard Wolf (forthcoming).

62 Paul Edward Dutton, ed., *Charlemagne's Courtier: the Complete Einhard* (Peterborough, ON: Broadview Press, 1998).

63 Paul Binski, *The Painted Chamber at Westminster* (London: Society of Antiquaries, 1986).

64 Dutton and Kessler, *Poetry and Painting*; John Lowden, "The Royal/Imperial Book and the Image of Self-Image of the Medieval Rule," in *Kings and Kingship in Medieval Europe*, ed. Anne J. Duggan (London: King's College London Centre for Late Antique and Medieval Studies, 1993), 216-26.

65 Caviness, "Anchoress, Abbess, and Queen" 136; Hans-Walter Stork, *Die Bibel Ludwigs des Heiligen* (Graz: Akademisch Druck- und Verlagsanstalt, 1995); Lowden, *Making of the* Bibles Moralisées, vol. 2, 199-209.

66 Suzanne Lewis, *The Art of Matthew Paris in the* Chronica Majora (Berkeley and Los Angeles: University of California Press, 1987).

67 Caroline Bruzelius, review of Daniel Weiss, *Art and Crusade in the Age of Saint Louis*, *Speculum* 76 (2001): 813-15.

68 Andreas Bräm, "Friedrich II. als Auftraggeber von Bilderhandschriften?," in *Kunst im Reich Kaiser Friedrichs II. von Hohenstaufen*, ed. Kai Kappel et al. (Munich and Berlin: Klinkhardt & Biermann, 1996), 172-84; Julian Gardner, "Torriti's Birds," in *Medioevo: i modelli*, 605-14.

69 Prado-Vilar, "In the Shadow of the Gothic Idol."

70 Giulia Orofino, "Il rapporto con l'antico e l'osservazione della natura nell'illustrazione scientifica di età sveva in Italia meridionale," in *Intellectual Life at*

the Court of Frederick II Hohenstaufen, ed. William Tronzo (Washington: National Gallery of Art, 1994), 129-49; Valentino Pace, "Pittura e miniatura sveva da Federico II a Corradino: storia e mito," in *Federico II e l'Italia. Percorsi, Luoghi, Segni e Strumenti* (catalogue of an exhibition) (Rome: Edizioni de Luca, 1995), 103-10.

71 Jacques Le Goff et al., *Le sacre royal à l'époque de Saint Louis* (Paris: Gallimard, 2001).

72 Alexander, *Medieval Illuminators*, 16.

73 Pace, "Jacopo Torriti."

74 Wolfgang Kemp, *The Narratives of Gothic Stained Glass* (Cambridge: Cambridge University Press, 1997), 200-17 et passim.

75 Michael Camille, *Mirror in Parchment. The Luttrell Psalter and the Making of Medieval England* (London: Reaktion Books, 1998).

76 Wilhelm Schlink, "War Villard de Honnecourt Analphabet?," in *Pierre, lumière, couleur. Études d'histoire de l'art du Moyen Âge en l'honneur d'Anne Prache*, ed. Fabienne Joubert and Dany Sandron (Paris: PUF, 1999), 213-21.

77 Brigitte Buettner, "Profane Illuminations, Secular Illusions: Manuscripts in Late Medieval Courtly Society," *Art Bulletin* 74 (1991): 75-90.

78 Richard H. Rouse and Mary A. Rouse, *Manuscripts and their Makers: Commercial Book Producers in Medieval Paris, 1200-1500* (Turnhout: Harvey Miller, 2000).

79 Rouse and Rouse, *Manuscripts and their Makers*, Vol. 1, 203-260 et passim.

80 Christel Meier, "Labor improbus oder opus nobile," *Frühmittelalterliche Studien* 30 (1996): 315-42.

81 Skubiszewski, "L'intellectuel et l'artiste;" Eberlein, *Miniatur und Arbeit*, 234-35; Hamburger, *Nuns as Artists*, 184.

82 Skubiszewski, "L'intellectuel et l'artiste;" Mariaux, "La 'double' formation de l'artiste."

83 Skubiszewski, "L'intellectuel et l'artiste;" Leclerq-Marx, "Signatures iconiques."

84 Kemp, *Narratives*, 167.

85 Skubiszewski, "L'intellectuel et l'artiste."

86 Skubiszewski, "L'intellectuel et l'artiste."

87 Meier, "*Labor improbus*."

88 Wilhelm Kölmel, "Ornatus mundi-Contemptus mundi: Zum Weltbild und Menschenbild des 12. Jahrhunderts," in *L'homme et son univers au Moyen Âge*, ed. Christian Wenin (Louvain-la-Neuve: Éditions de l'Institut Supérieur de

Philosophie, 1986), 356-64; Conrad Rudolph, "In the Beginning: Theories and Images of Creation in Northern Europe of the Twelfth Century," *Art History* 22 (1999): 3-55.

89 Frank Hentschel, "Robert Grossetestes Brief *De unica forma omnium* im Spiegel kunsttheoretischer Interpretationen," in *Mittelalterliches Kunsterleben*, 224-48; Rudolph, "In the Beginning"; Lowden, *Making of the* Bibles Moralisées, 104 et passim; Steffen Bogen, *Träumen und Erzählen. Selbstreflexion der Bildkunst vor 1300* (Munich: Fink, 2001); Maęgorzata Krasnodłbska-D'Aughton, "Decoration of the *In principio* Initials in Early Insular Manuscripts: Christ as a Visible Image of the Invisible God," *Word and Image* 18 (2002): 105-22.

90 Romano, *San Francesco ad Assisi*, 101-39.

91 Romano, *San Francesco ad Assisi*, 207-20 et passim.

92 For example, *Committenti e Produzione*; see especially Enrico Castelnuovo, "Discorso conclusivo" in this volume, 885-98.

93 Claussen, "Nachrichten," in *Autour de Hugo d'Oignies*, ed. Robert Didier and Jacques Toussaint (Namur: Société archéologique de Namur, 2003).

94 Cf. Julian Gardner, "The French Connection: Thoughts about French Patrons and Italian Art, c. 1250-1300," in *Art and Politics in Late Medieval and Early Renaissance Italy: 1250-1500*, ed. Charles Rosenberg (Notre Dame, IN: University of Notre Dame Press, 1990), 81-102.

95 Andreina Draghi, "Il ciclo di affreschi rinvenuto nel Convento dei SS. Quattro Coronati a Roma: Un capitolo inedito della pittura romana del duecento," *Rivista dell'Istituto Nazionale d'Archaeologia e Storia dell'Arte*, 54 (3 ser., 22), 1999: 115-66.

96 Herbert L. Kessler, *Old St. Peter's and Church Decoration in Medieval Italy* (Spoleto: Centro italiano di studi sull'alto medioevo, 2002).

97 Klaus Krüger, *Der frühe Bildkult des Franziskus in Italien. Gestalt- und Funktionswandel des Tafelbides im 13. und 14. Jahrhundert* (Berlin: Gebr. Mann Verlag, 1992).

98 Henk von Os, *The Sienese Altarpieces. 1215-1460* (Groningen: Egbert Forsten Publishing, 1984-90).

99 Dutton and Kessler, *Poetry and Paintings*.

100 Beat Brenk, "Bildprogrammatik und Geschichtsverständnis der Kapetinger im Querhaus der Kathedrale von Chartres," *Arte medievale*, 2nd ser., 5 (1991): 71-96; Brigitte Kurmann-Schwarz, "Récits, Programme, Comanditaires, Concepteurs, Donateurs: publications récentes sur l'iconographie des vit-

raux de la cathédrale de Chartres," *Bulletin monumental* 154 (1996): 55-71.

101 Colette Manhes-Deremble, Les vitraux narratifs de la cathédrale de Chartres. Étude iconographique (Paris: Le Léopard d'or, 1993).

102 Brigitte Kurmann-Schwarz and Peter Kurmann, *Chartres. Die Kathedrale* (Munich: Schnell and Steiner, 2001), 139-73.

103 Kemp, *Narratives*, 163-77.

104 Jane Welch Williams, *Bread, Wine, and Money: The Windows of the Trades at Chartres Cathedral* (Chicago: University of Chicago Press, 1993).

105 Wilhelm Schlink, "Der Stifter schleicht sich in die Heilsgeschichte ein. Zum Chartreser Samariterfenster," in *Für irdischen Ruhm und himmlischen Lohn. Stifter und Auftraggeber in der mittelalterlichen Kunst*, ed. Hans-Rudolf Meier, Carola Jäggi, and Philippe Büttner (Berlin: D. Reimer, 1995), 203-11.

106 Donna Sadler, "The King as Subject, the King as Author: Art and Politics of Louis IX," in *European Monarchy: Its Evolution and Practice from Roman Antiquity to Modern Times*, ed. Heinz Durchhardt et al. (Stuttgart: Steiner, 1992), 53-68.

107 Beat Brenk, "The Sainte-Chapelle as a Capetian Political Program," in *Artistic Integration in Gothic Buildings*, 195-213; Weiss, *Art and Crusade*; Alyce A. Jordan, "Stained Glass and the Liturgy: Performing Sacral Kingship in Capetian France," in *Objects, Images, and the Word*, 274-97.

108 Weiss, *Art and Crusade*.

109 Daniel Weiss et al., *Die Kreuzritterbibel*, (Luzern: Verlag Luzern, 1999); *The Book of Kings. Art, War, and the Morgan Library's Medieval Picture Bible* (Baltimore: The Walters Art Gallery, 2002).

110 Donna Sadler, "King as Subject" and "Lessons Fit for a King: The Sculptural Program of the Verso of the West Façade of Reims Cathedral," *Arte medievale* 9 (1995): 49-68.

111 Lowden, *Making of the* Bibles Moralisées.

112 See discussion by Rosamond McKitterick, "Royal Patronage of Culture in the Frankish Kingdoms under the Carolingians: Motives and Consequences," in *Committenti e produzione*, 131-35.

113 *Kaiserin Theophanu. Begegnung des Ostens und Westens um die Wende des ersten Jahrtausends*, ed. Anton von Euw and Peter Schreiner (Cologne: Schnütgen-Museum, 1991); *Kunst im Zeitalter der Kaiserin Theophanu*, ed. Anton von Euw and Peter Schreiner (Cologne: Verlag Locher, 1993)

114 Caviness, "Anchoress, Abbess, and Queen"; Elizabeth Parker, "The Gift of the Cross in the New Minster *Liber Vitae*," in *Reading Medieval Images*, 176-86.

115　Richard Gameson, "The Gospels of Margaret of Scotland and the Literacy of an Eleventh-Century Queen," in *Women and the Book. Assessing the Visual Evidence*, ed. Jane H.M. Taylor and Lesley Smith (London: The British Library, 1996), 148-71.

116　van der Velden, *Donor's Image,* 191-222.

117　Dutton and Kessler, *Poetry and Paintings*, 31-32 et passim.

118　Lowden, "Sutton Hoo."

119　van der Velden, *Donor's Image*, 191-222.

120　Thunø, *Image and Relic*, 157-78.

121　Robert Deshman, "Servants of the Mother of God in Byzantine and Medieval Art," *Word and Image* 5 (1989): 33-70.

122　Cohen, *Uta Codex*, 39-51.

123　Gerhard Wolf, "Nichtzyklische narrative Bilder im italienischen Kirchenraum des Mittelalters: Überlegungen zu Zeit- und Bildstruktur der Fresken in der Unterkirche von S. Clemente (Rome) aus dem späten 11. Jahrhundert," in *Hagiographie und Kunst. Der Heiligenkult in Schrift, Bild und Architektur*, ed. Gottfried Kerscher (Berlin: Reimer, 1993), 319-39; Patrizia Carmassi, "Die hochmittelalterlichen Fresken der Unterkirche von San Clemente in Rom als programmatische Selbstdarstellung des Reformpapsttums," *Quellen und Forschungen aus italienischen Archiven und Bibliotheken* 81 (2001): 1-66; Cristiana Filippini, "La chiesa e il suo santo: gli affreschi dell'undicesimo secolo nella chiesa di S. Clemente a Roma," in *Art, Cérémonial et Liturgie au Moyen Âge*, ed. Nicolas Bock et al. (Rome: Viella, 2002), 107-24.

124　Lisa Victoria Ciresi, "A Liturgical Study of the Shrine of the Three Kings in Cologne," in *Objects, Images, and the Word*, 202-30.

125　Wolfgang Kemp, "Substanz wird Form. Form ist Beziehung. Zum Remaklus-Altar der Abtei Stavelot," in *Kunst und Sozialgeschichte. Festschrift für Jutta Held*, ed. Martin Papenbrock et al. (Pfaffenweiler: Centaurus, 1995), 219-34; Susanne Wittekind, "Liturgiereflexion in den Kunststiftungen Abt Wibalds von Stablo," in *Art, Cérémonial et Liturgy*, 503-24.

126　Freeman and Meyvaert, "Theodulf's Apse Mosaic."

127　Caviness, "Anchoress, Abbess, and Queen."

128　Rudolph, *Violence & Daily Life.*

Notes to Chapter Three

1 *The Book of Sainte Foy*, trans. and introd. Pamela Sheingorn (Philadelphia: University of Pennsylvania Press, 1995).

2 Rudolph, *The "things of greater importance," 318-19 et passim.*

3 Kemp, *Narratives*, 167.

4 Nino M. Zchomelidse, *Santa Maria Immacolata in Ceri. Pittura sacra al tempo della Riforma Gregoriana* (Rome: Archivio Guido Izzi, 1996), 64-65.

5 Conrad Rudolph, "La resistènza sull'arte nel Occidentale," in *Arti e storia nel Medioevo* (Turin: Einaudi, 2004).

6 Jean-Claude Schmitt, "Les idoles chrétiennes," in *L'idolâtrie (Rencontres de l'École du Louvre)* (Paris: La Documentation Française, 1990), 107-18; Kessler, *Spiritual Seeing*, 29-32, 192-95 et passim.

7 *Opus Caroli regis Contra Synodum*, ed. Ann Freeman and Paul Meyvaert (Hannover: Hahnsche Buchhandlung, 1998). See also Édouard Jeauneau, "De l'art comme mystagogie (Le Judgement dernier vu par Érigène)," in *De l'art comme mystagogie. Jugement dernier, Apocalypse et perspectives eschatologiques* (Poitiers: CESCM, 1996), 1-8.

8 Kirstin Faupel-Drevs, *Vom Rechten Gebrauch der Bilder im Litugischen Raum* (Leiden: Brill, 2000), 215-23 et passim.

9 Joachim E. Gaehde, "La decorazione. Le miniature," in *Commentario della Bibbia di San Paolo fuori le mura* (Rome: Istituto poligrafico e zecca dello stato, 1993), 235-328.

10 Thunø, *Image and Relic*, 163-67.

11 Werner Telesko, "Das theologische Programm des Kölner Dreikönigenschreins," *68. Jahrbuch 1997 des Kölnischen Geschichtsvereins*, 25-47.

12 I.N. Wood, "Ripon, Francia and the Franks Casket in the Early Middle Ages," *Northern History* 26 (1990): 1-26; *Making of England*, 101-03.

13 Freeman and Meyvaert, "Meaning of Theodulf's Apse Mosaic."

14 Hans Jørgen Frederiksen and Lise Godtfredsen, *Troens billeder. Romansk kunst i Danmark* (Copenhagen: Sistime, 1987).

15 Sheingorn, *Book of Sainte Foy*, 79.

16 Caviness, *Sumptuous Arts*, 37-43.

17 Kühnel, *Earthly to the Heavenly Jerusalem*, 68-90 et passim; Janes, *God and Gold*, 52-56; Andrea Marensi, "L'iconografia della croce gemmata: una rassegna di esempi tardoantichi ed altomedievali," in *Gemme dalla corte*, 99-110.

18 Jülich, "Gemmenkreuze;" Kötzsche, "Gemmenfries; Wibiral, "*Augustus patrem figurat.*"

19 Patricia Stirnemann, "L'illustration du commentaire d'Haymon sur Ezékiel," in *L'École carolingienne d'Auxerre de Murethach à Remi 830-908* (Paris: Beauchesne, 1991), 93-104; Kessler, *Spiritual Seeing*, 116-19

20 Rudolph, The *"things of greater importance,"* 22-36.

21 Vivian B. Mann, *Jewish Texts on the Visual Arts* (Cambridge: Cambridge University Press, 2000).

22 Gabrielle Sed-Rajna, "Hebrew Illuminated Manuscripts from the Iberian Peninsula," in *Convivencia. Jews, Muslims, and Christians in Medieval Spain* (New York: George Braziller, 1992), 133-55 and *L'art juif* (Paris: Citadelles & Mazenod, 1995); Marc Michael Epstein, *Dreams of Subversion in Medieval Jewish Art and Literature* (University Park, PA: Penn State Press, 1997); Katrin Kogman-Appel, "Hebrew Manuscript Painting in Late Medieval Spain: Signs of a Culture in Transition," *Art Bulletin* 84 (2002): 246-72.

23 Thérèse Metzger, "Josué ben Abraham ibn Gaon et la *masora* du Ms. Iluminado 72 de la Biblioteca nacional de Lisbonne," *Codices manuscripti* 15 (1990): 1-27; Elisabeth Revel-Neher, *Le témoignage de l'absence. Le objets du sanctuaire à Byzance et dans l'art juif du XIe au XVe siècles* (Paris: De Boccard, 1998); Kogman-Appel, "Hebrew Manuscript Painting."

24 Heinz Schreckenberg and Kurt Schubert, *Jewish Historiography and Iconography in Early Medieval Christianity* (Assen/Maastricht: Van Gorcum, 1992); Gabrielle Sed-Rajna, "Haggadah and Aggadah: Reconsidering the Origins of the Biblical Illustrations in Medieval Hebrew Manuscripts," in *Byzantine East, Latin West: Art-Historical Studies in Honor of Kurt Weitzmann*, ed. Doula Mouriki et al. (Princeton: Princeton University Press, 1995), 415-23; Bezalel Narkiss, *The Golden Haggadah* (London: British Library, 1997); Kogman-Appel, "Hebrew Manuscript Painting."

25 *Byzance et les images*, ed. André Guillou and Jannic Durand (Paris: La Documentation française, 1994); Leslie Brubaker and John Haldon, *Byzantium in the Iconoclast Era (ca 680-850): The Sources* (Aldershot: Ashgate, 2001); Charles Barber, *Figure and Likeness. On the Limits of Representation in Byzantine Iconoclasm* (Princeton: Princeton University Press, 2002). On the relationship between Byzantine theory and Western attitudes toward images see Belting, *Likeness and Presence*, 149-55, and David Freedberg, "Holy Images and Other Images," in *The Art of Interpreting*, 68-87.

26 Lawrence Duggan, "Was Art Really the 'Book of the Illiterate'?," *Word and Image* 5 (1989): 227-51; Celia Chazelle, "Pictures, Books, and the Illiterate:

Pope Gregory I's Letters to Serenus of Marseille," *Word and Image* 6 (1990): 138-53; Gerhard Wolf, *Salus populi Romani. Die Geschichte römanisher Kultbilder im Mittelalter* (Weinheim: VCH Acta humaniora, 1990); Pascal Weitmann, *Sukzession und Gegenwart. Zu theoretischen Äusserungen über bildende Künste und Musik von Basileios bis Hrabanus Maurus* (Wiesbaden: Reichert Verlag, 1997), 179-261; William Diebold, *Word and Image. An Introduction to Early Medieval Art* (Boulder: Westview Press, 2000); Herbert L. Kessler, "Gregory the Great and Image Theory in Northern Europe during the Twelfth and Thirteenth Centuries," in *A Companion to Medieval Art: Romanesque and Gothic in Northern Europe*, ed. Conrad Rudolph (Oxford: Blackwell, 2005).

27 Celia Chazelle, "Matter, Spirit, and Image in the *Libri Carolini*," *Recherches augustiniennes* 21 (1986), 163-84.

28 Rainer Kahsnitz, "Der christologische Zyklus im Odbert-Psalter," *Zeitschrift für Kunstgeschichte* 51 (1988): 33-125.

29 Belting, *Likeness and Presence*, 64-69; Serena Romano, "L'archeropita lateranense: storia e funzione," in *Volto di Cristo*, 39-41; Maria Andoloro, "L'archeropita in ombra del Laterano," in *Volto di Cristo*, 43-49; Wolf, *Schleier und Spiegel*, 43-47 et passim.

30 Wolf, *Salus populi Romani*, 37-59; Bacci, *Pennello*, 250-80.

31 Wolf, *Salus populi Romani*, 39-40. An early fourteenth-century copy of the Lateran *Acheropita* in Palombara Sabina captures the way in which the sacred image of Christ would have been seen: the head is in the heavens and the body is encased in a golden reliquary, recalling the sacred city; Walter Angelelli, "La diffusione dell'immagine lateranense: le repliche del Salvatore nel Lazio," in *Volto di Cristo*, 46-49 and 61.

32 Thunø, *Image and Relic*, 166.

33 Belting, *Likeness and Presence*, 218-22 et passim; Peter K. Klein, "From the Heavenly to the Trivial: Vision and Visual Perception in Early and High Medieval Apocalypse Illustration," in *The Holy Face and the Paradox of Representation*, ed. Herbert L. Kessler and Gerhard Wolf (Bologna: Nuova Alfa Editoriale, 1998), 247-78; *Volto di Cristo*, 103-211; Tiziana Maria di Blasio, *Veronica. Il mistero del Volto* (Rome: Città Nuova, 2000); Wolf, *Schleier und Spiegel*, 49-63 et passim.

34 Ewa Kuryluk, *Veronica and Her Cloth* (Oxford: Basil Blackwell, 1991); Jeffrey Hamburger, *The Visual and the Visionary. Art and Female Spirituality in Late Medieval Germany* (New York: Zone Books, 1998), 316-82.

35 Suzanne Lewis, *Reading Images. Narrative Discourse and Reception in the*

Thirteenth-Century Illuminated Apocalypse (Cambridge: Cambridge University Press, 1995), 218-19; Kessler, *Spiritual Seeing*, 9-12; *Volto di Cristo*, 174; Wolf, *Schleier und Spiegel*, 57-58.

36 Schmitt, *Le corps des images*, 217-71; Wolf, *Schleier und Spiegel*, 44.

37 Cf. Celia Chazelle, "An *Exemplum* of Humility: The Crucifixion Image in the Drogo Sacramentary," in *Reading Medieval Images*, 27-33.

38 Henry N. Claman, *Jewish Images in the Christian Church. Art as the Mirror of the Jewish-Christian Conflict 200-1250 C.E.* (Macon, GA: Mercer University Press, 2000); Chazelle, *Crucified God*, 261.

39 Bonne, "De l'ornement à l'ornementalité."

40 Yves Christe, *L'apocalypse de Jean* (Paris: Picard, 1996), 109 et passim.

41 van Os, *Way to Heaven*, 119-24.

42 Arnulf, *Versus ad Picturas*, 276-79.

43 Naomi Reed Kline, *Maps of Medieval Thought* (Woodbridge, Suffolk: Boydell, 2001), 226-29.

44 Emma Simi Varanelli, "'Diversi, non adversi': L'interpretazione del timpano della Pentecoste di Vézelay, Un unicum nel panorama dei modelli medievali della comunicazione visiva," *Arte medievale*, n.s. 1 (2002): 55-75; Low, "'You who once were far off.'"

45 Kessler, *Spiritual Seeing*, 135-37.

46 Caviness, *Visualizing Women*, 7 et passim; Rachel Fulton, *From Judgment to Passion. Devotion to Christ & The Virgin Mary, 800-1200* (New York: Columbia University Press, 2002).

47 Anton Legner, *Reliquien in Kunst und Kult. Zwischen Antike und Aufklärung* (Darmstadt: Wissenschaftliche Buchgesellschaft, 1995), 239-42.

48 Marco Ciatti, "The Typology, Meaning, and Use of Some Panel Paintings from the Duecento and Trecento," in *Italian Panel Painting of the Duecento and Trecento*, ed. Victor Schmidt (Washington: National Gallery of Art, 2002), 15-29.

49 David Freedberg, *The Power of Images. Studies in the History and Theory of Response* (Chicago: University of Chicago Press, 1989), 94.

50 Freedberg, *Power of Images*, 94-95.

51 Pietro Amato, *De vera effigie Mariae. Antiche icone romane* (Rome: Arnoldo Mondadori, 1988); Belting, *Likeness and Presence*, 57-63 et passim; Wolf, *Salus populi romani*

52 Belting, *Likeness and Presence*, 314-29; Wolf, *Salus populi romani*; Enrico Parlato, "Le icone in processione," in Maria Andaloro and Serena Romano, *Arte e iconografia a Roma da Costantino a Cola di Rienzo* (Milan: Jaca Book,

2000), 69-92; Bacci, *Pennello*, 251-72 et passim.

53 Maria Menna, "Niccolò IV, i mosaici absidiali di S. Maria Maggiore e l'Oriente," *Rivista dell'istituto nazionale d'archeologia e la storia dell'arte*, third series, 10 (1987): 201-24; Tomei, *Iacobus Torriti Pictor*, 153-56; Christoph Eggenberger, "Zur Marienkrönung des Franziskaner-Papstes Nikolaus IV. in Santa Maria Maggiore zu Rom," in *Das Denkmal und die Zeit: Alfred A. Schmid zum 70. Geburtstag* (Lucerne: Faksimile Verlag Luzern, 1990), 270-82.

54 Prado-Vilar, "Shadow of the Gothic Idol," 67-75.

55 Horst Wenzel, "Verkündigung"; Deshman, *Benedictional of Æthelwold*, 24-26 et passim, and "Another Look at the Disappearing Christ: Corporeal and Spiritual Vision in Early Medieval Images," *Art Bulletin* 79 (1997), 518-46.

56 Ann van Dijk, "The Angelic Salutation in Early Byzantine and Medieval Annunciation Imagery," *Art Bulletin* 81 (1999): 420-36.

57 Rainer Kahsnitz, "Inhalt und Aufbau der Handschrift. Die Bilder," in *Das kostbare Evangeliar des Heiligen Bernward* (Munich: Prestel, 1993). 18-55.

58 Kahsnitz, "Bronzetüren im Dom"; Cohen and Derbes, "Bernward and Eve."

59 Dutton and Kessler, *Poetry and Paintings*, 98-99.

60 *Abt Suger von Saint-Denis*, 32-34 et passim; Poirel, "*Symbolice et anagogice*."

61 Kessler, *Spiritual Seeing*, 189-203.

62 Hughes, "Visual Typology;" Diebold, "Ottonian Ivory."

63 Martina Pippal, "Inhalt und Form bei Nicolaus von Verdun. Bemerkungen zum Klosterneuburger Ambo," in *Studien zur Geschichte der europäischen Skulptur*, 367-80.

64 Lowden, *Making of the Bibles Moralisées*.

65 Donat de Chapeaurouge, "Der Christ als Christus: Darstellungen der Angleichung an Gott in der Kunst des Mittelalters, *Wallraf-Richartz-Jahrbuch*, 48-49 (1987-88), 77-96; Cynthia Hahn, "Picturing the Text: Narrative in the Lives of the Saints," *Art History* 13 (1990): 1-13; "Absent No Longer: The Sign and the Saint in Late Medieval Pictorial Hagiography," in *Hagiographie und Kunst*, 152-78; and *Portrayed on the Heart*; Kessler, *Spiritual Seeing*, 179-86 et passim; Hamburger, *St. John the Divine*.

66 Hamburger, *The Visual and the Visionary*, 358-59, and *St. John the Divine*, 171.

67 Michael Camille, "Word, Text, Image and the Early Church Fathers in the Egino Codex," in *Testo e immagine (Settimane di studio del Centro italiano di studi sull'alto mediovo, 41)*, 65-92; Eberlein, *Miniatur und Arbeit*, 31-45.

68 Cohen, *Uta Codex*, 47-48.

69 Eberlein, *Miniatur und Arbeit*; Kessler, *Spiritual Seeing*, 184-85.

70　Michael Camille, "Philological Iconoclasm: Edition and Image in the *Vie de Saint Alexis*," in *Medievalism and the Modernist Temper*, ed. R. Howard Bloch and Stephen G. Nichols (Baltimore: Johns Hopkins University Press, 1996), 371-401.

71　Kessler, *Spiritual Seeing*, 184-85; Kessler and Dutton, *Poetry and Paintings*, 65-66.

72　William Diebold, "Nos quoque morem illius imitari cupientes. Charles the Bald's Evocation and Imitation of Charlemagne," *Archiv für Kulturgeschichte* 75 (1993): 271-300; Nikolaus Staubach, *Rex Christianus. Hofkultur und Herrschaftspropaganda im Reich Karls des Kahlen* (Cologne: Böhlau, 1993).

73　Ulrich Kuder, "Die Ottonen in der ottonischen Buchmalerei: Identifikation und Ikonographie," in *Herrschaftsrepräsentation in ottonischen Sachsen*, ed. Gerd Althoff and Ernst Schubert (Sigmaringen: Thorbecke, 1998), 137-234.

74　Weiss, *Art and Crusade*, 53-74 et passim and *Kreuzritterbibel*; C. Griffith Mann, "Picturing the Bible in the Thirteenth Century," in *The Book of Kings*, 38-59; Jordan, "Stained Glass and the Liturgy."

75　Agostino Paravicini Bagliani, *Le Chiavi e la Tiara. Immagini e simboli del papato medievale* (Rome: Viella, 1998), 22-26.

76　Michel Pastoureau, "Les sceaux et la fonction sociale des images," in *L'Image. Fonctions et usages*, 275-308; Brigitte Bedos-Rezak, "Medieval Identity: A Sign and a Concept," *The American Historical Review* 105 (2000): 1489-1533; Fulton, *Judgment to Passion*, 255-60.

77　*Volto di Cristo*, 176-78; Wolf, *Schleier und Spiegel*, 115.

78　Hamburger, *St. John the Divine*, 178-81.

79　Achille Comoretto, *Le miniature del Sacramentario Fuldense di Udine* (Udine: Arti Grafiche Friulane, 1988); Éric Palazzo, *Les sacramentaires de Fulda. Études sur l'iconographie et la liturgie à l'époque ottonienne* (Münster: Aschendorff, 1994).

Notes to Chapter Four

1　Cf. Eamonn P. Kelly, "The Lough Kinale Book Shrine: the Implications for the Manuscripts," in *Book of Kells*, 280-89.

2　Michel Jeanneret, *A Feast of Words: Banquets and Table Talk in the Renaissance*, trans. Jeremy Whiteley and Emma Hughes (Cambridge: Polity, 1991), 118-39; Horst Wenzel, "Die Schrift und das Heilige," in *Die Verschriftlichung der*

Welt. Bild, Text und Zahl in der Kultur des Mittelalters und der Frühen Neuzeit, ed. Horst Wenzel, Wilfried Seipel, and Gotthart Wunberg (Milan: Skira, 2000), 14-57; Catherine E. Karkov, *Text and Picture in Anglo-Saxon England. Narrative Strategies in the Junius 11 Manuscript* (Cambridge: Cambridge University Press, 2001), 179.

3 Dutton and Kessler, *Poetry and Paintings*, 109.

4 Brenk, "Schriftlichkeit und Bildlichkeit", 50; Reudenbach, *Godescalc-Evangelistik*.

5 Wenzel, "Schrift und das Heilige," 35.

6 Diebold, "'Except I shall see'"

7 Ulrich Ernst, *Carmen Figuratum. Geschichte des Figurengedichts von den antiken Ursprüngen bis zum Ausgang des Mittelalters* (Cologne, Weimar, Vienna: Böhlau, 1991), 572-73; *I vangeli dei popoli*, ed. Francesco D'Aiuto, Giovanni Morello, Ambrogio Piazzoni (Vatican: Edizioni Rinnovamento nello Spirito Santo, 2000).

8 Ernst, *Carmen Figuratum*; Carol Farr, *The Book of Kells. Its Function and Audience* (London: The British Library, 1997), 181-83.

9 Raban Maur, *Louanges de la Sainte Croix*, trans. Michel Perrin (Paris: Berg International, 1988); Ernst, *Carmen Figuratum*, 222-332; Elizabeth Sears, "Louis the Pious as *Miles Christi*: The Dedicatory Image in Hrabanus Maurus's *De laudibus sanctae crucis*," in *Charlemagne's Heir: New Perspectives on the Reign of Louis the Pious* (Oxford: Clarendon Press, 1990), 605-28; Michele Ferrari, "*Hrabanica*. Hrabans *De laudibus sanctae crucis* im Spiegel der neueren Forschung," in *Kloster Fulda in der Welt der Karolinger und Ottonen*, ed. Gangolf Schrimpf (Frankfurt: Josef Knecht, 1996), 493-526, and *Il "Liber sanctae crucis" di Rabano Mauro: testo-immagine-contesto* (Bern: Peter Lang, 1999); Chazelle, *Crucified God*, 99-131.

10 Ernst, *Carmen Figuratum*, 602-14 et passim;

11 Gabrielle Sed-Rajna, *Les manuscrits Hébreux enluminés des Bibliothèques de France* (Louvain: Peeters, 1994).

12 Reiner Sörries, *Christlich-Antike Buchmalerei im Überblick* (Wiesbaden: Dr. Ludwig Reichert, 1993); Kemp, *Christliche Kunst*; Lowden, "The Beginnings of Biblical Illustration," in *Imaging the Early Medieval Bible*, 9-59.

13 Cf. Angelika Geyer, *Die Genese narrativer Buchillustration* (Frankfurt am Main: Vittorio Klostermann, 1989); David Wright, *The Vatican Vergil. A Masterpiece of Late Antique Art* (Berkeley and Los Angeles: University of California Press, 1993) and *Der Vergilius Romanus und die Ursprünge mittelalterlichen Buches* (Stuttgart: Belser, 2001); Alfred Stückelberger, *Bild und Wort. Das illus-*

trierte Fachbuch in der antiken Naturwissenschaft, Medizin und Technik (Mainz: Philipp von Zabern, 1994); *Vedere i classici*, ed. Guglielmo Cavallo (Rome: Palombi, 1996).

14 John Williams, "The Bible in Spain," in *Imaging the Early Medieval Bible*, 179-218.

15 Cf. Midori Tsuzumi, "On Textual Illustrations of the Medieval Psalters: State of Research," *Bulletin of Nagoya University of Arts* 15 (1994): 1-19, and "The Utrecht Psalter and the Late Antique Paintings: Source of Its Composition," *Memories of the Faculty of Education of Toyama University* 54 (2000): 63-77; Koert van der Horst, "The Utrecht Psalter: Picturing the Psalms of David," in *Utrecht Psalter*, 22-84; William Noel, "Medieval Charades and the Visual Syntax of the Utrecht Psalter," in *Studies in the Illustration of the Psalter*, ed. Brendan Cassidy and Rosemary Muir Wright (Stamford, Lincolnshire: Shaun Tyas, 2000), 34-41.

16 van der Horst, "Utrecht Psalter," 77.

17 *The Apocalypse in the Middle Ages*, ed. Richard K. Emmerson and Bernard McGinn (Ithaca: Cornell University Press, 1992); Yves Christe, *L'Apocalypse de Jean* (Paris: Picard, 1996); Klein, "From the Heavenly to the Trivial."

18 Deshman, *Benedictional of Æthelwold*, 156-57 et passim; van der Horst, "Utrecht Psalter," 81-83; Chazelle, "Archbishop Ebo and Hincmar of Reims," and *Crucified God*, 242-43 et passim.

19 K.M. Openshaw, "The Battle between Christ and Satan in the Tiberius Psalter," *Journal of the Warburg and Courtauld Institutes* 52 (1989): 14-33, and "The Symbolic Illustration of the Psalter: An Insular Tradition," *Arte medievale* 6 (1992): 41-60.

20 Peter K. Klein, "Stellung und Bedeutung des Bamberger Apokalypse-Zyklus," in *Das Buch mit 7 Siegeln. Die Bamberger Apokalypse*, ed. Gude Suckale-Redlefsen and Bernhard Schemmel (Luzern: Faksimile Verlag, 2000), 105-36.

21 Lewis, *Reading Images*.

22 *Gold und Purpur*, 27-37.

23 Reudenbach, *Godescalc-Evangelistar*, 11-36.

24 Anton von Euw, "Die ottonische Kölner Malerschule. Synthese der künstlerischen Strömungen aus West und Ost," in *Kaiser in Theophanu*, 251-80; Henry Mayr-Harting, *Ottonian Book Illumination. An Historical Study* (London: Harvey Miller, 1991), 99-117.

25 Sörries, *Christlich-Antike Buchmalerei*, 34-36; Lowden, "Beginnings," 43-45;

Richard Marsden, "The Gospels of St Augustine," in *St Augustine and the Conversion of England*, ed. Richard Gameson (Phoenix Mill, Gloucestershire: Sutton Publishing, 1999), 285-312.

26 *Das kostbare Evangeliar des Heiligen Bernward*, ed. Micheal Brandt (Munich: Prestel, 1993).

27 Lewis, *Reading Images*, 21-24.

28 Mildred Budny, "The *Biblia Gregoriana*," in *St Augustine and the Conversion of England*, 237-84.

29 Diane Reilly, "French Romanesque Giant Bibles and their English Relatives: Blood Relatives or Adopted Children?," *Scriptorium* 56 (2002): 294-311.

30 *Le bibbie atlantiche.*

31 Nees, "Problems of Form and Function," 148-74.

32 Kessler, *Spiritual Seeing*, 175-87; Dutton and Kessler, *Poetry and Painting*, 65-66.

33 Gaehde, "La decorazione."

34 Ulrich Kuder, "Die dem Hiobbuch vorausgestellten Bildseiten des 2. Bandes der Bible von Floreffe," in *"Per assiduum studium scientiae adipisci margaritam"*: *Festgabe für Ursula Nilgen zum 65. Gerburtstag*, ed. Annelies Amberger (St. Ottilien: EOS, 1997), 109-36; Anne-Marie Bouché, "The Spirit in the World: The Virtues of the Floreffe Bible Frontispiece: British Library, Add. MS 17738, ff. 3v-4r," in *Virtue & Vice. The Personifications in the Index of Christian Art*, ed. Colum Hourihane (Princeton: Department of Art and Archaeology of Princeton University, 2000), 42-65; Hamburger, *St. John the Divine*, 83-91.

35 Kessler, *Spiritual Seeing*, 11-12, 42-61 et passim; Hamburger, *St. John the Divine*, 171.

36 von Euw, "Ottonische Kölner Malerschule," 251-54

37 Cahn, *Romanesque Manuscripts*, vol. 2, 79-80; Travis, "Daniel in the Lions' Den."

38 Lewis, *Reading Images*, 217; Kessler, *Spiritual Seeing*, 9-10.

39 Chazelle, *Crucified God*, 242-43.

40 Eran Lupu, Sussan Babaie, Vera Basch Moreen, "Übersetzungen," in *Kreuzritterbibel*, 91-174; William Noel, "The First Iconographer of the Morgan Picture Bible," in *Book of Kings*, 109-19.

41 John Williams, *The Illustrated Beatus: A Corpus of Illustrations of the Commentary on the Apocalypse* (London: Harvey Miller, 1994).

42 Stirnemann, "L'illustration du commentaire d'Haymon."

43 Curschmann, "Imagined Exegesis."

44 *Regensburger Buchmalerei. Von frühkarolingischer Zeit bis zum Ausgang des Mittelalters* (Munich: Prestel-Verlag, 1987), 52-55.

45 Rudolph, *Violence & Daily Life.*

46 *Hildegardis Bingensis Liber Divinorum Operum*, ed. Derolez and Dronke.

47 Lowden, *Bibles Moralisées*, vol. 2, 199-209.

48 Prado-Vilar, "Shadow of the Gothic Idol," 52-58 et passim.

49 Christel Meier, "Illustration und Textcorpus. Zu kommunikations- und ordnungsfunktional Aspekten der Bilder in den mittelalterlicher Enzyklopädiehandschriften," *Frühmittelalterlichen Studien*: 31 (1997): 1-31; Robert Maxwell, "Seeing Signs and the Art of Transcribing in the Vierzon Cartulary," *Art Bulletin* 81 (1999): 576-97.

50 Rabani Mauri, *De universo aut De rerum naturis*, ed. Guglielmo Cavallo (Ivrea: Priuli & Verlucca, 1994); Giulia Orofino, *I codici decorati dell'Archivio di Montecassino*, vol. 2, pt. 2 (Rome: Istituto Poligrafico e zecca dello stato, 2000), 50-87.

51 Caviness, "Anchoress, Abbess, and Queen."

52 Lucy Freeman Sandler, *Omne bonum. A Fourteenth-Century Encyclopedia of Universal Knowledge. British Library MS Royal 6 E VI-6 E VII* (London: Harvey Miller, 1996).

53 *Age of Chivalry. Art in Platagenet England 1200-1400*, ed. Jonathan Alexander and Paul Binski (London: Weidenfeld and Nicolson, 1987), 148; Lina Bolzoni, *La rete delle immagini. Predicazione in volgare dalle origini a Bernadino da Siena* (Turin: Einaudi, 2002), 62-71.

54 Michael Camille, "Before the Gaze. The Internal Senses and Later Medieval Practices of Seeing," in *Visuality Before and Beyond the Renaissance*, 197-223.

55 Cf. Karkov, *Text and Picture*; Mary Coker Joslin and Carolyn Coker Joslin Watson, *The Egerton Genesis* (London: The British Library, 2001).

56 Benjamin C. Withers, "A 'secret and feverish genesis': the Prefaces of the Old English Hexateuch," *Art Bulletin* 81 (1999): 53-71.

57 Rainer Kahsnitz, "Inhalt und Aufbau der Handschrift," in *Kostbare Evangeliar*, 18-55.

58 John Lowden, "Illuminated Books and the Liturgy," in *Objects, Images, and the Word*, 17-53.

59 Éric Palazzo, *Le Moyen Âge. Des origines au XIIIe siècle* (Paris: Beauchesne,

1993), 145-49.

60 Éric Palazzo, *Le Moyen Âge*, 60-83; *Sacramentaires de Fulda*; and *L'évêque et son image*; Deshman, *Benedictional of Æthelwold;* Le Goff et al., *Le sacre royal*; Lowden, "Illuminated Manuscripts and the Liturgy."

61 Cf. Christine Jakobi-Mirwald, *Text-Buchstabe-Bild. Studien zur historisierten Initiale im 8. und 9. Jahrhundert* (Berlin: Reimer, 1998), 40-45 et passim; Kendrick, *Animating the Letter*, 80-81, 86-90 et passim.

62 Palazzo, *Sacramentaires*; Comoretto, *Miniature*.

63 Pierre Alain Mariaux, *Warmond d'Ivrée et ses images. Politique de création icono-graphique autour de l'an mil* (Bern: Peter Lang, 2002).

64 *Bonifacio VIII e il suo tempo*, ed. Marina Righetti Tosti-Croce (Milan: Electa, 2000), 138.

65 However, see Lowden, "Illuminated Books," 27-28.

66 Lucinia Speciale, *Montecassino e la Riforma Gregoriana. L'Exultet Vat. Barb. lat. 592* (Rome: Viella, 1991); *Exultet. Rotoli liturgici*; Beat Brenk and Guglielmo Cavallo *Exultet. Roma, Biblioteca Casantense, Cas. 724 [B.I.13] III* (Pavone Canavese: Priuli & Verlucca, 1994).

67 Magdalena Carrasco, "Spirituality in Context: the Romanesque Illustrated Life of St. Radegund of Poitiers (Poitiers, Bibl. Mun., MS 250)," *Art Bulletin* 72 (1990): 414-35; Barbara Abou-El-Haj, *The Medieval Cult of Saints. Formations and Transformations* (Cambridge: Cambridge University Press, 1994); Hahn, *Portrayed on the Heart*, 161-63 et passim; Lowden, "Illuminated Books."

68 Cahn, *Romanesque Manuscripts*, vol. 2, 13-14.

69 Hahn, "Voices of Saints."

70 Roger S. Wieck, *Time Sanctified. The Book of Hours in Medieval Art and Life* (New York: Braziller, 1988); Hamburger, *Visual and the Visionary*, 149-90; *Women and The Book*.

71 Michael Camille, *Image on the Edge. The Margins of Medieval Art* (Cambridge, MA: Harvard University Press, 1992), 11-14.

72 Kogman-Appel, "Hebrew Manuscript Painting."

73 Krasnodbska-D'Aughton, "Decoration of the *In principio* Initials."

74 Yolanta Załuska, *Manuscrits enluminés de Dijon* (Paris: Editions CNRS, 1991), 71-74; Cahn, *Romanesque Manuscripts*, vol. 1, 79-80; Travis, "Daniel in the Lions' Den."

75 Jeffrey Hamburger, *The Rothschild Canticles. Art and Mysticism in Flanders and*

the Rhineland circa 1300 (New Haven: Yale University Press, 1990), 134–36.

76 *Buch und Bild im Mittelalter* (Hildesheim: Ulrich Knapp, 1999), 91–115.

77 Rudolph, *Violence & Daily Life*.

78 Kendrick, *Animating the Letter*; Jakobi-Mirwald, *Text-Buchstabe-Bild*; Charles S. Buchanan, "Late Eleventh-Century Illuminated Initials from Lucca. Partisan Political Imagery During the Investiture Struggle," *Arte medievale*, 2nd ser. 12/13 (1998/1999): 65–73.

79 Giulia Orofino, "Il rapporto con l'antico e l'osservazione della natura nell'illustrazione scientifica di età sveva in Italia meridionale," in *Intellectual Life at the Court of Frederick II*, 129–49; Bräm, "Friedrich II. als Auftraggeber."

80 J.J.G. Alexander, "Ideological Representation of Military Combat in Anglo-Norman Art," *Anglo-Norman Studies* 15 (1992): 1–23.

81 *Mise en page et mise en texte du livre manuscrit*, ed. Henri-Jean Martin and Jean Vezin (Promodis: Editions du Cercle de la Librairie, 1990); Camille, *Image on the Edge*; Jeffrey Hamburger, review of Camille, *Art Bulletin* 75 (1993): 319–27; Veronika Sekules, "Beauty and the Beast: Ridicule and Orthodoxy in Architectural Marginalia in Early Fourteenth-Century Lincolnshire," *Art History* 18 (1995): 37–62; Lucy Freeman Sandler, "The Word in the Text and the Image in the Margin: The Case of the Luttrell Psalter," *Journal of the Walters Art Gallery* 54 (1996): 87–100; and "The Study of Marginal Imagery: Past, Present, and Future," *Studies in Iconography* 18 (1997): 1–49.

82 Cohen, *Uta Codex*, 33–38 et passim.

83 Kühnel, *Crusader Art*, 115–21.

84 Barbara Zeitler, "'Sinful Sons, Falsifiers of the Christian Faith': The Depiction of Muslims in a 'Crusader' Manuscript," *Mediterranean Historical Review* 12 (1997): 25–50.

85 Cahn, *Romanesque Manuscripts*, vol. 1, pl. IX.

86 Travis, "Daniel in the Lions' Den." On three-dimensional meander, cf. Wirth "Peintre et Perception."

87 Deshman, *Benedictional of Æthelwold*, 181–83.

88 Rouse and Rouse, *Manuscripts and their Makers*, vol. 1, 140–42.

89 Deshman, "Another Look."

90 Jean Wirth, "Les singes dans les marges à drôleries des manuscrits gothiques," *Micrologus* 8 (2000): 429–44.

91 Madeline Caviness, "No Laughing Matter: Imag(in)ing Chimeras and Freaks Around 1300," in *Magistro et Amico amici discipulique: Lechowi Kalinowskiemu w osiemdziesiolecie urodzin* (Crakow: Jagiellonian University, 2000), 87–100.

92 Hamburger, *St. John the Divine*, 49-50.

93 Dutton and Kessler, *Poetry and Paintings*, 34-35 et passim.

94 Hamburger, *Rothschild Canticles*, 72-82 et passim.

95 Kahsnitz, "Inhalt und Aufbau."

96 Kumiko Maekawa, *Narrative and Experience* (Frankfurt am Main: Peter Lang, 2000).

97 Reudenbach, *Godescalc-Evangelistar*, 51-67.

98 Bianca Kühnel, *From the Earthly to the Heavenly Jerusalem. Representations of the Holy City in Christian Art of the First Millennium* (Rome: Herder, 1987), 128-37.

99 Lewis, *Reading Images*, 293-94; Klein, "From the Heavenly to the Trivial," 269-74.

100 Rudolph, *Violence & Daily Life*, 44-49.

101 Dutton and Kessler, *Poetry and Paintings*, 94-95.

Notes to Chapter Five

1 Jean-Claude Schmitt, "L'Occident, Nicée II et les images du VIIIe au XIIIe siècle," *Nicée II* (Paris: Cerf, 1987), 271-301, and "Ecriture et image: les avatars médiévaux du modèle gregorien," in *Théories et pratiques de l'écriture au Moyen Âge* (Nanterre: Centre de recherches du Département de français de Paris X-Nanterre, 1988), 119-50; Duggan, "Was Art Really the 'Book of the Illiterate'?"; Chazelle, "Pictures, Books, and the Illiterate"; Wolf, *Salus populi romani*; Michael Curschmann, "Pictura laicorum litteratura," in *Pragmatische Schriftlichkeit im Mittelalter*, ed. Hagen Keller et al. (Munich: Fink, 1992), 211-29; Guglielmo Cavallo, "Testo e immagine: una frontiera ambigua," *Testo e immagine nell'alto medioevo*, 31-62; Celia Chazelle, "Memory, Instruction, Worship: Gregory's Influence on Early Medieval Doctrines of the Artistic Image," in *Gregory the Great. A Symposium* (Notre Dame, IN: University of Notre Dame, 1995), 181-215; Michael Camille, "The Gregorian Definition Revisited: Writing and the Medieval Image," in *L'image. Fonctions et usages*, 89-107; Weitmann, *Sukzession und Gegenwart*, 58-61; Hamburger, *Visual and the Visionary*; 111-13 Lawrence G. Duggan, "Reflections on 'Was Art Really the Book of the Illiterate?,'" in *Reading Images and Texts: Medieval Images and Texts as Forms of Communication*, ed. Mariëlle Hageman and Marco Mostert (Turnhout: Brepols, 2004); Kessler, "Gregory the Great and Image Theory."

2 Kurt Weitzmann and Herbert L. Kessler, *The Cotton Genesis* (Princeton: Princeton University Press, 1986), 18-20 et passim.

3 Jacoff, *Horses of San Marco*, 82.

4 Martin Büchsel, "Die Schöpfungsmosaiken von San Marco. Die Ikonographie der Erschaffung des Menschen in der frühchristlichen Kunst," *Städel Jahrbuch*, n.f., 13 (1991): 29-80.

5 Weitzmann and Kessler, *Cotton Genesis*, 57; Jolly, *Made in God's Image?*, 25.

6 Büchsel, "Schöpfungsmosaiken."

7 Søren Kaspersen, "Cotton-Genesis, die Toursbibeln und die Bronzetüren — Vorlage und Aktualität," in *Bernwardinishe Kunst*, 79-103; Rainer Kahsnitz, "Bronzetüren im Dom;" Cohen and Derbes, "Bernward and Eve"; Stahl, "Eve's Reach."

8 Stahl, "Eve's Reach."

9 Grodecki, *Études sur les vitraux*, 51-91.

10 *Le bibbie atlantiche.*

11 Calvin B. Kendall, *The Allegory of the Church. Romanesque Portals and their Verse Inscriptions* (Toronto: University of Toronto Press, 1998), 12.

12 Jérôme Baschet, *Lieu sacré, lieu d'images. Les fresques de Bominaco (Abruzzes, 1263) thèmes, parcours, fonctions* (Paris-Rome: Éditions la découverte, 1991).

13 Bruno Reudenbach, "'Ornatus materialis domus Dei'. Die theologische Legitimation handwerklicher Künste bei Theophilus," in *Studien zur Geschichte der europäischen Skulptur*, 1-16; Alexandre-Bidon, "Une foi en deux ou trois dimensions?"

14 Giselle de Nie, "Paulinus of Nola and the Image within the Image," in *Reading Images and Texts*.

15 Herbert L. Kessler, "Storie sacre e spazi consacrati: la pittura narrativa nelle chiese medievali (sec. IV-XII)," in *L'arte medievale nel Contesto. Iconografia, funzioni, tecniche*, ed. Paolo Piva (Milan: Jaca Books, 2004), 275-302.

16 Mariaux, "La 'double' formation;" Alexandre-Bidon, "Une foi en deux ou trois dimensions?"

17 Zchomelidse, *Santa Maria Immacolata*, 131-45.

18 Jerrilyn Dodds, "Las Pinturas de San Julián de los Prados: Arte, diplomacia, y herejia," *Goya* 191 (1986): 258-63.

19 Suckale, *Mittelalterliche*.

20 Roberto Tollo, "Le pitture dell'oratorio inferiore della cappella di San Nicola a Galluccio," *Bollettino d'Arte* 86-87 (1994): 85-110; Kirsten Noreen, "Lay Patronage and the Creation of Papal Sanctity during the Gregorian

Reform: The Case of Sant'Urbano alla Caffarella, Rome," *Gesta* 40 (2001): 61-79; Kessler, *Old St. Peter's*, 45-95.

21 Jerrilyn Dodds, "Wall Paintings (Hermitage of San Baudelio de Berlanga)," in *Art of Medieval Spain*, 223-28.

22 Gillian Mackie, *Early Christian Chapels in the West. Decoration, Function, and Patronage* (Toronto: University of Toronto Press, 2003).

23 Helmut Schlunk, *Die Mosaikkuppel von Centcelles* (Mainz: Philipp van Zabern, 1988); ed. Javier Arce, *Centcelles. El monumento tardorromano* (Rome: L'Erma di Bretschneider, 2002); Mackie, *Early Christian Chapels*, 154-56.

24 Hélène Toubert, *Un art dirigé* (paris: Edition du Cerf, 1990) 367-402.

25 Franz Alto Bauer, "La frammentazione liturgica nella chiesa Romana del primo medioevo," *Rivista di Archeologia Cristiana* 75 (1999): 385-446, and "Überlegungen zur liturgischen Parzellierung des römischen Kirchenraums im frühen Mittelalter," in *Bildlichkeit und Bildorte von Liturgie. Schauplätze in Spätantike, Byzanz, und Mittelalter*, ed. Rainer Warland (Wiesbaden: Reichert, 2002), 75-96; John Crook, *The Architectural Setting of the Cult of Saints in the Early Christian West c. 300-c.1200* (Oxford: Oxford University Press, 2000).

26 Cristiana Filippini, "La chiesa e il suo santo: gli affreschi dell'undicesimo secolo nella chiesa di S. Clemente a Roma," in *Art, Cérémonial et Liturgie au Moyen Âge*, 107-24.

27 Paolo Piva, "San Pietro al Monte de Civate (Lecco): lecture iconographique en 'contexte,'" *Cahiers archéologiques* 49 (1992): 69-84.

28 Jens T. Wollesen, *Pictures & Reality. Monumental Frescoes and Mosaics in Rome around 1300* (New York: Peter Lang, 1998), 51-73.

29 Erik Thunø, "The Dating of the Facade Mosaics of S. Maria Maggiore in Rome," *Analecta Romana* 23 (1996): 61-82.

30 Low, "'You who once were far off.'"

31 Peter K. Klein, "Programmes eschatologiques, fonction et réception historiques des portails du XIIe siècle: Moissac-Beaulieu-Saint-Denis," *Cahiers de civilisation médiévale* 33 (1990): 317-49.

32 Piotr Skubiszewski, "Le trumeau et le linteau de Moissac: Un cas du symbolisme médiéval," *Cahiers archéologiques* 40 (1992): 51-90.

33 Skubiszewski, "Trumeau"; Antonio Iacobini, "L'albero della vita nell'immaginario medievale: Bisanzio e l'Occidente," in *L'architettura medievale in Sicilia: la cattedrale di Palermo* (Rome: Istituto della Enciclopedia Italiana, 1994), 241-90.

34 Valentino Pace, "'Dalla morte assente alla morte presente': Zur bildlichen Vergegenwärtigung des Todes im Mittelalter," in *Tòd im Mittelatler*, ed. Arno Borst, Gerhart von Graevenitz, Alexander Patschovsky, and Karlheinz Stierle (Konstanz: UVK, 1993), 335-76; Ilene Forsyth, "Narrative at Moissac: Schapiro's Legacy," *Gesta* 41 (2002): 71-93.

35 Jérôme Baschet, *Le sein du père. Abraham et la paternité dans l'occident médiéval* (Paris: Gallimard, 2000).

36 Schlink, *Beau-Dieu*; Murray, *Notre-Dame*.

37 Willibald Sauerländer, "Reliquien, Altäre und Portale," in *Kunst und Liturgie*, 121-34.

38 Binski, *Medieval Death*, 71-92.

39 Filippini, "Chiesa."

40 Josef Engemann, *Deutung und Bedeutung frühchristlicher Bildwerke* (Darmstadt: Primus Verlag, 1997).

41 Richard Gem, "Documentary References to Anglo-Saxon Painted Architecture," in *Early Medieval Wall Painting and Painted Sculpture in England*, ed. Sharon Cather, David Park, and Paul Williamson (Oxford: BAR, 1990), 1-12.

42 Creighton Gilbert, *The Saints' Three Reasons for Paintings in Churches* (Ithaca: Clandestine Press, 2001).

43 Diether Rudloff, *Zillis: die romanische Bilderdecke der Kirche St Martin* (Basel: P. Hemen, 1989); Wolfgang Kemp, "Medieval Pictorial Systems," in *Iconography at the Crossroads*, ed. Brendan Cassidy (Princeton: Department of Art and Archaeology, 1993), 121-33; Wirth, *L'image à l'époque romane*, 333-61 et passim.

44 Grazio Gianfreda, *Il mosaico di Otranto. Biblioteca medioevale in immagini* (Lecce: Edizioni del Grifo, 2001).

45 Xavier Barral I Altet, "Il mosaico pavimentale," in *La pittura in Italia. L'Altomedioevo*, ed. Carlo Bertelli (Milan: Electa, 1994), 480-98, and "La mosaïque de pavement romane et les tapis de sol," in *Milieux naturels, espaces sociaux. Etudes offertes à Robert Delort* (Paris: Publications de la Sorbonne, 1997), 409-20.

46 Kemp, "Medieval Pictorial Systems" and *Christliche Kunst*.

47 Kessler, *Old St. Peter's*, 152-57 et passim.

48 Marilyn Lavin, *The Place of Narrative. Mural Decoration in Italian Churches, 431-1600* (Chicago: University of Chicago Press, 1990).

49 Herbert L. Kessler, "San Pietro in Valle: fonti e significato," in *San Pietro in Valle presso Ferentillo*, ed. Giulia Tamanti (Naples: Electa, 2003), 77-116.

50 Russo, "Espace peint."

51 Piva, "San Pietro."

52 Baschet, *Lieu sacré*.

53 Arnulf, *Versus ad Picturas*, 293-95.

54 Kessler, *Old St. Peter's*, 166-70 et passim; Nino Zchomelidse, "Das Bild im Busch. Zu Theorie und Ikonographie der alttestamentlichen Gottesvision im Mittelalter," in *Die Sichtbarkeit des Unsichtbaren zur Korrelation von Text und Bild im Wirkungskreis der Bibel* (Stuttgart: Deutsch Bibelgesellschaft, 2003), 165-89. The reference is specifically to the Lateran *acheropita*. Christ is also pictured in the burning bush at Saint-Denis.

55 van Dijk, "The Angelic Salutation;" Deshman, "Servants of the Mother of God."

56 Anne Derbes, *Picturing the Passion in Late Medieval Italy. Narrative Paintings, Franciscan Ideologies, and the Levant* (Cambridge: Cambridge University Press, 1996); Fulton, *From Judgment to Passion*, 78-87 et passim.

57 Marcia Kupfer, "Spiritual Passage and Pictorial Strategy in the Romanesque Frescoes at Vicq," Art Bulletin 68 (1986): 35-53 and *Romanesque Wall Painting*, 129.

58 Anna Kartsonis, *The Anastasis. The Making of an Image* (Princeton: Princeton University Press, 1986), 88-93.

59 Norbert Wibiral, *Die romanische Klosterkirche in Lambach und ihre Wandmalereien* (Vienna: Verlag der österreichischen Akademie der Wissenschaften, 1998).

60 Kupfer "Spiritual Passage" and *Romanesque Wall Painting*, 133. See also Hélène Toubert, "*La Vierge et les sages-femmes. Un jeu iconographique entre les Évangiles apocryphes et le drame liturgique*," in *Marie. Le culte de la Vierge dans la société médiévale*, ed. Dominique Iogna-Prat et al. (Paris: Beauchesne,1995), 327-52.

61 van Dijk, "Jerusalem, Antioch, Rome, and Constantinople."

62 Hahn, "Seeing and Believing."

63 Romano, *La basilica di San Francesco*, 101-39 et passim.

64 Jean-Claude Schmitt, "Les reliques et les images," in *Les reliques. Objets, cultes, symboles*, ed. E. Bozóky and A.-M. Helvétius (Turnhout: Brepols, 1999), 145-59.

65 Claudia Zaccagnini, "Nuove osservazioni sugli affreschi altomedievali della chiesa romana di S. Prassede," *Rivista dell'istituto nazionale d'archeologia e storia dell'arte*, 54, ser. 3, 12 (1999): 83-114.

66 Dale, *Relics, Prayer, and Politics*, 66-76.

67 Zchomelidse, *Santa Maria Immacolata*, 137-40. It is telling that the theme was introduced through a borrowing from secular art; cf. *Vedere i classici*, figs. 132-33.

68 Maria Andaloro and Serena Romano, "L'immagine nell'abside," in *Arte e iconografia*, 93-132.

69 Neuheuser, "Kirchweihbeschreibungen von Saint-Denis"; Bonne, "Entre l'image et la matière."

70 Jérôme Baschet, "Ornementation et structure narrative dans les peintures de la nef de Saint-Savin," in *Le rôle de l'ornement dans la peinture murale du Moyen Age* (Poitiers: CESCM, 1995), 165-76.

71 Barral I Altet, "Il mosaico pavimentale."

72 Caviness, *Sumptuous Arts*, 37-39.

73 Kemp, *Christliche Kunst*, 149-81.

74 Kessler, "San Pietro in Valle."

75 Zchomelidse, *Santa Maria Immacolata*.

76 Kupfer "Spiritual Passage" and *Romanesque Wall Painting*, 132-44.

77 Jacqueline Jung, "Beyond the Barrier: The Unifying Role of the Choir Screen in Gothic Churches," *Art Bulletin* 82 (2000): 622-57.

78 Bram Kempers and Sible de Blaauw, "Jacopo Stefaneschi, Patron and Liturgist. A New Hypothesis Regarding the Date, Iconography, Authorship and Function of His Altarpiece for Old Saint Peter's," *Mededelingen Rome*, 47 n.s. 12 (1987): 83-113.

79 Jürg Goll, "Bei Salome in Müstair," in *Wege zur Romanik* (Innsbruck-Bozen: Arunda, 2001), 87-98.

80 Andaloro and Romano, "L'immagine nell'abside;" Ursula Nilgen, "Die Bilder über dem Altar," in *Kunst und Liturgie,* 74-89.

81 Freeman and Meyvaert, "Meaning of Theodulf's Apse."

82 Telesko, "Ein Kreuzreliquiar in der Apsis?"; Bonne, "De l'ornement à l'ornementalité."

83 Miklos Boskovits, "Appunti per una storia della tavola medioevo: osservazioni preliminari," in *Arte cristiana* 753 (1992): 422-38; Elvio Lunghi, *Il Crocefisso di Giunta Pisano e l'Icona del "Maestro di San Francesco" alla Poziuncola* (Assisi: Edizioni Porziuncola, 1995).

84 Dodds, "Wall Paintings."

85 Eric Thunø, *"Decus suus splendet ceu Phoebus in orbe*. Zum Verhältnis von Text und Bild in der Apsis Santa Maria in Dominica in Rom," in *Sichtbarkeit*

des Unsichtbaren, 147-64.

86 Wolf, *Salus populi romani*, 171-96; Tomei, *Iacobus Torriti*, 99-125.

87 William Tronzo, "Between Icon and the Monumental Decoration of a Church: Notes on Duccio's *Maestà* and the Definition of the Altarpiece," in *Icon*, ed. Gary Vikan (Washington, DC: The Trust for Museum Exhibitions, 1988), 36-47.

88 Kessler, "Storie sacre."

89 *Abt Suger von Saint-Denis*, 344-45.

90 Caviness, *Sumptuous Arts*, 43-45.

91 Paul Binski, "The Angel Choir at Lincoln and the Poetics of the Gothic Smile," *Art History* 20 (1997): 350-74.

92 Kessler, *Spiritual Seeing*, 111-13.

93 Yves Christe, "L'autel des innocents: Ap 6, 9-11 en regard de la liturgie de la toussaint et des saints innocents," in *Kunst und Liturgie*, 91-100.

94 John Mitchell, "The Crypt Reappraised," in *San Vincenzo al Volturno 1*, ed. Richard Hodges (London: British School at Rome, 1993), 75-114.

95 Dale, *Relics, Prayer, and Politics*.

96 Martina Bagnoli, "Le fonti e i documenti per l'indagine iconografica," in *Un universo di simboli. Gli affreschi della cripta nella cattedrale di Anagni*, ed. Gioacchino Giammaria (Rome: Viella, 2001), 71-86.

97 Russo, "Espace peint"; Bonne, "Concordia discors temporum."

98 Klaus Krüger, "Das Aschaffenburger Tafelbild. Überlegungen zur Funktion und Deutung," in *Das Aschaffenburger Tafelbild. Studien zur Tafelmalerei des 13. Jahrhunderts*, ed. Erwin Emmerling and Cornelia Ringer (Munich: Bayerisches Landesamt für Denkmalpflege, 1997), 293-306.

99 Julian Gardner, "Altars, Altarpieces, and Art History: Legislation and Usage," in *Italian Altarpieces 1250-1550*, ed. Eve Borsook and Fiorella Superbi Gioffredi (Oxford: Clarendon 1994), 5-40.

100 *L'altare d'oro di Sant'Ambrogio*, ed. Carlo Capponi (Cinisello Balsamo: Silvano Editoriale, 1996); Cynthia Hahn, "Narrative on the Golden Altar of Sant'Ambrogio in Milan: Presentation and Reception," *Dumbarton Oaks Papers* 53 (1999): 167-87; Bogen, *Träumen und Erzählen*, 95-98; Werner Telesko, "Bildgeschichte und Geschichtsbild. Untersuchungen zur Vorbildlichkeit christologischer Bildtypen von 'Teppich von Bayeux' bis zur 'Historia Troiana,'" in *Krieg und Sieg. Narrative Wanddarstellungen von Altägypten bis ins Mittelalter*, ed. Manfred Bietak and Mario Schwarz (Vienna: Eisenbrauns, 2002), 201-25.

101 Wolfgang Kemp, "Substanz wird Form. Form ist Beziehung. Zum Remaklus-Altar der Abtei Stavelot," in *Kunst und Sozialgeschichte*, ed. Martin Papenbrock et al. (Pfaffenweiler: Centaurus, 1995), 219-34; Susanne Wittekind, "Liturgiereflexion in den Kunststiftungen Abt Wibalds von Strabo," in *Art, Cérémonial et Liturgie*, 503-24.

102 Suckale, *Mittelalterliche Bild*, 46-55.

103 Paul Binski, "The English Parish Church and its Art in the Later Middle Ages: A Review of the Problem," *Studies in Iconography* 20 (1999): 1-25.

104 Marco Ciatti, "The Typology, Meaning, and Use of Some Panel Paintings from the Duecento and Trecento," in *Italian Panel Painting of the Duecento and Trecento*, 15-29; Lars Jones, "Visio Divina? Donor Figures and Representations of Imagistic Devotion: The Copy of the 'Virgin of Bagnolo' in the Museo dell'Opera del Duomo, Florence," in *Italian Panel Painting*, 30-55.

105 Cohen, *Uta Codex*, 81-86.

106 Durand, "Grande Châsse."

107 Anita Moskowitz, "Arnolfo, Non-Arnolfo: New (and Some Old) Observations on the Ciborium of San Paolo fuori le mura," *Gesta* 37 (1998): 88-102.

108 William Tronzo, "The Shape of Narrative. A Problem in the Mural Decoration of Early Medieval Rome," in *Roma nell'alto medioevo* (*Settimane di studio del Centro italiano di studi sull'alto medioevo*, 48) (Spoleto: CISAM, 2001), 457-87.

109 Kessler, *Old St. Peter's*, 153, 156.

110 Iris Grötecke, *Das Bild des Jüngsten Gerichts* (Worms: Wernersche Verlagsgesellschaft, 1997).

111 Peter Klein, "L'emplacement du Jugement Dernier et de la Seconde Parousie dans l'art monumental du Haut Moyen Age," in *L'emplacement et la fonction des images dans la peinture murale du Moyen Age* (Saint-Savin: Abbaye de Saint-Savin, 1993), 89-101.

112 Piva, "San Pietro in Monte."

113 Wisskirchen, *Mosaiken*, 54-65.

114 Jordan, "Stained Glass and the Liturgy."

115 Kees van der Ploeg, "How Liturgical Is a Medieval Altarpiece?" in *Italian Panel Painting*, 103-21.

116 Bonne, "Concordia discors temporum."

117 On the "copious chaos" of church interiors, cf. Binski, "English Parish Church."

118 Alexandre-Bidon, "Une foi en deux ou trois dimensions?"

119 Schmitt, "L'Occident" and "Ecriture"; Chazelle, "Pictures" and "Memory, Instruction, Worship: Gregory's Influence on Early Medieval Doctrines of the Artistic Image," in *Gregory the Great. A Symposium* (Notre Dame, IN: University of Notre Dame, 1995), 181-215; Duggan, "Book of the Illiterate"; Camille, "Gregorian Definition."

120 Kessler, "Storie sacre."

121 Arnulf, *Versus ad Picturas*, 293-95.

122 Kessler, *Old St. Peter's*, 105-24.

123 Rudolph, *"Things of greater importance."*

124 Duggan, "Books of the Illiterate." The precise meaning of "lay" is highly contested.

125 Rudolph, *"Things of Greater Importance."*

126 Willene B. Clark, *The Medieval Book of Birds. Hugh of Fouilloy's Aviarium* (Binghamton, NY: Center for Medieval and Renaissance Studies, 1992).

127 Klaus Krüger, "Die Lesbarkeit von Bildern. Bermerkungen zum bildungssoziologischen Kontext von kirchlichen Bildausstattungen im Mittelalter," in *Bild und Bildung*, ed. Christian Rittelmeyer and Erhard Wiersing (Wiesbaden: Wolfenbüttler Forschungen, 1991), 105-33.

128 Kessler, *Old St. Peter's*, 135-39; Filippini, "Chiesa."

129 Toubert, *Un art dirigé*, 365-402.

130 Kessler and Zacharias, *Rome 1300*, 159-60.

131 Thomas E. A. Dale, "Monsters, Corporeal Deformities, and Phantasms in the Cloister of St-Michel-de-Cuxa," *Art Bulletin* 83 (2001): 402-36.

132 Jean-Claude Schmitt, "Les dimensions multiples du voir. Les rêves et l'image dans l'autobiographie de conversion d'Hermann le Juif au XII siècle," in *La visione e lo sguardo nel Medio Evo* (Turnhout: Brepols, 1998), 1-27.

133 Freedberg, "Holy Images and Other Images."

134 Kessler, *Old St. Peter's*, 163-65.

135 Kessler, *Spiritual Seeing*, 136-39.

136 Faupel-Drevs, *Vom rechten Gebrauch*, 205-46.

137 Bonne, "Concordia discors temporum."

138 Rudolph, *Artistic Change*, 57-63; Bonne, "Pensée de l'art;" Vasilu, "Mot et le verre"; Christoph Markschies, *Gibt es eine "Theologie der gotischen Kathedrale?" Nochmal: Suger von Saint-Denis und Sankt Dionys vom Areopag* (Heidelberg: Heidelberger Akademie der Wissenschaften, 1995), 23-54; Kessler; *Spiritual Seeing*, 190-205; Andreas Speer, "L'abbé Suger et le trésor de Saint-Denis: Une approche de l'expérience artistique au Moyen Âge," in *L'abbé Suger,*

59-82; Francesca dell'Acqua, *"Illuminando colorat"* La vetrata tra l'età tardo imperiale e l'alto medioevo: le fonti, l'archeologia (Spoleto: CISAM, 2003).

Notes to Chapter Six

1 Geyer, *Genese narrativer Buchillustration*; Stückelberger, *Bild und Wort*; *Vedere i classici*.

2 Bianca Kühnel, *End of Time in the Order of Things* (Regensburg:Schnell & Steiner, 2003), 75-78 et passim.

3 Anton von Euw, "Die Maiestas-Domini-Bilder der ottonischen Kölner Malerschule im Licht des platonische Weltbildes. Codex 192 der Kölner Dombibliothek," in *Kaiserin Theophanu*, vol. 1, 379-98.

4 *Der Leidener Aratus. Antike Sternbilder in einer karolingischen Handschrift* (Munich: Bayerische Staatsbibliothek, 1989).

5 Beat Brenk, "Antikenverständnis und weltliches Rechtsdenken im Skulpturenprogramm Friedrichs II. in Capua," in *Musates. Festschrift für Wolfram Prinz zu seinem 60. Geburtstag am 5. Februar 1989*, ed. Ronald Kecks (Berlin: Gebr. Mann, 1989), 93-103; Orofino, "Rapporto con l'antico."

6 Lewis, *Art of Matthew Paris*, 71-75.

7 Minta Collins, *Medieval Herbals. The Illustrative Traditions* (London: The British Library, 2000).

8 Xénia Muratova, "Sources classiques et paléochrétiennes des illustrations des manuscrits des Bestiaires," *Bulletin de la Société nationale des antiquaires de France* 1991: 29-50 and "Le Bestiaire médiéval et la culture normand," in *Manuscrits et enluminures dans le monde normand*, ed. Monique Dosdat and Pierre Bouet (Caen: Presses Universitaires de Caen, 1999), 151-66; *Bestiaires du Moyen Age*, ed. Gabriel Bianciotto (Paris: Stock, 1995); Joyce E. Salisbury, *The Beast Within: Animals in the Middle Ages* (New York: Routledge, 1994); Ron Baxter, *Bestiaries and their Users in the Middle Ages* (London: Sutton, 1998)

9 Clark, *Medieval Book of Birds.*

10 Stückelberger, *Bild und Wort*, 93-94.

11 Uta Lindgren, "Gerbert von Reims und die Lehre des Quadriviums," in *Kaiserin Theophanu*, vol. 2, 291-303; Bruce Eastwood, "The Astronomy of Macrobius in the Carolingian Empire: Dungal's Letter of 811 to Charles the Great," *Early Medieval Europe* 3 (1994): 117-34; Barbara Obrist, "Le dia-

gramme isidorien des saisons, son contenu physique et les représentations figuratives," *Mélanges de l'École française de Rome, Moyen Age* 108 (1996): 95-164; Meier, "Illustration und Textcorpus."

12 von Euw, "Maiestas-Domini-Bilder."

13 Cohen, *Uta Codex*, 157-73.

14 Kühnel, *End of Time*, 222-24 et passim.

15 *Rabano Mauro. De rerum naturis*; Orofino, *I codici decorati*.

16 Sandler, *Omne bonum*; Meier, "Illustration und Textcorpus."

17 von Euw, "Maiestas-Domini-Bilder;" Kühnel, *End of Time*, 218-19.

18 Orofino, "Rapporto con l'antico."

19 R.N. Swanson, "Passion and Practice: the Social and Ecclesiastical Implications of Passion Devotion in the Late Middle Ages," in *The Broken Body. Passion Devotion in Late-Medieval Culture*, ed. A. A. MacDonald et al. (Groningen: Egbert Forsten, 1998), 1-30.

20 Zchomelidse, *Santa Maria Immacolata*, 137-40.

21 Prado-Vilar, "Shadow of the Gothic Idol,", 65-75.

22 Christel Meier, "Malerei des Unsichtbaren. Über den Zusammenhang von Erkenntnistheorie und Bildstruktur im Mittelalter," in *Text und Bild, Bild und Text*, ed. Wolfgang Harms (Stuttgart: J. B. Metzler, 1990), 35-64.

23 van der Horst et al., eds., "Utrecht Psalter," 80 et passim.

24 Kessler, "Rome's Place between Judaea and Francia in Carolingian Art."

25 Manuel Antonio Castiñeiras González, "From Chaos to Cosmos: The Creation Iconography in the Catalan Romanesque Bibles," *Arte medievale*, n.s. 1 (2002): 35-50.

26 Peter S. Baker and Michael Lapidge, *Byrhtferth's Enchiridion* (Oxford: Oxford University Press, 1995); Jennifer O'Reilly, "Patristic and Insular Traditions," in *Le Isole britanniche e Roma in etá romanobarbarica* (Rome: Herder, 1998), 77-94; Kühnel, *End of Time*, 181-83; Nees, "Reading Aldred's Colophon."

27 Robert Stevick, "The Harmonic Plan of the Harburg Gospels' Cross-page," *Artibus et Historiae* 23 (1991): 39-51, and *The Earliest Irish and English Book Arts. Visual and Poetic Forms before A.D. 1000* (Philadelphia: University of Pennsylvania Press, 1994).

28 O'Reilly, "Patristic and Insular Traditions."

29 Bagnoli, "Le fonti e i documenti."

30 Cf. Sicard, *Diagrammes médiévaux*; Fabio Troncarelli, "A Terrible Beauty. Nascità ed evoluzione del *Liber Figurarum*," *Florensia* 11 (1997): 7-40.

31 Cohen, *Uta Codex*, 157-73; Annette Krüger and Gabriele Runge, "Lifting

the Veil: Two Typological Diagrams in the *Hortus Deliciarum*," *Journal of the Warburg and Coutauld Institutes* 60 (1997): 1-22.

32 Meier, "Malerei des Unsichtbaren"; Édouard Jeauneau, "A New Edition of Eriugena's *Periphyseon*," in *Corpus Christianorum Continuatio Mediaevalis*, 161-65 (Turnhout: Brepols, 1995), 17-26.

33 Gaetano Curzi, *La pittura dei Templari* (Cinisello Balsamo: Sylvana, 2002).

34 Serafín Moralejo, "El mapa de la diaspora apostolica en San Pedro de Rocas: Notas para su interpretación y filiación en la tradición cartógrafica de los 'beatos,'" *Compostellanum* 31 (1986): 315-40; Anna-Dorothee von den Brincken, *Fines Terrae. Die Enden der Erde und der vierte Kontinent auf mittelal-terlichen Weltkarten* (Hannover: Hahnsche Buchhandlung, 1992); Marcia Kupfer, "Medieval World Maps: Embedded Images, Interpretive Frames," *Word and Image* 10 (1994): 262-88, and "The Lost Wheel Map of Ambrogio Lorenzetti," *Art Bulletin* 78 (1996): 286-310; David S. Areford, "The Passion Measured: A Late-Medieval Diagram of the Body of Christ," in *Broken Body*, 210-38; David Connolly, "Imagined Pilgrimage in the Itinerary Maps of Matthew Paris," *Art Bulletin* 81 (1999): 598-622.

35 Binski, *Painted Chamber*, 44; Kupfer, "Medieval World Maps."

36 Kemp, "Medieval Pictorial Systems."

37 Birgit Hahn-Wörnle, *Die Ebstorfer Weltkarte* (Stuttgart: Josef Fink, 1987); Kline, *Maps of Medieval Thought*, 52-75 et passim.

38 Kupfer, "Medieval World Maps."

39 Bonne, "*Concordia discors temporum.*"

40 Kessler, *Spiritual Seeing*, 197-99.

41 Forsyth, "Narrative at Moissac."

42 Michael Camille, "Mouths and Meanings: Towards an Anti-Iconography of Medieval Art," in *Iconography at the Crossroads*, 43-57.

43 Jean-Claude Schmitt, *La raison des Gestes dans l'Occident médiéval* (Paris: Gallimard, 1990), 263-65; Dale, "Monsters."

44 Schmitt, *Raison des Gestes*, 264.

45 Camille, *Mirror in Parchment*, 244-45.

46 Diane Wolfthal, "'A Hue and a Cry': Medieval Rape Imagery and its Transformation," *Art Bulletin* 75 (1993): 39-64.

47 Jonathan J.G. Alexander, "Dancing in the Streets," *Journal of the Walters Art Gallery* 54 (1996): 147-62.

48 Joslin and Watson, *Egerton Genesis*, 176-77.

49 Wirth, *L'Image à l'époque romane*, 304-14 et passim; *L'image*, 256; Forsyth, "Narrative at Moissac."

50 Dale, "Monsters."

51 Arnulf, *Versus ad Picturas*, 293-95.

52 Camille, *Image on the Edge*; Joslin and Watson, *Egerton Genesis*.

53 Kölmel, "Ornatus mundi-Contemptus mundi"; Rudolph, "In the Beginning.

54 Jolly, *Made in God's Image*.

55 Clark, *Medieval Book of Birds*, 223.

56 Stephen G. Nichols, "Ekphrasis, Iconoclasm, and Desire," in *Rethinking the Romance of the Rose. Text, Image, Reception*, ed. Kevin Brownlee and Sylvia Huot (Philadelphia: University of Pennsylvania Press, 1992), 133-60.

57 Camille, "Before the Gaze"; James Bugslag, "'contrefais al vif': Nature, Ideas and Representation in the Lion Drawings of Villard de Honnecourt," *Word and Image* 17 (2001): 360-78.

58 Lewis, *Art of Matthew Paris*, 212-16; Bugslag, "'contrefais al vif.'"

59 Draghi, "Ciclo di affreschi."

60 Jonathan Alexander, "*Labeur* and *Paresse*: Ideological Representations of Medieval Peasant Labor," *Art Bulletin* 72 (1990): 436-52.

61 Tomei, *Iacobus Torriti Pictor*, 109; Gardner, "Torriti's Birds."

62 Kelly M. Holbert, "Picturing the World in the Thirteenth Century," in *Book of Kings*, 60-67; Stephen N. Fliegel, "The Art of War: Thirteenth-Century Arms and Armor," in *Book of Kings*, 82-97.

63 Thurre, "Trésors ecclésiastiques," 52-54.

64 Gude Suckale-Redlefsen, *Mauritius: Der heilige Mohr* (Munich: Schnell & Steiner, 1987).

65 Rudolph, *Violence & Daily Life*, 51-56 et passim.

66 Bolzoni, *Rete delle immagini*, 63-71.

67 Andreas Speer, "The Discovery of Nature. The Contribution of the Chartrians to Twelfth-Century Attempts to Found a *Scientia Naturalis*," *Traditio* 52 (1997): 135-51; Michael Camille, "Bestiary or Biology? Aristotle's Animals in Oxford, Merton College, Ms. 271," in *Aristotle's Animals in the Middle Ages and Renaissance*, ed. Carlos Steel, Guy Guldentops, and Pieter Buellens (Louvain: University of Leuven Press, 1999), 355-96; Jeffrey Hamburger, "Idol Curiosity," in *Curiositas. Welterfahrung und ästhetische Neugierge in Mittelalter und früher Neuzeit*, ed. Klaus Krüger (Gottingen: Wellstein, 2002), 21-58.

68 Piero Morpurgo, "*Philosophia naturalis* at the Court of Frederick II: From the Theological Method to the *ratio secundum physicam* in Michael Scot's *De Anima*," in *Intellectual Life at the Court of Frederick II*, 241-28; Massimo

Oldoni, "La promozione della scienza: L'Università di Napoli," in *Intellectual Life*, 251-61.

69 Alain Besançon, *The Forbidden Image. An Intellectual History of Iconoclasm*, trans. Jane Marie Todd (Chicago: University of Chicago Press, 2000), 158-64.

70 *Sancta Sanctorum*; Wirth, "Peinture et perception."

71 Hamburger, "Seeing and Believing."

72 T.A. Heslop, "Attitudes to the Visual Arts: The Evidence from Written Sources," in *Age of Chivalry*, 26-32; Camille, *Gothic Idol*, 214-15.

73 Bynum, *Resurrection of the Body*.

74 Klaus Krüger, "Mimesis als Bildlichkeit des Scheins — Zur Fiktionalität religiöser Bildkunst im Trecento," in *Künstlerischer Austausch*, ed. Thomas Gaehtgens (Berlin: Akademie Verlag, 1994), 423-36; Joseph Koerner, "The Icon as Iconoclash," in *Iconoclash*, ed. Bruno Latour and Peter Weibel (Cambridge, MA: MIT Press, 2002), 164-213.

75 Victoria M. Morse, "Seeing and Believing. The Problem of Idolatry in the Thought of Opicino de Canistris," in *Orthodoxie, Christianisme, Histoire*, ed. Susanna Elm, Éric Rebillard, and Antonella Romano (Rome: École Française, 2000), 163-76.

76 Hamburger, *Visual and Visionary*.

77 Jean Wirth, "Structure et fonctions de l'image chez saint Thomas d'Aquin," in *L'.image. Fonctions et usages*, 39-57.

78 Madeline Caviness, "'The Simple Perception of Matter' and the Representation of Narrative, ca. 1180-1280," *Gesta* 30 (1991): 48-64; Bogen, *Träumen und Erzählen*, 326-36 et passim.

79 Norbert H. Ott, "Texte und Bilder. Beziehungen zwischen den Medien Kunst und Literatur in Mittelalter und früher Neuzeit," in *Verschriftlichung der Welt*, 105-43; Michael Curschmann, "Wort-Schrift-Bild. Zum Verhältnis von volkssprachigem Schrifttum und bildender Kunst vom 12. bis. zum 16. Jahrhundert," in *Mittelalter und frühe Neuzeit Übergänge, Umbrüche und Neuansätze*, ed. Walter Haug (Tübingen: Niemeyer, 1999), 378-470.

80 Alison Stones, "The Illustrated Chrétien Manuscripts and their Artistic Context," in *The Manuscripts of Chrétien de Troyes*, ed. Keith Busby, Terry Nixon, Alison Stones, and Lori Walter (Amsterdam and Atlanta: Rodopi, 1993), 227-322; Sandra Hindman, *Sealed in Parchment: Readings of Knighthood in the Illuminated Manuscripts of Chrétien de Troyes* (Chicago: University of Chicago Press, 1994); Maxwell, "Seeing Signs."

81 Helen Solterer, "Letter Writing and Picture Reading: Medieval Textuality and the *Bestiaire d'Amour*," *Word and Image* 5 (1989): 131-47; Curschmann, "Pictura laicorum litteratura?"

82 Michael Curschmann, "Images of Tristan," in *Gottfried von Strassburg and the Medieval Tristan Legend*, ed. Adrian Stevens and Roy Wisby (Rochester: D.S. Brewer, 1990), 1-17; Norbert Ott, "Text und Bilder" and "Bildstruktur statt Textstruktur," in *Bild und Text im Dialog*, ed. Klaus Dirscherl (Passau: Wissenschaftsverlag Rothe, 1993), 53-70.

83 William Melczer, *The Pilgrim's Guide to Santiago de Compostela* (New York: Italica Press, 1993); Alison Stones, "The Decoration and Illumination of the *Codex Calixtinus* at Santiago de Compostela," in *The* Codex Calixtinus *and the Shrine of St. James*, ed. John Williams and Alison Stones (Tübingen: Narr, 1992), 137-84, and "The Codex Calixtinus and the Iconography of Charlemagne," in *Roland and Charlemagne in Europe: Essays on the Reception and Transformation of a Legend*, ed. Karen Pratt (London: King's College, 1996), 169-203.

84 Sylvia Huot, *The* Romance of the Rose *and its Medieval Readers* (Cambridge: Cambridge University Press, 1993); Lori Walters, "Illuminating the *Rose*: Gui de Mori and the Illustrations of MS 101 of the Municipal Library, Tournai," in *Rethinking the Romance of the Rose*, 166-200.

85 Elmar Mittler and Wilfried Werner, *Codex Manesse. Die grosse Heidelberger Liederhandschrift. Texte, Bilder, Sachen* (Heidelberg: Brauss, 1988); Michael Camille, *The Medieval Art of Love* (New York: Harry N. Abrams, 1998), 36-37; Curschmann, "Wort-Schrift-Bild."

86 Robert Melzak, "Antiquarianism in the Time of Louis the Pious and Its Influence on the Art of Metz," in *Charlemagne's Heir*, 629-40.

87 *Kaiserin Theophanu.*

88 Wolfgang Grape, *The Bayeux Tapestry* (Munich: Prestel, 1994); Suzanne Lewis, *The Rhetoric of Power in the Bayeux Tapestry* (Cambridge: Cambridge University Press, 1999).

89 Werner Telesko, "'Quid est ergo tempus,'? Überlegungen zu den Verbindungslinien zwischen Zeitbegriff, Heilsgeschichte und Typologie in der christlichen Kunst des Hochmittelalters," *Mediaevistik* 13 (2000): 87-116.

90 Lewis, *Rhetoric of Power*, 59-73.

91 Jaroslav Folda, *The Art of the Crusaders in the Holy Land, 1098-1187* (Cambridge: Cambridge University Press, 1995).

92 Lewis, *Art of Matthew Paris*, 49.

93 Hahn, *Portrayed on the Heart*, 288-306 et passim.

94 Michael Curschmann, "*Der aventiure bilde nemen*: The Intellectual and Social Environment of the Iwein Murals at Rodenegg Castle," in *Chrétien de Troyes and the German Middle Ages*, ed. Martin H. Jones and Roy Wisbey (Cambridge: D.S. Brewer, 1993), 219-27; and *Von Wandel im bildlichen Umgang mit literarischen Gegenständen. Rodenegg, Wildenstein und das Flaarsche Haus in Stein am Rhein* (Freiburg: Universitätsverlag, 1997); James A. Rushing, *Images of Adventure. Ywain in the Visual Arts* (Philadelphia: University of Pennsylvania Press, 1995); Volker Schupp and Hans Szklenar, *Ywain auf Schloss Rodenegg: Eine Bildergeschichte nach dem "Iwein" Hartmanns von Aue* (Sigmaringen: Thorbecke, 1996).

95 James A. Rushing, "Hartmann's Works in the Visual Arts," in *A Companion to the Works of Hartmann von Aue*, ed. Francis Gentry (Rochester, NY: Camden House, forthcoming 2004).

96 Sears, "Ivory and Ivory Workers."

97 C. Jean Campbell, *The Game of Courting and the Art of the Commune of San Gimignano, 1290-1320* (Princeton: Princeton University Press, 1997).

98 Sears, "Ivory and Ivory Workers."

99 C. Jean Campbell, "Courting, Harlotry, and the Art of Gothic Carving," *Gesta* 34 (1995): 11-19; Richard H. Randall, Jr., "Popular Romances Carved in Ivory," in *Images in Ivory*, 63-79; James A. Rushing, "Adventure in the Service of Love: Yvain on a Fourteenth-Century Ivory Panel," *Zeitschrift für Kunstgeschichte* 61 (1998): 55-65.

100 Susan L. Smith, *The Power of Women: A Topos in Medieval Art and Literature* (Philadelphia: University of Pennsylvania, 1995).

101 Jean-Pierre Jossua, *La Licorne: Images d'un Couple* (Paris: Cerf, 1994).

102 Suzanne Lewis, "Images of Opening, Penetration, and Closure in the *Roman de la Rose*," *Word and Image* 8 (1992): 215-42; Caviness, *Visualizing Women*; Heather Arden, "The Slings and Arrows of Ourtrageous Love in the *Roman de la Rose*," in *The Medieval City Under Siege*, ed. Ivy Coris and Michael Wolfe (Woodbridge: Boydell, 1996), 191-205; Michael Camille, *Gothic Art. Glorious Visions* (New York: Harry N. Abrams, 1996), 171-72; and *Medieval Art of Love*, 64-65 et passim.

103 Jean-Claude Schmitt, *Les revenants: les vivants et les morts dans la société médiévale* (Paris: Gallimard, 1994), Eng. trans. Teresa Fagan (Chicago: University of Chicago Press, 1998); Binski, *Medieval Death*.

104 Pace, "'Dalla morte assente alla morte presente,' 335-76; Wirth, *L'Image à l'époque romane*, 304-14 et passim; Forsyth, "Narrative at Moissac."

105 Julian Gardner, *The Tomb and the Tiara: Curial Tomb Sculpture in Rome and the Middle Ages* (Oxford; Oxford University Press, 1992); Kessler and Zacharias, *Rome 1300*, 138-40; Saxer, *Sainte-Marie-Majeure*, 205-06.

106 Binski, *Medieval Death*, 92-115.

107 Binski, *Medieval Death*, 56.

108 Anna Maria D'Achille, "La scultura," in *Roma nel Duecento. L'arte nella città dei papi da Innocenzo a Bonifacio VIII*, ed. Angiola Maria Romanini (Turin: Seat, 1991), 145-235.

109 Michel Pastoureau, "Les sceaux et la fonction sociale des images," in *L'Image, Fonctions et Usages*: 275-308; Maxwell, "Seeing Signs"; Bedos-Rezak, "Medieval Identity."

110 Pastoureau, "Sceaux."

111 Enrico Castelnuovo, *Das künstlerische Portait in der Gesellschaft. Das Bildnis und seine Geschichte in Italien von 1300 bis Heute* (Berlin: K Wagenbach, 1988); Bruno Reudenbach, "Individuum ohne Bildnis? Zum Problem künstlerischer Ausdrucksformen von Individualität im Mittelalter," in *Individuum und Individualität im Mittelalter*, ed. Jan Aertsen and Andreas Speer (Berlin and New York: Walter de Gruyter, 1996), 807-18.

112 Belting, *Bild-Anthropologie*, 143-88 et passim.

Notes to Chapter Seven

1 Among other general publications, Belting, *Likeness and Presence*; Henk van Os et al., *The Art of Devotion in the Late Middle Ages in Europe 1300-1500* (Princeton: Princeton University Press, 1994); Simon Coleman and John Elsner, *Pilgrimage. Past and Present in the World Religions* (Cambridge: Harvard University Press, 1995); Franz Kohlschein and Peter Wünche, *Heiliger Raum: Architectur, Kunst und Liturgie im mittelalterlichen Kathedralen und Stiftskirchen* (Maria Laach: Institut der Abtei, 1998); *Romei & Giubilei. Il pellegrinaggio medievale a San Pietro (350-1350),* ed. Mario D'Onofrio (Milan: Electa, 1999); Éric Palazzo, *Liturgie et société au Moyen Âge* (Paris: Aubier, 2000); *Kunst und Liturgie im Mittelalter*; Michele Bacci, *"Pro remedio animae" Immagini sacre e pratiche devozionali in Italia centrale (secoli XIII e XIV)* (Pisa: Edizioni ETS,

2000); *Art, Cérémonial et Liturgie*; *Bildlichkeit und Bildorte*; *Frömmigkeit im Mittelalter. Politisch-soziale Kontexte, visuelle Praxis, körperliche Ausdrucksformen*, ed. Klaus Schreiner (Munich: Wilhelm Fink, 2002).

2 Jean-Claude Schmitt, "Rituels de l'images et récits de vision," in *Testo e immagine*, 419-59; Freedberg, "Holy Images and Other Images."

3 Catherine Conybeare, *Paulinus Noster. Self and Symbols in the Letters of Paulinus of Nola* (Oxford: Oxford University Press, 2000), 95-99.

4 Dorothy F. Glass, *Romanesque Sculpture in Campania. Patrons, Programs, and Style* (University Park: Penn State Press, 1991), 213-20.

5 Murray, *Notre-Dame*, 116-23. Most sermons were ad hoc and ephemeral, but a fourteenth-century compendium of vernacular sermons suggests that some were collected, read, and meditated; Bolzoni, *Rete delle immagini*.

6 Kemp, *Narratives*, 154-59 et passim.

7 Jens T. Wollesen, "Spoken Words and Images in Late Medieval Italian Painting," in *Oral History of the Middle Ages. The Spoken Word in Context*, ed. Gerhard Jaritz and Michael Richter (Krems: Medium Aevum Quotidianum, 201), 257-76.

8 Prado-Vilar, "Shadow of the Gothic Idol."

9 Heck, *L'échelle céleste*, 70-73; Constant Mews, *Listen, Daughter: The* Speculum Virginum *and the Formation of Religious Women in the Middle Ages* (New York: Palgrave, 2001).

10 Conrad Rudolph, *"First, I Find the Center Point": Reading the Text of Hugh of Saint Victor's* The Mystic Ark (Philadelphia: American Philosophical Society, 2004). But cf. Carruthers, *Book of Memory*, 41-45.

11 Jean-Philippe Antoine, *"Ad perpetuam memoriam. Les nouvelles fonctions de l'image peinte en Italie: 1200-1400,"* *Mélanges de l'École française de Rome* 100 (188): 541-615.

12 Christine Heck, *L'échelle céleste dans l'art du Moyen Âge. Une image de la quête du ciel* (Paris: Flammarion, 1997), 70-73.

13 Conybeare, *Paulinus Noster*, 91-110; Thomas Lentes, "'Andacht' und 'Gebärde,'" in *Kulturelle Reformation. Sinnformation im Umbruch 1400-1600*, ed. Bernhard Juseen and Craig Koslofsky (Göttingen: Vandenhoeck & Rupprecht, 1999), 29-67, and "Inneres Auge, Äusserer Blick und heilige Schau," in *Frömmigkeit im Mittelalter*, 179-220.

14 Albert Castes, "La dévotion privée et l'art à l'époque carolingienne: le cas de sainte Maure de Troyes," *Cahiers de Civilisation Médiévale* 33 (1990): 3-18; Jean-Claude Schmitt, "Rituels de l'image" and "La culture de l'imago,"

Annales 51(1996): 3-36; Bacci, *"Pro remedio animae,"* 82-83.

15 Zchomelidse, *Santa Maria Immacolata*, 100-09. The devotional character of the narrative was recognized in the fifteenth century when an altar was built around the fresco, framing the section of the Crucifixion.

16 Filippini, "Chiesa."

17 Hamburger, *Nuns as Artists*, 181-92 et passim.

18 Belting, *Likeness and Presence*, 362-70 and 410-19; Peter Dinzelbacher, "Religiöses Erleben vor bildender Kunst in autobiographische und biographische Zeugnissen des Hoch- und Spätmittelalters," in *Frömmigkeit im Mittelalter*, 299-330.

19 Krüger, *Frühe Bildkult*, 25-26; Jones, "*Visio Divina*?"

20 Sandler, *Omne bonum*, vol. 1, 127-28 et passim.

21 Paul Saenger, "Books of Hours and the Reading Habits of the Later Middle Ages," in *The Culture of Print. Power and the Uses of Print in Early Modern Europe*, ed. Roger Chartier (Princeton: Princeton University Press, 1989), 141-73; Wieck, *Time Sanctified;* Hamburger, *Visual and the Visionary*, 149-90.

22 Ursula Nilgen, "Byzantinistinen im westlichen Hochmittelalter," in *Lithostroton. Studien zur byzantinischen Kunst und Geschichte. Festschrift für Marcell Restle* (Stuttgart: Anron Hiersemann, 2000), 173-90.

23 Hamburger, *Visual and the Visionary*, 316-82.

24 Hamburger, *Visual and the Visionary*, 131-34; Rouse and Rouse, *Manuscripts and their Makers*, vol. 1, 155-57; Jones, "*Visio Dei?*"; Gia Toussaint, *Das Passional der Kundigunde von Bohmen: Bildrhetorik und Spiritualitat* (Paderborn: Schoningh, 2003)

25 Stahl, "Narrative Structure."

26 Joanna E. Ziegler, *Sculpture of Compassion: The Pietà and the Beguines in the Southern Low Countries, c. 1300-1600* (Brussels: Institut historique belge de Rome, 1992); Jeffrey F. Hamburger, "'To make women weep.' Ugly Art as 'Feminine' and the Origins of Modern Aesthetics," *Res* 31 (1997): 9-33.

27 Areford, "The Passion Measured"; Jean-Marie Sansterre, "L'image blessée, l'image souffrante: quelques récits de miracles entre Orient et Occident (VIe-XIIe siècle), in *Les images dans les société médiévales: Pour une histoire comparée*, ed. Jean-Marie Sansterre and Jean-Claude Schmitt (Brussels: Institut historique belge de Rome, 1999), 113-30.

28 *The Image of Christ* (cat. of the exhib. *Seeing Salvation*), ed. Gabriele Finaldi (London: National Gallery Company, 2000); Bernard McGinn, "On Mysticism & Art," *Daedalus* (Spring 2003): 131-34.

29 Jeffrey Hamburger, *Rothschild Canticles*, 72-77, and "Speculation on Speculation. Vision and Perception in the Theory and Practice of Mystical Devotion," in *Deutsche Mystik im abendländischen Zusammenhang*, ed. Walter Haug and Wolfram Schneider-Lastin (Tübingen: Max Niemeyer, 2000), 353-408; Flora Lewis, "The Wound in Christ's Side and the Instruments of the Passion: Gendered Experience and Response," in *Women and The Book*, 204-29.

30 Martin Zlatohlávek, "The Bride in the Enclosed Garden. Iconographic Motifs from the Biblical Song of Songs," in *The Bride in the Enclosed Garden* (Prague: National Gallery, 1995), 34-73.

31 P.-A. Sigal, *L'homme et le miracle dans la France médiévale (XIe-XIIe siècle)* (Paris: Cerf, 1985); Schmitt, "Rituels"; Jean-Marie Sansterre, "Un saint récent et son icône dans le Latium méridional au XIe siècle," *Byzantino-Slavica*, 56 (1995), 447-52; "La vénération des images à Ravenne dans le haut Moyen Âge: Notes sur une forme de dévotion peu connue," *Revue Mabillon*, n.s., 68 (1996): 5-21, and "Attitudes occidentale à l'égard des miracles d'im-ages dans le Haut Moyen Âge," *Annales* 53 (1998): 1219-41; Bacci, "*Pro reme-dio animae*."

32 Dominique Iogna-Prat, "'La Vierge en Majesté' du manuscrit 145 de la Bibliothèque municipale de Clermont-Ferrand," in *L'Europe et la Bible* (Cleremont-Ferrand: Bibliothèque Municipale et Interuniversitaire, 1992), 87-108; Schmitt, "Rituels."

33 Jones, "*Visio Divina?*"

34 Nigil Morgan, *Early Gothic Manuscripts* (London: Harvey Miller, 1982-88), no. 101; *Age of Chivalry*, 331-32.

35 Chiara Fugoni, *Francesco e l'invenzione delle stimmate. Una storia per parole e immagini fino a Bonaventura e Giotto* (Turin: Einaudi, 1993); Elvio Lunghi, "Francis of Assisi in Prayer before the Crucifix in the Accounts of the First Biographers," in *Italian Panel Painting*, 340-53.

36 Krüger, *Frühe Bildkult*, 50-56.

37 Richard C. Trexler, *The Christian at Prayer: An Illustrated Prayer Manual Attributed to Peter the Chanter* (Binghamton, NY: Medieval & Renaissance Texts & Studies, 1987); Schmitt, *Raison des gestes*, 289-320.

38 Simon Tugwell, "The Nine Ways of Prayer of St. Dominic: A Textual Study and Critical Edition," *Medieval Studies* 47 (1985): 1-124; Schmitt, *Raison des gestes*, 311-13.

39 Belting, *Likeness and Presence*, 412-14; Jones, "*Visio Divina?*"

40 Guglielmo Cavallo, "Cantare le immagini," in *Exultet*, 53-59.

41 Nino Zchomelidse, "Liturgisches Bild und liturgische Handlung, Bilder der Ostervigil in süditaliensichen Buchrollen," in *Bildlichkeit und Bildorte*, 105-14.

42 Legner, *Reliquien*, 256-61; Hahn, "Voices of the Saints."

43 Dorothy Hoogland Verkerk, "Exodus and Easter Vigil in the Ashburnham Pentateuch," *Art Bulletin* 77 (1995): 94-105.

44 Travis, "Daniel in the Lions' Den."

45 Faupel-Drevs, *Vom rechten Gebrauch*, 349-61.

46 Wolf, "Nichtzyklische narrative Bilder"; Filippini, "Chiesa."

47 Franz Hofmann, *Der Freskenzyklus des Neuen Testaments in der Collegiata von San Gimignano. Ein herausragendes Beispiel italienischer Wandmalerei zur Mitte des Trecento* (Munich: Scaneg Verlag, 1996); C. Griffith Mann, *From Creation to the End of Time: The Nave Frescoes of San Gimignano's Collegiata and the Structure of Civic Devotion*, unpub. Ph.D. diss. (Baltimore: Johns Hopkins University, 2002).

48 Toubert, *Un art dirigé*, 365-402; Palazzo, *Liturgie et société*, 162-63.

49 Binski, "English Parish Church"; Krüger, "Aschaffenburger Tafelbild"; van der Ploeg, "How Liturgical Is a Medieval Altarpiece?"

50 *Trésor de Saint-Denis*, 124.

51 Madeline Caviness, "Stained Glass Windows in Gothic Chapels, and the Feasts of the Saints," in *Kunst und Liturgie*, 135-48.

52 Wenzel, *Hören und Sehen*, 99.

53 Ursula Nilgen, "Die Bilder über dem Altar. Triumph- und Apsisbogenprogramme in Rom und Mittelitalien und ihr Bezug zur Liturgie," in *Kunst und Liturgie*, 75-89.

54 Wisskirchen, *Mosaikprogramm*, 122-23.

55 Kessler, *Spiritual Seeing*, 111-12.

56 Kupfer, *Romanesque Wall Painting*, 135-37.

57 Jung, "Beyond the Barrier."

58 Kessler, "Ciclo di San Pietro in Valle."

59 Marco Collareta, "Le immagini e l'arte. Riflessioni sulla scultura dipinta nelle fonti letterarie," in *Scultura lignea: Lucca 1220-1425*, ed. Clara Baracchini (Florence: Studio per edizioni scelte, 1995), 1-7.

60 Carlo Ginzburg, *Wooden Eyes. Nine Reflections on Distance*, trans. Martin Ryle and Kate Soper (New York: Columbia University Press, 2001), 63-78; Wolf, *Schleier und Spiegel*, 65-86.

61 Faupel-Drevs, *Vom rechten Gebrauch*, 356-60.

62 Hamburger, *Visual and the Visionary*, 317-18.

63 Michele Bacci, "The Berardenga Antependium and the *Passio Ymaginis* Office," *Journal of the Warburg and Courtauld Institutes* 61 (1998): 1-16.

64 Laura Jacobus, "'Flete mecum': The Representation of the Lamentation in Italian Romanesque Art and Drama," *Word & Image* 12 (1996): 110-26; Bacci, "*Pro remedio animae*," 131-36 et passim.

65 H.-J. Krause, "'Imago ascensionis' und 'Himmelloch': Zum 'Bild'-Gebrauch in der spätmittelalterlichen Liturgie," in *Skulptur des Mittelalters: Funktion und Gestalt*, ed. Friederich Möbius and Ernst Schubert (Weimar: H. Böhlaus Nachfolger, 1987), 280-323.

66 Fulton, *Judgment to Passion*, 244-88.

67 Binski, "English Parish Church"; Bruno Reudenbach, "Der Altar als Bildort: Das Flügelretabel und die liturgische Inszenierung des Kirchenjahres," in *Goldgrund und Himmelslicht: Die Kunst des Mittelalters in Hamburg,* ed. Uwe Schneede (Hamburg: Dölling & Galitz, 1999), 26-33; Wollesen, "Spoken Words and Images".

68 Palazzo, *L'évêque*; Mariaux, *Warmond d'Ivrée*.

69 Le Goff et al., *Sacre royal*.

70 Bonne, "*Concordia discors temporum*."

71 Leah Rutchick, "A Reliquary Capital at Moissac: Liturgy and Ceremonial Thinking in the Cloister," in *Decorations for the Holy Dead. Visual Embellishments on Tombs and Shrines of Saints*, ed. Stephen Lamia and Elizabeth Valdez del Álamo (Turnhout: Brepols, 2002), 129-50.

72 Caviness, "Stained Glass Windows."

73 Telesko, "Theologische Programm."

74 Wittekind, "Liturgiereflexion."

75 Bolzoni, *Rete delle immagini*, 3-46.

76 Diane J. Reilly, "Picturing the Monastic Drama: Romaneque Bible Illustrations of the Song of Songs," *Word & Image* 17 (2001): 389-400.

77 Sarah Beckwith, "Ritual, Church and Theatre: Medieval Dramas of the Sacramental Body," in *Culture and History 1350-1600*, ed. David Aers (Detroit: Wayne State University Press, 1992), 65-89; Glass, *Romanesque Sculpture*, 216-17; Philine Helas, *Lebende Bilder in der italienischen Festkultur des 15. Jahrhunderts* (Berlin: Akademie Verlag, 1999).

78 Götz Pochat, *Theater und bildende Kunst im Mittelalter und in der Renaissance in Italien* (Graz: Akademische Druck- und Verlagsanstalt, 1990).

79 Toubert, *Un art dirigé*, 365-402; Palazzo, *Liturgie et société*, 162-63.

80 Toubert, "Vierge."

81 Travis, "Daniel in the Lions' Den."

82 Johannes Tripps, *Das handelnde Bildwerk in der Gotik. Forschungen zu den Bedeutungsschichten und der Funktion des Kirchengebäudes und seiner Ausstattung in der Hoch- und Spätgotik* (Berlin: Gebr. Mann, 1998); Helas, *Lebende Bilder.*

83 Margot Fassler, "Liturgy and Sacred History in the Twelfth-Century Tympana at Chartres," *Art Bulletin* 75 (1993): 499-520.

84 Herklotz, *Eredi di Costantino,* 41-94.

85 Wolf, "Nichtzyklische narrative Bilde"; Caramassi, "Hochmittelalterlichen Fresken"; Filippini, "Chiesa"; Sible de Blaauw, "Following the Crosses: The Processional Cross and the Typology of Processions in Medieval Rome," in *Christian Feast and Festival,* ed. Paulus Post (Louvain: International Books, 2001), 319-43.

86 Ulrike Koenen, *Das "Konstantinskreuz" im Lateran und die Rezeption frühchristlicher Genesiszyklen im 12. und 13. Jahrhundert* (Worms: Wernersche Verlagsgesellschaft, 1995).

87 Belting, *Likeness and Presence,* 311-32; Wolf, *Salus populi romani,* 37-78; Serena Romano, "L'archeropita lateranense: storia e funzione," in *Volto di Cristo,* 39-41; Maria Andoloro, "L'archeropita in ombra del Laterano," in *Volto di Cristo,* 43-49.

88 Enrico Parlato, "Le icone in processione," in *Arte e iconografia,* 69-92.

89 Andaloro and Romana, "L'immagine nell'abside."

90 Wolf, *Schleier und Spiegel,* 47-62.

91 Elizabeth Lipsmeyer, "Devotion and Decorum: Intention and Quality in Medieval German Sculpture," *Gesta* 34 (1995): 20-27.

92 *Book of Sainte Foy.*

93 Rocío Sánchez Ameijeiras, "Imagery and Interactivity: Ritual Transaction at the Saint's Tomb," in *Decorations for the Holy Dead,* 21-38.

94 Joanna Cannon, "Popular Saints and Private Chantries: The Sienese Tomb-Altar of Margherita of Cortona," in *Kunst und Liturgie,* 149-62.

95 Low, "'You who once were far off'."

96 Gerhard Wolf, "'Pinta della nostra effige.' La veronica come richiamo dei romei," in *Romei & Giubilei,* 211-18.

97 Brian Spencer, *Pilgrim Souvenirs and Secular Badges* (London: Station Office Books, 1998); *Romei & Giubilei,* 338-65.

98 *Bonifacio VIII e il suo tempo.*

99 Gary Dickson, "The Crowd at the Feet of Pope Boniface VIII: Pilgrimage,

Crusade and the First Roman Jubilee (1300)," *Journal of Medieval History* 25 (1999): 279-307; Silvia Maddalo, "Ancora sulla Loggia di Bonifacio VIII al Laterano. Una proposta di ricostruzione e un'ipotesi attributiva," *Arte medievale* 12/13 (1999): 211-30.

100 Wolfang Georgi, "Ottonianum und Heiratsurkunde 962/972"; in *Kaiserin Theophanu*, vol. 2, 135-60; Anton von Euw, "Ikonologie der Heiratsurkunde der Kaiserin Theophanu," in *Kaiserin Theophanu*, vol. 2, 175-91.

101 Richard Brilliant, "The Bayeux Tapestry: A Stripped Narrative for Their Eyes and Ears," *Word and Image* 7 (1991): 98-126; Lewis, *Rhetoric of Power*, 3-7.

102 Campbell, *Game of Courting*, 194-95 et passim.

Notes to Chapter Eight

1 Schmitt, "Question des images."

2 Morrison, *Conversion and Text*, 82-83; Schmitt, "Dimensions multiples du voir."

3 Marie José Mondzain, "The Holy Shroud/ How Invisible Hands Weave the Undecidable," in *Iconoclash*, 324-35.

4 Schmitt, "Dimensions multiples du voir"; François Bœspflug and Yolanta Załuska, "Le dogme trinitaire et l'essor de son iconographie en Occident de l'époque carolingienne au IVe Concile du Latran (1215)," *Cahiers de civilisation médiévale Xe-XII siècle* 37 (1994): 181-240; Bœspflug, "La vision-en-reve."

5 Bonne, "Pensée de l'art"; Kessler, *Spiritual Seeing*, 193-94 et passim.

6 Lipsmeyer, "Devotion and Decorum."

7 Christopher Wood, "'Curious Pictures' and the Art of Description," *Word and Image* 11 (1995): 332-52; Hamburger, "Idol Curiosity."

8 Besançon, *Forbidden Image*, 164; Jean Wirth, "La critique scolastique de la théorie thomiste de l'image," in *Crises de l'image religieuse. De Nicée à Vatican II*, ed. Olivier Christin and Dario Bamboni (Paris: Éditions de la Maison des Sceinces de l'homme, 1999), 93-109.

9 Wirth, "Structure et fonctions."

10 Stahl, "Eve's Reach."

11 Deshman, "Another Look." The final scene on the Hildesheim doors (Fig. 9) makes the same point by merging the *Noli me tangere* with the Ascension; Stahl, "Eve's Reach."

12 Hughes, "Visual Typology"; Diebold, "Ottonian Diptych."

13 Diebold, "Ottonian Diptych"; cf. also Lowden, "Illuminated Books and the Liturgy."

14 van Os, *Way to Heaven*, 122; Arnulf, *Versus ad Picturas*, 298; Peter Schmidt, "Beschriebene Bilder. Benutzernotizien als Zeugnisse frommer Bildpraxis im späten Mittelalter," in *Frömmigkeit im Mittelalter*, 347-84; Hamburger, *Visual and Visionary*, 186.

15 Deshman, "Another Look."

16 On the use of framing elements, cf. Barbara Raw, *Trinity and Incarnation in Anglo-Saxon Art and Thought* (Cambridge: Cambridge University Press, 1997), 147-48.

17 Deshman, "Another Look."

18 Jean Wirth, "Structure et fonctions de l'image chez Saint Thomas d'Aquin," *L'image*, 39-57; Schmitt, "Question des images."

19 Deshman, "Another Look"; Raw, *Trinity and Incarnation*, 50-52.

20 Lewis, *Art of Matthew Paris*, 130-31.

21 Belting, *Likeness and Presence*, 220; Lewis, *Art of Matthew Paris*, 126-27; Neil MacGregor, *Images of Christ in Art* (New Haven: Yale University Press, 2000), 92-93.

22 Hahn, "Voices of the Saints."

23 Lowden, "Illuminated Books and the Liturgy."

24 Wittekind, "Liturgiereflexion."

25 Speciale, *Montecassino e la riforma*, 76 et passim.

26 Deshman, *Benedictional of Æthelwold*, 156-57; François Bœspflug, "La vision de la Trinité de Christine de Markyate et le *Psautier de Saint-Alban*," in *Micrologus* 6 (1998), vol. 2, 95-111.

27 Wirth, "Structure et fonctions"; Lentes, "Inneres Auge."

28 Katharine Park, "Impressed Images: Reproducing Wonders," in *Picturing Science, Producing Art*, ed. Caroline A. Jones and Peter Galison (London: Routledge, 1998), 254-71.

29 Lewis, *Art of Matthew Paris*, 126.

30 Hamburger, *Visual and Visionary*, 355-58.

31 Hamburger, *St. John the Divine*, 171-72.

32 Hans Belting, *The Image and its Public in the Middle Ages. Form and Function of Early Medieval Paintings of the Passion*, trans. Mark Bartusis and Raymond Meyer (New York: Aristide D. Caratzas, 1990), 6.

33 Hamburger, *Visual and the Visionary*, 350-62.

34 Jan A. Aertsen, "Beauty in the Middle Ages: A Forgotten Transcendental?," *Medieval Philosophy & Theology* 1 (1991): 68-97; Andreas Speer, "Beyond Art and Pain. In Search of the Object of Philosophical Aesthetics," *International Journal of Philosophical Studies* 8 (2000), 73-88.

35 Bescançon, *Forbidden Image*, 159-61.

36 Lentes, "Inneres Auge." Eriugena had already assigned a mystagogic function to the beauty of forms and colors; Jeauneau, "L'art comme mystagogie."

37 Bonne, "Entre l'image et la matière."

38 Bonne, "L'ornemental."

39 Schlink, *Der Beau Dieu*, 74-76.

40 van Os, *Way to Heaven*, 122.

41 Kessler, *Spiritual Seeing*, 19.

42 Kessler, "Ciclo di San Pietro in Valle."

43 Hamburger, "Idol Curiosity."

44 Lipsmeyer, "Devotion and Decorum."

45 Kessler, *Spiritual Seeing*, 104-48; Klaus Krüger, "Medium and Imagination: Aesthetic Aspects of Trecento Panel Painting," in *Italian Panel Painting*, 57-81.

46 Hughes, "Visual Typology."

47 For example, in the Benedictional of Aethelwold, Boulogne Gospels, and Hitda Codex; cf. Deshman, *Benedictional of Æthelwold*, 66-69 et passim.

48 Wolf, *Schleier und Spiegel*, 57-58.

49 Thunø, "*Decus suus splendet.*"

50 *Carlo Magno a Roma* (cat. of an exhib.) (Rome: Retablo, 2001), 156-57.

51 Kessler, *Spiritual Seeing*, 9-12; *Volto di Cristo*, 174. Peter of Celle interpreted the whole tabernacle as a material image of the invisible: "if you believe you have only a likeness and not the truth itself, let the likeness lead you to the truth"; cf. Caviness, *Sumptuous Arts*, 43.

52 Hamburger, *Visual and the Visionary*, 374-75; Wolf, *Schleier und Spiegel*, 125-26; Kessler, "Face and Firmament."

53 Kessler, *Spiritual Seeing*, 187-88; Brigitte Kurmann-Schwarz, *Glasmalerei im Aargau Konigsfelden, Zofingen, Staufberg* (Aarau: Lehrmittelverlag des Kantons Aargau, 2002), 56-60.

54 Belting, *Bild-Anthropologie*, 189-211.

55 Alexandre-Bidon, "Un foi en deux ou trois dimensions."

56 Valentino Pace, "Cristo-Luce a Santa Prassede," in *Per Assiduum Studium Scientiae Adipisci Margaritam*, 185-200.

57 Wisskirchen, *Mosaiken*, 121; Kessler and Zacharias, *Rome 1300*, 119.

58 Klein, "From the Heavenly to the Trivial."

59 Manhes-Deremble, *Les Vitraux narratifs*; Elizabeth Pastan, "The Torture of Saint George Medallion from Chartres Cathedral in Princeton," *Record of the Art Museum of Princeton University*, 56 (1997), 11-34.

60 Caviness, "Stained Glass Windows."

61 Vasilu, "Mot et le verre"; Travis, "Daniel in the Lions' Den."

62 Gabriella Federici Vescovini, "Vision et réalité dans la perspective au XIVe siècle," *Micrologus* 5 (1997): 161-80.

63 Sansterre, "Attitudes occidentales."

64 Alexandre-Bidon, "Un foi en deux ou trois dimensions"; Eve Borsook," Rhetoric or Reality: Mosaics as Expressions of a Metaphysical Idea," *Mitteilungen des Kunsthistorischen Institutes in Florenz*, 44 (2000); 2-18; Thunø, *"Decus suus splendet."*

65 Cynthia Hahn, "*Visio dei*. Changes in Medieval Visuality," in *Visuality Before and Beyond the Renaissance*, 169-96.

66 Neuheuser, "Kirchweihbeschreibung."

67 Caviness, "Stained Glass Windows."

68 Kupfer, *Romanesque Wall Painting*, 142-43; Palazzo, *Liturgie et société*, 144-47.

69 Andrew Breeze, "The Blessed Virgin and the Sunbeam through Glass," *Celtica* 23 (1999): 19-29

70 Caviness, "Stained Glass Windows."

71 Murray, *Notre-Dame*, 116-17.

72 Hamburger, *Visual and Visionary*, 317-82; Koerner, "Icon and Iconoclash."

73 Gerhard Wolf, "Christ in His Pain and Beauty. Concepts of Body and Image in an Age of Transition," in *Art of Interpreting*, 163-97; Koerner, "Icon as Iconoclash"; Krüger, "Medium and Imagination."

74 Jean-Michel Sansterre, "Vénération et utilisation apotropaïque de l'image à Reichenau vers la fin du Xe siècle: un témoignage des *Gesta* de l'abbé Witigowo," *Revue Belge de Philologie et d'Histoire* 73 (1995): 281-85.

75 Sansterre, "Saint récent."

76 Schmitt, *Raison des gestes*, 297-98.

77 Hamburger, "'To make women weep.'"

78 Richard C. Trexler, "Habiller et déshabiller les images: Esquisse d'une analyse," in *L'image et la production du sacré*, ed. Françoise Durand, Jean-Michel Spieser, and Jean Wirth (Paris: Méridiens Klincksieck, 1991), 195-231.

79 Caviness, "Stained Glass Windows."

80 Carruthers, *Book of Memory*, 221-29; Raw, *Trinity*, 90-91; Jakobi-Mirwald, *Text-Buchstabe-Bild*, 139-42; Jean Wirth, "L'emprunt des propriétes du nom par l'image médiévale," in *Verba vel Imagines. Contributions théoriques à la relation entre texte et image* (*Études de lettres* 3-4 [1994]): 61-92; Peter Parshall, "The Art of Memory and the Passion," *Art Bulletin* 81 (1999): 456-72.

81 Kessler, *Spiritual Seeing*, 121 et passim.

82 Mary Carruthers, *Craft of Thought: Meditation, Rhetoric, and the Making of Images, 400-1200* (Cambridge: Cambridge University Press, 1998), 206-09.

83 Faupel-Drevs, *Vom rechten Gebrauch*, 213-14 et passim.

84 Carruthers, *Book of Memory*, 96-99, and *Craft of Thought*, 118-22; Lentes, "Inneres Auge."

85 C. Gibson-Wood, "The Utrecht Psalter and the Art of Memory," *Revue d'art canadienne/Canadian Art Review* 14 (1987) 9-15; Carruthers, *Book of Memory*, 226-27.

86 Amy G. Remensnyder, "Legendary Treasure at Conques: Reliquaries and Imaginative Memory," *Speculum* 71 (1996): 884-906; Palazzo, "Livre dans les trésors."

87 Bolzoni, *Rete delle immagini*, 63.

88 Lewis, *Art of Matthew Paris*, 194-97.

89 Sandler, *Omne bonum*, vol. 1, 127, and "Face to Face."

90 See *Revue de l'Abbaye Royale de Fontrevaud*.

91 *The Lindisfarne Gospels. Turning the Pages CD-Rom* (London, The British Library).

92 Stephen Murray, *The Power of Change in Gothic—Notre-Dame Cathedral of Amiens* (Columbia University website: <http://www.learn.columbia.edu/Mcahweb/index-frame.html>).

Photo Credits

Photographs are reproduced with the permission of the following:

Pl. 1 Pino Abbrescia, Rome

Pl. 2 © CMN, Paris; (Pascal Lemaître)

Pl. 3 Museo del Duomo, Agrigento.

Pl. 4 Hessisches Landesmuseum, Darmstadt.

Pl. 5 Real Colegiata de San Isidoro, León © 1993 Metropolitan Museum of Art, New York

Pl. 6. Fig. 20 National Museum of Denmark, Copenhagen.

Pl. 7. Fig. 41 Giraudon/ArtResource, New York

Pl. 8, 9, 10. Fig. 6, 39 Herbert L. Kessler, Baltimore

Pl. 11 © 1984, Inventaire Général Centre ADAGP (R. Malnoury).

Pl. 12. Fig.18 Rheinisches Bildarchiv, Cologne

Fig. 1 Deutsches Archäologisches Institut, Rome

Fig. 2 Domschatzkammer und Diözesanmuseum, Osnabrück

Fig. 3 © Patrimonio nacional, Madrid

Fig. 4 © Dom-Museum, Hildesheim (Lutz Engelhardt)

Fig. 5	ArtResource, New York; permission of Staatliche Museen zu Berlin (Joerg Anders)
Fig. 7	© Arch.Pict.Paris; Caisse nationale des monuments historiques et des sites, Paris
Fig. 8	Presses de l'Université Paris, Sorbonne
Fig. 9	Bibliothèque municipale de Dijon (François Perrodin)
Fig. 10	Bibliothèque nationale de France, Paris
Fig. 11, 29, 31	By permission of the British Library
Fig. 12	The Board of Trinity College, Dublin
Fig. 13, 16	Musei Vaticani
Fig. 14	Dombibliothek, Hildesheim
Fig. 15	Biblioteca statale, Lucca, su concessione del Ministero per i Beni e le Attività culturali
Fig. 17, 22, 24	By permission of The Pierpont Morgan Library, New York
Fig. 19	© IRPA-KIK, Brussels
Fig. 21	Biblioteca nacional, Lisbon.
Fig. 23	Scala/ArtResource, New York
Fig. 25	Istituto centrale per il catalogo e la documentazione, Rome
Fig. 26	Foto Viola, Udine
Fig. 27	Colegiata de San Isidoro, León
Fig. 28	Bibliotheek der Rijksuniversiteit, Utrecht
Fig. 30	Biblioteca Apostolica Vaticana
Fig. 32, 33, 34, 35	© James Austin
Fig. 36	Fratelli Alinari, Florence
Fig. 37	Bibliothèque municipale, Laon
Fig. 38	Giulia Orofino, Universitá di Cassino
Fig. 40	Foto Marburg/ArtResource, New York
Fig. 42	James Rushing, Rutgers University

Index

Italicized page numbers refer to Illustrations